Evolution, Denken, Kultur

Robin Dunbar ist Leiter der Arbeitsgruppe für Soziale und Evolutionäre Neurowissenschaft an der Universität Oxford. Er veröffentlichte neben anderen Werken das 2004 erschienene Buch *Grooming, Gossip and the Evolution of Language* [dt. *Klatsch und Tratsch: wie der Mensch zur Sprache fand*] und formulierte die „Dunbar-Zahl", die besagt, dass stabile soziale Gruppen beim Menschen nicht mehr als ungefähr 150 Personen umfassen können.

Clive Gamble ist Professor für Archäologie an der Universität Southampton. Er beschäftigt sich mit unseren ältesten Vorfahren und insbesondere mit dem zeitlichen Ablauf der weltweiten Besiedelung. Neben anderen Werken veröffentlichte er das Buch *Archaeology: The Basics* (2007).

John Gowlett ist Professor für Archäologie an der Universität Liverpool. Seine Spezialgebiete sind evolutionäre Archäologie und Anthropologie; insbesondere befasst er sich mit den Voraussetzungen und dem Ursprung der Begriffsbildungsfähigkeit der Menschen. Er schrieb unter anderem *Ascent to Civilization* (1992) [dt. *Auf Adams Spuren: die Archäologie der Frühen Menschen*]. Die drei Autoren leiteten gemeinsam das große Forschungsprojekt „Lucy to Language – The Archaeology of the Social Brain".

Clive Gamble John Gowlett
Robin Dunbar

Evolution,
Denken, Kultur

Das soziale Gehirn und die Entstehung
des Menschlichen

Aus dem Englischen übersetzt von Sebastian Vogel

 Springer Spektrum

Clive Gamble
Faculty of Humanities
University of Southampton
Southampton
UK

Robin Dunbar
Department of Experimental
Psychology
University of Oxford
Oxford, OX
UK

John Gowlett
Department of Archeology
University of Liverpool
Liverpool
UK

Übersetzung der englischen Ausgabe „Thinking Big – How the Evolution of Social Life Shaped the Human Mind" von Clive Gamble, John Gowlett, Robin Dunbar. Published by arrangement with Thames and Hudson Ltd, London. © 2015 Thames & Hudson Ltd, London

ISBN 978-3-662-46767-1 ISBN 978-3-662-46768-8 (eBook)
DOI 10.1007/978-3-662-46768-8

Die Deutsche Nationalbibliothek verzeichnet diese Publikation in der Deutschen National-bibliografie; detaillierte bibliografische Daten sind im Internet über http://dnb.d-nb.de abrufbar.

Springer Spektrum
© Springer-Verlag Berlin Heidelberg 2016

Planung: Frank Wigger
Redaktion: Maren Klingelhöfer

Gedruckt auf säurefreiem und chlorfrei gebleichtem Papier

Springer Spektrum ist Teil der Fachverlagsgruppe Springer Science+Business Media (www.springer.com)

Vorwort

Im Großen zu denken ist etwas zutiefst Menschliches. Wir verfügen über eine bemerkenswerte Fantasie, die uns zurück in die Vergangenheit und weit in die Zukunft führen kann. Wir begeistern uns für Filme und Literatur, und wir grübeln über die Kreativität des menschlichen Geistes. Wenn wir uns an das Leben in Megametropolen anpassen, kommen wir mit den Neuerungen im zwischenmenschlichen Umgang ohne Weiteres zurecht. Wir arbeiten in einer globalen Wirtschaft, und was wir über diese große Welt wissen, entnehmen wir rund um die Uhr den Nachrichten. Aber obwohl wir oft in großen Dimensionen denken, bleiben wir in manchen wesentlichen Belangen engstirnig. Unsere Kognitionsfähigkeit beschränkt uns auf den Umgang mit einer nur kleinen Zahl von Menschen. Auch wenn die Größe der Bevölkerung exponentiell gewachsen ist, bleiben wir im Innersten das Produkt der kleinen sozialen Welt unserer Evolutionsvergangenheit.

In diesem Buch wollen wir der Frage nachgehen, wie unser leistungsfähiges soziales Gehirn in der Evolution entstanden ist. Zu diesem Zweck betrachten wir einerseits uns selbst und unsere engsten lebenden Verwandten – die Groß- und Kleinaffen – und andererseits die Schädel und Arte-

fakte unserer fossilen Vorfahren. Zwischen beiden besteht eine Verbindung, nämlich die Größe des Gehirns und der Umfang der kleinen sozialen Gesellschaften, in denen sie leben. Wir werden uns mit dem Gedanken beschäftigen, dass unser Sozialleben der Faktor war, der das Wachstum unseres charakteristischsten Merkmals, des menschlichen Gehirns, vorangetrieben hat.

Unsere Fähigkeit, im Großen zu denken, ist ein Teil unserer Evolutionsgeschichte. Aus dem Wunsch heraus, mehr über diesen unentbehrlichen Bestandteil des Menschseins zu erfahren, machten wir uns an ein sieben Jahre dauerndes Projekt (2003–2010), das die British Academy zur Feier ihres hundertjährigen Bestehens finanzierte. Wir nannten das Vorhaben *Lucy to Language: The Archeology of the Social Brain* („Von Lucy zur Sprache: die Archäologie des sozialen Gehirns"); auf den folgenden Seiten werden wir viel darüber erfahren, wie Lucy von einem Vorfahren mit kleinem Gehirn zu einer global verbreiteten, geistig aufgeschlossenen Spezies wurde.

Das Lucy-Projekt war von interdisziplinärer Zusammenarbeit geprägt. Den dahinterstehenden Gedanken unterstrich Sir Adam Roberts, der Präsident der British Academy, als er darüber schrieb, welchen Wert Geistes- und Sozialwissenschaften für die Öffentlichkeit haben: „Die Geisteswissenschaften beschäftigen sich mit der Frage, was es heißt, ein Mensch zu sein: mit Worten, Ideen, Erzählungen sowie den Kunstwerken und Artefakten, die uns helfen, in unserem Dasein und der Welt, in der wir leben, einen Sinn zu finden; mit der Frage, wie wir sie geschaffen haben oder von ihr erschaffen werden. Die Sozialwissenschaften streben danach, durch Beobachtung und Überlegung die

Prozesse aufzudecken, die das Verhalten von Einzelnen und Gruppen beherrschen. Gemeinsam helfen sie uns, uns selbst, unsere Gesellschaft und unseren Platz in der Welt zu verstehen." Damit war die Absicht unseres Lucy-Projekts zusammengefasst: Wir wollten die Vergangenheit und die Gegenwart erforschen, um so ein vollständigeres Bild davon zu zeichnen, woher wir kommen und warum wir so und nicht anders handeln.

Unser größter Dank gilt der British Academy und ihrer Entscheidung, ein Projekt zu finanzieren, das Geistes- und Gesellschaftswissenschaft verbindet. Ebenso hatten wir großes Glück mit der Lenkungskommission mit Garry Runciman, Wendy James und Ken Edmond, die unsere Berichte lasen, an allen unseren Tagungen teilnahmen und mit ihrer begeisterten Unterstützung und Beratung unschätzbar zum Erfolg der Forschungsarbeiten beitrugen. Außerdem danken wir David Phillipson FBA für die Förderung unserer Forschung in Afrika.

Während unserer gesamten Arbeit profitierten wir von der Ermutigung und klugen Beratung der Ehrenmitarbeiter des Projekts: Leslie Aiello, Holly Arrow, Filippo Aureli, Larry Barham, Alan Barnard, Robin Crompton, William Davies, Bob Layton, Yvonne Marshall, John McNabb, Jessica Pearson, Susanne Shultz, Anthony Sinclair, James Steele, Mark van Vugt, Anna Wallette, Victoria Winton und Sonia Zakrzewski.

Eines unserer Ziele war es, die nächste Generation von Wissenschaftlern dazu zu bringen, dass sie bei der Erforschung der Evolution des Menschen die Grenzen zwischen Sozial- und Geisteswissenschaften überschreiten. Wir hatten großes Glück, dass wir mit einer Gruppe so begabter

Postdocs und Doktoranden zusammenarbeiten konnten, von denen viele heute an Universitäten auf der ganzen Welt tätig sind. Unsere Postdocs waren Quentin Atkinson, Max Burton, Margaret Clegg, Fiona Coward, Oliver Curry, Matt Grove, Jane Hallos, Mandy Korstjens, Julia Lehmann, Stephen Lycett, Anna Machin, Sam Roberts und Natalie Uomini; Forschungsassistenten waren Anna Frangou und Peter Morgan; und als Doktoranden arbeiteten bei uns Katherine Andrews, Isabel Behncke, Caroline Bettridge, Peter Bond, Vicky Brant, Lisa Cashmore, James Cole, Richard Davies, Hannah Fluck, Babis Garefalakis, Iris Glaesslein, Charlie Hardy, Wendy Iredale, Minna Lyons, Marc Mehu, Dora Moutsiou, Emma Nelson, Adam Newton, Kit Opie, Ellie Pearce, Phil Purslow, Yvan Russell und Andy Shuttleworth. In Bezug auf die Forschung in Afrika und die Untersuchungen zum Feuer dankt John Gowlett besonders auch Stephen Rucina, Isaya Onjala, Sally Hoare, Andy Herries, James Brink, Maura Butler, Laura Basell, den National Museums of Kenya und NCST Kenya; außerdem Nick Debenham, Richard Preece, David Bridgland, Simon Lewis, Simon Parfitt, Jack Harris, Richard Wrangham und Naama Goren-Inbar.

Finanziert wurden die Forschungs- und Studienstipendien vor allem vom Centenary Project der British Academy; unsere Tagungen, Freilandarbeiten und Forschungsfreisemester wurden durch Stipendien der Finanzierungsprogramme Research Professorship, Small Grants, Conference und Exchange der British Academy ermöglicht. Für weitere Finanzierungsmittel danken wir dem Arts and Humanities Research Council, dem Economic and Social Research Council, dem Engineering and Physical Sciences Research

Council, dem Natural Environment Research Council, dem Leverhulme Trust, dem Boise Fund sowie den EU-Programmen FP6 und FP7. Großzügige Unterstützung erhielten wir auch von unseren Herkunftsinstitutionen, der Universität Oxford, der Universität Liverpool sowie der Royal Holloway und der Universität Southampton.

Jedes langwierige Projekt wird durch die natürlichen Rhythmen des Lebens geprägt. Fünf Babys wurden geboren, und keines von ihnen hieß Lucy! Wir können mit Freude berichten, dass sich das soziale Gehirn bei allen sehr hübsch entwickelt.

Clive Gamble
John Gowlett
Robin Dunbar

Inhalt

1

Psychologie trifft Archäologie

Die Evolution des Menschen ist eine legendäre Geschichte, die uns immer wieder aufs Neue fasziniert und verzaubert. In unserer Vergangenheit verbirgt sich einer der Triumphe der Evolution: der Prozess, durch den sich sowohl die äußere Gestalt als auch die Lebensweise eines gewöhnlichen afrikanischen Menschenaffen so veränderten, dass er am Ende zur beherrschenden Spezies der Erde wurde. Erst seit rund hundert Jahren können wir wirklich einschätzen, was für eine großartige Geschichte das ist und wie oft sie durch Augenblicke der Unsicherheit und des Beinahe-Aussterbens gefährdet war.

Kleine Anfänge

Rund 7 Mio. Jahre trennen uns von der Zeit, in der die Vorfahren von Menschen und Schimpansen eine einzige biologische Art waren: ein kleiner, unauffälliger Menschenaffe im afrikanischen Miozän.[1] Seinen Abschluss fand dieser Teil unserer Geschichte in den letzten 5000 Jahren, als wir als einzige Tiere alle Lebensräume auf den Landflächen der Erde besiedelt hatten, von den tropischen Wäldern bis zur arktischen Tundra und von Hochgebirgsebenen bis zu weit abgelegenen Inseln im Ozean. Während dieser langen Geschichte verdreifachte sich die Größe unseres Gehirns, und unsere Technologie entwickelte sich von einfachen Steinwerkzeugen bis zu den Wundern des Digitalzeitalters. Wir gingen aufrecht, sprachen, schufen jede Menge Kunst und bauten im Namen von Religion, Politik und Gesellschaft ganze Welten von ungeheurer fantasievoller Komplexität. Menschenaffen sind wir wirklich nicht mehr.

Während des größten Teils dieser 7 Mio. Jahre waren wir nicht allein. Wo unsere entfernten Vorfahren lebten, teilten sie sich den Platz häufig mit anderen, eng verwandten Arten. Dieses uralte Prinzip wandelte sich vor 60.000 Jahren, als Menschen wie wir, Jetztmenschen, aus Afrika in die Alte Welt auswanderten. Ältere Arten wie die Neandertaler in Europa und Westasien wurden verdrängt und starben aus. Die gleichen Jetztmenschen überwanden auch die Grenzen der Alten Welt und besiedelten zum ersten Mal sowohl Australien als auch Amerika. Vor 11.000 Jahren, als die letzte

[1] Das Miozän ist die Zeit vor ungefähr 23 bis 5,3 Mio. Jahren; die Phase vor 5,3 bis 2,6 Mio. Jahren nennt man Pliozän, und die letzte große geologische Epoche, das Pleistozän, war die Zeit vor 2,6 Mio. bis 11.700 Jahren.

Eiszeit zu Ende ging, waren wir die einzige verbliebene Spezies; jetzt war der *Homo sapiens*, aus Sicht der Evolution betrachtet, allein.

Wenig später wurden wir zur globalen Spezies. Der Wechsel zur Landwirtschaft führte einerseits zu Städten, Zivilisation und einem ungeheuren Bevölkerungszuwachs, andererseits ermöglichte die Domestizierung von Pflanzen aber auch seit der Zeit vor 5000 Jahren Seereisen in abgelegene Regionen des Pazifiks, und nachdem man sich die Kraft der Tiere zu Nutze gemacht hatte, konnte man kalte und heiße Wüsten durchqueren. Da ist es kein Wunder, dass die europäischen Entdeckungsreisenden überall Menschen vorfanden; und das ist noch nicht alles: Die Entdecker bestätigten wieder und wieder durch erfolgreiche, wenn auch nicht immer einvernehmliche Paarung den historischen Umstand, dass der *Homo sapiens* eine einzige biologische Spezies ist.

Diese 7 Mio. Jahre alte Geschichte tragen wir bis heute in unserem Körper und unserem Gehirn mit uns herum. Die wissenschaftlichen Erkenntnisse, die aus dem anatomischen Vergleich zwischen uns und den Menschenaffen erwachsen, haben entscheidend dazu beigetragen, dass wir den Ablauf der Evolution verstehen konnten, und die Revolution der Genetik hat neue Indizien erbracht, sodass wir durch Untersuchung heutiger und alter DNA den Abstammungslinien unserer Vorfahren nachspüren können. Auch Fossilien von Skeletten, Schädeln und Zähnen liefern Informationen über die Evolution und sind deshalb Gegenstand der Wissenschaft. Gleichzeitig konnten Archäologen die Entwicklung der Technologie nachzeichnen und wichtige Fragen im Zusammenhang mit Ernährung, Verhalten

und der zuverlässigen Sicherung der Nahrungsversorgung aufklären. Insgesamt ergibt sich daraus ein viel reichhaltigeres, genaueres Bild unserer ältesten Vergangenheit.

Unsere wissenschaftliche Laufbahn begann Ende der 1960er-Jahre, als die Landschaft der Evolutionsforschung noch ganz anders aussah. Es gab nur wenige Fossilien, und wissenschaftlich begründete Datierungsmethoden (allen voran die Radiokarbonmethode) steckten noch in den Kinderschuhen. Fundstätten und Material mit eigenen Augen zu sehen, war sowohl schwierig als auch teuer, bis der Jumbojet 1970 eine Umwälzung des internationalen Reiseverkehrs einleitete. Computer füllten ganze Kellergeschosse und mussten mit Lochkarten programmiert werden. Es gab weder Touchscreens noch Suchmaschinen, und der größte Luxus, über den wir als Doktoranden verfügten, war ein Fotokopiergerät, das teure Bilder auf glänzendem Papier erzeugte.

Es kann einem fast schwindlig werden angesichts des Tempos des technologischen Wandels und der Geschwindigkeit, mit der sich neue Erkenntnisse über unsere Ursprünge angesammelt haben. Alles hat einmal klein angefangen, wenn man es mit der Gegenwart vergleicht. Man sollte aber nicht annehmen, dass „klein" gleichbedeutend mit „unwichtig" wäre. Wie wir in diesem Buch deutlich machen werden, zielt der materielle Wandel trotz aller Differenziertheit nach wie vor darauf ab, einige uralte Fragen des Menschseins zu beantworten. Diese Fragen betreffen vor allem unser Sozialleben, das nach unserem Eindruck bei der Erforschung unserer Ursprünge mehr oder weniger übergangen wurde.

Unsere wichtigste Aussage in diesem Buch lautet: Es hat immer einen Zusammenhang zwischen unserem Gehirn – oder genauer gesagt: der Größe unseres Gehirns – und der Größe unserer grundlegenden sozialen Einheiten gegeben. Dieser Zusammenhang ist in unseren Augen von entscheidender Bedeutung, wenn wir unsere Evolution als die der einzigen globalen Spezies verstehen wollen, die in Städten von der Größe Rio de Janeiros leben kann und täglich auf eine Riesenmenge an Informationen zurückgreift, um das eigene Leben zu bewerkstelligen. In dem heutigen Weltbürger steckt ein soziales Lebewesen, und dieses führt nach wie vor ein Sozialleben, das in seinen grundlegenden Aspekten dem vor 5000 oder 50.000 Jahren sehr ähnlich ist. Im Mittelpunkt unserer Überlegungen steht die Beobachtung, dass es, was die Größe unseres Beziehungsnetzes angeht, eine Obergrenze von ungefähr 150 Personen gibt. Diese Zahl ist als Dunbar-Zahl bekannt, weil einer von uns, nämlich Robin Dunbar, sie durch seine Forschungsarbeiten nachgewiesen hat. Dieser Grenzwert ist fast dreimal so groß wie der des Schimpansen, womit sich sofort die Frage stellt: Wie konnte es in der Evolution zu der Steigerung kommen? Dies wirft aber auch eine andere Frage auf: Wenn die Grenze bei 150 liegt, wie können wir dann in so großen Städten zusammenleben und uns in so ungeheuer bevölkerungsreiche Nationen wie China oder die Vereinigten Staaten einordnen?

Mit diesem Buch möchten wir den Evolutionsweg von unseren kleinen Anfängen bis zum heutigen Zustand nachzeichnen. Dabei lassen wir uns vor allem von Psychologen und Archäologen leiten, beteiligt sind aber auch viele ande-

re Fachgebiete. Mit unserer gruppenorientierten Sichtweise auf die Evolution der Menschen machen wir uns daran, neue Aufschlüsse über einige zentrale Themen zu gewinnen:

- Gibt es in unserem Gehirn oder unserer Kognitionsfähigkeit eine Grenze, die dafür sorgt, dass wir nur in sozialen Gruppen einer bestimmten Größe leben können?
- Wenn ja: Wie erlangte unsere Kognitionsfähigkeit in der Evolution die Fähigkeit, mit einer immer größeren Zahl von Menschen zurechtzukommen, als die Gesellschaften von den kleinen sozialen Gruppen der Jäger und Sammler zu den heutigen Megastädten heranwuchsen?
- Was meinen wir angesichts der Tatsache, dass unsere Vorfahren ein viel kleineres Gehirn hatten als wir, wenn wir vom Sozialleben in der entfernten Vergangenheit sprechen?
- Werden wir jemals genau wissen, wann im Gehirn der Homininen ein menschlicher Geist entstand?

Die Liste ließe sich natürlich beliebig verlängern, aber die genannten Kernfragen machen deutlich, dass unser Interesse sich zuallererst nicht auf die Geschichte der Technologie oder die anatomischen Einzelheiten fossiler Schädel richtet, sondern auf den zwischenmenschlichen Bereich. Außerdem zeigen sie, dass es uns um die Frage der Kognition geht, dass wir verstehen wollen, wie und warum wir so und nicht anders denken und handeln. Unsere Herangehensweise hat ihr Fundament in der Evolutionstheorie, und unser Ziel besteht darin, die Erkenntnisse aus dem experimentellen Fachgebiet der Psychologie auf die historische Disziplin der Archäologie anzuwenden. Das wurde noch selten versucht

und ist niemals einfach. Aber zunächst geben wir einige Hintergrundinformationen.

Eine Idee nimmt Gestalt an

Im Jahr 2002 schrieb die British Academy, in Großbritannien die nationale Körperschaft für Geistes- und Sozialwissenschaften, einen Wettbewerb aus. Es ging um ein Forschungsprojekt, mit dem ihr hundertjähriges Bestehen gefeiert werden sollte. Der größte Einzeletat aller Zeiten sollte für ein geistes- und sozialwissenschaftliches Leuchtturmprojekt vergeben werden. Wir hatten zwar ganz unterschiedliche Sichtweisen und Interessen, aber wir hatten alle drei einen großen Teil unseres Berufslebens auf die Erforschung der Evolution des Menschen verwendet. Einer von uns war ein Steinzeitarchäologe, der sich vor allem für Afrika interessierte, einer ein Sozialarchäologe mit besonderem Interesse an den Gesellschaften des späten Paläolithikums in Europa und der dritte ein Evolutionspsychologe, der sich vor allem mit dem Verhalten von Menschen und Primaten beschäftigte.

Als wir darüber nachdachten, welche Gelegenheiten ein solches Projekt bieten könnte, sah es für uns so aus, als würden wir genau die richtigen Voraussetzungen mitbringen, um die Herausforderung, vor die uns die British Academy gestellt hatte, anzunehmen. Wir stellten die größte Einzelfrage, die man überhaupt stellen kann (Wie wurden wir zu Menschen?), und wir konnten zu ihrer Beantwortung neuartige Fachkenntnisse beisteuern. War man bei der Erforschung der menschlichen Evolution früher darauf ange-

wiesen gewesen, sich auf die begrenzten physischen Belege zu stützen, die zur Verfügung standen (nämlich Steine und Knochen), so befanden wir uns in der glücklichen Lage, dass wir auch neuere Befunde über Sozialverhalten und Gehirnevolution nutzen konnten, von denen wir uns Aufschluss über die Bedeutung von Steinen und Knochen versprachen. Außerdem gehörte die Archäologie zum geisteswissenschaftlichen Teil der Akademie, die Psychologie dagegen zum sozialwissenschaftlichen Teil; wir konnten also die getrennten Lager, denen die Akademie vorstand, überbrücken und ein Musterbeispiel für interdisziplinäre Forschung liefern. Sehr schnell packte uns die Begeisterung; wir setzten uns zusammen und sandten eine Bewerbung ein.

Ein Projekt, wie es hier angeboten wurde, eröffnete buchstäblich grenzenlose Möglichkeiten. Was die Zusammenführung von Psychologie und Archäologie anging, stand die wissenschaftliche Welt noch ganz am Anfang. Im vorangegangenen Jahrzehnt hatten wir miterlebt, wie unter der Führung des britischen Archäologen Colin Refrew und des amerikanischen Archäologen Thomas Wynn das Fachgebiet der kognitiven Archäologie entstanden war. Im Mittelpunkt ihres Ansatzes stand die Frage, welche Anforderungen die Werkzeugherstellung und die Schaffung von Kunstwerken an die Kognition stellt. Nach unserem Eindruck würden wir aber angesichts der in jüngster Zeit gewonnenen Erkenntnisse über das Verhalten unserer engsten lebenden Verwandten, der Klein- und Menschenaffen, und über wichtige Themen wie die Evolution des Gehirns in der Lage sein, einen Schritt weiterzukommen und etwas über das Sozialleben der Homininen (s. Tab. 1.1) sagen zu können; dazu mussten wir viel weiter in die Vergangenheit

Tab. 1.1 Im Zusammenhang mit der Evolution des Menschen häufig verwendete Begriffe

Anthropoiden	Alle Primaten (Klein- und Menschenaffen einschließlich ihrer fossilen Vorfahren), Homininen und Menschen
Hominiden	Alle Menschenaffen (Gorillas, Orang-Utans, Schimpansen, Bonobos, Gibbons), Homininen und Menschen
Homininen	Alle unsere fossilen Vorfahren (*Ardipithecus, Australopithecus, Homo*)
Menschen	Nur die modernen Menschen (*Homo sapiens*)
Anatomisch moderne Menschen	*Homo sapiens*, aber ohne nennenswerte Belege für kulturelle Errungenschaften (Kunst, Bestattungen, Verzierungen, Musikinstrumente)

vordringen, als die meisten Kognitionsarchäologen es bis dahin gewagt hatten. Vor allem die Theorie, die unter dem Schlagwort „Hypothese des sozialen Gehirns" bekannt geworden war – die Vorstellung, dass das Gehirn sich in der Evolution so entwickelt hatte, dass Klein- und Menschenaffen in einem ungewöhnlich komplexen sozialen Umfeld zurechtkommen –, bot neue Erkenntnisse und zahlreiche Ansatzpunkte, von denen man ausgehen konnte, um die soziale Evolution der Homininen genauer zu erforschen.

Unsere Bewerbung trug den hochtrabenden Titel *Lucy to Language: The Archeology of the Social Brain* („Von Lucy zur Sprache: die Archäologie des sozialen Gehirns"). Lucy war das berühmte Fossil eines frühen Australopithecinen, das der Paläoanthropologe Don Johanson und seine Arbeitsgruppe 1974 in der Wüste im Nordosten Äthiopiens aus-

gegraben hatten (und das nach dem Beatles-Song *Lucy in the Sky with Diamonds*, der während der Grabungsarbeiten auf einem Tonbandgerät lief, benannt wurde). Lucy und ihre Familie hatten vor rund 3,5 Mio. Jahren gelebt und stellten die ältesten gut dokumentierten Homininen dar. Da die Australopithecinen noch viele Ähnlichkeiten mit unseren gemeinsamen Vorfahren, den Menschenaffen, aufweisen – zumindest was die Gehirngröße betrifft –, schien es naheliegend, bei ihnen mit unseren Arbeiten zu beginnen. Die Sprache ist das Kennzeichen für die Entstehung der Jetztmenschen, also unserer selbst, und schien damit der natürliche Endpunkt zu sein. So kam das Projekt zu seinem Namen.

Nachdem wir unseren Antrag eingereicht hatten, konnten wir nur noch abwarten. In den Natur- oder Geisteswissenschaften eine Forschungsfinanzierung zu erhalten, ist heutzutage in keinem Land einfach, und deshalb machten wir uns über das Ergebnis keine Illusionen. Die Bewilligungsquoten sind bei allen britischen Forschungsförderungsinstitutionen notorisch niedrig: Nur für ungefähr 10 % aller beantragten Projekte werden Mittel bewilligt, und das, obwohl in fast allen Fällen spannende, neue, innovative Forschungsarbeiten vorgeschlagen werden. Wir rechneten fest damit, dass wir anschließend über einem weiteren abgelehnten Antrag brüten würden. Deshalb waren wir überrascht und auch aufgeregt, als wir hörten, dass unser Projekt für das letzte Stadium der Befragungen in die engere Wahl gekommen war. Wir hatten also zumindest eine Chance!

Am Ende ging die Geschichte natürlich glücklich aus, sonst hätten wir dieses Buch nicht geschrieben. Unser Vorhaben wurde von der British Academy als Jubiläumsforschungsprojekt ausgewählt. Wie sich herausstellte, war die Konkurrenz weitaus größer gewesen, als wir uns vorgestellt hatten. Insgesamt waren mehr als 80 Anträge eingereicht worden. Viele andere potentiell spannende Projekte hatten mit einer Enttäuschung geendet, und die Antragsteller jammerten oder knirschten mit den Zähnen, wie es unter solchen Umständen unvermeidlich ist. Nachdem uns aber die Finanzmittel für ein siebenjähriges Projekt zugesagt waren, mussten wir nur noch eine Mannschaft aus begeisterten jungen Wissenschaftlern zusammenstellen, dann konnten wir uns ins Unbekannte aufmachen. *Evolution, Denken, Kultur* ist die Geschichte unseres Projekts.

Das soziale Gehirn und seine Evolution

Kernstück unseres Projekts war die Hypothese vom sozialen Gehirn, deren erste zögernde Entwicklungsschritte in den 1970er-Jahren stattgefunden hatten. Damals wurde man darauf aufmerksam, dass Klein- und Menschenaffen im Verhältnis zur Körpergröße ein viel größeres Gehirn haben als alle anderen Tiere. Als die Primatenforscher darüber nachdachten, kamen mehrere von ihnen mehr oder weniger unabhängig auf die Idee, dies könne daran liegen, dass Affen in ungewöhnlich komplexen Gesellschaften leben. Später, in den 1980er-Jahren, äußerten die Primaten-

forscher Andy Whiten und Dick Byrne von der University of St. Andrews die Vermutung, die Primatengesellschaften seien vielleicht gerade wegen des Verhaltens der Tiere selbst so komplex. Eine Affengruppe ist etwas anderes als ein Bienenstock, dessen ungeheure strukturelle Komplexität daraus erwächst, dass die einzelnen Individuen darauf programmiert sind, verschiedene Aufgaben auszuführen. Ein Bienenstock ist im Wesentlichen das Ergebnis einer strengen chemischen Verhaltenssteuerung: Die einzelnen Bienen entscheiden sich nicht dafür, die Funktion einer Arbeiterin, einer Drohne oder einer Königin zu übernehmen, sondern sie werden durch das Zusammenwirken ihrer Gene und der chemischen Signale, die sie vom übrigen Bienenstock empfangen, dazu gezwungen. Affen dagegen sind Individuen und stellen ihr Verhalten in den Grenzen ihrer individuellen Psychologie auf die Unwägbarkeiten der Umstände ein, in denen sie gerade leben.

Die Komplexität der Primatengesellschaften entsteht durch die Besonderheiten in den Interaktionen zwischen den Individuen. Und wie jeder Freilandprimatenforscher bestätigen wird, ist die Seifenoper des alltäglichen Lebens in einer Affengruppe der Grund, warum diese Gruppe so faszinierend und gleichzeitig so kompliziert ist. Whiten und Byrne begeisterten sich für die Tatsache, dass Klein- und Menschenaffen einander ständig täuschen und überlisten, im ständigen Versuch, sich im großen Wettlauf des Lebens einen Vorsprung zu verschaffen. Ein Affe versteckt unter Umständen immer wieder eine schmackhafte Frucht, damit ein anderer sie nicht sieht; oder er stößt einen Alarmruf aus, um die anderen abzulenken, damit sie nicht bemerken,

dass er eine besonders hübsche Knolle gefunden hat und gerade dabei ist, sie auszugraben, was eine gewisse Zeit in Anspruch nimmt. Whiten und Byrne sprechen in diesem Zusammenhang von der Hypothese der machiavellistischen Intelligenz – eine Hommage an Niccolò Machiavelli, den italienischen politischen Philosophen aus der Renaissance, der in seinem bahnbrechenden Buch *Der Fürst* die hinterhältigen politischen Strategien formulierte, die einem spätmittelalterlichen Herrscher am besten den Erfolg und ein langes Leben sichern.

Manche Fachleute erhoben allerdings Einwände gegen die unausgesprochene Vermutung, die Politik der Primaten werde von den gleichen hinterhältigen Überlegungen angetrieben wie die Politik der Menschen; deshalb änderte man später den Namen der Theorie, und damit war die Hypothese vom sozialen Gehirn geboren. Teilweise wurde damit anerkannt, dass es nicht nur um das komplexe Verhalten der großen und kleinen Affen ging, sondern auch um die Größe ihrer Gruppen. Weiteren Rückhalt erhielten diese Überlegungen in den 1990er-Jahren, als man nachweisen konnte, dass die durchschnittliche Größe der sozialen Gruppen einer Spezies mit ihrer Gehirngröße korreliert (s. Abb. 1.1); oder, um genauer zu sein, korreliert sie mit der Größe des Neocortex (wörtlich „neue Rinde"), der äußeren Schicht des Gehirns, die das sogenannte alte Gehirn (Hirnstamm und Mittelhirn mit dem limbischen System und den Teilen, die den größten Teil der autonomen Tätigkeiten des Organismus steuern) umgibt. Die Größe des Neocortex hat im Laufe der Primatenevolution explosionsartig zugenommen. Seine massive Ausweitung war der Grund,

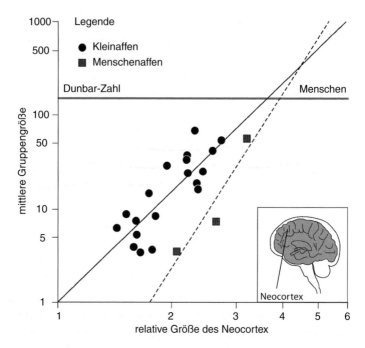

Abb. 1.1 Die Größe der sozialen Gruppen verschiedener Klein- und Menschenaffenarten, aufgetragen gegen die relative Größe des Neocortex. Der Neocortex ist die äußere Gehirnrinde, die für das komplexe Denken zuständig ist. Der Index der relativen Neocortexgröße (Neocortexverhältnis) ist das Volumen des Neocortex, dividiert durch das Volumen des übrigen Gehirns; mit seiner Hilfe können wir angesichts der unterschiedlichen Gehirngröße standardisieren. (Nach © Gamble 2007; Abb. 8.1)

warum Primaten ein größeres Gehirn haben als andere Säugetiere. Der Neocortex taucht zum ersten Mal in der Abstammungslinie der Säugetiere auf – einen vergleichbaren Gehirnteil gibt es allerdings auch bei Vögeln.

In den 60 bis 70 Mio. Jahren, seit die Primaten in der Evolution erstmals als eigene Säugetiergruppe auf der Bildfläche erschienen, ist ihr Neocortex immer stärker gewachsen, während sich eine Spezies aus der anderen entwickelte. Er liegt heute über dem „Reptiliengehirn", wie man es nennen kann, und ermöglicht es den Säugetieren, ihr Verhalten weitaus raffinierter auf die Unwägbarkeiten des Alltagslebens einzustellen. Die Komplexität des Verhaltens und die dahinterstehenden psychologischen Eigenschaften sind zwar der Schlüssel zur Hypothese des sozialen Gehirns, unter dem Strich kann man aber sagen: Die Gehirngröße einer Spezies erlegt offenbar der Größe ihrer sozialen Gruppen eine Beschränkung auf. Wachsen Gruppen über das speziestypische Limit hinaus, zerfallen sie, weil die Tiere es nicht mehr schaffen, dauerhafte Beziehungen zueinander aufrechtzuerhalten.

In diesem Zusammenhang scheint zweierlei wichtig zu sein. Das eine ist der hohe psychologische Entwicklungsstand der Klein- und Menschenaffen einschließlich ihrer offenkundigen Fähigkeit, Strategien zu entwickeln und zu täuschen. Das zweite ist die Tatsache, dass eine solche Form der sozialen Kognition im Hinblick auf die „Rechenleistung" sehr aufwendig ist: Die Neuronen im Gehirn müssen hart arbeiten. Beide Themen werden wir in späteren Kapiteln genauer untersuchen; vorerst möge es reichen, wenn wir sagen, dass beide Bestandteile eng verknüpft sind. Wir konnten nachweisen, dass die Form der Geselligkeit, über die Menschen verfügen, von einer Fähigkeit namens Gedankenlesen oder Mentalisierung abhängt – damit ist die Fähigkeit gemeint, zu verstehen oder zu vermuten, was ein

anderer denkt. Mit ihrer Hilfe können wir die Absichten mehrerer Menschen gleichzeitig im Kopf behalten und unser Verhalten so darauf einstellen, dass ihren Interessen ebenso gedient ist wie unseren, wenn wir auf eine bestimmte Weise handeln. Zusätzlich konnten wir nachweisen, dass diese Fähigkeit, mit den geistigen Zuständen vieler Individuen umgehen zu können, entscheidend vom Volumen der Nervensubstanz in bestimmten Teilen des Neocortex abhängt. Diese Regionen in den Stirn- und Schläfenlappen bilden ein Netzwerk von Nervenzellknoten, die bekanntermaßen für die Mentalisierung unentbehrlich sind.

Für unsere Geschichte ist ein zentraler Aspekt in der Hypothese vom sozialen Gehirn besonders interessant: Sie macht sehr genaue Voraussagen über die Größe von Menschengruppen. Nach der Gleichung, die bei Menschenaffen die Größe der sozialen Gruppen einer Spezies mit dem Volumen ihres Neocortex in Zusammenhang bringt, liegt die natürliche Gruppengröße für Menschen bei ungefähr 150 Individuen, und dieser Wert ist, wie wir bereits erfahren haben, heute als Dunbar-Zahl bekannt. Dass sie für unsere Geschichte wichtig ist, liegt unter anderem daran, dass die in Abb. 1.1 gezeigte Relation für die ganze Abfolge von den Schimpansen (die repräsentativ für den letzten gemeinsamen Vorfahren von Menschenaffen und Menschen stehen) bis hin zu den Jetztmenschen gilt: Alle heute ausgestorbenen Homininenvorfahren müssen auf der Linie zwischen diesen beiden Punkten liegen. Wir müssen nun herausfinden, wo sie dort im Einzelnen stehen und welche Folgerungen sich daraus für ihr Sozial- und Geistesleben ergeben.

Die Dunbar-Zahl in der Welt von heute

Die Hypothese vom sozialen Gehirn sagt voraus, dass die natürliche Gruppengröße von Menschen bei ungefähr 150 liegt. Aber stimmt das wirklich? Wir müssen uns nur ansehen, wo die meisten von uns heute leben, dann wird eines sofort offensichtlich: Menschen wohnen in Dörfern und Städten, die beträchtlich mehr als 150 Einwohner haben. Die Einwohnerzahl vieler Großstädte unserer heutigen Welt geht in den zweistelligen Millionenbereich. Wie kommt es also, dass die Gleichung des sozialen Gehirns uns eine so niedrige Zahl liefert? Vielleicht ist die Theorie einfach falsch. Vielleicht sagt sie uns aber auch, dass die Zahl der Menschen, die man in einem verworrenen Chaos aus Elektroleitungen, gewundenen Sträßchen und Kanalisationsrohren zusammenpferchen kann, nicht viel mit der Welt unserer sozialen Beziehungen zu tun hat. Wir können in einer Stadt mit Millionen Menschen leben, aber unser persönliches soziales Umfeld – die Welt der Menschen, die wir tatsächlich kennen – ist mit 150 Personen winzig klein. Wenn diese zweite Annahme stimmt, gibt die Dunbar-Zahl vielleicht nur die Obergrenze für die Zahl von Personen an, zu denen wir eine Beziehung haben können. Wenn wir daran denken, was die ursprüngliche Gleichung über Klein- und Großaffen besagt, so geht es stets um die Zahl der Individuen, die jeden Tag in einer Gruppe zusammenleben. Diese Gruppen sind klein, und von wenigen Ausnahmen abgesehen, begegnen die Tiere sich jeden Tag von morgens bis abends. Aber auch mit noch so viel Fantasie können wir

uns nicht vorstellen, dass jeder, der in London, New York, Mumbai oder Peking lebt, jede andere dort lebende Person jeden Tag sieht, oder auch nur jeden Monat oder jedes Jahr – und schon gar nicht die Menschen aus einer der anderen Städte. Und selbst wenn es durch Zufall geschähe, könnten sie sich sicher nicht an alle anderen erinnern. Tatsächlich sieht es so aus, als läge die Obergrenze für die Zahl von Gesichtern, denen wir einen Namen zuordnen können, bei ungefähr 1500 bis 2000, erheblich weniger als die Einwohnerzahl eines kleinen Dorfes in der modernen Welt.

Dieses Rätsel war für uns der Anlass, uns zu fragen, was für Belege wir eigentlich brauchten, um die Voraussagen der Gleichung des sozialen Gehirns zu überprüfen. Es lag nahe, an zwei Punkten anzusetzen. Die eine Möglichkeit waren Kleingesellschaften wie jene, in denen sich die Evolutionsvergangenheit unserer Spezies zum größten Teil abgespielt hat. Einige solche Gesellschaften gibt es noch heute, aber dabei handelt es sich um abgelegene Stammesgruppen an den Rändern der modernen Welt. Solche Gesellschaften finden wir bei den Jägern und Sammlern, bei Völkern wie den San in der Kalahari im südlichen Afrika, den ostafrikanischen Hadza, vielen Stämmen in den südamerikanischen Regenwäldern und – zumindest historisch – bei den australischen Aborigines. Die zweite Möglichkeit bestand darin, uns selbst und unser eigenes persönliches Umfeld zu betrachten, das Netzwerk der Personen, zu denen wir zwischenmenschliche Beziehungen unterhalten.

Über die Gruppengröße in Gesellschaften von Jägern und Sammlern gibt es nur spärliche Literatur. Das liegt zum Teil daran, dass die Anthropologen solche Daten nicht be-

sonders eifrig gesammelt haben. Außerdem kommt eine andere Quelle der Verwirrung hinzu: Von vornherein ist nicht ohne Weiteres klar, was man bei Jägern und Sammlern als Gemeinschaft bezeichnen kann. Vielfach ist man von der nicht unvernünftigen Annahme ausgegangen, dass es sich bei der grundlegenden Gruppe um die Menschen handelt, die jeden Tag zusammen ihr Lager errichten. Solche Gruppen umfassen in der Regel 35 bis 50 Menschen, also nur ein Drittel der Dunbar-Zahl. Die Gesellschaften der Jäger und Sammler bestehen aber wie unsere aus verschiedenartigen Gemeinschaften, die in der Regel als Hierarchie organisiert sind – Familien bilden Sippen, Sippen leben in Dörfern zusammen, und Dörfer bilden größere regionale Gruppen. Dieser letzte Punkt ist besonders interessant, denn auf dieser Ebene der gesellschaftlichen Organisation – und nur auf dieser – liegt die Gruppengröße in der richtigen Größenordnung. Der Durchschnitt beträgt genau 150. Es spricht also manches dafür, dass die natürliche Größe menschlicher Gemeinschaften tatsächlich genau die ist, die von der Hypothese des sozialen Gehirns vorausgesagt wird.

Abbildung 1.2 zeigt den Blick von oben auf eine Population; das Bild gibt wieder, wie die Menschen sich über den geographischen Raum verteilen. Aber wie steht es mit der Größe der persönlichen zwischenmenschlichen Netzwerke? Wie sieht das soziale Umfeld von unten, aus Sicht des Einzelnen aus? In unserem ersten Versuch, dies zu klären, benutzten wir Weihnachtskarten. Viele von uns setzen sich jedes Jahr hin und verwenden viel Zeit, Mühe und Geld darauf, Karten an Menschen zu verschicken, mit denen sie in Kontakt bleiben wollen. Deshalb baten wir in einem Jahr

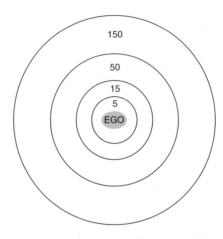

Abb. 1.2 Die Kreise der Freundschaft. Das Beziehungsnetzwerk eines Menschen besteht aus ungefähr 150 Angehörigen und Freunden. Diese sind in Schichten angeordnet, die verschiedenen Beziehungsqualitäten entsprechen und jeweils eine ganz charakteristische Größe haben. Jede Schicht in der Reihe ist dabei ungefähr dreimal so groß wie die darunterliegende. Die Schichten entsprechen ungefähr intimen Freunden, besten Freunden, guten Freunden und Freunden. (Nach © Roberts 2008; Abb. 1)

ungefähr 45 Probanden, eine Liste aller Mitglieder der Familien aufzustellen, an die sie Karten schickten. Das Ergebnis zeigt Abb. 1.3. Die Schwankungsbreite war recht groß, aber der Durchschnitt lag tatsächlich bei 154 und damit so nahe bei dem vorhergesagten Wert, wie man es sich nur wünschen kann.

Daraufhin wurden wir ein wenig ehrgeiziger: Im Laufe der folgenden Jahre stellten wir eine große Datenbank mit 250 Personen zusammen, und diese fertigten vollständige Listen aller Menschen an, die sie in ihrem persönlichen Leben für wichtig erachteten. Das war zugegebenermaßen ein

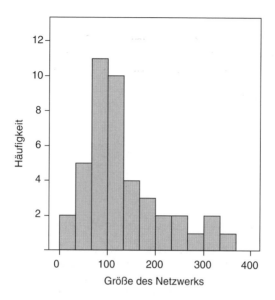

Abb. 1.3 Die Weihnachtskartenlisten von 45 Personen. Unsere Beziehungsnetzwerke umfassen in der Regel etwa 150 Personen, die Zahl unserer Freunde und Verwandten schwankt aber stark: Manche Menschen haben sehr kleine Netzwerke (investieren dann aber meist in jede Beziehung mehr Mühe), bei anderen sind sie beträchtlich größer, wobei der Aufwand für jede Beziehung in der Regel geringer ist. (© Robin Dunbar)

mühsames Unterfangen, denn wir baten sie auch, uns eine Fülle von Einzelheiten über die Personen auf den Listen zu erzählen – wie sie mit ihnen verwandt waren, wann sie sie zum letzten Mal gesehen hatten, wie eng sie sich emotional mit ihnen verbunden fühlten. Das Endergebnis war aber sehr lohnend, denn auch hier kristallisierte sich die 150 als entscheidende Zahl heraus.

Offensichtlich sprechen also Daten aus verschiedenen Quellen dafür, dass unser soziales Umfeld tatsächlich recht klein und auf ungefähr 150 andere Menschen beschränkt ist. Aus unserem großen Datenbestand konnten wir noch zwei weitere wichtige Schlussfolgerungen ziehen. Erstens gibt es hinsichtlich der Zahl der Freunde, die jemand hat, große Unterschiede. Die Variationsbreite um die Kennzahl von 150 reicht vermutlich von 100 bis 200. Zweitens – und das überraschte uns – handelte es sich bei den 150 Bekannten eines Menschen zur Hälfte um Angehörige und zur Hälfte um Freunde.

Da die Menschen in unserer Stichprobe ausschließlich aus Europa stammten (genauer gesagt, aus Großbritannien und Belgien), hatten wir angenommen, dass es sich bei Familienmitgliedern vorwiegend um enge Verwandte handelt – Mutter, Vater, Brüder, Schwestern, Großeltern, vielleicht hier und da eine Tante, ein Onkel oder ein Cousin. Wir hatten aber geglaubt, die Zahl müsse recht klein sein. In traditionellen Gesellschaften ist die Verwandtschaft – auch die entfernte Verwandtschaft – natürlich wichtig. Verwandtschaftsverhältnisse waren sogar das tägliche Brot der anthropologischen Forschung, seit das Fachgebiet vor rund eineinhalb Jahrhunderten seinen Anfang nahm. Wir waren aber davon ausgegangen, dass nur traditionelle Gesellschaften noch heute Verwandtschaft in diesem weiteren Sinn „betreiben": In den Industrieländern, so unsere Vermutung, haben wir solche Vorstellungen aufgegeben und bevorzugen die Vorteile der sozialen Mobilität gegenüber den Bindungen von Heim und Herd; auch wenn wir natürlich unsere unmittelbare Familie nach wie vor schätzen, hatten wir deshalb vermutet, dass unser soziales Umfeld durch

Freundschaften und berufliche Bekanntschaften beherrscht würde. Diese Annahme erwies sich als falsch. Ungefähr die Hälfte der Menschen, die wir zu unserem sozialen Umfeld zählen, sind Angehörige unserer größeren Familie. Wir konnten sogar nachweisen, dass Menschen, die aus Groß-familien stammen, in die Liste ihres sozialen Umfeldes we-niger Freunde aufnehmen. Es sieht also so aus, als sei 150 eine echte Grenze für die Zahl persönlicher Beziehungen, die man unterhalten kann. Wir haben nur 150 Plätze frei und räumen zuallererst unseren Angehörigen die Priorität ein; was übrig bleibt, wird dann mit Freunden aufgefüllt.

Natürlich gibt es viele Wege, um die Begrenzung zu um-gehen. Man *muss* Familienangehörige nicht in die Liste aufnehmen. Manche Menschen entzweien sich mit ihren engen Verwandten und sehen sie nie wieder. Es geht aber darum, dass die Menschen normalerweise den Angehöri-gen eine höhere Priorität einräumen als den Freunden. Wer nicht viele Angehörige hat oder mit ihnen zerstritten ist, füllt die freien Plätze mit Freunden auf – oder mit den Lieblingsgestalten aus der Seifenoper, dem Haustier oder sogar der Lieblingstopfpflanze, wenn man das Gefühl hat, dass zu ihr eine echte Beziehung besteht! Und wenn man sich danach fühlt, kann man natürlich auch Personen hin-zunehmen, die physisch nicht existieren wie Gott oder die Heiligen. Wichtig ist nur, dass Beziehungen, Bande, Ver-bindungen – man kann sie nennen, wie man will – von uns im Rahmen unseres Soz04sllebens aufgebaut werden. Mutter und Vater können wir uns wie alle anderen biologischen Verwandten nicht aussuchen. Aber in den meisten Fällen lässt sich unser Verhalten eher als Verhandlung beschreiben: Wir bauen ein persönliches Netzwerk ausgewählter Freun-

de, geliebter Menschen und Bekannter auf. Die Zahl 150 stellt das Ergebnis der Auswahl aus vielen Alternativen dar.

Die Gründe für diese Begrenzung, die Dunbar-Zahl, werden wir in späteren Kapiteln untersuchen. Hier soll nur kurz der Begriff der kognitiven Belastung eingeführt werden: Mit ihm können wir unsere mentale Fähigkeit beschreiben, uns zu erinnern und aufgrund von Informationen zu handeln, in diesem Fall im Zusammenhang mit anderen Menschen in unserem sozialen Umfeld. Wir alle kennen das Gefühl vor einer Prüfung oder einer wichtigen Präsentation: Unser Gehirn ist vollgestopft, es scheint vor Informationen zu platzen; eine ähnliche Überlastung stellt sich auch ein, wenn die Zahl unserer zwischenmenschlichen Beziehungen zunimmt. Können wir uns an Namen oder persönliche Geschichten erinnern und unsere Verpflichtungen gegenüber anderen erfüllen? Offensichtlich erreichen wir mit der Zahl 150 die Grenzen unserer kognitiven Fähigkeit, uns zu erinnern und auf einheitliche, zwischenmenschlich produktive Weise zu reagieren. Die kognitive Belastung wirkt also wie eine Bremse für unsere sozialen Bestrebungen.

Epochen der Vergangenheit

An dieser Stelle kommt die Archäologie ins Spiel – und mit ihr die Vergangenheit. Bisher haben wir nur eine Seite der Medaille betrachtet: den Zusammenhang zwischen dem Gehirn und dem sozialen Umfeld heute lebender Arten. Jetzt müssen wir uns einem ebenso wichtigen zweiten Aspekt unseres Themas zuwenden: der Erforschung der ent-

fernten Vergangenheit. Sie ist die Stärke der Archäologie; diese Wissenschaft hat ihre Wurzeln in der vor 300 Jahren einsetzenden Begeisterung für die Antike und wurde während der Aufklärung zu einem Brennpunkt der intellektuellen Neugier. Die Archäologie, wie wir sie heute kennen, ist aber ein Produkt des 19. Jahrhunderts. In dessen erster Hälfte wurden Funde nach einem System der drei Zeitalter eingeteilt: Steinzeit, Bronzezeit und Eisenzeit. Später erwuchsen daraus die Belege für eine einfache Evolution der Gesellschaft von Jägern und Sammlern über die Bauern bis hin zu den Hochkulturen.

Die Frage, die Archäologen und Geologen am dringlichsten beantworten wollten, war die nach dem Alter der Menschheit. Gab es sie schon in der Eiszeit – dann läge ihr Ursprung sehr weit zurück – oder erst im jüngsten geologischen Zeitraum, was viele glaubten, die bei der Frage nach dem chronologischen Ablauf nicht über die Bibel hinausblickten? Die Antwort wurde vor mehr als 150 Jahren gegeben. Im Jahr 1859 gingen die beiden Engländer Joseph Prestwich und John Evans, die später zu beherrschenden Gestalten ihrer Fachgebiete der Geologie und Archäologie werden sollten, den Behauptungen des Franzosen Boucher de Perthes nach: Danach gab es im Tal der Somme in Nordfrankreich Belege dafür, dass Menschen und ausgestorbene Tiere wie Wollhaarnashorn und Mammut zur gleichen Zeit gelebt hatten. An einem Nachmittag im April fanden Prestwich und Evans das Gesuchte in einer Kiesgrube bei St. Acheul (s. Abb. 1.4), einem Vorort von Amiens (deshalb wurde diese Epoche der Werkzeugherstellung später als „Acheuléen" bezeichnet). Vom Augenblick ihrer Entdeckung machten sie sogar ein Foto; es zeigt, wie ein Stein-

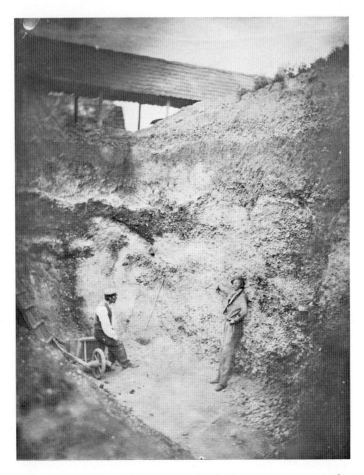

Abb. 1.4 Die Kiesgrube von St. Acheul, einem Vorort von Amies im französischen Sommetal. Das Foto wurde am 27. April 1859 aufgenommen. Der Steinbrucharbeiter deutet auf den Faustkeil (Abb. 1.5), den man im Kies aus der Eiszeit gefunden hatte. (© Bibliothèques d'Amiens Métropole)

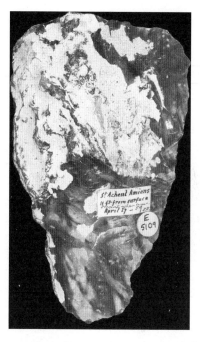

Abb. 1.5 Ein Faustkeil, der für die Geschichte der Steinzeitforschung von zentraler Bedeutung ist. Der Fund, den Clive Gamble und Robert Kruszynski kürzlich an einen neuen Ort brachten, trägt noch das Etikett von 1859. (© Natural History Museum/Science Photo Library)

werkzeug an seinem Fundort aus dem Kies herausragt, in dem sie auch die Knochen ausgestorbener Tiere gefunden hatten. Zu Hause in London wurden ihre Befunde von der Royal Society und der Society of Antiquaries sofort anerkannt. Die wissenschaftliche Erforschung der Ursprünge des Menschen konnte damit einen bemerkenswerten Erfolg verzeichnen. Faszinierenderweise verschwand allerdings der

steinerne Faustkeil, der ihre Aussage bewiesen hatte, zunächst von der Bildfläche; erst genau 150 Jahre später fanden Clive Gamble und Robert Kruszynski ihn wieder: Er lag sicher verwahrt in der Sammlung von Artefakten, die Prestwichs Witwe dem heutigen Natural History Museum übergeben hatte, nachdem ihr Mann 1896 gestorben war (Abb. 1.5). Es war eindeutig ein Stein, der die Welt veränderte: Er widerlegte die biblische Chronologie und eröffnete den Zugang zu einer fernen Vergangenheit, über deren gewaltigen Umfang man mangels genauer Datierungsverfahren nur Vermutungen anstellen konnte.

In dem Wissenschaftsgebiet, das sich mit dem Ursprung der Menschen beschäftigte, interessierte man sich auch für die Gesellschaft früherer Zeiten. Sir John Lubbock gab seinem beliebten, 1865 erschienenen Buch *Pre-Historic Times* den Untertitel as *Illustrated by Ancient Remains and the Manners and Customs of Modern Savages* („illustriert mit antiken Überresten sowie mit den Sitten und Gebräuchen moderner Wilder"). Menschen wie die Ureinwohner Tasmaniens, die vom Jagen und Sammeln lebten, hielt man für moderne Vertreter der Menschen, die den Faustkeil von St. Acheul hergestellt hatten – die Menschen von Lubbocks Paläolithikum (Altsteinzeit). Man unterschied sie von jenen, die später, im Neolithikum (Jungsteinzeit) polierte Äxte verwendet hatten – zu jener Zeit war die Landwirtschaft bereits als Mittel zur Sicherung des Lebensunterhalts an die Stelle der Jagd getreten. Solche Vergleiche stellte man viele Jahre lang an, aber irgendwann erkannte man, dass man schlechte Geschichtsforschung betreibt und unter Umständen völlig in die Irre geht, wenn man direkte Parallelen zwischen Vergangenheit und Gegenwart zieht. Und nebenbei

bemerkt geht man mit einem solchen Ansatz auch fälschlicherweise davon aus, dass manche heutigen Menschen sich nicht verändert haben, sondern lebende Fossilien sind.

Später konzentrierten die Archäologen ihre Anstrengungen darauf, möglichst viele Informationen zu sammeln – zuerst aus Europa, später auch aus Asien und Afrika. Im 20. Jahrhundert interessierten sie sich weniger für das Sozialleben der Frühmenschen als dafür, was sie herstellten und was sie aßen. Aber der soziale Aspekt gehört zwangsläufig zu den Kerngedanken der Archäologie. In den Mittelpunkt des Bildes rückte er wieder durch den hervorragenden australischen Wissenschaftler Vere Gordon Childe, dessen Buch *Social Evolution* 1951 erschien. Er vertrat die Ansicht, die Archäologie müsse für die Anthropologie die gleiche Rolle spielen wie die Paläontologie für die Zoologie; wie wir in Kap. 3 noch genauer erfahren werden, begann die Gesellschaft für Childe allerdings erst mit der Landwirtschaft. So unvollständig die Spuren auch erhalten waren, die Archäologen erforschten Gesellschaften. Und als Graham Clark und Stuart Piggott sich 1965 daran machten, eine umfassende Darstellung der Entwicklung der Menschheit zu schreiben, gaben sie ihr den Titel *Prehistoric Societies* („Prähistorische Gesellschaften“).

Solche Ziele strebte man an, aber die Rahmenbedingungen der Evolution – der unentbehrliche Hintergrund für unsere „Menschwerdung“ – ließen sich immer nur aus den ältesten, spärlichen Befunden ableiten. Die Entschlossenheit von Pionieren und große Entdeckungen waren notwendig, um uns in das moderne Zeitalter der Evolutionsforschung zu katapultieren. Der größte Meilenstein war die Entdeckung, die Louis und Mary Leakey 1959/1960 in der

Olduvaischlucht in Ostafrika machten: Sie fanden Fossi-
lien früher Homininen zusammen mit Steinwerkzeugen in
einem Umfeld, das man auf ein Alter von fast 2 Mio. Jahren
datieren konnte.

Nun war die Entwicklung mit einem Schlag dreimal län-
ger, als man es bisher meist für möglich gehalten hatte. Für
die Entstehung der Menschen eröffnete sich ein Zeitrah-
men, über den Prestwich und Evans, die ihn höchstens auf
ein paar hunderttausend Jahre geschätzt hätten, verblüfft
gewesen wären. Jene Freilandsaison in der Olduvaischlucht
war der Zeitpunkt, zu dem der zeitliche Maßstab unserer
Vergangenheit in modernen Begriffen formuliert wurde;
entscheidend waren dafür wissenschaftliche Datierungsme-
thoden wie die Kalium-Argon-Datierung, die den Befunden
zusätzliches Gewicht verliehen. Aber auch andere Wissen-
schaftsgebiete einschließlich der Psychologie klopften be-
reits an die Tür. Louis Leakey hatte es zeitlich hervorragend
getroffen – es gelang ihm, seine entscheidenden Befunde in
einem Buch unterzubringen, das zur Feier des hundertsten
Jahrestages von Darwins *Entstehung der Arten* veröffentlicht
wurde. Darin konzipierte Leslie White die „vier Stadien der
Geistwerdung", und Irving Hallowell schrieb über „Ich,
Gesellschaft und Kultur". Warum also konnten wir nicht
schon damals den wichtigen Schritt machen und den Geist
des Frühmenschen vollständig erfassen?

Die Bremswirkung stammte zum Teil aus anderen
scheinbar positiven Entwicklungen. Eine davon war eine
Revolution, von der die Archäologie in den 1960er-Jahren
erschüttert wurde – und die unter der Bezeichnung „New
Archaeology" lief. Für uns war sie ein zweischneidiges
Schwert. Einige ihrer wichtigsten Vertreter, unter anderem

Lewis Binford, zeigten die Grenzen archäologischer Beweisführungen auf, indem sie offenlegten, wie die Befunde durch unterschiedliche Erhaltungsbedingungen verfälscht werden können und wie leicht man „moderne Mythen" darüber erfindet, wie man das Leben von Menschen rekonstruieren kann. Wenn man Steinwerkzeuge zusammen mit Tierknochen und auch mit Fossilien von Menschen findet, kann man nicht einfach davon ausgehen, dass man einen „Lagerplatz" oder auch nur eine „Schlachtstelle" gefunden hat. Die gleiche Fundsituation kann ihre Ursache auch in vielen anderen, natürlichen Faktoren haben.

Der Menschenclub und WYSWTW

Zwei Aspekte waren nicht nur für die Archäologen frustrierend, sondern auch für Wissenschaftler anderer Fachrichtungen, die sich um eine Interpretation der Funde bemühten. Erstens lehnte die New Archaeology die traditionelle, erzählende Berichterstattung ab; die Begründung: Unsere Befunde seien keine Geschichte und könnten deshalb nicht zur Grundlage einer zusammenhängenden historischen Darstellung dienen. Zweitens – und das war noch wichtiger – kristallisierte sich nach und nach eine Sichtweise heraus, wonach man über *alles, was man nicht unmittelbar an den Funden beobachten kann, nicht einmal nachdenken darf.* Dieser Gedanke, dieses What You See is What There Was oder WYSWTW [„Was du siehst, ist, was da war"] schloss große Teile dessen, was Menschsein bedeutet – beispielsweise Gefühle und Absichten – von vornherein aus der Erforschung des Ursprungs der Menschen aus. Das Ganze

erinnerte an den langen Schatten des Behaviorismus, der
große Teile der Psychologie vom Ersten Weltkrieg bis in die
1970er-Jahre beherrscht hatte. Die Psychologie beschäf-
tigt sich ursprünglich mit der Funktionsweise des Geistes,
und die Behavioristen hatten die Ansicht vertreten, da man
den Geist selbst nicht unmittelbar beobachten könne, sei
er auch kein Gegenstand für Diskussionen. Auch im Zu-
sammenhang mit dem Ursprung des Menschen hatten vie-
le Wissenschaftler den Eindruck, man müsse hoch entwi-
ckelte Fähigkeiten so nachweisen, dass keine begründeten
Zweifel mehr blieben. Nur wenn sie ihre Vorstellungen in
materieller Form ausdrückten – als Kunstwerke oder hand-
werkliche Produkte –, konnten die Frühmenschen darauf
hoffen, in den Club der modernen Menschen aufgenom-
men zu werden.

Die Vorstellung von einem Club der modernen Men-
schen zieht sich seit den 1970er-Jahren durch die Archäo-
logie. Damals tauchte in der Literatur ein neuer Begriff auf:
der „anatomisch moderne Mensch". Mit ihm wollte man
Vorfahren beschreiben, die wie wir aussahen und sogar
unsere Gene besaßen, sich aber nicht wie wir verhielten. Es
gab bei ihnen weder Kunst noch Anfänge einer Architektur.
Ihre Begräbnisstätten waren in der Regel nicht reichhaltig,
sondern einfach und enthielten weder Grabbeigaben noch
Anhaltspunkte für Bestattungszeremonien. Die anatomisch
modernen Menschen fand man in solchen Grabstätten in
Afrika und im Nahen Osten, die 200.000 bis 50.000 Jah-
re alt sein sollen. Im Rückblick erkennt man, dass mit der
Mitgliedschaft im Club der modernen Menschen in Wirk-
lichkeit die Mitgliedschaft im Club der Europäer gemeint

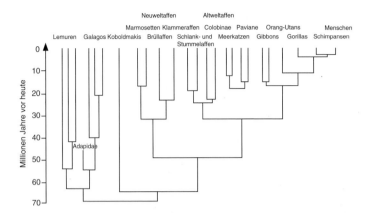

Abb. 1.6 Schema der Primatenevolution mit den wichtigsten Unterteilungen und den Zeitpunkten ihres Auftretens. Links stehen die Halbaffen (heute repräsentiert durch Lemuren und Galagos); ganz rechts erkennt man die Familie der Menschenaffen (Gibbons, Orang-Utans, Gorillas, Schimpansen und uns selbst); dazwischen stehen die Alt- und Neuweltaffen. (© Robin Dunbar)

war, denn Kunst und hoch entwickelte Bestattungen waren schon seit einiger Zeit als Bestandteile des europäischen oberen Paläolithikums bekannt.

Aber was verstehen wir hier eigentlich unter „Menschwerdung"? Für manche Experten gibt es nur die Vollmitgliedschaft: Die Vorfahren müssen sein „wie wir", und damit sind wir eigentlich auf die letzten 200.000 Jahre der Homininenevolution beschränkt. In diesem Buch interessieren wir uns aber für eine weiter gefasste Sichtweise: Wir sind Primaten, und an unsere Primatenverwandten wie Schimpansen und Bonobos bindet uns ein Stammbaum, der sich mindestens über einige Millionen Jahre in die Vergangenheit erstreckt (s. Abb. 1.6). Alles an ihm und nicht nur die letzten paar Prozent bedarf einer Erklärung.

Die lange Entwicklung wird nachgezeichnet

Glücklicherweise hat eine solche längere Entwicklung einen gewaltigen Reiz. Der erweiterte Bereich der entfernten Vergangenheit erweckt den Anschein, als hätten die Archäologen ein Klappbett ausgezogen und plötzlich erkannt, wie viel Platz sie haben. Die Pioniere gingen mit ungeheurer Begeisterung und Energie ans Werk: Sie nahmen Freilandprojekte in Angriff, mit denen sie 2 Mio. Jahre in die Vergangenheit vordrangen, und damit lockten sie auch Wissenschaftler aus vielen anderen Fachgebieten an. Die wenigsten Menschen wissen, wie viel archäologische Forschung eigentlich betrieben wird und wie viele ihrer Aspekte untereinander in Beziehung stehen. Manche Biologen sind der Ansicht, Archäologen hätten nur „ein paar Steine und Knochen". Aber betrachten wir nur einmal die Arbeiten einiger der großen Clarks aus der Archäologie – Graham Clark, Experte für europäische Vorgeschichte, J. Desmond Clark, Afrikanist, F. Clark Howell, Paläoanthropologe, oder David L. Clarke, ein großartiger Theoretiker, der tragisch früh, im Alter von 38 Jahren starb –, dann erkennt man, wie ungeheuer vielfältig die Tätigkeiten sind, mit denen man zu so umfangreichen Kenntnissen gelangte, dass ein Einzelner sie unmöglich alle erfassen kann.

Einer der Pioniere, Louis Leakey, trug entscheidend dazu bei, die Erforschung von Vergangenheit und Gegenwart auch im Hinblick auf die Menschenaffen voranzubringen; damit verschaffte er uns ganz neue Erkenntnisse über den Hintergrund der Evolution des Menschen. Leakey wurde

1903 in Kenia geboren, und da er in Afrika aufgewachsen war, brachte er eine besondere Wertschätzung für das Verhalten von Tieren und Menschen in einer ursprünglichen Umwelt mit. Neben seinen Erlebnissen im Busch erhielt er aber auch eine westliche Ausbildung, und später konnte er Fundstätten aus allen Perioden untersuchen, nicht nur in der berühmten Olduvaischlucht, sondern auch rund um den Victoriasee, wo Menschenaffen aus dem frühen Miozän entdeckt wurden, und im Großen Rifttal, wo man Überreste aus der späteren Steinzeit entdeckte. Eine solche Fundstätte trug – übrigens ganz zufällig – den Namen Gamble's Cave!

Mit seinem breiten Wissen in Verbindung mit einer ein wenig eigenwilligen, unkonventionellen Persönlichkeit irritierte Leakey häufig seine europäischen Kollegen, er konnte sich mit ihrer Hilfe aber auch auf die Frage konzentrieren, was das tatsächliche Leben in der Savanne und in den Wäldern früher im Wesentlichen ausgemacht haben könnte. Sein Kollege, der Anatom Philip Tobias, bemerkte einmal, Leakey sei ein Musterbeispiel für den Gedanken, dass man nie viel erreicht, wenn man keine Fehler macht, und meinte damit insbesondere Leakeys Vision. Leakey erkannte, dass er nur dann darauf hoffen konnte, ausgestorbene Tiere zu verstehen, wenn er „ihren Körperbau, ihre Funktionen und ihr Verhalten" unter Zuhilfenahme heutiger Tiere interpretierte. Er war seiner Zeit weit voraus, denn er schätzte bereits richtig ein, wie viel wir von Affen lernen können, und zwar nicht nur über sie selbst, sondern auch über die Rahmenbedingungen unserer Evolution und über unser eigenes Wesen. Neben vielen anderen Tätigkeiten ebnete er

Abb. 1.7 Der verstorbene Glynn Isaac war einer der Vordenker in der Generation der „New Archaeology". (Mit freundlicher Genehmigung von © Jeanne Sept)

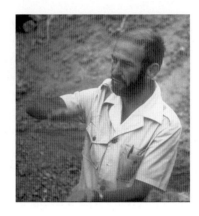

den Weg für die Forschungsarbeiten von Jane Goodall an Schimpansen, von Diane Fossey an Gorillas und von Birute Galdikas an Orang-Utans.

Von den 1960er- bis zu den 1980er-Jahren herrschte in der Paläoanthropologie große Aufregung. Es war eine Zeit großer internationaler Forschungsexpeditionen, die sich vorwiegend auf Afrika konzentrierten und unsere detaillierten Kenntnisse über die Ursprünge des Menschen bis auf 4 Mio. Jahre in die Vergangenheit und bis zum letzten gemeinsamen Vorfahren mit den Menschenaffen ausweiteten. Louis' Sohn Richard Leakey und der energische, in Südafrika geborene Archäologe Glynn Isaac (s. Abb. 1.7) erschlossen die Weiten der Region East Turkana; F. Clark Howell und die Gruppe der Harvard University arbeitete weiter nördlich in Omo; Don Johanson und Maurice Taieb leiteten eine bahnbrechende Evolution, die ihren Höhepunkt in den spektakulären Entdeckungen rund um Hadar im Norden Äthiopiens fand – der Heimat Lucys und ihrer Ver-

wandten der Spezies *Australopithecis afarensis*. Der Paläoan-thropologe Tim White und seine Arbeitsgruppe machten in der gleichen Region so umfangreiche Entdeckungen, dass ihre Implikationen bis heute nicht vollständig geklärt sind. Und Afrika war auch nicht alles: Europa wurde ebenfalls neu erforscht, dann folgten der Ferne Osten und Austra-lien. Alle trugen entscheidende Befunde bei, die es uns er-möglichten, die Zusammenschau auf den folgenden Seiten zu erstellen.

Die Geschichte der Homininenevolution, die sich nach einem Jahrhundert der Fossilsuche, der sorgfältigen Frei-landarbeit und der Analyse in Museen herauskristallisiert hat, war natürlich im Laufe der Jahrzehnte, als immer neue Kenntnisse hinzukamen, beträchtlichen Veränderungen unterworfen. Hier ist weder der richtige Zeitpunkt noch der richtige Ort, um diese Geschichte der Entdeckungen noch einmal zu erzählen. Wir müssen aber die Geschich-te der Menschen, wie wir sie derzeit verstehen, zumindest skizzieren, auch wenn sie sich in Teilen zweifellos weiter verändern wird, wenn man in den nächsten Jahrzehnten neue Fossilien entdeckt. Aber für unsere Zwecke brauchen wir einen Rahmen, wie er in Abb. 1.6 und Tab. 1.2 darge-stellt ist, um dann die nachfolgenden Kapitel um ihn her-um aufbauen zu können.

Unsere Geschichte beginnt mit dem letzten gemeinsa-men Vorfahren oder LGV, der unsere Abstammungslinie mit den afrikanischen Menschenaffen und insbesondere mit den Schimpansen (mit denen wir unter allen Menschenaf-fen am engsten verwandt sind) verbindet. Er lebte vor rund 7 Mio. Jahren. Wir haben keine Ahnung, wie dieser Vor-

Tab. 1.2 Zehn Schritte in der Geschichte von Hominen und Menschen

1. Nach mindestens 20 Mio. Jahren des Affendaseins lebte vor rund 7 Mio. Jahren der letzte Vorfahre, den wir mit den Menschenaffen gemeinsam haben

2. Vor mindestens 4,4 Mio. Jahren, als die ältesten fossilen Homininen in den Funden auftauchen, entstand der aufrechte Gang, und die Zähne veränderten sich

3. Seit der Zeit vor 2,6 Mio. Jahren wurde die Steintechnologie immer wichtiger

4. Vor 2,4 Mio. Jahren begann mit dem Auftauchen der ersten Homininen, die als *Homo* bezeichnet werden können, eine deutliche Größenzunahme des Gehirns

5. Nach 2 Mio. Jahren wanderten Frühmenschen von Afrika durch die gesamte Alte Welt und kamen bis in Regionen jenseits des 55. nördlichen Breitengrades

6. Mit *Homo heidelbergensis* nahm die Gehirngröße vor 600.000 Jahren deutlich zu; Sprache war vermutlich vorhanden, allerdings nicht unbedingt so, wie wir sie heute kennen

7. Vor 200.000 Jahren erschienen den Fossilfunden und genetischen Befunden zufolge in Afrika die ersten anatomisch modernen Menschen auf der Bildfläche

8. Vor 60.000 Jahren (oder schon früher) hatten sich die Jetztmenschen von Afrika aus verbreitet. Sie verdrängten vorhandene Homininen und wanderten in neue Regionen wie Australien ein; vor 20.000 Jahren hatten sie auch Amerika erreicht. Das Zeitalter einer einzigen, weltweit verbreiteten Menschenspezies hatte begonnen

9. Älteste Belege für Kunst, Verzierungen und symbolische Verhaltensweisen findet man bei den Jetztmenschen in Afrika, bevor sie den Kontinent verließen; weltweit verbreitet waren sie vor 40.000 Jahren; Komplexität und Häufigkeit nahmen zu

10. Wichtige Veränderungen in Größe und Organisation der Gesellschaften setzten vor 10.000 Jahren ein, als die Landwirtschaft als Fundament der Wirtschaft an die Stelle des Jagens und Sammelns trat

fahre aussah, denn man kennt keine Fossilien, die man als LGV identifizieren könnte. Er sah sicher nicht genau wie ein Schimpanse aus, denn die Schimpansen haben wie wir eine eigene Evolution von 7 Mio. Jahren durchgemacht, seit der LGV durch die Wälder Zentralafrikas streifte. Auch aus den ersten 2 Mio. Jahren nach dem LGV haben wir nur sehr wenig vorzuweisen – eine Hand voll kürzlich entdeckter Knochen aus Ostafrika und einen eindrucksvollen Schädel vom Rand der Sahara in Westafrika. Die Besonderheit, die diese Fossilien kennzeichnet, ist offenbar die aufrechte Haltung, eine einzigartige Form der Fortbewegung auf zwei Beinen. Alle anderen Menschen- und Kleinaffen gehen auf allen Vieren, und bei den Menschenaffen verbindet sich diese Fortbewegung mit einer charakteristischen Körperform mit kurzen Beinen und langen Armen, die sich besonders dafür eignet, an den Stämmen großer Urwaldbäume emporzuklettern. Unsere Abstammungslinie dagegen war offenbar von Anfang an durch eine aufrechte Haltung mit längeren Beinen und kürzeren Armen gekennzeichnet; dieser Körperbau war eine Anpassung an das Gehen durch die offene Landschaft zwischen den Bäumen. Die ältesten Homininen haben zwar noch nicht eine ganz so elegante Silhouette wie wir, sie sind aber ebenfalls bereits durch dieses charakteristische Merkmal gekennzeichnet. Es ist sogar die einzige Eigenschaft, durch die sich die Mitglieder der Homininenfamilie von den anderen Menschenaffen unterscheiden.

Aus ökologischer Sicht haben wir es dennoch im weitesten Sinne mit Menschenaffen zu tun. Sie hatten sich aber auseinanderentwickelt und auf verschiedene ökologische

Nischen verteilt, die für heutige Menschenaffen nicht bewohnbar gewesen wären, weil in den extremen Phasen der Trocken- und Regenzeit weder Früchte noch weiche Baumschößlinge zur Verfügung standen. Zu ihnen gehörten die robusten Australopithecinen mit ihren mächtigen Zähnen, die sogenannten grazilen Australopithecinen mit schlankeren Kiefern und Zähnen, und der noch schlanker gebaute und vielleicht stärker „generalistische" frühe *Homo*. Im Vergleich mit Menschenaffen waren sie alle vermutlich stärker auf Wurzeln, Knollen, Nüsse, Samen und tierisches Protein angewiesen; dies wurde durch moderne Isotopenanalysen und mikroskopische Untersuchungen bestätigt – die detaillierte Erforschung ihrer Ernährung ist allerdings bis heute nicht abgeschlossen. Einen wichtigen Platz in der Geschichte der Paläoanthropologie nimmt *Homo habilis* ein – von dem Leakey und Tobias ursprünglich glaubten, er sei das erste Mitglied der Gattung *Homo* (heute wissen wir, dass es schon früher einige Kandidaten gab). Er wurde in der Olduvaischlucht (s. Abb. 1.8) in den gleichen Gesteinsschichten wie ein robuster Australopithecine (*Zinjanthropus*, oder richtiger *Australopithecus boisei*) und in Verbindung mit den einfachen Gesteinssplittern und Kernsteinen der sogenannten Oldowan-Kultur gefunden. Die Hersteller dieser Werkzeuge hinterließen nach heutiger Kenntnis grazilere, stärker menschlich aussehende Fossilien und erhielten deshalb den lateinischen Artnamen *Homo habilis* oder „geschickter Mensch". Heute wissen wir, dass die Herstellung von Steinwerkzeugen schon mehr als eine halbe Million Jahre früher begann, aber welche Spezies dafür verantwortlich war, ist noch nicht geklärt. Es muss sich höchstwahrschein-

Abb. 1.8 Die Olduvaischlucht in Tansania stand für die Leakeys viele Jahre lang im Mittelpunkt der Forschungsarbeiten. Wasserläufe haben eine tiefe Schlucht in die Landschaft geschnitten und alte Seeböden wie auch die Tätigkeit früher Homininen offen gelegt. Die Homininen transportierten Steine für die Werkzeugherstellung von den Felshügeln im Umland heran und lieferten damit einen der ältesten Anhaltspunkte für die Erforschung ihrer vernetzten Tätigkeiten. (© Staffan Widstrand/Corbis)

lich nicht um einen Angehörigen der Abstammungslinie *Homo* gehandelt haben – auch Schimpansen sind geschickte Werkzeugmacher und Werkzeugnutzer, und auch dass Vertreter der späteren Australopithecinenarten Werkzeuge herstellten, können wir nicht mit Sicherheit ausschließen. Die Anfänge der Gattung *Homo* sind zwar nur schwer zu erkennen, weil wir aus der Zeit vor 2,0 bis 2,5 Mio. Jahren nur spärliche Fossilfunde besitzen, die vielfältigen Funde aus der Zeit unmittelbar nach dieser Periode lassen aber auf

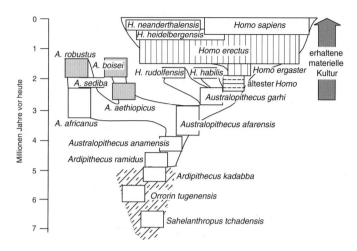

Abb. 1.9 Die wichtigsten bekannten Homininenarten aus den letzten 7 Mio. Jahren. Ihre Verwandtschaftsbeziehungen sind umstritten, aber unsere Interpretation deutet auf einen sehr alten Stamm hin, von dem aus vor rund 3 Mio. Jahren die Auseinanderentwicklung der Arten begann. (© John Gowlett)

eine komplexe Frühgeschichte schließen (s. Abb. 1.9). Es war eine Zeit des schnellen Klimawandels, in der zahlreiche biologische Arten ausstarben und neu entstanden; die Zusammenhänge nachzuzeichnen, ist also nicht einfach, aber einige wenige Funde aus Äthiopien und Kenia, die auf ein Alter von 2,3 bis 2,4 Mio. Jahren datiert wurden, belegen bereits die Existenz irgendeiner Form des frühen Homo.

In der Zeit vor 1,9 bis 1,8 Mio. Jahren finden wir eine vielgestaltige Gruppe des frühen *Homo*, in der insbesondere eine Spezies, der *Homo erectus*, nach dem Maßstab ihrer evolutionären Lebensdauer höchst erfolgreich war. Nimmt man die lokalen Varianten hinzu, die in Ostafrika häufig

als *Homo ergaster* und in Georgien als *Homo georgicus* bezeichnet werden, beherrscht die Gruppe des *Homo erectus* während der nächsten Million Jahre die Funde. Es waren vermutlich die ersten Homininen, die auch die Grenzen Afrikas überwanden und große Teile Eurasiens besiedelten.

Es ist zwar üblich zwischen den frühen afrikanischen Arten (*Homo ergaster*) und späteren Formen aus Asien (*Homo erectus*) zu unterscheiden, in Wirklichkeit handelt es sich aber um eine einzige Gruppe höchst erfolgreicher Altweltarten, die ein beträchtliches Maß an zeitlicher und geographischer Variationsbreite aufweist. Der *Homo erectus* entwickelte ein charakteristisches Werkzeugarsenal; im Mittelpunkt stand dabei der Faustkeil, dessen Gestaltung und Funktionen während eineinhalb Millionen Jahren im Wesentlichen unverändert blieben. Von ihren Australopithecinenvorgängern unterschieden sich die ersten Angehörigen unserer Gattung durch ihre größere, elegantere Gestalt und ihr beträchtlich größeres Gehirn. Sie lebten offensichtlich stärker nomadisch – ihr Körperbau eignete sich dazu, große Entfernungen zurückzulegen, und nach Ansicht mancher Experten waren sie sogar zum Ausdauerlauf in der Lage, was ihnen bei der Jagd einen Vorteil verschafft hätte. Wir können davon ausgehen, dass der *Homo erectus* während seiner ganzen langen Geschichte eine ruhelose Spezies war, von deren Population sich regelmäßig kleine Gruppen abspalteten, die zwischen Afrika und Europa in beiden Richtungen hin und her wanderten.

Während der *Homo erectus* in Asien noch bis vor 50.000 Jahren überlebte, standen in Afrika bereits vor 600.000 Jahren größere Veränderungen bevor. Bei einer der afrikanischen Populationen von *Homo ergaster* entwickelte sich ein

größeres Gehirn, und die weitere Evolution verwandelte ihn
– vielleicht über eine Reihe kurzlebiger Zwischenformen –
in den *Homo heidelbergensis* (der so genannt wird, weil der
erste Fund dieser Spezies 1907 in der Ortschaft Mauer bei
Heidelberg ausgegraben wurde). Das Werkzeugarsenal von
Homo heidelbergensis stellte im Vergleich zu den Faustkeilen
des *Homo erectus* einen Fortschritt dar und enthielt auch
einige der ersten zusammengesetzten Werkzeuge, bei denen
Steinspitzen mit einem Schaft aus Holz zu Speeren zusam-
mengebunden wurden.

Aus dem *Homo heidelbergensis* entstanden im Laufe der
weiteren Evolution nach und nach in Europa die Neander-
taler (*Homo neanderthalensis*) und in Afrika die anatomisch
modernen Menschen (*Homo sapiens*). Aber erst vor 60.000
Jahren verließen die anatomisch modernen Menschen Af-
rika und wanderten entlang der Südküste Asiens bis nach
Australien. Am östlichen Mittelmeer kreuzten sich ihre
Wege sicher mit denen der Neandertaler, aber erst vor rund
40.000 Jahren, als sie von den Steppen Südrusslands zurück
nach Europa zogen, kamen sie mit diesen nördlichen Ho-
mininen in engeren Kontakt.

Die Neandertaler hatten zu jener Zeit in Europa schon
seit mehreren hunderttausend Jahren überlebt, und in ihrer
Evolution hatten sich leistungsfähige anatomische Anpas-
sungen an die unwirtlichen und manchmal eisigen Lebens-
bedingungen entwickelt. Grundlage ihrer Lebensweise war
die Jagd auf alle möglichen Tiere, von Hirschen und Pfer-
den bis zu Nashörnern und Mammuts – Arten, die zwar
reichlich vorhanden waren und viel Fleisch lieferten, aber
auch eine gefährliche Jagdbeute darstellten, wenn man sie
ganz aus der Nähe mit Speerwürfen töten wollte. Dennoch

musste eine nennenswerte Weiterentwicklung der Werkzeuge auf die lange kulturelle Entwicklung der anatomisch modernen Menschen warten, die vor rund 200.000 Jahren auf der Bildfläche erschienen. Und nochmals 100.000 Jahre älter sind in Afrika die ersten Anhaltspunkte für höher entwickelte Werkzeuge und Kunstwerke, beispielsweise Halsketten. Weitere 60.000 Jahre vergingen, bis Europa mit einer Fülle von kleinen Figuren, Knochenflöten, Perlen und Höhlenmalereien mit der Revolution des oberen Paläolithikums im Spiel der Symbole gleichgezogen hatte.

Die letzten Neandertaler starben in Südspanien vielleicht erst vor weniger als 40.000 Jahren aus, als der Höhepunkt der letzten Eiszeit herannahte. Am Ende stellte sich heraus, dass sie mit den Unbilden des nördlichen Klimas weniger gut zurechtkamen als die anatomisch modernen Menschen, was vielleicht daran lag, dass es ihnen an kultureller Flexibilität fehlte. Die Jetztmenschen hatten zur gleichen Zeit bereits Australien besiedelt und standen kurz davor, die Beringstraße zu überqueren und auch nach Amerika einzuwandern. Die große „Landnahme" der Jetztmenschen war nahezu abgeschlossen. Nur die abgelegenen Regionen der Ozeane blieben für diese einzigartige Spezies noch zu besiedeln, womit ihre Reise um die ganze Welt ihr Ende fand – das allerdings geschah erst in den letzten 5000 Jahren.

Zusammenarbeit

In den letzten 50 Jahren haben Paläoanthropologen und Archäologen mit ihren Leistungen die Büchse der Pandora ihrer Entdeckungen weiter vergrößert. Wären wir archäo-

logische Puristen, wir könnten aus diesen Funden eine gan-
ze Geschichte ableiten – wir könnten behaupten, nur die
Archäologie könne die Vergangenheit der Menschen auf-
grund der materiellen Überreste beschreiben und interpre-
tieren. Dann würden wir vielleicht damit durchkommen,
dass wir mit den Menschenfossilien nur eine Art Doppel-
nummer aufführen und sie als zusätzliche Bereicherung
der Funde betrachten. Aber am Ende reicht das nicht. Die
Archäologie ist zwar das Kernstück der kulturellen Vergan-
genheitsforschung, sie war aber immer darauf angewiesen,
dass zahlreiche Fachleute aus anderen Disziplinen Licht in
ihre Fragestellungen brachten. Geologen, Umweltforscher
und Datierungsspezialisten spielen für archäologische Be-
schreibungen eine entscheidende Rolle. Und in jüngster
Zeit haben auch Primatenforscher, Genetiker, Neurowis-
senschaftler – und natürlich die Evolutionspsychologen –
ihre Beiträge geleistet.

Ist aus dieser Zusammenarbeit auch bereits eine zusam-
menhängende Geschichte über die Evolution erwachsen?
Wir würden sagen: noch nicht ganz. Den ersten Grund hat
unser Kollege, der Paläoanthropologe Rob Foley, schon häu-
fig genannt: Man hat sich bisher zu wenig darum bemüht,
die Evolutionstheorie in Erklärungen über die Evolution
der Menschen einzubeziehen. In der Archäologie galt die
Evolution der Menschen immer als etwas Einzigartiges und
nicht als das „normale" Produkt der üblichen Evolutions-
kräfte – die den Menschen nur zu einer von vielen hundert-
tausend einzigartigen biologischen Arten machen würden.
Wenn wir versuchen, die Menschen als etwas Besonderes
zu definieren, vergessen wir die allmähliche Evolution der
Vergangenheit – und die Tatsache, dass unsere engsten Ver-

wandten nahezu in jeder Hinsicht die gleichen Eigenschaften haben wie wir. Deshalb sollten wir untersuchen, wie und warum wir uns von den anderen Menschenaffen entfernt haben und zu dem geworden sind, was wir sind, aber wir sollten uns selbst nicht vollständig und künstlich von ihnen abgrenzen.

Vor zwei Generationen begriffen Denker wie Julian Huxley, wie wichtig die psychosoziale Evolution ist, wie er sie nannte. Zu seiner Zeit war der Geist das Lieblingsthema mehrerer großer Evolutionsbiologen, darunter Bernhard Rensch und Theodosius Dobzhansky. Im Rückblick sehen wir aber, dass etwas fehlte: Diese Wissenschaftler konzentrierten sich fast immer auf die Anpassungen von Anatomie und Verhalten, die einzelne Arten charakterisierten – aber sie beschäftigten sich kaum mit der inneren Dynamik, mit der Frage, wie die Wechselbeziehungen zwischen den Individuen eine Gesellschaft prägen und den weiteren Verlauf ihrer Evolution beeinflussen. Um diese Kräfte in den Mittelpunkt des Interesses zu rücken, bedurfte es einer neuen Runde der Wechselbeziehungen mit der Psychologie.

Obwohl wir zahlreiche Entwicklungen untersucht haben, bleibt eine Lücke, die erstmals von dem französischen Denker Pierre Teilhard de Chardin eindeutig umrissen wurde. Huxleys psychosozialer Bereich war für ihn die Noosphäre, die Sphäre des menschlichen Denkens; er sprach von der „unwiderstehlichen Flut, die seit den letzten hundert Jahren Naturgeschichte und Menschheitsgeschichte näher zusammengeführt hat". Dennoch betrachteten Historiker die soziale Evolution als abgelegenes, von der Biologie getrenntes Teilgebiet. Teilhard de Chadin formulierte es so: „Die Domäne der Zoologie und die Domäne der Kultur: Sie

sind nach wie vor zwei Abteilungen, vielleicht auf rätselhaf-
te Weise in ihren Gesetzen und ihrer Anordnung ähnlich,
aber dennoch zwei verschiedene Welten." Und doch strahlt
die eine zwangsläufig und unmerklich auf die andere aus.

In den letzten Jahren haben Primatenforscher wie Andy
White und Bill McGrew, aber auch Psychologen wie Mi-
chael Tomasello sich darum bemüht, solche kulturellen
Themen besser zu verstehen. Im Vergleich zur Tätigkeit von
Schimpansen ist die Kultur der Menschen natürlich von
unübersehbarer Wandlungsfähigkeit. Deshalb hielten An-
thropologen, die sich mit der soziokulturellen Entwicklung
beschäftigen, die Bemühungen der Biologen häufig für ab-
surd „reduktionistisch". Dieser Ansicht liegt aber eine fal-
sche Interpretation dessen zugrunde, worum Biologen sich
in Wirklichkeit bemühen. Im richtigen Zusammenhang
betrachtet, erforschen sie die Grundlagen, die Fundamen-
te des Sozialverhaltens, aber sie versuchen nicht zu erklä-
ren, warum wir ins Theater gehen, Hochzeiten feiern oder
Kunstausstellungen besuchen.

Zusammenfassung

Auf den folgenden Seiten werden wir uns mit allen diesen
ungelösten Fragen auseinandersetzen. Das Lucy-Projekt
vereinigte in sich zwei ganz unterschiedliche Wege, sich mit
der Evolution der Menschen zu beschäftigen: Die Psycho-
logen brachten den Blickwinkel der experimentellen Wis-
senschaft mit, der von den Archäologen um die Methoden
einer historischen Wissenschaft ergänzt wurden. Indem wir
die ganz unterschiedlichen Sphären der Archäologie und

Evolutionspsychologie zusammenführen, wollen wir einige wichtige Positionen abstecken. Es geht uns darum, mithilfe des sozialen Gehirns einen besseren Zugang zu finden, als es mit ausschließlich archäologischem Material oder mit der Projektion von Gedanken aus der Gegenwart möglich wäre. Insbesondere stellt sich die Frage, wie Archäologen von der Perspektive, die das soziale Gehirn bietet, profitieren können. Vielleicht brauchen sie einen Impuls, um von ihrem intellektuellen Paradigma wegzukommen – dass Lebewesen, die in der Evolution immer klüger wurden, am Ende ganz oben stehen würden, erschien so offensichtlich, dass die Triebkraft zum Klugwerden keiner besonderen Erklärung zu bedürfen schien. Der Archäologe Osbert Crawford sagte 1921: „Zwischen dem ersten einfachen Steinwerkzeug und dem neuesten, hochspezialisierten Flugzeug mag eine breite Kluft liegen, aber wenn der erste Schritt erst einmal getan ist, wird alles andere vergleichsweise einfach." Heute müssen wir fragen: „Ja, aber warum?" Warum haben wir eine solche erstaunliche Reihe von Veränderungen durchgemacht? Wir, die wir heute leben, sind natürlich der Endpunkt einer großartigen Welle der Evolution. Aus den Eigenschaften, die wir dabei erworben haben, erwächst die Fähigkeit zu allem, was uns zu Menschen macht – die Fähigkeit, in großen politischen Organisationsformen zu leben, Kriege zu führen, uns mit Kultur, dem Erzählen von Geschichten, Religion und Wissenschaft zu beschäftigen. Am anderen Ende des Weges stehen die Menschenaffen, über die wir ebenfalls eine Menge wissen.

Dennoch ist es nicht unser Ziel, diese Vielfalt zu erklären, und wir werden auch nicht begründen, warum manche Arten gescheitert sind und andere am Leben blieben. Dies

ist keine Geschichte über den stetigen Aufstieg im großen Treppenhaus der Evolution. Unsere Familiengeschichte umfasst unzählige Zweige, die eine beliebige Zahl verschiedener Wege zum Überleben ausprobiert haben. Manche, so die Neandertaler und viele Australopithecinen, waren zu ihrer Zeit sehr erfolgreich, mussten sich aber am Ende den Unwägbarkeiten von Klimawandel und ökologischer Konkurrenz geschlagen geben. Unsere Aufgabe wird vielmehr darin bestehen, die verwickelte Geschichte unserer eigenen Spezies zu erläutern, die Windungen und Wendungen, die von einem völlig normalen Menschenaffen in den Wäldern Afrikas zu der Spezies führten, die letzten Endes wohl oder übel den Planeten beherrscht, auf dem wir leben.

Üblicherweise erzählt man diese Geschichte anhand der aufeinanderfolgenden Fossilien und Werkzeuge, der anatomischen und manchmal auch ökologischen Unterschiede zwischen Vorfahren- und Nachkommenarten. Wir wollen es mit einem anderen Ansatz versuchen: Was heißt es, ein Mensch zu sein, und wie sind wir so geworden? Das Schwergewicht liegt dabei auch auf der Psychologie sowie auf dem Wechselspiel zwischen den kognitiven und sozialen Aspekten unseres Verhaltens auf der einen Seite und den Werkzeugen und Artefakten, die unsere Vorfahren benutzten und hinterließen, auf der anderen.

2

Was ist ein soziales Wesen?

Der Preis des Soziallebens

In der Familie der Primaten machte die Evolution eine groß-
artige Erfindung: das Sozialleben. Aber das Leben in Grup-
pen hat seinen Preis. Je mehr Tiere die Gruppe umfasst, des-
to größere Strecken muss man jeden Tag zurücklegen, denn
jedes Tier muss in einem ungefähr gleich großen Gebiet
auf die Suche gehen, um die benötigte Nahrung zu finden.
Das bedeutet eine Belastung: In der gleichen Zeit könn-
ten die Tiere sich sonst still im Schatten eines Busches aus-
ruhen oder gesellig mit ihren „Freunden" zusammen sein.
Das Leben in Gruppen erfordert aber auch physiologischen
Aufwand: Wenn Artgenossen zusammentreffen und sich
gegenseitig von einem besonders saftigen Stück Nahrung
oder einem sicheren Schlafplatz vertreiben, kommt Stress

auf. Solche Zwischenfälle werden mit zunehmender Gruppengröße zwangsläufig häufiger. Auch wenn sie als Einzelereignisse vielleicht unbedeutend sind, erzeugen sie, wenn sie sich Tag für Tag abspielen, einen beträchtlichen Stress, und Stresshormone wie Cortisol verursachen nicht nur eine Abnutzung von Körper und Geist, sondern sie können insbesondere bei Weibchen auch beträchtlichen Schaden anrichten. Stress, ob körperlicher oder psychologischer Natur, wirkt destabilisierend auf die Hormone, die den Menstruationszyklus steuern. Die Folge ist eine Amenorrhö: Im Menstruationszyklus findet kein Eisprung mehr statt, sodass das Weibchen vorübergehend unfruchtbar wird.

Das alles bedeutet beträchtlichen Aufwand und führt dazu, dass das Leben in der Gruppe sich nicht lohnt, es sei denn, an anderer Stelle ergibt sich ein Nutzen. Für Klein- und Menschenaffen besteht dieser Nutzen im Schutz vor natürlichen Feinden. Indem sie sich in Gruppen zusammentun, machen sie es Raubtieren schwerer, erfolgreich einzelne Beutetiere herauszugreifen. Sie können einen Angreifer sogar piesacken und vertreiben. Dass Paviane so etwas tun, wurde in Afrika dokumentiert. Raubtiere wie Hyänen und Leoparden sind eines der Hauptprobleme, mit denen Primaten es in ihrem Alltagsleben zu tun haben: Die Verringerung der Gefahr, versehentlich zur Beute zu werden, wird damit ganz buchstäblich zu einer Frage von Leben und Tod (s. Abb. 2.1). Das Thema spielt insbesondere dann eine große Rolle, wenn man die relative Sicherheit des Waldes verlässt und sich in die offene Savanne begibt, wo Verstecke selten und weit voneinander entfernt sind. Umgekehrt haben potentielle Jäger weitaus bessere Aussichten auf Beute (s. Kap. 3).

Abb. 2.1 Leoparden sind die wichtigsten natürlichen Feinde der Paviane und vieler anderer Affen in der Alten Welt – aber Paviane verteidigen sich manchmal auch. (© Marius Coetzee)

Die „Dreierregel" in den Gemeinschaften der Menschen

Menschengruppen unterscheiden sich in vielerlei Hinsicht nicht allzu stark von den Rudeln der Klein- und Menschenaffen: Auch in ihnen gibt es verschiedene Beziehungsniveaus, die durch ihr Zusammenwirken immer größere Gemeinschaften entstehen lassen. Diese Niveaus haben verschiedene Namen – Horde, lokale Gruppe, Lagergemeinschaft –, wir wollen uns hier aber auf die Gemeinschaft konzentrieren, die wir mit der Dunbar-Zahl 150 in Verbindung bringen.

In kleinen, traditionellen Gesellschaften setzen sich diese Niveaus aus Familien zusammen, die Horden (oder Grup-

pen für das Nachtlager) bilden, und die Horden tun sich ihrerseits zu Gemeinschaften zusammen. Die Mitgliedschaft der Lagergruppen ändert sich im Laufe der Zeit, weil Familien und Individuen kommen und gehen. Wenn sie aber zwischen verschiedenen Lagergruppen wechseln, geschieht das immer zwischen Gruppen, die zu derselben Gemeinschaft von rund 150 Individuen gehören. Und wie wir in Kap. 1 erfahren haben, kennen sie die Mitglieder einer solchen Gemeinschaft bereits. In Gesellschaften von Jägern und Sammlern ist eine solche Gemeinschaft (die manchmal auch als Clan oder regionale Gruppierung bezeichnet wird) in der Regel eine Gruppe von Individuen, die das Zugriffsrecht auf bestimmte Ressourcen haben, beispielsweise auf ganzjährige Wasserstellen. In sesshaften Gesellschaften, die Gartenbau betreiben, treten sie in der Regel als Dörfer, die Ländereien besitzen, in Erscheinung.

Der Wechsel zwischen verschiedenen Gemeinschaften kommt dagegen viel seltener vor. Trotzdem tun sich aber auch Gemeinschaften unter Umständen zu größeren Gruppierungen zusammen, in denen mehr Sympathiebeziehungen bestehen als zwischen völlig Fremden. Solche Übergemeinschaften wurden in der archäologischen Literatur als „Megahorden" und von Anthropologen als „endogame Horden" bezeichnet, es handelt sich aber in Wirklichkeit nicht um Horden im Sinn von Gruppen, die über Nacht gemeinsam lagern. Eher kann man sie als Handelsnetzwerke bezeichnen: Nachbargemeinschaften kennen einander so gut, dass sie bereit sind, Gegenstände untereinander zu tauschen, beispielsweise Rohstoffe für die Herstellung von Werkzeugen, aber auch bearbeitete Werkzeuge und andere

Objekte, die man selbst nur unter Schwierigkeiten anfertigen kann. Außerdem dienen solche Netzwerke auch dazu, Ehepartner zu finden.

Die Hierarchie setzt sich auch über die Ebene der Megahorden hinaus fort: Diese tun sich ihrerseits zu noch größeren Gruppen zusammen, in denen alle Individuen die gleiche Sprache sprechen. Solche Verbände werden manchmal als Stämme oder ethnolinguistische Gemeinschaften bezeichnet (Anthropologen vermeiden oft das Wort „Stamm", aber in diesem besonderen Sinn passt es gut, und in Australien, wo die Strukturen besonders leicht zu erkennen sind, wurde es häufig benutzt). Wie sich herausstellt, haben die Gruppierungen auf den verschiedenen Hierarchieebenen ganz bestimmte Größen, die zueinander ungefähr in einem Verhältnis von 1 zu 3 stehen. Mit anderen Worten: Jede Hierarchieebene ist ungefähr dreimal so groß wie die darunterstehende. Stämme sind dreimal so groß wie Megahorden, Megahorden sind dreimal so groß wie Gemeinschaften, und Gemeinschaften sind dreimal so groß wie Horden (s. Tab. 2.1). Die zugehörigen Zahlen lauten in der Regel 1500, 500, 150 und 50.

Die gleiche hierarchische Struktur sehen wir auch, wenn wir die Landschaft nicht aus der Vogelperspektive betrachten, sondern von unten, von der Ebene des Individuums nach oben (s. Abb. 1.2). Bittet man Menschen, eine Liste ihrer sämtlichen Freunde und Angehörigen zu erstellen und auch mitzuteilen, wie oft sie mit diesen zusammentreffen, so hat das Muster der Beziehungen, das sich dabei herauskristallisiert, genau die gleiche Form: Wir sind von Hierarchieebenen der Beziehungen umgeben, die sich sowohl in

Tab. 2.1 Die Dreierregel in Gesellschaften von Jägern und Sammlern (von oben nach unten) und in persönlichen Netzwerken, die es in allen Gesellschaften gibt (von unten nach oben)

Soziale Gruppen bei Jägern und Sammlern	Zahl	Persönliches Netzwerk
Stamm (Sprache)	1500	Entfernte Bekannte
Megahorde (Eheschließung und Handel)	500	Nahe Bekannte
Gemeinschaft (Dunbar-Zahl)	150	Freunde
Horde (Nachtlagergruppe)	50	Gute Freunde
Gruppe von Nahrungssammlern (Unterstützergruppe)	15	Beste Freunde
Inteme Gruppe (Seelenverwandte)	5	Enge Partner

der Intensität der Beziehung als auch in der Häufigkeit, mit der wir die betreffenden Menschen sehen, unterscheiden. Diese Ebenen aus 5, 15, 50, 150 und 500 Menschen sind mehr oder weniger gleichbedeutend mit engsten Angehörigen, besten Freunden, guten Freunden, Freunden und Bekannten.

In einer wichtigen Hinsicht besteht offenbar ein großer Unterschied zwischen der Gemeinschaft von 150 Personen und den Hierarchieebenen, die darüber hinausgehen: In der Gruppe von 150 Personen haben wir Beziehungen auf Gegenseitigkeit mit Vertrauen und Verpflichtungen. Es sind Beziehungen, die eine Geschichte haben – wir kennen die betreffenden Menschen seit einiger Zeit, und sie kennen uns. Die Menschen jenseits der 150 würden wir vielleicht als Bekannte bezeichnen – mit ihnen haben wir eine sehr lockere Beziehung, die keine gegenseitigen Verpflichtungen einschließt und nicht zur gegenseitigen Hilfeleistung ver-

pflichtet. Dieser grundlegende Unterschied hat große Aus-
wirkungen auf unsere Bereitschaft, uns gegenüber anderen
Individuen altruistisch zu verhalten.

Die oberste Ebene, die ungefähr 1500 Menschen ein-
schließt, entspricht offenbar der Zahl der Gesichter, die wir
mit Namen verbinden können – sie ist eine reine Frage des
Gedächtnisses, und die Grenze wird nur durch die Kapa-
zität der Speicherelemente im Gehirn festgelegt. Dies ist
ein Beispiel dafür, welche Begrenzungen uns die kognitive
Belastung auferlegt, die mit der Erinnerung und Umset-
zung von derart vielen sozialen Informationen verbunden
ist (s. Kap. 1). Zu den rund 1500 Personen würden wir
neben Angehörigen, Freunden und Bekannten auch alle
Menschen zählen, die wir erkennen, ohne aber zu ihnen
eine Beziehung zu haben: Diese Menschen kennen wir,
aber sie kennen uns nicht. Für die meisten von uns würden
dazu ohne Zweifel Präsident Obama und vielleicht auch
die Königin von England gehören, außerdem eine Reihe
von Rockstars, der regulären Sprecher unserer regulären
Fernsehnachrichten, ein Prominenter, dem wir auf Twitter
folgen, und so weiter – Menschen, die wir auf der Straße
erkennen würden, die aber umgekehrt nicht die geringste
Ahnung haben, wer wir sind.

Die Tatsache, dass diese beiden Sichtweisen – die Welt als
Ganzes aus der Vogelperspektive und die von unten betrach-
tete soziale Welt des Individuums – so gut übereinstimmen,
ist rätselhaft; wir haben dafür eigentlich keine Erklärung
und können vielleicht nur vermuten, dass die Welt der Or-
ganisationen gerade diese und keine andere Form hat, weil
Organisationen die persönlichen Beziehungen ihrer einzel-
nen Mitglieder als Grundlage haben. Mit anderen Worten:

Organisationen haben gerade diese Hierarchiestufen und Größen, weil sie aus den Begrenzungen erwachsen, die sich aus der Fähigkeit des Einzelnen, unterschiedlich intensive Beziehungen zu handhaben, ergeben.

Die Form von Armeen

Die Dreierregel, die offensichtlich die aufeinanderfolgenden Hierarchieebenen definiert, wiederholt sich im wirklichen Leben auch in einem anderen Kontext, der einer Erwähnung wert ist: beim Militär. Moderne Armeen haben im Wesentlichen stets die gleiche Struktur; sie haben sich aus den lockeren Verbänden entwickelt, mit denen sich Feudalherrscher gegen ihre Oberherren verteidigten. Während des Dreißigjährigen Krieges, der Nordeuropa zwischen 1618 und 1648 verwüstete, marodierten protestantische und katholische Armeen im ganzen Land, brachten Unheil über die Bauern und sorgten auch untereinander für viel Tod und Zerstörung. Der führende Kriegsherr auf protestantischer Seite war König Gustav Adolf V. von Schweden; sein Beitrag zur Militärgeschichte bestand darin, dass er die Anfänge der modernen militärischen Organisation definierte. Im Wesentlichen stand er vor einem Verwaltungsproblem. Um im 17. Jahrhundert auf einem Schlachtfeld den Sieg davonzutragen, musste man zwei widersprüchliche Probleme lösen: Einerseits musste man möglichst viele Männer auf das Schlachtfeld bringen (je größer die Armee, desto größer die Wahrscheinlichkeit des Sieges – jedenfalls meistens) und andererseits die Koordination zwischen verschiedenen Soldatengruppen aufrechterhalten (die Möglichkeit

der Koordination nimmt mit der Größe der Armee drastisch ab). Aus den von Gustav Adolf eingeleiteten Reformen ging schließlich die moderne militärische Organisation hervor, in der sich strukturelle Einbindung mit einer robusten Disziplin verbinden (man muss dem vorgesetzten Offizier gehorchen). Für uns ist vor allem der Aspekt der strukturellen Organisation interessant.

Moderne Militäreinheiten sind genau nach der gleichen Dreierregel aufgebaut wie die Gemeinschaften der Menschen, und die Größe der Einheiten entspricht nahezu exakt der, die wir auch im alltäglichen Sozialleben vorfinden. In der Regel bilden drei Abteilungen von jeweils ungefähr 12 Personen einen Zug von 40 bis 50 Soldaten, und drei Züge sind zu einer Kompanie von ungefähr 150 zusammengefasst; drei Kompanien bilden ein Bataillon (500), drei Bataillone ein Regiment (1500), drei Regimenter eine Brigade (5000) und drei Brigaden eine Division (15.000). In Wirklichkeit sind die Einteilungen natürlich oftmals geringfügig anders. Verschiedene Armeen bedienen sich unterschiedlicher Bezeichnungen, aber die Zahlen sind in der Regel ähnlich – die Größe der Kompanien schwankt beispielsweise in allen modernen Armeen nur zwischen ungefähr 120 und 180. Die Kompanie gilt in dieser Struktur als Grundeinheit: Sie ist die kleinste Einheit, die allein und selbstständig operieren kann, und sie wird fast als Familie betrachtet. Auffällig ist, dass wir es beim Militär oberhalb der Stammesebene von 1500, die man in traditionellen Kleingesellschaften findet, noch mit mindestens zwei weiteren Ebenen zu tun haben. Interessant ist auch – womit wir auf die Archäologie zurückgreifen –, wenn man sieht, wie die Römer experimentierten und immer wieder zu dem

gleichen System zurückkehrten. Die Manipel, eine takti-
sche Kampfeinheit, die 315 v. Chr. eingeführt wurde, be-
stand aus drei Linien von jeweils 40 Mann; die Zenturie der
späteren kaiserlichen Legion war eine kleinere Einheit, aber
in der angesehenen ersten Kohorte stieg ihre Größe wieder
auf 160 Mann.

Zeit, Freundschaft und Verwandtschaft

Auffällige Unterschiede bestehen in der Häufigkeit, mit der
wir den Personen auf den einzelnen Ebenen unseres persön-
lichen sozialen Umfeldes begegnen. Wir verwenden täglich
im Durchschnitt ungefähr 2 h auf zwischenmenschliche
Interaktionen – nicht eingerechnet sind dabei Interaktio-
nen am Arbeitsplatz, die wir richtigerweise nicht als zwi-
schenmenschlich, sondern als beruflich bezeichnen müssen,
und natürlich auch keine Interaktionen mit Arzt, Anwalt,
Bäcker usw. Diese Zeit kann man als soziales Kapital be-
zeichnen; das ist ein festes Zeitbudget für soziale Bemü-
hungen, das wir in jeden unserer Freunde und Bekannten
investieren können. Ungefähr 40 % davon widmen wir den
5 Menschen in unserem innersten Kreis – jeder von ihnen
bekommt also rund 8 % von unserer verfügbaren Zeit ab.
Weitere 20 % gehen an die 10 übrigen Menschen in der
15er-Schicht, in die wir demnach jeweils rund 2 % unseres
sozialen Kapitals investieren. Die 35 verbliebenen Personen
in der 50er-Schicht bekommen jeweils rund 0,4 % unserer
Zeit, und die 100 restlichen auf der äußeren Schicht rund

ein Viertel davon – das entspricht ungefähr einem Zusammentreffen im Jahr. Wie wichtig die Zeit für das Sozialleben von Primaten ist, wird im Kasten „Die große Bedeutung der Zeit" genauer erörtert.

Die große Bedeutung der Zeit

Zeit ist für Klein- und Menschenaffen aus zwei Gründen wichtig. Erstens müssen sie die gesamte Tätigkeit des Nahrungssammelns und ihre Wanderungen zwischen den Fundstellen für Nahrung in ihrer täglichen 12-stündigen Wachperiode erledigen – nicht zuletzt, weil sich Klein- und Menschenaffen schon in einem frühen Stadium ihrer Evolution auf eine streng tagaktive Lebensweise festgelegt haben und deshalb über eine schlechte Nachtsicht verfügen. Die Zunahme der Körper- und Gehirngröße muss durch eine Verlängerung der Zeit ausgeglichen werden, die für das Fressen aufgewendet wird; nur so ist sichergestellt, dass ausreichend viel Energie und lebenswichtige Nährstoffe aufgenommen werden.

Der zweite Grund ist die Zeit, die für soziale Zuwendung gebraucht wird. Da Primaten ihre Sozialbeziehungen durch Kraulen schaffen und die Stärke der Beziehungen unmittelbar davon abhängt, wie viel Zeit die Tiere gegenseitig dafür aufwenden, müssen Arten, die in großen Gruppen leben, dem Kraulen proportional mehr Zeit widmen. Je größer die Gruppe ist, desto mehr Zeit müssen die Tiere für die gegenseitige Zuwendung aufwenden.

Die Aufteilung der Zeit auf diese Kerntätigkeiten ist von entscheidender Bedeutung für die Fähigkeit der Tiere, einen bestimmten Lebensraum zu besiedeln, aber auch für die Größe der Gruppe, in der sie leben können. Genau herauszufinden, wie unterschiedliche Arten von Klein- und Menschenaffen ihre Zeit einteilen und welche Klima- und Umweltfaktoren diese Einteilung beeinflussen, war ein wichtiger Teil des Lucy-Projekts. Die Projektmitarbeiterinnen Julia Lehmann und Mandy Korstjens entwickelten eine Reihe von Modellen für die Zeitbudgets afrikanischer Klein- und Menschenaffen. Wie sich dabei herausstellte, sind Temperatur und Jahreszeit die wichtigsten Einfluss-

faktoren. Die Temperatur ist wichtig, weil sie sich einerseits auf die Qualität des verfügbaren Futters auswirkt (fleischige Früchte findet man vorwiegend in schattigen Wäldern, wo am Boden niedrigere Temperaturen herrschen) und weil andererseits hohe Temperaturen in der Mittagszeit die Tiere zwingen, schattige Plätze aufzusuchen und sich auszuruhen (womit sich ihre aktive Tageszeit weiter verkürzt).

Caroline Bettridge, eine Doktorandin aus dem Projekt, ging später mithilfe dieser Modelle der Frage nach, welchen zeitlichen Beschränkungen die Australopithecinen unterlagen und wie sie damit zurechtkamen. Wären die Australopithecinen gewöhnliche Menschenaffen gewesen, so ihre Feststellung, hätten sie in den Lebensräumen, in denen sie tatsächlich zu Hause waren, nicht überleben können. Das lag vor allem daran, dass die zum Wandern erforderliche Zeit deutlich länger wurde. Eine partielle Lösung war offenbar der aufrechte Gang: Er ist energieeffizienter, und die längeren Beine ermöglichen eine gewisse Zeitersparnis. Das allein hätte sie aber nicht in die Lage versetzt, die Lebensräume, in denen sie lebten, zu besetzen. Zusätzlich musste der zeitliche Aufwand für das Fressen auch durch eine Ernährungsumstellung verringert werden. Zu dieser Ernährungsumstellung gehörte offenbar eine wachsende Abhängigkeit von Wurzeln und Knollen, die Nährstoffe in konzentrierter Form enthielten.

Wie wir in Kap. 1 erfahren haben, gibt es aus kognitiven Gründen eine Beschränkung für die Größe sozialer Gruppen (oder zumindest eine kognitive Beschränkung in Abhängigkeit von der Gehirngröße) – wir sprechen von der kognitiven Belastung. Die Zeit spielt hier aber ebenfalls eine wichtige Rolle. In unseren Studien an persönlichen zwischenmenschlichen Netzwerken sollten die Befragten uns sagen, wie häufig sie mit jedem ihrer Freunden zusammentrafen und welche gefühlsmäßige Nähe sie zu ihnen empfanden. Die emotionale Nähe maßen wir auf einer sehr einfachen Skala von 1 bis 10, die aber trotz ihrer Ein-

fachheit sehr gut mit anderen Maßstäben für gefühlsmä-
ßige Nähe übereinstimmt, die von Psychologen verwendet
wurden. Die auf diese Weise gemessene emotionale Nähe
steht, wie sich herausstellte, in engem Zusammenhang mit
der Häufigkeit der Kontakte: Je öfter man mit jemandem
Kontakt hat, desto näher fühlt man sich ihm (s. Abb. 2.2)
Aus diesem Befund ergibt sich eine offenkundige Folge-
rung: Wenn man aus irgendeinem Grund weniger häufig

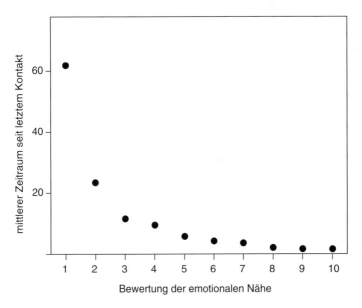

Abb. 2.2 Je näher wir uns einem anderen Menschen fühlen, des-
to öfter treffen wir mit ihm zusammen. Das Diagramm zeigt die
durchschnittliche Zahl von Monaten seit der letzten Begegnung
für Beziehungen mit unterschiedlicher emotionaler Qualität (an-
gegeben als emotionale Nähe, wobei 10 einer sehr großen Nähe
entspricht). (© Robin Dunbar)

mit jemandem interagiert – beispielsweise weil man in eine andere Stadt zieht und einander nicht mehr ohne Weiteres treffen kann –, wird sich die Beziehung nach dem Maßstab der emotionalen Nähe wahrscheinlich sehr schnell verschlechtern.

Um diese Hypothese zu überprüfen, sahen wir uns an, wie sich echte Beziehungen im Laufe der Zeit entwickeln. Zu diesem Zweck mussten wir eine Gruppe von Menschen studieren, die von zu Hause wegzogen und es deshalb schwer hatten, die Interaktionen mit den ursprünglichen Angehörigen ihres sozialen Umfeldes in der gleichen Häufigkeit aufrechtzuerhalten. Für das Projekt, das von Sam Roberts geleitet wurde, rekrutierten wir 30 Schüler von 18 Jahren während ihres letzten Schulhalbjahres; als Gegenleistung erhielten sie für eineinhalb Jahre einen kostenlosen Handyvertrag. Auf diese Weise konnten wir uns ein Bild davon machen, wie ihr soziales Umfeld in den sechs Monaten vor dem Wechsel zur Universität aussah, und anschließend konnten wir sie im ersten Jahr an der Universität beobachten, wo sich viele Gelegenheiten bieten, neue Freunde kennenzulernen, während es wegen der physischen Entfernung von zu Hause nicht möglich ist, alte Bekannte regelmäßig zu treffen.

Wir gelangten zu verblüffenden Ergebnissen. Wenn die Häufigkeit der Interaktionen zurückging, verringerte sich innerhalb von höchstens sechs Monaten auch das Gefühl der emotionalen Nähe in den Beziehungen. Es geschah erstaunlich schnell. Natürlich könnte es sich dabei um eine Besonderheit von Teenagern handeln, die im Hinblick auf ihre Beziehungen ohnehin wankelmütig sind. Allerdings glauben wir das nicht, und zwar aus mehreren Gründen.

Erstens handelte es sich nicht um Kinder, sondern um Menschen an der Schwelle zum Erwachsenwerden. Gegen Ende der Studie hatten alle den 20. Geburtstag hinter sich. Und zweitens war unsere Studie nicht die einzige, in der ein solcher Effekt nachgewiesen wurde: Auch in früheren Untersuchungen hatte sich gezeigt, dass sich sogar die Freundschaften von Erwachsenen verändern, wenn man in eine andere Stadt zieht. Im Gegensatz zu früheren Studien konnten wir mit unserem Projekt aber nicht nur erfassen, welche Beziehungen im Sande verliefen und welche nicht, sondern wir konnten auch genau nachzeichnen, in welchem Zusammenhang dies mit der Wahrnehmung der emotionalen Nähe und der Häufigkeit der Begegnungen stand. Kurz gesagt, ist Zeit das Entscheidende, und eine Beziehung, in die man keine Zeit investiert, verläuft im Sande.

Die Qualität von Beziehungen ist wichtig, denn sie hat Einfluss darauf, wie altruistisch wir zueinander sind. In unseren Studien stießen wir auf deutliche Unterschiede im Ausmaß des Altruismus gegenüber den Freunden, die davon abhängen, wie nahe sie uns stehen. Je enger die Beziehung, desto eher sind wir bereit, ihnen zu helfen oder einen Gefallen zu tun. In einer anderen unserer Studien bat Oliver Curry die Versuchspersonen, in jeder Hierarchieebene ihres persönlichen sozialen Netzwerks bis hin zu der äußeren Ebene von 150 jeweils eine Person zu benennen und dann zu erklären, ob sie dieser Person eine Niere spenden würden, wenn man sie darum bäte. Die Bereitschaft, für den inneren Zirkel von 15 Personen so etwas zu tun, war um 15 % höher, als wenn es um Personen in der äußeren Ebene von 150 ging.

Natürlich ist es ganz etwas anderes, ob man jemanden fragt, ob er beispielsweise bereit wäre, eine Niere zu spenden, oder ob man es im Ernstfall wirklich tut. In einer anderen Studie sollten unsere Versuchspersonen jedoch eine schmerzhafte Gymnastikübung ausführen, um damit Geld für einen namentlich benannten Verwandten zu verdienen. Es handelte sich um eine Standardübung aus der Skigymnastik: Man setzt sich mit dem Rücken gegen eine Wand, als würde man auf einem Stuhl sitzen, nur ohne Stuhl. Die Übung soll die Oberschenkelmuskulatur stärken, sodass man auf der Piste besser elegante Schwünge fahren kann. Anfangs fühlt sich die Haltung ganz bequem an, aber nach ungefähr drei Minuten wird sie quälend schmerzhaft, und die meisten Menschen lassen sich nach vier oder fünf Minuten auf den Fußboden fallen, weil sie die Schmerzen nicht mehr aushalten. Wir zahlten den Versuchspersonen ein britisches Pfund für jede Minute, die sie die Position halten konnten, und das bei jeder Sitzung verdiente Geld wurde unmittelbar an eine zuvor benannte Person geschickt – an die Versuchsperson selbst, einen Elternteil, eine Schwester oder einen Bruder, eine/n Tante/Onkel/Nichte/Neffe, einen Cousin oder einen Freund gleichen Geschlechts. Ganz gleich, in welcher Reihenfolge diese Personen benannt wurden, die verdienten Geldbeträge gingen in der genannten Abstufung zurück (wobei Frauen – aber nicht Männer – sich allerdings in der Regel für eine Freundin etwas mehr anstrengten als für eine Cousine). (Nebenbei bemerkt, stellten wir auch eine bekannte soziale Einrichtung für Kinder zur Wahl, aber die schnitt stets viel schlechter ab als alle anderen Nutznießer.) Hier handelte es sich um echten Altruismus, denn die Versuchspersonen mussten Schmer-

zen erdulden, um Geld zu verdienen. Sie waren bereit, für Menschen, die ihnen sehr nahe standen, mehr Schmerzen in Kauf zu nehmen, als für solche, zu denen die Beziehung lockerer war. Emotionale Nähe und Altruismus gehen also Hand in Hand.

Allerdings gibt es eine auffällige Ausnahme: Freundschaftliche Beziehungen sind zwar empfindlich und verschlechtern sich schnell, wenn sie nicht bestärkt werden; mit Beziehungen zu Angehörigen der eigenen Familie sieht es aber ganz anders aus. In unserer eineinhalbjährigen Studie an Studierenden, die in eine andere Stadt an die Universität gingen, erwiesen sich Beziehungen innerhalb der Familie auch bei fehlenden Interaktionen als unglaublich stabil. Dabei handelte es sich auch nicht nur um Beziehungen zu Eltern und Geschwistern, sondern auch um die zur gesamten Familie bis hin zu Cousins und Cousinen zweiten Grades. Die Tatsache, dass man zu einer Tante, einem Onkel oder einer Cousine seit über einem Jahr keinen Kontakt hatte, spielt offenbar nicht die geringste Rolle dafür, wie nahe man sich ihnen emotional fühlt oder welche Gefühle sie selbst haben. Wenn überhaupt, kamen mit längerer Abwesenheit von zu Hause stärkere Gefühle der emotionalen Nähe zu Verwandten zum Ausdruck.

Diese Bevorzugung der eigenen Verwandtschaft erstreckt sich zwangsläufig auch auf das Verhalten. Ganz gleich, auf welcher Hierarchieebene unseres sozialen Umfeldes sich die Angehörigen befinden, wir sind ihnen gegenüber großzügiger als gegenüber Freunden. Legt man die Bereitschaft zu einer Nierenspende als Maßstab an, ist Verwandtschaft im Durchschnitt um 40 % mehr wert als Freundschaft. Diese erhöhte Großzügigkeit gegenüber Angehörigen ist natür-

lich nichts Neues. Wir haben es hier mit einem Evolutionsprozess zu tun, der unter dem Namen Verwandtenselektion bekannt ist: Wir bevorzugen Verwandte gegenüber Außenstehenden, weil die Verwandten einen Teil ihrer Gene mit uns gemeinsam haben. Das ist, wie wir noch genauer erfahren werden, ein wichtiges Merkmal kleinerer Gemeinschaften und traditioneller Gesellschaften.

Die emotionale Seite

Im vorigen Abschnitt war davon die Rede, wie die Zeit unseren Beziehungen wichtige Dienste leistet. Aber Zeit ist nicht der einzige wichtige Faktor, der darüber bestimmt, wie viele Freunde wir höchstens haben können. Unsere Beziehungen sind eine emotionale Angelegenheit, und deshalb bestimmen wahrscheinlich auch psychologische Aspekte mit darüber, wie wir mit ihnen umgehen. Dabei gibt es zwei Seiten: einerseits die Empathie, andererseits die Frage, wie gut wir unsere Freunde verstehen.

Gefühle zu untersuchen, ist selbst unter besten Voraussetzungen schwierig, und Psychologen gehen diesem Thema seit fast einem Jahrhundert im Wesentlichen aus dem Weg. Das liegt vermutlich teilweise daran, dass emotionale Reaktionen (stark vereinfacht betrachtet) Phänomene der rechten Gehirnhälfte sind. Die Sprachzentren dagegen liegen auf der linken Seite und sind offenbar nicht übermäßig gut mit den Emotionszentren verknüpft; das könnte der Grund sein, warum es uns überraschend schwerfällt, über unsere emotionalen Zustände nachzudenken, und warum wir sie nicht sonderlich gut in Worte fassen können. Da wir nicht

über die sprachlichen Mittel verfügen, um solche inneren Zustände zu beschreiben, fehlt uns auch der wissenschaftliche Maßstab, mit dem wir die Intensität oder Qualität einer Emotion messen könnten. Das wiederum bedeutet, dass es nahezu unmöglich ist, die emotionalen Zustände zweier Personen zu vergleichen. Ist meine Trauer oder mein Glück größer oder kleiner als deines? Wir wissen es nicht, und wir können eigentlich nicht darüber sprechen – das ist zweifellos der Grund, warum Teenager glauben, ihr eigener Kummer sei viel größer, als der jedes anderen Menschen jemals sein könnte. In dieser ausweglosen Situation vertraten die Behavioristen in den 1920er-Jahren die Ansicht, man solle alle Diskussionen über mentale Zustände bei Tieren (und Menschen) vermeiden und sich stattdessen auf das konzentrieren, was wir tatsächlich sehen und messen können: das *Verhalten*.

Aber auch wenn man versucht war, der Frage der Emotionen aus dem Wege zu gehen, stellte sich bald heraus, dass dies nicht möglich ist. Emotionen spielen in unseren Beziehungen eine wichtige Rolle, denn diese hängen eindeutig mit Gefühlen von Wärme und Glück zusammen, und vielfach finden sie ihr Ende inmitten besonders heftiger Gefühle von Wut und Verärgerung. In einer unserer Studien, die von Max Burton geleitet wurde, berichteten uns 540 Versuchspersonen über den Bruch ihrer Beziehungen, den sie im Laufe des vergangenen Jahres erlebt hatten. In einem überraschend großen Teil der Fälle (65 %) ging es dabei um Beziehungen zu engen Familienangehörigen (bis hin zu Cousins und Cousinen), die größte Kategorie stellten aber zwangsläufig mit 34 % die Liebespartner dar. Die häufigste Ursache für das Scheitern der Beziehungen

war ein vermeintlicher Mangel an Zuwendung, nicht weit dahinter kamen Eifersucht und Neid. Sie alle waren von einem dramatischen Rückgang des Gefühls der emotionalen Nähe begleitet, ganz zu schweigen von den damit verbundenen Gefühlen von Angst und Kummer.

Wenn eine Beziehung funktioniert, empfinden wir natürlich die entgegengesetzten Gefühle, um was für Gefühle es sich dabei aber eigentlich handelt, war nur schwer dingfest zu machen. Wenn Beziehungen gerade gut laufen, erweisen sich die verbalen Beschreibungen unserer mentalen Zustände häufig als unzusammenhängend und skizzenhaft. Über einen Aspekt jedoch können wir durchaus sprechen: über das Gefühl der Wärme, das wir in erfolgreichen Beziehungen erleben.

Die Emotionen haben aber noch eine andere Dimension, und die steht in unmittelbarem Zusammenhang mit unserer Evolution und dem sozialen Gehirn. Wie man in Tab. 2.2 erkennt, lassen sich Emotionen in drei Ebenen einteilen. Ganz unten stehen die Stimmungen, die „Vibrationen", die wir von Orten und Menschen aufnehmen. Auf

Tab. 2.2 Eine Leiter der Emotionen mit einigen ausgewählten Beispielen

Gefühle		
Sozial	Schuldgefühl, Scham, Mitleid, Stolz	Kann sich nur mit einer Theorie des Geistes auf das Verhalten auswirken
Primär	Angst, Wut, Glück, Traurigkeit	Reagiert auf Bedrohungen und Bedürfnisse
Stimmung	Unheimlichkeit, Bezauberung	Wirkt sich auf Aufenthaltsort und Zusammenkünfte aus

Gefühle wie Sicherheit und Wertschätzung reagieren wir, ohne dass wir unbedingt in der Lage sein müssten, genau zu definieren, wie sie entstehen. Eine sichere Zuflucht und ein unheimlicher Ort sind grundlegende Aspekte in unserem Verständnis für Orte und Menschen. Auf der nächsten Ebene finden wir die primären Emotionen. Diese sind unter dem Gesichtspunkt des Überlebens sinnvoll. Gefühle wie Angst, Wut und Glück haben wir mit allen anderen Säugetieren gemeinsam. Sie ermöglichen uns eine emotionale Reaktion auf Bedrohungen und Gefahren. Und schließlich gibt es die komplexeren sozialen Emotionen. Zu ihnen gehören die menschlichen Gefühle von Schuld, Mitleid und Stolz. Charakteristisch menschlich werden sie, weil sie nur mit der Fähigkeit der Mentalisierung funktionieren. Scham hängt von der Erkenntnis ab, dass ein anderer eine Überzeugung hat. (Wir bemerken, dass auch Hunde sehr gut Schuld und Scham empfinden können – aber der bereits erwähnte Daniel Dennett hält sie unter den Tieren für die große Ausnahme; nach seiner Ansicht wurden sie von uns so geformt, dass sie auch viele unserer Geisteszustände übernommen haben.)

Absichten, Mentalisierung und die Theorie des Geistes

Wir müssen hier noch ein paar Worte über einen Aspekt der Beziehungspsychologie verlieren, der früher völlig undurchschaubar erschien; ungefähr in den letzten zehn Jahren haben wir darüber aber eine Menge in Erfahrung

gebracht. Gemeint ist das Phänomen, das wir in Kap. 1 und im vorangegangenen Abschnitt als Mentalisierung bezeichnet haben: die Fähigkeit, die geistigen Zustände eines anderen und insbesondere seine Intentionen zu verstehen. Daraus leitet sich eine andere Bezeichnung ab, die von dem Philosophen Daniel Dennett geprägt wurde: der *intentionale Standpunkt*.

Der intentionale Standpunkt ist unsere außerordentlich gute Fähigkeit, genau das zu verstehen, was ein anderer mitteilen will, wenn er spricht. Worte sind bekanntlich unscharf, und für sich genommen sind sie in ihrer Bedeutung häufig recht zweideutig. Manchmal, beispielsweise wenn wir Metaphern gebrauchen oder sarkastisch sind, bedeuten sie sogar das Gegenteil dessen, was sie scheinbar aussagen. Wir sind in der Lage, die wahre Bedeutung einer Aussage zu erkennen, weil der Sprecher uns in der Regel Hinweise in Form von Tonfall oder Gesten gibt. Dass wir diese komplizierte, für uns aber ganz normale zwischenmenschliche Aufgabe bewältigen können, liegt an der kognitiven Fähigkeit der Mentalisierung. Diese steht im Zusammenhang mit Empathie, ist aber nicht genau das Gleiche: Während man die Empathie als „heiße" Form der Kognition betrachten kann (wir *fühlen*, was der andere fühlt), handelt es sich bei der Mentalisierung eher um „kalte" Kognition (wir *verstehen* es). Dieser Fähigkeiten bedienen wir uns Tag für Tag, einfach um herauszufinden, was andere Menschen wollen, wie sie auf unser Handeln reagieren und wie wir uns am besten verhalten sollen, um andere dazu zu veranlassen, das zu tun, was wir wollen.

Kinder erwerben die Fähigkeit zur Mentalisierung mit ungefähr 5 Jahren: In diesem Alter wird ihnen zum ersten

Mal klar, dass andere Menschen einen eigenen Geist haben – einen Geist, der sogar bewirken kann, dass sie über die Welt ganz andere Ansichten haben. Psychologen bezeichnen diese Fähigkeit als „Theory of Mind" (was bedeutet, dass das Kind jetzt eine Theorie über den Geist hat). Wenn Kinder diese Fähigkeit beherrschen, sind sie zu zwei wichtigen Dingen in der Lage, die sie zuvor nicht gut konnten. Erstens können sie überzeugend lügen, weil sie jetzt wissen, dass der andere das Gesagte hinnimmt, sodass sie falsche Informationen vermitteln können. Und zweitens können sie fiktive Spiele spielen. Das Kaffeekränzchen der Puppen hat jetzt eine Realität: Die Puppen können den Inhalt ihrer (leeren) Tassen verschütten und sich ihre Kleider beschmutzen. Oder ein Stück Holz an einer Schnur ist ein echtes Auto, das über die Rennstrecke im Garten fährt. Diese wichtige Fähigkeit schafft eine neue Möglichkeit, die weit wichtiger ist als Kinderspiele: Erst sie macht letztlich Kultur möglich. Auf diesen Teil der Geschichte werden wir in einem späteren Abschnitt des Kapitels zurückkommen. Zunächst aber wollen wir fragen: In welchem Zusammenhang steht die beschriebene Fähigkeit mit zwischenmenschlichen Beziehungen?

Die Theorie des Geistes ist in der Form, die Fünfjährige beherrschen, im größeren Zusammenhang keine ungeheuer eindrucksvolle Fähigkeit. Zu ihr gehört, dass man in der Lage ist, sich in einen anderen hineinzuversetzen, und wir wissen, dass schon Klein- und Menschenaffen in der Lage sind, sich die Sichtweise eines anderen zu eigen zu machen. Die Theorie des Geistes besteht zwar nicht nur darin, die Dinge durch die Augen eines anderen zu sehen (man muss dazu nicht nur die Sichtweise des anderen ver-

stehen, sondern auf ihrer Grundlage auch die Absichten des anderen begreifen), vermutlich ist sie aber etwas, das wir mit anderen Menschenaffen gemeinsam haben. Der intentionale Standpunkt verschafft uns dabei einen natürlichen Maßstab, denn die Intentionalität bildet eine Hierarchie, die wir uns als eine Reihe reflexiver Geisteszustände vorstellen können. Die Tatsache, dass ich eine Ansicht über etwas habe (ich kenne meinen eigenen Geist) wird als Intentionalität erster Ordnung bezeichnet, und wenn ich eine Ansicht über deine Ansichten (deinen Geisteszustand) habe, handelt es sich um Intentionalität zweiter Ordnung. Diesen Stand haben Fünfjährige erreicht, wenn sie die Theorie des Geistes beherrschen. Erwachsene beherrschen sie aber noch beträchtlich besser. Unsere Studien legen sogar die Vermutung nahe, dass erst die Intentionalität fünfter Ordnung für die Mehrzahl der Menschen eine natürliche Obergrenze darstellt. Das entspricht etwa der Fähigkeit, zu sagen: Ich *frage* mich, ob du *annimmst*, dass ich die *Absicht* habe, dich *denken* zu lassen, dass ich *glaube*, dass X wahr ist. Die fünf kursiv geschriebenen Wörter stehen für geistige Zustände, die von den Philosophen zusammenfassend als *Intentionalität* bezeichnet werden.

Das ist schon recht eindrucksvoll, aber manche Menschen können es sogar noch besser. Unseren Forschungsergebnissen zufolge kommen rund 20 % der Bevölkerung zuverlässig mit Aussagen über Intentionalität sechster Ordnung zurecht, und ein winziger Bruchteil bewältigt sogar die Intentionalität siebter Ordnung. Natürlich gibt es Schwankungen auch in der anderen Richtung. Ein bescheidener Anteil der Menschen schafft nur die vierte Ordnung, und einige wenige bleiben schon bei der dritten Ordnung

stecken. Die Verteilungskurve läuft in beide Richtungen sehr lang aus, denn eine kleiner Anteil der Erwachsenen beherrscht die Theorie des Geistes (Intentionalität zweiter Ordnung) überhaupt nicht; solche Menschen werden in der Medizin gewöhnlich als Autisten definiert und verfügen im Wesentlichen nur über die Intentionalität erster Ordnung. Sie liefern uns ein besonders schmerzliches, aber auch aufschlussreiches Beispiel, denn das Defizit verbindet sich mit einer völligen Unfähigkeit, im sozialen Umfeld von Erwachsenen zurechtzukommen. Das gilt selbst dann, wenn die Betroffenen einen normalen (oder sogar überdurchschnittlichen) Intelligenzquotienten besitzen.

Da die Mentalisierung von so entscheidender Bedeutung für unsere Fähigkeit ist, uns in unserem unglaublich komplexen sozialen Umfeld zurechtzufinden, stellten wir uns die Frage, ob die Leistung von Menschen bei der Lösung von Intentionalitätsaufgaben im Zusammenhang mit der Größe ihres sozialen Umfeldes steht. In gewisser Weise liegt hier eine Analogie zum Jonglieren vor: Genau wie ein geschickter Jongleur, der mehr Bälle zur gleichen Zeit in der Luft halten kann als ein weniger geschickter, so verfügt auch jemand, der mit Intentionalität sechster Ordnung zurechtkommt, möglicherweise über die Fähigkeit, mehr Menschen in seinem sozialen Umfeld zu halten, als jemand, der nur die vierte Ordnung beherrscht. Diese Frage wurde erstmals von Jamie Stiller in einem Forschungsprojekt untersucht. Er prüfte mithilfe sehr kurzer Geschichten oder Episoden (von jeweils ungefähr 200 Wörtern) die Fähigkeit der Menschen, die verschiedenen in der Geschichte erwähnten geistigen Zustände zu verstehen. Dabei zeigte sich ein sehr signifikanter Zusammenhang zwischen der

Leistungsfähigkeit der Versuchspersonen bei dieser Aufgabe und der Zahl der Freunde, die sie in Bezug auf die beiden innersten Ebenen ihres Netzwerks von Freunden und Bekannten aufgezählt hatten (die 15er-Schicht, s. Tab. 2.1).

Sozialverhalten, verkörpert im Gehirn

Die Hypothese vom sozialen Gehirn besagt, dass die Größe der sozialen Gruppen bei den Primaten generell durch die Größe des Neocortex oder zumindest durch einen Aspekt dieser Größe begrenzt wird. Zu dieser Behauptung gibt es eine naheliegende Erweiterung: Wenn sie zwischen den Arten stimmt, sollte sie auch innerhalb einer Art gelten. Mit anderen Worten: Es sollte sich nachweisen lassen, dass individuelle Unterschiede in der Gehirngröße mit Unterschieden in der Größe des sozialen Umfeldes korrelieren. Diese Voraussage lag derart auf der Hand, dass wir zusammen mit unseren Kollegen Penny Lewis, Joanne Powell und Neil Roberts darangingen, sie mit der leistungsfähigen neuen Gehirnscantechnologie unmittelbar zu überprüfen. Mit bildgebenden Verfahren kann man Bilder vom Gehirn lebender Menschen aufzeichnen, weil die entsprechenden Apparaturen die unterschiedliche Dichte der Gehirnmasse, die winzigen elektrischen Signale der Gehirnaktivität oder die Durchblutung des Gehirns aufzeichnen. Mit verschiedenen Methoden kann man dabei verschiedene Dinge erfassen – die eine misst beispielsweise das Volumen verschiedener Gehirnteile, und mit einer anderen kann man

zusehen, wie hart das Gehirn arbeitet, wenn der Mensch sich mit einer bestimmten Aufgabe beschäftigt.

Die Tests waren relativ unkompliziert: Unsere Versuchspersonen sollten einfach alle Menschen aufführen, mit denen sie im vorangegangenen Monat regelmäßig Kontakt hatten (was ungefähr der 15er-Schicht entspricht), und dann wurden sie mit dem Gehirnscanner beobachtet, während sie die Tests auf Intentionalität durchliefen, von denen im vorigen Abschnitt die Rede war. Dabei gelangten wir zu zwei wichtigen Erkenntnissen. Erstens sind immer die gleichen Gehirnareale aktiv, unabhängig davon, ob die Versuchspersonen Aufgaben mit Intentionalität höherer Ordnung lösen oder sich mit der einfachen Theorie des Geistes (das heißt mit Intentionalität zweiter Ordnung) befassen. Es handelt sich dabei um Abschnitte im Schläfenlappen unmittelbar oberhalb der Ohren und um einige Teile des präfrontalen Cortex über den Augen (s. Abb. 2.3). Als neue

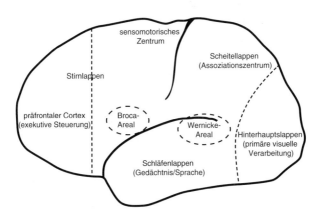

Abb. 2.3 Das Gehirn des Menschen mit seinen wichtigsten Arealen und ihren Funktionen. (© Robin Dunbar)

Erkenntnis stellte sich aber in unserer Studie heraus, dass diese Areale bei Menschen, die mit Intentionalität höherer Ordnung zurechtkommen, größer sind. Und zweitens ist insbesondere der orbitofrontale Cortex bei Menschen, die mehr Freunde haben und höhere Ordnungen der Intentionalität handhaben können, größer. Noch wichtiger ist, dass sich dabei eine deutliche Kausalbeziehung zeigte: Menschen mit größerem orbitofrontalem Cortex kommen mit höheren Ordnungen der Intentionalität zurecht, und da sie mit höheren Ordnungen der Intentionalität zurechtkommen, haben sie mehr Freunde.

An diesem recht verblüffenden Befund können wir zweierlei ablesen. Erstens gilt die Hypothese des sozialen Gehirns innerhalb einer Spezies genauso wie zwischen verschiedenen Arten. Das ist beruhigend, denn es zeigt, dass die evolutionäre Sperrklinke auch für die Selektion die Möglichkeit schafft, die Gehirngröße während der Evolution der Arten wachsen zu lassen. Evolution spielt sich ab, wenn die natürliche Selektion auf die Unterschiede zwischen Individuen einwirkt, denn diese Unterschiede stehen im Zusammenhang mit der Fitness (das heißt im Wesentlichen mit der Zahl der Nachkommen, die ein Individuum hinterlässt). Wir können also die Hypothese aufstellen, dass Individuen mit einem größeren Gehirn (oder zumindest mit einem größeren orbitofrontalen Cortex) sozial erfolgreicher waren und entsprechend mehr Kinder und Enkel hinterließen, was im Laufe der Generationen zu einer stetigen Zunahme der Gehirngröße führte. Was die Menschen angeht, wissen wir das nicht mit Sicherheit, aber aus Untersuchungen an Pavianen in Ostafrika ist bekannt, dass Weibchen, die mehr Freunde haben (was mangels einer Sprache an der Zahl der

regelmäßigen Kraulpartner abzulesen ist), auch mehr überlebende Nachkommen bekommen als weniger sozial eingestellte Weibchen. Freunde sind wirklich von Bedeutung, und das liegt vermutlich daran, dass sie einen Puffer gegen die anstrengenden Belastungen des Gruppenlebens darstellen. Sie kommen einem zu Hilfe, wenn man angegriffen wird, und – was vielleicht noch wichtiger ist – schon durch ihre Gegenwart halten sie Bösewichter fern. Und zweitens erinnert es uns daran, warum es so schwierig sein kann, sich in der sozialen Welt zurechtzufinden. Es setzt eine große Leistungsfähigkeit des Gehirns voraus, obwohl es sich dabei um implizite (das heißt instinktive) Prozesse handelt und nicht um explizite Vorgänge (an denen bewusstes Denken beteiligt wäre).

Das sollte uns an eine weitere Erkenntnis über die Evolution erinnern. Da Gehirngewebe extrem kostspielig ist (es verbraucht je Gramm ungefähr zwanzigmal so viel Energie wie Muskelgewebe), vollzieht sich die Evolution eines größeren Gehirns nicht ohne Aufwand, das heißt, sie muss durch einen sehr starken Selektionsdruck begünstigt werden. Die Hypothese vom sozialen Gehirn sagt genau, was für ein Selektionsdruck das war: die Notwendigkeit, größere, zusammenhaltende soziale Gruppen zu schaffen, in denen eine entsprechend größere Zahl von Beziehungen besteht. Das sagt natürlich nichts darüber aus, welcher Selektionsdruck die größeren sozialen Gruppen notwendig machte, aber aus Studien an Klein- und Menschenaffen wissen wir, dass die Notwendigkeit, natürliche Feinde in Schach zu halten, offenbar der entscheidende Faktor war. In jedem Fall können wir den Schluss ziehen, dass der von natürlichen Feinden ausgehende Druck groß genug war,

damit sich bei denjenigen, die gefährliche Lebensräume besiedeln wollten, eine soziale Gegenstrategie entwickelte. Wie wir später noch genauer erfahren werden, ist damit nicht vollständig erklärt, was in der Abstammungslinie der Menschen geschah – dort müssen am Ende auch andere Kräfte ins Spiel gekommen sein. Es erinnert uns aber daran, dass hinter jeder Beziehung zwischen Gehirn und Kognition eine Frage lauert, die unter dem Gesichtspunkt der Evolution beantwortet werden muss. Da es ein Gehirn nicht umsonst gibt und da Tiere mehr bessere Nahrung zu sich nehmen müssen, um die Kosten für das große Gehirn zu decken, brauchen sie einen wirklich guten Grund, der es rechtfertigt, diesen Evolutionsweg einzuschlagen.

Kraulen und die Chemie des Gehirns

Wir haben zuvor bereits die heikle Frage nach der Existenz von Gefühlen aufgeworfen und erläutert, wie schwierig es ist, sie zu erforschen. Jetzt müssen wir auf dieses Thema zurückkommen und einen anderen wichtigen Aspekt der sozialen Bindungen untersuchen. Bei Kleinaffen, Menschenaffen und Menschen gehört zur sozialen Bindung offenbar eine Art doppelter Prozess. Ein Teil dieses Mechanismus ist die Kognition: Sie ermöglicht uns die mentalen Berechnungen, die an Prozessen wie der Theorie des Geistes beteiligt sind. Gleichzeitig bildet sie die Grundlage für die leichter erkennbaren kognitiven Prozesse, die bei Vertrauen und Gegenseitigkeit mitwirken – wir verfolgen, wer uns einen Gefallen tut und wer seine Verpflichtungen nicht einhält. Der zweite Teil des Mechanismus sieht ganz anders aus; er ähnelt eher der „heißen" Kognition, die wir mit Gefüh-

len in Verbindung bringen. Er erwächst daraus, dass eine Gruppe von Neuropeptiden, die als Endorphine bezeichnet wird, und unter ihnen insbesondere die Untergruppe der β-Endorphine, offenbar bei Klein- und Menschenaffen in engem Zusammenhang mit dem Sozialverhalten steht. Diese Substanzen werden im Hypothalamus produziert, einem winzigen Areal, das tief im alten Teil des Gehirns unterhalb des Neocortex liegt, aber ihre Rezeptoren sind im ganzen Gehirn weit verbreitet; eine besonders hohe Dichte erreichen sie allerdings in Arealen, die mit der Bekämpfung von Schmerzen zu tun haben.

Wichtig ist an den Endorphinen vor allem, dass sie vom Gehirn als Reaktion auf körperliche Schmerzen oder Stress ausgeschüttet werden. Auch bei psychischem Stress werden sie produziert. Da sie chemisch mit Morphium verwandt sind, betäuben sie den Schmerz und hellen die Stimmung genauso auf wie Morphium und andere Opiate. Der Unterschied besteht nur darin, dass wir nach der gehirneigenen Version dieser Substanzen nicht auf die gleiche Weise körperlich süchtig werden wie nach künstlichen Opiaten. Zu den Situationen, in denen Endorphine ausgeschüttet werden, gehört auch das soziale Kraulen (*grooming*), und diese Tätigkeit ist natürlich auch der zentrale Mechanismus der sozialen Bindungen bei Affen (Abb. 2.4). Der Grund: Eine besondere Gruppe von Nerven reagiert ausschließlich auf leichte Berührungen und Streicheln von Fell oder Haut, wie es beim Kraulen der Fall ist, sodass im Gehirn die Ausschüttung der Endorphine in Gang gesetzt wird.

Opiate wirken als Belohnung, und deshalb wollen die Menschen immer mehr davon. Das Gleiche gilt natürlich auch für die Endorphine. Wegen des Lustgefühls, das sie uns verschaffen, wollen wir den Vorgang, der ihre Aus-

Abb. 2.4 Gekrault zu werden, ist für diesen Japanmakaken sehr entspannend; das liegt an den Endorphinen, deren Ausschüttung durch die Streichelbewegungen des Partners ausgelöst wird. (© Robin Dunbar)

schüttung in Gang gesetzt hat, wiederholen. Gleichzeitig schafft ihr Entspannungseffekt einen psychologischen Geisteszustand, mit dessen Hilfe wir eine Vertrauensbeziehung zu jedem aufbauen können, der gerade da ist. Affen kraulen nicht jedes beliebige Mitglied ihrer Gruppe, sondern sie haben ganz bestimmte Kraulpartner, die ihnen auch als wichtige Verbündete dienen und sie vor den unvermeidlichen Belastungen des Gruppenlebens schützen.

Auch körperliche Anstrengung löst die Ausschüttung von Endorphinen aus – eine natürliche Folge der Schmerzen, die bei der Tätigkeit entstehen; am Ende einer Trainingseinheit befinden wir uns in einem Opiat-„High" und sind mit uns selbst und der Welt zufrieden. Viele Menschen entscheiden sich sogar, regelmäßig zu trainieren – das bestätigt uns jeder Spaziergang, der uns um 8 Uhr morgens an einem Fitnessstudio im Stadtzentrum vorüberführt. Damit erhalten wir natürlich alle Belohnungen und Nutzeffekte, die von den ausgeschütteten Opiaten ausgehen. Es scheint sogar, als würden die Endorphine das Immunsystem „abstimmen" und uns damit einen echten medizinischen Nutzen verschaffen. Einer Tätigkeit, bei der Endorphine ausgeschüttet werden, mit einem anderen zusammen nachzugehen, verstärkt den Effekt erheblich. Warum das so ist, verstehen wir nicht, aber die Folgen sind bei Affen deutlich zu erkennen: Das gegenseitige Kraulen führt zu Koalitionen, die stark von gegenseitiger Unterstützung geprägt sind – die Kraulpartner sind bereit, sich bei Bedarf auch angesichts überwältigend schlechter Chancen gegenseitig zu verteidigen. Oder kurz gesagt: Endorphine schaffen Freundschaften und bauen Beziehungen auf.

Wie sich herausgestellt hat, gibt es noch mindestens zwei weitere Faktoren, die zu wichtigen Auslösern für die Endorphinausschüttung werden: Lachen und Musik. Uns faszinierte die Tatsache, dass diese beiden typisch menschlichen Tätigkeiten für uns so erfreulich sind – sie machen sogar so viel Spaß, dass wir bereit sind, beträchtliche Geldsummen auszugeben, um sie zu erleben. Der Psychologe Steven Pinker tat zwar bekanntlich die Musik als evolutionären Käsekuchen ab, der weder besondere Folgen noch

einen besonderen Wert hat, aber eine evolutionsbiologische Faustregel besagt: Wenn ein Lebewesen bereit ist, stark in etwas zu investieren, muss dieses Etwas eine Funktion haben. Die Tatsache, dass wir mit Vergnügen Geld für etwas ausgeben, sollte uns also darauf aufmerksam machen, dass dieses Etwas unter Evolutionsgesichtspunkten einen echten Wert für die Funktion hat. Worin dieser Nutzen genau besteht, werden wir in Kap. 5 genauer erfahren. Vorerst halten wir nur fest, dass Musik und Lachen in der Endorphingeschichte eine Rolle spielen.

Um der Frage genauer nachzugehen, stellten wir eine Reihe von Experimenten mit Lachen und Musik an; dabei dienten uns (wie es auch in der Schmerzforschung üblich ist) die Schmerzgrenzen als Stellvertreter für die Endorphinausschüttung. Dahinter steht eine sehr einfache Überlegung. Wenn Endorphine zum System der Schmerzsteuerung gehören (und wenn sie vor allem dann ausgeschüttet werden, wenn wir Schmerz erleben), ist eine Steigerung der Schmerzschwelle nach einem Lachanfall oder nachdem man Musik gemacht hat, ein Beleg für die Endorphinausschüttung. Vor diesem Hintergrund maßen wir mit unserem Experiment die Schmerztoleranz, indem wir den Versuchspersonen eine Weinflaschenkühlmanschette um den Arm legten. Zur Messung der Schmerzgrenze stellten wir fest, wie lange oder kurz sie das aushielten. Anschließend mussten die Versuchspersonen einer Tätigkeit nachgehen, die sie zum Lachen brachte, oder sie sollten in irgendeiner Form Musik aufführen; anschließend wurde die Schmerzgrenze erneut gemessen. Wenn sie sich nicht änderte oder nach der Tätigkeit sogar *niedriger* war als zuvor, konnten wir den Schluss ziehen, dass diese sich nicht auf die En-

dorphinausschüttung ausgewirkt hatte. Lag die Schmerz-
grenze dagegen nach der Tätigkeit *höher*, musste es zu einer
Aktivierung der Endorphinausschüttung gekommen sein.
Um unsere Befunde abzusichern, machten wir parallel zu
dem Experiment auch einen Versuch mit einer Kontroll-
gruppe, die ähnliche Tätigkeiten ausführen musste, ohne
dass daran aber Lachen oder aktives Musikmachen beteiligt
war. Wenn die Schmerzgrenze unter den Bedingungen des
Experiments stieg, während sie sich in der Kontrollgruppe
nicht änderte, konnten wir sicher sein, dass die fragliche
Tätigkeit der Auslöser der Endorphinausschüttung war.

Wir führten insgesamt sechs Lachexperimente durch,
darunter eines bei Comedyaufführungen im Rahmen des
Edinburgh Festival Fringe. Bei den anderen brachten wir
die Versuchspersonen mit kommerziell erhältlichen Co-
medyvideos zum Lachen, und dann verglichen wir sie mit
Versuchspersonen, die sich – so hofften wir wenigstens –
langweilige Filme ansahen, darunter Tourismuswerbung,
Religionssendungen oder Golflehrvideos (die *sehr* langwei-
lig sein können!). Die musikalischen Experimente liefen
etwas anders ab, denn hier mussten die Versuchspersonen
aktiv Musik machen. In diesem Fall führten wir drei Ver-
suchsreihen durch. In der einen wurden zwei Formen von
Gottesdienst – ein Gebetsgottesdienst und ein charismati-
scher Gottesdienst mit Gesang und Tanz – verglichen; in
der zweiten wurde eine Trommelgruppe mit den Verkaufs-
mitarbeitern eines größeren Musikeinzelhändlers (die zwar
den ganzen Tag über viel Musik hörten, sie aber nicht selbst
ausübten) verglichen; und in der dritten betrachteten wir
eine „fließende" und eine unterbrochene Musikaufführung

(beispielsweise eine Probe, in der die Musik häufig unterbrochen wird, weil Fehler korrigiert werden müssen).

Alle diese Experimente führten im Wesentlichen zu dem gleichen Ergebnis: Die Versuchspersonen in den experimentellen Gruppen, die sich Comedyvideos ansahen und dabei lachten oder aktiv Musik machten, hatten nach den jeweiligen Aufgaben stets eine höhere Schmerzschwelle. In den Kontrollgruppen dagegen, in denen die Versuchspersonen langweilige Videos sahen, beteten oder nur Musik hörten, war das nicht der Fall. Mit anderen Worten: Lachen und Musikmachen sind gute Auslöser des Endorphineffekts. Und diese Wirkung haben sie, weil sie den Organismus unter Stress setzen.

Am offensichtlichsten ist das, wenn man ein Instrument spielt: Dies ist eine sehr körperbetonte Tätigkeit, die viel Anstrengung erfordert (und manchmal auch mit psychologischer Konzentration verbunden ist, die ebenfalls Stress darstellt). Lachen und Singen sind vermutlich aus einem geringfügig anderen Grund mit Stress verbunden: Hier müssen das Zwerchfell und die Muskulatur des Brustkorbs sich anstrengen und sehr kontrolliert zusammenarbeiten, um die benötigten Geräusche zu erzeugen. Singen ist beispielsweise viel anstrengender als Sprechen. Und Lachen ist nicht nur für die Muskulatur anstrengend, sondern es macht auch müde, weil wir dabei immer wieder ausatmen, ohne Luft zu holen, sodass die Lunge leer ist und ein Zustand der Atemlosigkeit einsetzt. Nicht umsonst sprechen wir von „Lachen bis der Bauch weh tut".

Die Fähigkeit des Lachens haben wir zwar mit den Schimpansen und vermutlich auch den anderen Menschenaffen gemeinsam, beim Menschen hat es aber eine deutlich an-

dere Struktur. Wenn Schimpansen lachen, findet dabei einfach eine Reihe von Aus- und Einatmungsvorgängen statt: Nach jedem Lachen holt der Affe wieder Luft. Wegen dieses wichtigen Unterschiedes leiden Menschenaffen nicht unter dem gleichen Ermüdungseffekt wie wir. Beim Menschen wurde das einfache Lachen der Menschenaffen offenbar in zwei wichtigen Aspekten verändert: strukturell, sodass es uns stärker ermüdet, und sozial, sodass es den verstärkten Endorphineffekt verursacht, den wir auch mit anderen sozialen Endorphinauslösern wie dem Kraulen erleben.

Ganz ähnlich wirkt offenbar auch das Musikmachen – und das ist natürlich ebenfalls eine sehr soziale Tätigkeit. Wichtig ist dabei, dass nur die aktive *Mitwirkung* bei der Musik auf diese Weise wirkt: Zuhören hat nicht annähernd den gleichen Effekt; ob die emotionalen Erschütterungen, die Musik in uns auslösen kann, etwas mit dem Endorphineffekt oder anderen neurologischen Wirkungen und Neuropeptidmechanismen zu tun haben, ist allerdings derzeit eine offene Frage. Wir haben aber die Vermutung, dass dieser Effekt auch erklärt, warum uns das Tanzen so viel Spaß macht und warum es im Sozialverhalten der Menschen eine so wichtige Rolle spielt.

Zusammenfassung

In diesem Kapitel haben wir uns auf Aspekte im Verhalten der heutigen Menschen konzentriert, das heißt auf den Endpunkt unserer Evolutionsvergangenheit. Dabei haben wir eine bemerkenswerte Übereinstimmung zwischen der Struktur kleiner Populationen – beispielsweise der Jäger

und Sammler – und den Hierarchieebenen in unserem eigenen sozialen Umfeld gefunden. Diese Gruppierungen unterliegen einer Dreierregel, das heißt, jede Ebene ist dreimal größer als die darunterliegende. Außerdem haben wir erfahren, dass der Aufbau unseres Gehirns der Erinnerung an Menschen und unseren Reaktionen darauf eine Grenze auferlegt. Die Regel der kognitiven Belastung gilt sowohl für Individuen – dies kann man selbst überprüfen, indem man sich das Adressbuch des Handys ansieht und die dort gespeicherten Personen nach den Beschreibungen in Tab. 2.1 einteilt – als auch für die Ebenen in ganz unterschiedlichen sozialen Einheiten wie Jäger-und-Sammler-Gruppen oder Armeen. Außerdem haben wir nachgewiesen, wie wichtig die kalte Kognition ist, das heißt die Fähigkeit, zu verstehen, was Menschen wollen, und diese Informationen zu nutzen. Dies hat uns zur Theorie des Geistes und den emotionalen Grundlagen vieler unserer Handlungen geführt.

In diesem Überblick über das moderne Sozialleben erkennen wir bereits, wie sich eine Kluft zwischen Gegenwart und Vergangenheit öffnet. Wie können wir aus einem Steinhaufen etwas über Gefühle erfahren? Werden wir nie wissen, welche zwischenmenschlichen Absichten ein Neandertaler hatte? Im nächsten Kapitel begeben wir uns in die entfernte Vergangenheit und fragen, wie das, was wir heute an den Menschen beobachten, entstanden ist. Es ist an der Zeit, dass unsere Vorfahren auf der Bildfläche erscheinen.

3
Sozialleben in alter Zeit

Ideen werden ausgegraben

Der schwierigste Teil jedes Forschungsprojekts ist die Über-
prüfung von Ideen. Sie macht aber auch am meisten Spaß.
Die Archäologen, die in diesem Kapitel die weitere Ge-
schichte erzählen, überprüfen ihre Ideen mithilfe handfes-
ter Belege. Ausgrabungen haben nicht den Zweck, antike
Gegenstände um ihrer selbst willen zu bergen, sondern wir
wollen damit Fragen beantworten – wollten wir das nicht,
sollten wir uns nicht als Archäologen bezeichnen. Wir ste-
cken nie einen Spaten in den Boden, ohne eine Vorstellung
davon zu haben, was wir finden werden oder zu finden hof-
fen und welches Licht es auf die Geschichte der Menschheit
werfen wird. Anhaltspunkte an der Oberfläche helfen uns
zu entscheiden, wo wir am besten nachsehen: abgeschla-

gene Flintsteine, Tierknochen und auch frühere Arbeiten, die schneller in größere Tiefen vorgestoßen sind als moderne Ausgrabungen. Dennoch lautet die goldene Regel für Archäologen: „Erwarte das Unerwartete." Als John Gowlett, damals noch ein junger Wissenschaftler, in Kenia an der Fundstätte Chesowanja grub, suchte er nach alten Steinwerkzeugen. Er fand aber einen der ersten Belege für die Beherrschung des Feuers. Und man stelle sich nur vor, wie überrascht der australische Archäologe Mike Morwood im Jahr 2003 gewesen sein muss, als er in der Höhle Liang Bua auf der indonesischen Insel Flores eine Reihe winziger menschlicher Skelette ans Licht brachte – die sogenannten Hobbits, die den Anlass gaben, die Lehrbücher über die Vielfalt der Menschen neu zu schreiben.

Eines aber, das wissen die Archäologen ganz genau, werden sie *niemals* finden: fossile Beispiele für Freundschaft, Verwandtschaft oder Intentionalität fünfter Ordnung, wie sie im letzten Kapitel beschrieben wurden. Es gibt einfach kein Steinwerkzeug, das eindeutig sagt „Sie war meine Freundin", und kein verkohlter Tierknochen schafft die Möglichkeit, präzise zwischenmenschliche Überlegungen zu rekonstruieren wie beispielsweise „Als er ein Steak briet, hatte er die Absicht, sie glauben zu machen, dass er sie wegen ihres Geistes liebte". Selbst wenn man bei Ausgrabungen eine geschnitzte kleine Figur aus Elfenbein findet, ruft diese nicht „Jetzt hatten sie eine Sprache!" Und nachdem man in der deutschen Höhlenfundstätte Geißenklösterle die älteste Flöte aus Vogelknochen ausgegraben hatte, hieß das nicht, dass wir den Augenblick nachgewiesen hätten, in dem vor 40.000 Jahren die Musik ihren Anfang nahm.

Archäologen reagieren auf solche Herausforderungen in der Regel auf zweierlei Weise. Einerseits bezeichnen sie häufig alles, was im vorangegangenen Kapitel über Sozialverhalten gesagt wurde, als Spekulationen, Ideen und Modelle über den Lauf der Welt, die man mit archäologischen Befunden nicht überprüfen kann. Solche Archäologen ziehen sich unter ihre Kuschelecke zurück: Sie beschreiben die Flintsteine, die sie gefunden haben, verfeinern die Zeittafeln, um sie einzuordnen, und halten sich an die Grundlagen des Daseins – was wurde gegessen, wie wurde es gefangen und warum wurde gerade diese Nahrung ausgewählt? Die zweite Möglichkeit besteht darin, sich dem schwierigen Teil zu widmen und Forschung zu betreiben, wie wir es mit unserem Lucy-Projekt taten; dabei wurde uns eines klar: Wenn die Archäologie in Bezug auf die Erforschung der menschlichen Evolution gehört werden will, muss sie Wege finden, um die vielfältigen Gedanken zu überprüfen, die sich aus der Untersuchung heutiger Primaten und Menschen ergeben. Unser Ausgangspunkt war das Konzept vom sozialen Gehirn. Die schwierige Aufgabe, von der in diesem Kapitel die Rede sein soll, bestand darin, in das soziale Gehirn vorzudringen und es der Überprüfung durch archäologische Daten zugänglich zu machen.

Viel Gehirn, wenig Sozialleben

In seinem 1999 erschienenen Werk *The Paleolithic Societies of Europe* schrieb Clive Gamble, es sei längst überfällig, „von den magengesteuerten, gehirntoten Erklärungen

[über den Zeitraum] wegzukommen und unseren analytischen Erfindungsreichtum auf die reichhaltigen sozialen Daten anzuwenden, die in den Funden enthalten sind". Es war das Manifest für die archäologische Komponente des Lucy-Projekts. Man braucht nur die meisten älteren archäologischen Darstellungen über die Altsteinzeit zu lesen, dann wird einem klar, dass die Archäologen nicht sehr weit gekommen waren. Dort findet man Berichte über die Neandertaler, Menschen, die ein ähnlich großes Gehirn hatten wie wir und deren Sozialleben man dennoch für armseliger hielt als das eines heutigen Pavianrudels. Man braucht nur das ungeheuer einflussreiche, 1990 erschienene Buch *How Monkeys See the World: Inside the Mind of Another Species* (dt. *Wie Affen die Welt sehen*) von Dorothy Cheney und Robert Seyfarth mit *The Neanderthal Legacy* (1996) des Archäologen Paul Mellar zu vergleichen. Das reichhaltige Sozialleben und die alltäglichen Interaktionen von Primaten mit kleinem Gehirn stand in krassem Gegensatz zu dem fast nicht vorhandenen sozialen Dasein eines fossilen Vorfahren mit gewaltiger Gehirnmasse. Aber wenigstens widmet auch Mellars dem Sozialleben seiner Neandertaler ein Kapitel. Damit ist sein Buch ein ganzes Stück besser als das von Gordon Childe, der mit seinem kleinen, 1951 erschienenen Buch *Social Evolution* (dt. *Soziale Evolution*) die gesamte Diskussion der nachfolgenden fünfzig Jahre prägte.

Als Australier stammte Childe von einem Kontinent der Jäger und Sammler, und als marxistischer Historiker hatte er fest gefügte Ansichten über die gesellschaftlichen Kräfte der Produktion und deren Abhängigkeit von einer materiellen Basis. Er konzentrierte seine ungeheuren analytischen

Fähigkeiten auf die Entstehung der Landwirtschaft und den Aufstieg der Zivilisation; dabei wandelte er an der Schnittstelle zwischen der Vorgeschichte der Menschen in Europa und dem Heraufdämmern der schriftkundigen Kultur im Nahen Osten. Von Jägern und Sammlern hatte er aber leider eine sehr schlechte Meinung. Nach Angaben von Childe lebten diese Menschen in einem Zustand der Wildheit auf der untersten Sprosse der Evolutionsleiter, eine Vorstellung, die er von dem Amerikaner Lewis Henry Morgan und aus dessen 1877 erschienenem Werk *Ancient Society* übernommen hatte. Diesem gesellschaftlichen Stadium waren wir nach Childes Ansicht dank der neolithischen Revolution entkommen, die uns die Landwirtschaft brachte – eine sesshafte Lebensweise, für die wir ewig dankbar sein sollten.

Childes Interesse galt den Anhaltspunkten für langfristigen gesellschaftlichen Wandel. Die Bauwerke und Metallverarbeitung im prähistorischen Europa, die Ziggurats und Königsgräber im Nahen Osten und die Dörfer und Städte, die sich auf der Grundlage der Landwirtschaft entwickelten, das alles konnte man zu einer eindrucksvollen Geschichte über den historischen Ablauf verweben. Für Belege aus dem Paläolithikum, für die Jäger und Sammler früherer Zeiten galt das nicht. Childe formulierte es so: „In den archäologischen Funden mangelt es bedauernswerterweise, aber nicht überraschend an Hinweisen auf die gesellschaftliche Organisation oder ihr Fehlen in den Horden des unteren Paläolithikums. Aus den verfügbaren Bruchstücken Verallgemeinerungen abzuleiten, ist nicht zulässig."

Das Bauchgefühl veranlasste die meisten Archäologen, Childe zu folgen und darauf zu beharren, dass Sozialverhal-

ten an handfesten Belegen abzulesen sein muss. Seit 1951 gab es bei denen, die sich mit den von der Landwirtschaft abhängigen Gemeinschaften beschäftigten, eine Fülle von gesellschaftlich orientierten Ansätzen. Archäologen gewannen bemerkenswerte Erkenntnisse über die wachsende gesellschaftliche Komplexität auf allen Kontinenten bis hin zu den abgelegenen Inselgruppen Ozeaniens. Das Sozialleben wurde unter dem Gesichtspunkt entstehender gesellschaftlicher Strukturen analysiert: Gleichberechtigung, einflussreiche Männer, Häuptlinge, Hierarchien und gesellschaftliche Schichten. Die ideologischen und symbolischen Rahmenbedingungen für die Macht wurden unter demographischen und gesellschaftlichen Gesichtspunkten minutiös analysiert, vom Haushalt über den Stadtstaat bis zum Großreich. Man untersuchte Friedhöfe und interpretierte Grabbeigaben als Anzeichen für verschiedene Gesellschaftsformen. Mit Belegen für Kriege, Armeen und Sklaven wollte man Machtstrukturen und Erwerbsbevölkerung analysieren. Netzwerke für Handel und Tributzahlungen steuerten ebenso weitere Details bei wie Antworten auf die Frage, wie Kernregionen ihr Hinterland veränderten und damit erste Formen der Regionalisierung schufen.

Aber in diesem ganzen Hexenkessel der neuen archäologischen Forschungen fanden die Gruppen der altsteinzeitlichen Jäger und Sammler die geringste Aufmerksamkeit. Dennoch wurden sie in der Zeittafel der Evolution nicht mehr einem Stadium der Wildheit zugeschrieben. Man klassifizierte sie jetzt als Hordengesellschaft in der klassischen Entwicklung von der Horde über den Stamm zum Stammesfürstentum und von dort zum Staat, wie der Anthropologe Ellman Service (1962) und der junge Marshall

Sahlins (1963) sie postuliert hatten. (Diese Begriffe werden entsprechend unserer Ausführungen über die Dreierregel – s. Tab. 2.1 – anders definiert.) Den Wendepunkt brachte die höchst einflussreiche Tagung *Man the Hunter* 1966. Dort trafen Anthropologen und Archäologen zusammen und präsentierten einen globalen Überblick.

Im weiteren Verlauf unterschied man bei den Hordengesellschaften zwischen einfachen und komplexen Gesellschaften von Jägern und Sammlern, die mit unterschiedlichen Mechanismen darüber bestimmten, in welchem Tempo die Lebensmittelvorräte verbraucht wurden. Der Anthropologe James Woodburn bezeichnete sie als Systeme mit unmittelbarer (einfacher) und verzögerter (komplexer) Belohnung. Diese Unterscheidung stützte sich in großem Umfang auf moderne Beispiele und wurde kürzlich von Alan Barnard, einem der Beteiligten am Lucy-Projekt, ausführlich erörtert. Durch die Anwendung der Modelle auf archäologische Befunde wurden Fundstätten mit Bestattungen, Kunst und Architektur, wie man sie im oberen Paläolithikum in Europa findet, zu Beispielen für komplexe Gesellschaften, und alle anderen wurden definitionsgemäß als einfach eingestuft. Dazu gehörten die Neandertaler und alle anderen fossilen Vorfahren in der Alten Welt.

Archäologen sind auch heute noch misstrauisch gegenüber jenen, die behaupten, sie könnten Aussagen über die sozialen Aspekte des Frühmenschendaseins machen. Aber heute ist endlich die Zeit gekommen, in der wir sie mit der Kehrseite ihrer Haltung konfrontieren können: Lange Abschnitte in der Geschichte unserer Spezies wurden nicht erforscht. Ein Beispiel wird im Kasten „Sex und das monogame Gehirn" geschildert: Dort wird die Monogamie als

Thema der Evolution untersucht, und faszinierende neue Forschungsarbeiten zeigen *entgegen* der Ansicht von Childe, dass durchaus Belege verfügbar sind.

Wenn wir den Pessimisten nachgeben, zahlen wir einen hohen Preis: Wir werden dann unsere Evolution niemals wirklich verstehen, denn unser Evolutionserfolg war wie der aller Affen von unserem Verhalten und insbesondere unserem Sozialverhalten abhängig. Mit dem Lucy-Projekt standen wir vor der schwierigen Aufgabe, einen Weg aus der Sackgasse zu finden und konstruktive, sinnvolle Aussagen über das Sozial- und Geistesleben unserer Vorfahren machen zu können.

Was verstehen wir unter Sozialverhalten?

Wie sah eine Gesellschaft im Paläolithikum aus? Um diese Frage zu beantworten, verwarfen wir im ersten Schritt das Modell der Horde, denn es liefert uns kaum Aufschlüsse; es ist ein Etikett, mehr nicht. Allerdings können wir daraus entnehmen, wonach wir nicht suchen sollten. Es verkörpert ein Gesellschaftsmodell, das mit dem Blick von oben nach unten organisiert ist (andere Beispiele wurden in Kap. 2 erwähnt). In einer solchen Sichtweise ist die Gesellschaft eine Institution, wie sie einem Bürger der Vereinigten Staaten oder einem Dauerkarteninhaber von Manchester United vertraut ist. Institutionen gab es schon, bevor es uns gab, so wie Prinz George in die königliche Familie und die britische Monarchie hineingeboren wurde. Zu ihrem Mitglied

werden wir entweder wie Prinz George durch unsere Geburt, oder aber durch unsere eigene Entscheidung, wenn wir uns die Mitgliedschaft erkaufen. Die Horde der Jäger und Sammler war eine Institution, die von Anthropologen gestaltet wurde und eine Lücke füllen sollte. Seltsamerweise ist sie weniger durch das definiert, was sie ist, als vielmehr durch das, was sie nicht besitzt – Landwirtschaft, Siedlungen und Monumentalarchitektur. Sie ist ein wahrhaft kleiner Anfang für die spätere Verfeinerung der Gesellschaft. In dieser Hinsicht hatte Childe völlig recht: Die „Bruchstücke", die erhalten geblieben sind, ermöglichen uns kaum Aussagen über das Sozialverhalten. Wenn wir nach handfesten Belegen für Institutionen suchen, um mit ihrer Hilfe die Gesellschaft des Paläolithikums zu studieren, werden wir sie niemals finden.

Wenn man das Sozialleben der Vergangenheit erforschen will, gibt es aber noch einen anderen Weg; er beinhaltet eine Sichtweise, die ihre Anregung von den Primaten bezieht, und wird zutreffend nicht als von oben nach unten gehend, sondern als unten nach oben gehend beschrieben. Dabei werden die Regeln des Sozialverhaltens nicht von einer gesellschaftlichen Institution festgelegt und weitergegeben, sondern der Einzelne kommt selbst darauf. Die Schlüsselbegriffe lauten hier Interaktion und Bindung. Sozial zu sein, heißt, sich zusammenzutun, und das setzt Interaktionen zwischen den Mitgliedern einer Gemeinschaft voraus, ganz gleich, ob es sich um Paviane, Neandertaler oder Facebook-Freunde handelt, die sich insgesamt zur Dunbar-Zahl von 150 summieren.

Sex und das monogame Gehirn

In diesem Kapitel konzentrieren wir uns auf die Frage, wie soziale Gemeinschaften entstehen. Es gibt im Verhalten der Menschen aber einen wichtigen Aspekt, der in diesem Zusammenhang zwar etwas am Rande steht, für den Ablauf der Evolution aber eine wichtige Rolle spielt: das Paarungsverhalten. Das Paarungssystem einer Spezies ist ein fundamentaler Bestandteil ihrer biologischen Eigenschaften, denn letztlich ist es die Fortpflanzung, die den evolutionären Wandel vorantreibt. Außerdem ist das Paarungssystem in das soziale System der Spezies eingebettet. Bei den Paarungssystemen der Primaten kann man in der Regel wenige einfache Typen unterscheiden: monogame Paarbindung, Harem-Polygynie (wobei ein Männchen mit einer Gruppe von Weibchen zusammenlebt und das Monopol auf die Paarung mit ihnen hat) und die Vielmänner-Polygynie (bei der mehrere Männchen mit einer Gruppe von Weibchen zusammenleben und um die Paarung mit einzelnen Weibchen konkurrieren, wenn diese in die fruchtbare Phase eintreten). Der Vorläufer dieser sozialen Zustände ist nach allgemein anerkannter Ansicht eine Form halbeinsamer Vergesellschaftung, bei der die Männchen ein Monopol auf ihr Revier haben, in dem die Weibchen sich dann individuell aufhalten.

Die Paarbindung oder Monogamie war stets von besonderem Interesse, weil Menschen offenbar solche Beziehungen eingehen. Sie galt immer als zentraler Bestandteil der Evolution des Menschen, denn sie steht im Zusammenhang mit der Brutpflege durch beide Eltern: Ein Mann und eine Frau investieren mit vereinten Kräften gemeinsam in die Ernährung der Nachkommen mit ihrem großen Gehirn. Gerade weil die Aufzucht der Nachkommen bei Menschen so aufwendig ist, galt die Paarbindung sogar als unentbehrliche Voraussetzung für ihre Produktion. Die gleiche Argumentation steht übrigens auch hinter der Arbeitsteilung, einem weiteren entscheidenden gesellschaftlichen Merkmal, das nach heutiger Kenntnis die Menschen charakteri-

siert: Der Mann geht auf die Jagd, um Nahrung für seine Frau zu beschaffen, und sie versorgt währenddessen die aufwendigen Nachkommen – die höchste Form eines wirtschaftlichen Gemeinschaftsunternehmens.

Die Frage, ob Menschen in Wirklichkeit monogam oder polygam sind, ist bis heute heiß umstritten. Vielfach wird die Ansicht vertreten, Menschen seien grundsätzlich polygam, und die Monogamie sei ein gesellschaftlich oder wirtschaftlich erzwungener Zustand. Andere sind der Meinung, Männer seien eigentlich überflüssig: Danach nehmen die Großmütter mütterlicherseits letztlich die Mühe auf sich, Frauen bei der Aufzucht ihrer Nachkommen zu helfen (s. Kap. 4), und die Jagd ist eine Art Nebenbeschäftigung, die der Werbung um Partnerinnen dient: Großwild zu jagen, ist gefährlich, und Erfolg in diesem Bereich ist ein Kennzeichen für genetische Qualität, das man nicht vortäuschen kann: Der gut trainierte Körper und der vollkommene Geist können auf jeden Fluchtversuch des Beutetieres angemessen reagieren. Tatsächlich liegt der Mensch nach den meisten anatomischen Kennzeichen für Paarungssysteme (beispielsweise der relativen Größe der Hoden) ziemlich genau in der Mitte zwischen monogamen Primaten (wie den Gibbons) und polygamen Arten (wie Pavianen und Schimpansen). Die Männchen polygamer Arten haben im Verhältnis zur Körpergröße sehr große Hoden, bei monogamen Arten dagegen sind sie sehr klein. Das liegt nach heutiger Kenntnis daran, dass die Männchen polygamer Arten untereinander um Paarungsmöglichkeiten konkurrieren müssen, und je mehr Samenzellen sie bei jeder Kopulation in das Weibchen einbringen können, desto größer ist die Wahrscheinlichkeit einer Befruchtung. Da das Volumen des Ejakulats eine einfache Funktion der Hodengröße ist, müssen Menschen, die in der Paarungslotterie ein gutes Los ziehen wollen, die größtmöglichen Keimdrüsen haben.

Dabei stellt sich natürlich das Problem, dass Hoden aus weichem Gewebe bestehen und nicht fossilieren; deshalb fällt es schwer, eindeutige Erkenntnisse über die Paarungs-

systeme fossiler Arten zu gewinnen. Aber Emma Nelson, eine Doktorandin, die im Lucy-Projekt mitarbeitete, hatte eine neue Idee: Sie maß stellvertretend das Längenverhältnis zwischen Zeige- und Ringfinger (das auch als D2:D4 bezeichnet wird). Dieses Verhältnis ist bekanntermaßen abhängig vom Testosteronspiegel des Fetus und liegt deshalb bei den Männern stets niedriger als bei Frauen (das heißt, ihr Zeigefinger ist kürzer als der Ringfinger). Nelson konnte nachweisen, dass das D2:D4-Verhältnis bei Männchen und Weibchen monogamer Klein- und Menschenaffenarten nahe bei 1 (oder auch knapp darüber) liegt, während es bei Männchen und Weibchen polygamer Arten deutlich niedriger ist (in der Regel ungefähr bei 0,9).

Wie nicht anders zu erwarten, hilft auch dieses Maß bei modernen Menschen nicht weiter: Sie liegen in der Mitte zwischen den monogamen Gibbons und den promiskuitiven Menschenaffen. Als Nächstes untersuchte Nelson in Zusammenarbeit mit den Biologinnen Susanne Shultz und Lisa Cashmore (einer weiteren Studentin aus der Projektgruppe) die Fingerknochen fossiler Homininen. Wie sich dabei herausstellte, lag das 2D:4D-Verhältnis der meisten Homininen (darunter auch der sehr frühe *Ardipithecus* und die späteren Neandertaler) zweifelsfrei im polygamen Bereich. Nur bei *Australopithecus* lag das Verhältnis paradoxerweise sogar nahe bei dem der monogamen Gibbons – und auch sie unterschieden sich nicht nennenswert von den modernen Menschen mit ihrem nicht eindeutigen Paarungssystem (s. Abb. 3.1).

Manche Archäologen vertreten schon seit langer Zeit die Ansicht, die Paarbindung habe sich in der Evolution der Homininen schon frühzeitig entwickelt, nämlich vielleicht schon vor 5,5 bis 4,5 Mio. Jahren, der Lebenszeit des sehr alten *Ardipithecus* und rund eine Million Jahre vor den klassischen Australopithecinen wie Lucy und ihresgleichen. Die Messungen des 2D:4D-Verhältnisses legen aber die Vermutung nahe, dass alle Homininen einschließlich der Neandertaler und der sehr frühen anatomisch modernen Menschen

von der nahöstlichen Fundstelle Qafzeh ebenso polygam waren wie Schimpansen und Gorillas. Kurz gesagt, sieht es so aus, als seien alle unsere Vorfahren polygam gewesen. An keinem von ihnen erkennt man eine Neigung zu der ausschließlich monogamen Lebensweise der Gibbons, und nur die wenigsten waren auch nur so monogam wie wir.

Das widerspricht bis zu einem gewissen Grade der Behauptung, die Paarbindung habe sich bei Menschen entwickelt, um die Versorgung der Nachkommen durch beide Eltern möglich zu machen. Soweit eine solche Versorgung überhaupt stattfindet – womit nicht gesagt werden soll, dass es sie nicht gäbe –, war sie wahrscheinlich eine Folge der Gelegenheiten, die sich durch die Paarbindung boten, aber im Gegensatz zu vielen früheren Annahmen nicht die Ursache der Paarbindung.

Das könnte durchaus plausibel sein: Wie Suzanne Shultz, Kit Opie und Quentin Atkinson im Rahmen des Lucy-Projekts nachweisen konnten, ist die Monogamie in der sozialen Evolution der Primaten eine Art Endzustand: Wenn eine Spezies sie sich einmal zu eigen gemacht hat, wechselt sie nur sehr selten wieder in der umgekehrten Richtung. Die ausschließliche Monogamie hat also etwas Endgültiges. Das liegt vermutlich daran, dass eine derartige echte Monogamie in Verhalten und Kognition (und damit auch im Gehirn) größere Veränderungen erfordert, die rückgängig zu machen sehr schwierig ist. Die ausschließliche Monogamie ist eine evolutionäre Sackgasse – durch sie wird eine Art offensichtlich weniger flexibel, zumindest was ihr Sozialsystem betrifft. Und ein Verlust von Flexibilität ist kein Rezept für Evolutionserfolg. Wenn das stimmt, gab es möglicherweise deshalb keine wirklich monogamen Homininen, weil alle Evolutionsexperimente in dieser Richtung unter den Bedingungen des fortgesetzten Klimawandels, der unsere Vorfahren in den letzten 2 Mio. Jahren heimsuchte, sehr schnell zum Aussterben führten.

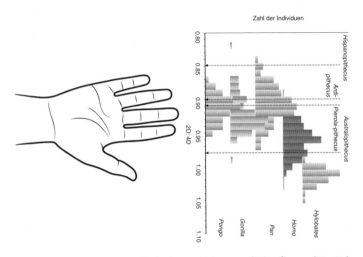

Abb. 3.1 Das Längenverhältnis von Zeige- und Ringfinger (2D:4D) ist bei verschiedenen Menschenaffenarten und Menschen je nach dem Paarungssystem unterschiedlich. Jetztmenschen (und vielleicht auch *Australopithecus afarensis*) sind nicht eindeutig: Bei ihnen liegt das Verhältnis in der Mitte zwischen dem der streng monogamen Gibbons und der polygamen Menschenaffen. Die Menschenaffen *Hispanopithecus* und *Pierolapithecus* aus dem Miozän, aber auch der frühe *Ardipithecus*, waren eindeutig ebenso polygam wie die anderen Menschenaffen. (© Nelson et al. 2011; Abb. 2, The Royal Society (unten) ©Anna Rassadnikova/iStockphoto.com)

Diese Interaktionen sehen unterschiedlich aus, je nachdem, welche Ressourcen die Spezies in die soziale Bindung einbringt. Zwei davon sind zentrale Bestandteile unseres Soziallebens: Material und Sinneswahrnehmung. Bei dem Material handelt es sich um Nahrung, Wasser, Steine, Holz und alle anderen Bestandteile der Umwelt. Die Sinneswahrnehmung ist für die Schaffung aller sozialen Bindungen notwendig; das liegt an unserem gemeinsamen senso-

rischen Erbe: Berührung, Sehen, Geschmack, Hören und Riechen. Und natürlich bringen alle Primaten und ebenso alle Homininen ihren Körper in eine soziale Begegnung ein. Der Körper besitzt die in Kap. 2 beschriebenen chemischen Systeme für Schmerzen und Belohnungen, aber auch unterschiedlich geformte Finger (die für das Kraulen unentbehrlich sind), Gliedmaßen und Zähne.

Damit konnten die sozialen Interaktionen und die Entstehung von Bindungen beginnen. Die grundlegende soziale Einheit ist die Zweiergruppe: Sie kann aus zwei beliebigen Menschen bestehen, am wichtigsten ist aber aus naheliegenden evolutionären Gründen die Zweiheit von Mutter und Kind. Jenseits der Zweiergruppe gibt es größere Gruppierungen aus engen Verwandten, Intimpartnern, Unterstützergruppen und vielfältigen Netzwerken, auf die ein Individuum zurückgreifen kann, um Nahrung zu finden oder Schutz zu suchen, wenn ein Streit ausbricht. Diese Gruppen bilden verschiedene Ebenen, die Clive Gamble ursprünglich als intime, effektive und erweiterte Netzwerke bezeichnete, eine Einteilung, die von Sam Roberts weiterentwickelt wurde.

Ein Pavian unterscheidet sich von einem Neandertaler nicht nur durch die Gehirngröße, sondern auch durch das Spektrum verschiedener Materialien und Sinneswahrnehmungen, die er einbringt, damit soziale Bindungen wirklich eine Bindungswirkung haben. Bei Pavianen geschieht dies vor allem durch Kraulen. Wie wir in Kap. 2 erfahren haben, bleibt im Tagesverlauf genügend Zeit, um den chemischen Lohn für diese Bindung durch Berührung einzustreichen.

Für Hominimen mit großem Gehirn wie die Neandertaler und uns selbst mit unserer Gemeinschaft aus 150 Individuen gilt das nicht. Angesichts der vorhergesagten Gruppengröße bleibt einfach nicht genügend Zeit, um die Bindungen auf ähnliche Weise durch engen Körperkontakt zu bestätigen.

Was sich im weiteren Verlauf der Evolution der Menschen abspielte, baute auf diesem Verhalten der Primaten auf: Man findet durch tägliche persönliche Interaktionen ständig neu heraus und wiederholt, wer man ist und in welcher Gesellschaft man lebt. Das Ganze hat keine Ähnlichkeit mit dem institutionellen Gesellschaftsmodell und seinen abgegrenzten Sphären von Religion, Politik, Justiz und Geschäftsleben. Vielmehr errichteten die Menschen rund um den Kern der Materialien und Sinneswahrnehmungen das Gerüst, das den Aufbau immer komplexerer Sozialbeziehungen ermöglichte. Dieses Gerüst nahm viele Formen an. Dazu gehörten Zeremonien, die tote und lebende Menschen verbanden, und sowohl reale als auch imaginäre Orte. Ebenso gehörten dazu die Erfindung neuer Werkzeuge und Bauwerke, mit denen man solche Begriffe zum Ausdruck brachte. Ihre Inspiration bezogen diese neuen sozialen Formen aber immer aus den Grundelementen des Sozialverhaltens. Das wiederum bedeutete, dass man mit Methoden zum Aufbau sozialer Bindungen experimentierte, die Menschen auf allen Ebenen ihrer Netzwerke und in der gesamten Gesellschaft dauerhafter zusammenhielten. Das Gerüst wurde nie abgebaut, sondern es entwickelten sich ständig neue soziale Formen – man denke nur an unser digitales Zeitalter. Die Fragen des sozialen Lebens, von denen in Kap. 1 die Rede war, beglei-

ten uns nach wie vor, und unsere Erfindungsgabe hat sich immer darauf gerichtet, sie zu beantworten.

Den ganzen Vorgang kann man als *Verstärkung* des bereits Vorhandenen bezeichnen: Ein existierendes, aus Gefühlen oder Stimmungen entspringendes Signal wird entweder durch körperliche Aktivität wie beispielsweise den Tanz zur Ausschüttung von Opiaten gesteigert, oder die gleiche Wirkung wird durch Gefühle für Objekte, die von ihnen heraufbeschworenen Erinnerungen einschließlich ihrer emotionalen Wirkungen oder die heiße Kognition von Empathie ausgelöst, die sie beim Zuschauer hervorrufen. Am einfachsten erkennt man das im Zusammenhang mit Materialien. Ein hölzerner Stock, mit dem man Termiten aus ihren Bauten locken kann, wird zu einem Grabstock weiterentwickelt, und dann wird daraus ein Speer, ein Pfeil, ein Schreibwerkzeug; mit jeder derartigen Umwandlung werden neue, andere soziale Beziehungen aufgebaut. Das sind die sozialen Formen in Abb. 3.2. Gleichzeitig können aber auch die Sinneswahrnehmungen verstärkt werden. Musik, Sprache, Kochen und Malen erzeugen sensorische Reize, die das soziale Zusammensein bereichern. Eines der sinnträchtigen Wörter, die wir zur Beschreibung dieses Vorganges gefunden haben, lautet *Überschäumen* (*effervescence*). Emile Durckheim, ein französischer Pionier der Soziologie, benutzte es für die Aufregung, die das soziale Leben schafft, für den Lohn, wenn man sich trifft und Tänze, Rituale und Zeremonien aufführt. Als Überschäumen kann man auch die Empfindung bezeichnen, die zurückbleibt, nachdem eine Versammlung sich aufgelöst hat – der kollektive Geist der Zusammengehörigkeit, der Klebstoff des Soziallebens.

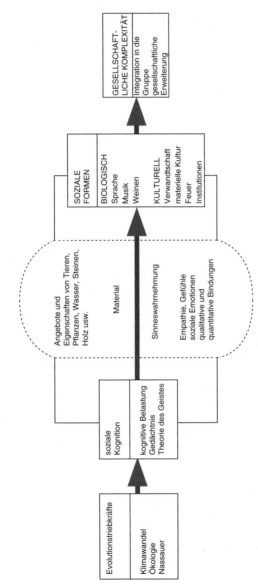

Abb. 3.2 Eine „Landkarte" mit den wichtigsten Bausteinen des sozialen Gehirns. Sinneswahrnehmungen und Materialien bilden einen Kern von Ressourcen; diese dienen zur Herstellung neuer, stärkerer Bindungen, mit denen man auch in größeren Gemeinschaften zurechtkommt. (Nach © Gamble et al. 2011; Abb. 1)

Menschen haben viele Wege ausprobiert, um die Stimmung zu verbessern und das Umfeld sozialer Zusammenkünfte zu verändern. Wenn wir Alkohol trinken, Musik hören oder mit den Aromen und Düften verschiedener Kochrezepte experimentieren, verstärken wir die wichtigsten Ressourcen, die zu sozialen Bindungen beitragen. Ebenso betreiben wir gemeinsame Aktivitäten, von denen wir wissen, dass sie unseren Organismus mit der Ausschüttung von Opiaten belohnen. Wie wir in Kap. 2 erfahren haben, erklärt das zum Teil unsere Leidenschaft für gemeinsamen Sport, gemeinsames Singen und das gemeinsame Lachen im Publikum. Außerdem verändern wir gezielt unsere unmittelbare Umgebung, sodass der Ort, an dem wir uns befinden, uns entweder bezaubert oder ängstigt und uns ein Gefühl der Sicherheit oder der Furcht vermittelt.

Wenn wir uns eine Vorstellung davon verschaffen wollen, wie eine soziale Archäologie des Paläolithikums aussehen könnte, müssen wir deshalb von diesen allgegenwärtigen, zentralen Ressourcen als den Bausteinen des Wandels ausgehen. Wir betrachten dabei von unten nach oben mindestens 2,6 Mio. Jahre der Evolution des Menschen und lassen uns von Werkzeugen helfen. Das Sozialleben jedes einzelnen Vorfahren, der in diesem gewaltigen Zeitraum lebte, diente dazu, dem Einzelnen einen Vorteil für sich selbst und seine Nachkommen zu verschaffen. Dies taten unsere Vorfahren von Angesicht zu Angesicht, wobei das Spektrum der möglichen Ergebnisse begrenzt war. Diese Grenzen wurden durch die geringe Populationsgröße vorgegeben, die ihrerseits, wie Stephen Shennan in seinem bahnbrechenden, 2001 erschienenen Buch *Genes, Memes and Human History*

überzeugend dargelegt hat, zu einer geringeren Akzeptanz von Neuerungen führte. Im Rahmen unseres Projekts beschäftigte sich Garry Runciman mit solchen Themen in *The Theory of Cultural and Natural Selection* (2009).

In einem Punkt können wir eine ganz klare Aussage machen. Eine von oben nach unten organisierte Institution namens Gesellschaft gab es nie. Deshalb können Archäologen in dem Sinn, wie Childe es sich vorstellte, nie etwas finden. Die Vorstellung von einer Gesellschaft, nach der wir in diesem Buch suchen, setzt deshalb eine ganz andere Sichtweise für die archäologischen Befunde voraus: Ihre Untersuchung ist nur dann sinnvoll, wenn man die Erkenntnisse über die Funktionsweise des sozialen Gehirns einbezieht. Deshalb haben wir auf Childe, der die soziale Organisation der Menschen in der Altsteinzeit überging, und auf die Bedenken anderer Archäologen wegen des Fehlens unmittelbarer Belege eine einfache Antwort: Ändert das Bild von dem, was ihr unter Sozialleben versteht. Vergesst die Suche nach Institutionen, die es nie gab. Kommt zurück auf die Bindungen zwischen den Menschen und die Mittel, die zur Verbesserung ihrer Stärke und Qualität zur Verfügung standen. Öffnet das soziale Gehirn und sucht darin nach seiner entfernten Vergangenheit.

Was wir dort finden, wurde von John Gowlett als das ewige Dreieck der Homininenevolution bezeichnet. Seine drei Eckpunkte sind der Wandel der Ernährung, soziale Kooperation und detaillierte Kenntnisse über die Umwelt. Hier fließen mehrere Elemente der Evolutionsgeschichte an einer entscheidenden Stelle zusammen. Wir wissen – dies wird unter anderem durch den Transport von Steinwerk-

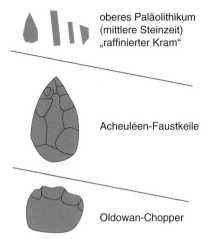

oberes Paläolithikum
(mittlere Steinzeit)
„raffinierter Kram"

Acheuléen-Faustkeile

Oldowan-Chopper

Abb. 3.3 Steinwerkzeuge wurden traditionell auf einer einfachen Leiter angeordnet: Auf Chopper folgen Faustkeile und dann die „raffinierteren" Werkzeugarsenale des oberen Paläolithikums – aber das ist bei weitem nicht die ganze Geschichte. (© John Gowlett)

zeugen bewiesen (s. Abb. 3.3) –, dass die frühen Homininen zur Nahrungssuche größere Strecken zurücklegen mussten als ihre Menschenaffenvettern, weil ihre Umwelt trockener und stärkeren jahreszeitlichen Schwankungen ausgesetzt war. Neben dieser Entwicklung mussten die Homininen sich aber auch darum bemühen, ihre Verbindungen durch ihre Netzwerke aufrechtzuerhalten; die stärkere Kommunikation brauchten sie sowohl zur gegenseitigen Unterstützung als auch, um Wissen zu teilen. Oder anders formuliert: Die größeren Gruppen, von denen man ausgeht, brauchten mehr Nahrung, und das führte dazu, dass die Menschen größere Gebiete oder Heimatreviere abdecken mussten.

Im Rahmen des Lucy-Projekts beschäftigten sich James Steele und Clive Gamble mit der Reviergröße von Menschenaffen und Raubtieren, während Susan Anton und ihre Kollegen nach dem Vorbild von Primatenforschern wie Richard Wrangham insbesondere die Unterschiede in der Ernährung von Menschenaffen und Menschen betrachteten. Menschenaffen ernähren sich von Früchten, Blättern und anderen pflanzlichen Nahrungsmitteln; bei Menschen kommen tierische Lebensmittel in stetig wachsender Menge hinzu, die weit über die Fleischrationen, die Schimpansen verzehren, hinausgeht. Im Gegensatz zu den bereits erwähnten kleinen Revieren der Menschenaffen kann das Revier von Fleischfressern, beispielsweise eines Vorfahren wie *Homo erectus*, bei einer Gruppengröße von ungefähr 100 Individuen eine Fläche von 500 Quadratkilometern erreichen, wenn es sich nicht in den ökologisch üppigen Tropen befindet. Das größere Gehirn und größere Gemeinschaften hatten also wichtige Auswirkungen auf die Ernährung und auf die Nutzung der Landflächen.

Was hat sich in zweieinhalb Millionen Jahren verändert?

Auf diese Frage gibt es eine einfache Antwort. Bei den Menschen entwickelte sich ein großes Gehirn, während es bei anderen Primaten bei dem uralten Größenverhältnis zwischen Gehirn und Körper blieb. Dieses Verhältnis,

Enzephalisationsquotient oder kurz EQ genannt, spiegelt das ungewöhnlich starke Gehirnwachstum bei Homininen und Menschen wider. Das Ergebnis ist ein Primat namens Mensch, dessen Gehirn das Dreifache der erwarteten Größe hat. Aus der Archäologie wissen wir auch, dass seine Technologie immer komplexer wurde. John Gowlett stellte diese Entwicklung graphisch dar und verglich sie mit der Entwicklung der Gehirngröße (s. Abb. 3.4). Zu diesem Zweck untersuchte er die begrifflichen Aspekte, die am Wandel der Technologie im Zusammenhang mit Steinen, Knochen und Feuer seit dem ersten Auftauchen von Steinwerkzeugen vor 2,6 Mio. Jahren deutlich werden.

So weit, so gut. Aber dass sich Gehirn und Werkzeuge während der Evolution der Menschen verändert haben, wussten wir bereits. Vor dem Hintergrund des sozialen Gehirns konnten wir jedoch das Schwergewicht wieder auf diejenigen Individuen legen, die ihr Sozialleben mit den unentbehrlichen materiellen Ressourcen sowie den Sinnesorganen und den chemischen Belohnungssystemen ihres Organismus aufbauten. Die Grundlage für das Verständnis dieser Gesellschaften einer entfernten Vergangenheit ist die Erkenntnis, dass es sich um aufrichtige, persönlich geprägte, kleine Gemeinschaften handelte. Hier untersuchen wir, welche Folgerungen sich aus der wachsenden Größe der Gemeinschaften ergaben; anschließend wollen wir betrachten, was sich abspielte, nachdem Menschen erstmals weit voneinander entfernt lebten.

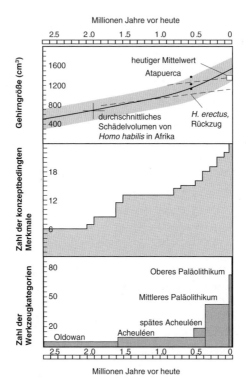

Abb. 3.4 Einige wichtige Indizienketten aus der Evolution des Menschen, dargestellt in einem gemeinsamen Zeitmaßstab. *Oben*: das gut erforschte Wachstum der Gehirngröße. *Mitte*: das Aufkommen neuer Konzepte in der materiellen Kultur, beispielsweise das Abschlagen von Steinen, die Herstellung von Knochenwerkzeugen und die Nutzung des Feuers. *Unten*: Zahl der Kategorien verschiedener Steinwerkzeuge in den aufeinanderfolgenden Perioden. (© John Gowlett nach Gowlett in Camps und Chauhan 2009; Abb. 1)

Die Größe von Gemeinschaften und Netzwerken

Die Tatsache, dass die Größe der Gemeinschaften bei Primaten und Jetztmenschen in so engem Zusammenhang mit der Größe des Neocortex steht, liefert uns sofort ein Anhaltspunkt, wenn wir abschätzen wollen, wie groß die Gemeinschaften unserer fossilen Vorfahren wahrscheinlich waren. Dahinter steht eine sehr einfache Überlegung. Wenn die Größe der Gemeinschaften von Klein- und Menschenaffen im Zusammenhang mit der Gehirngröße steht und wenn die modernen Menschen auf derselben ansteigenden Linie genau an der erwarteten Stelle liegen, müssen alle fossilen Homininenarten zwischen diesen beiden Punkten einzuordnen sein – es sei denn, unsere fossilen Vorfahren verhielten sich so völlig anders, dass sie nicht in die allgemeine Gesetzmäßigkeit für *alle* anderen Primaten einschließlich der modernen Menschen passen. Aber eine derart unplausible Überlegung ist kaum einer ernsthaften Betrachtung wert. Dennoch wurde manchmal widersinnigerweise behauptet, wir könnten solche Vermutungen über fossile Arten nicht anstellen. Die einfache Tatsache lautet: Wenn die Gehirngröße bei Kleinaffen, Menschenaffen und Menschen eine genaue Voraussage über die Größe der sozialen Gemeinschaften ermöglicht, muss das Gleiche auch für alle ausgestorbenen Arten gelten – es sei denn, wir wollten unterstellen, dass die fossilen Homininen plötzlich vom Weg abkamen und etwas völlig Unprimatenhaftes taten, um anschließend genau rechtzeitig wieder in die Spur zurückzukehren, bevor die modernen Menschen auf der Bildfläche erschienen.

Dennoch ist die Mahnung zur Vorsicht nicht völlig unbegründet. Denn die Gleichung über das soziale Gehirn stützt sich nicht auf die Abmessungen des gesamten Gehirns, sondern auf die Größe des Neocortex und – vielleicht noch besser – auf die Größe seiner vorderen Elemente (insbesondere die Stirnlappen). Wenn es aber um fossile Arten geht, kennen wir nur das Schädelvolumen (das heißt die Gesamtgröße des Gehirns), denn das Gehirn selbst verwest nach dem Tod schnell und bleibt nicht erhalten. Zum Fossil wird nur der Gehirnschädel. Nun stellt der Neocortex im Großen und Ganzen bei allen Klein- und Menschenaffen immer den gleichen Anteil an der Gesamtmasse des Gehirns; im Gesamtbild sollten solche Überlegungen also keine große Rolle spielen, selbst wenn sie über einzelne Arten vielleicht nur schlechte Voraussagen liefern. Betrachtet man die ganze Gruppe der Primaten, kann man sogar aus dem Gesamtvolumen des Gehirns die gleichen Aussagen über die Größe der Gemeinschaften ableiten wie aus dem Volumen des Neocortex. Es gibt aber individuelle Ausnahmen. Gorillas und Orang-Utans haben ein sehr großes Kleinhirn (das ist der kleine, wie ein Gehirn aussehende Knäuel, der auf der Rückseite des Gehirns unter den beiden Hälften des Großhirns liegt). Das Kleinhirn sorgt für die Nachrichtenweiterleitung und Koordination zwischen den verschiedenen Gehirnteilen; eine seiner wichtigsten Aufgaben ist die Mitwirkung an der Koordination der einzelnen Körperteile. Gorillas und Orang-Utans sind sehr groß, und ihren gewaltigen Körper im Geäst der Bäume richtig zu steuern, ist kompliziert. Deshalb ist es kein Wunder, dass sie über ein ungewöhnlich großes Kleinhirn verfügen. Entsprechend stellt das Kleinhirn einen besonders großen

Anteil des gesamten Gehirnvolumens, und der Neocortex ist bei ihnen im Vergleich zu anderen Affenarten relativ klein. Die Größe ihrer Gemeinschaften lässt sich anhand der Gesamtgröße des Gehirns nur schwer voraussagen, das tatsächliche Volumen des Neocortex dagegen ist eine gute Grundlage. Man muss also vorsichtig sein, wenn man Voraussagen über einzelne Arten macht; das gilt insbesondere für die Neandertaler, mit denen wir uns in Kap. 6 eingehend beschäftigen werden.

Mit diesem Vorbehalt im Hinterkopf können wir mithilfe der grundlegenden Relation zum Gehirnvolumen die Gemeinschaftsgröße unserer verschiedenen Vorfahren abschätzen. Wenn eine Spezies außerhalb der Tropen lebt, müssen wir dabei die Auswirkungen der geographischen Breite durch entsprechende Anpassungen berücksichtigen, denn solche Arten sind in der Regel größer; auch die Körpergröße muss berücksichtigt werden, denn ein größerer Körper braucht ein größeres Gehirn zur Steuerung. Abb. 3.5 zeigt das Spektrum der Gruppengrößen für alle Arten unserer Vorfahren und ihre Verwandten bis zurück zu den ältesten bekannten Homininen wie Lucy und ihresgleichen. Diese Ergebnisse legen die Vermutung nahe, dass die ältesten Homininen, die Australopithecinen, eigentlich nur Menschenaffen waren. Sie liegen mit einer Obergrenze von ungefähr 50 Individuen für die durchschnittliche Gruppengröße mehr oder weniger im gleichen Bereich wie die Schimpansen. Einzelne Gemeinschaften können diesen Wert auch bei heutigen Schimpansen überschreiten (die größten Schimpansengemeinschaften bestehen aus 80 bis 100 Individuen), aber solche großen Gemeinschaften sind nicht die Regel, sondern die Ausnahme. Schimpansenge-

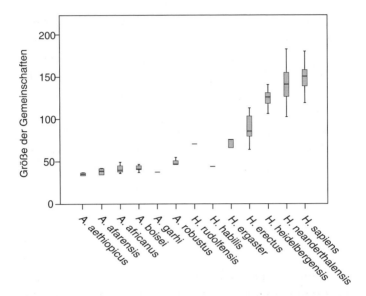

Abb. 3.5 Mittlere Gruppengröße (Aussagesicherheit von 50 % als Kasten, 95 % als Linien) der wichtigsten Homininenarten. (Nach © Gamble et al. 2011; Abb. 2)

meinschaften zerbrechen häufig und werden mit zunehmender Größe immer instabiler; diese Instabilität ist der Grund für eine durchschnittliche oder typische Größe von ungefähr 50.

Getrennt leben und in Kontakt bleiben

Keine dieser Voraussagen über die Gruppengröße berücksichtigt Veränderungen der Umwelt. Die Evolution der Menschen spielte sich während eines langfristigen Trends ab, in dessen Verlauf das globale Klima immer kälter und

trockener wurde. In Abständen von ungefähr einer Million Jahren führte dies immer wieder zu einer großflächigen Vereisung auf der nördlichen Erdhalbkugel, und in Indonesien wurden große Teile des Kontinentalsockels freigelegt – der tropische Paläokontinent Sunda entstand. Darüber hinaus wissen wir, dass sich während dieser 2,6 Mio. Jahre auch noch etwas anderes veränderte: Die Homininen zogen aus den Tropen in die höheren Breiten Nordeuropas und Südsibiriens. Das geschah lange bevor unsere eigene Spezies vor 60.000 Jahren erstmals aus Afrika auswanderte.

Betrachtet man nun den langfristigen Klimawandel in Verbindung mit der Ansiedlung von Homininen in nördlichen Breiten, so hat man eine Mischung aus bedeutsamen Umweltfaktoren, die man nicht unbeachtet lassen kann, wenn man aufgrund des sozialen Gehirns die Gemeinschaftsgröße voraussagt. Die Auswirkungen waren vermutlich vor allem im persönlichen Kontakt deutlich zu spüren. Wenn die Nahrungsversorgung üppig und berechenbar war, waren tägliche Interaktionen mit anderen Mitgliedern der Gemeinschaft möglich. Diese Gesetzmäßigkeit fand Robin Dunbar, als er in den 1970er-Jahren während langer, feuchter Monate die Dscheladas in Äthiopien beobachtete. Wenn die Nahrung aber weiter verstreut und je nach Jahreszeit in unterschiedlichen Mengen vorhanden ist, und wenn die Biomasse der essbaren Tiere und Pflanzen insgesamt abnimmt, haben die Homininen nicht nur mit der Ernährung, sondern auch mit der Gemeinschaft ein Problem. Die Reaktion auf eine weniger berechenbare Nahrungsversorgung besteht darin, die Gruppe aufzuteilen, und nicht auf Verschmelzung, sondern auf Spaltung zu setzen – mehr

darüber in Kap. 4. Hier wollen wir nur festhalten, dass irgendwann der Punkt erreicht war, an dem Spaltung und Verschmelzung im kleinen Maßstab – wie man sie bei allen Primaten beobachtet – nicht mehr möglich war. Um durchzuhalten, mussten die Homininen mit langen Phasen der Trennung zurechtkommen und dennoch die engen sozialen Bindungen aufrechterhalten, die im persönlichen Kontakt entstanden waren. Natürlich stand ihnen immer auch die andere Möglichkeit offen: Sie konnten dorthin ziehen, wo das Gras grüner war. In vielen Fällen stellten sich die winzigen Populationen tatsächlich auf diese Weise auf den Wandel der Nahrungsversorgung ein. Und ebenso häufig starben sie regional einfach aus.

Wie lange solche Phasen der erzwungenen Trennung sein durften, bevor die Bindungen zu zerfallen begannen, lässt sich nur schwer abschätzen. Wenn die Bindungen mit dem Erwachsenwerden in Zusammenhang standen, konnte man sie bei erneutem Zusammentreffen wieder aufnehmen. Allen und Beatrix Gardner zogen das Schimpansenweibchen Washoe wie ihr eigenes Kind groß und brachten ihr die Zeichensprache bei; als Washoe sie nach 20 Jahren wiedersah, machte sie sofort das Zeichen für ihren Namen. Wie Jane Goodall berichtet, tat Washoe dies aber nicht bei den anderen Schimpansen, mit denen sie zusammenlebte (s. Abb. 3.6). Zwei junge Männer aus London kauften in den 1960er-Jahren im Kaufhaus Harrods ein Löwenjunges namens Christian und zogen es in ihrer Wohnung auf, bis es zu groß war und nach Afrika zurückgebracht werden musste. Wenige Jahre später besuchten sie Christian. Er umarmte sie mit herzergreifender Leidenschaft, eine Szene, die

Abb. 3.6 Washoe war einer der ersten Schimpansen, die in einem menschlichen Haushalt aufwuchsen und sich an Studien zum Spracherwerb beteiligten. (© AP/Press Association Images)

sogar zum YouTube-Hit geworden ist (http://goo.gl/owJP). Christian erinnerte sich an seine früheren Eigentümer sicher genauso wie sie sich an ihn (s. Abb. 3.7). Und damit so etwas geschieht, brauchen auch keine Menschen beteiligt zu sein. In ihrer großartigen Studie an afrikanischen Wildelefanten berichtet Cynthia Moss, was geschieht, wenn zwei Untergruppen dieser höchst sozialen Spezies sich nach einer Trennung wieder treffen: „Sie laufen zusammen, grölen, trompeten und schreien, heben die Köpfe, schlagen die

Abb. 3.7 Christian erinnert sich an seine früheren Eigentümer und lässt ihnen eine freundliche Löwenumarmung angedeihen. Tiere sind in der Lage, sich an Sozialpartner zu erinnern – aber denken sie auch wie wir an ihre Freunde, wenn sie von ihnen getrennt sind? (© John Rendall/AP/Press Association Images)

Stoßzähne gegeneinander, wickeln die Rüssel umeinander, schlagen mit den Ohren, wirbeln herum und rempeln sich an, urinieren und koten und zeigen ganz allgemein große Aufregung. Eine solche Begrüßung dauert manchmal volle zehn Minuten." Nach Moss' Überzeugung haben solche emotional aufgeladenen Begrüßungszeremonien den

Zweck, die Bindungen zwischen Familienmitgliedern auf-
rechtzuerhalten und zu stärken: Sie sind ein Beispiel dafür,
wie der emotionale Teil des sozialen Kerns durch eine raf-
finierte, mit Gefühlen aufgeladene Begrüßungszeremonie
verstärkt wird (s. Abb. 3.2).

Für die Theorie vom sozialen Gehirn ist nicht in erster Li-
nie interessant, dass Washoe und Christian sich auch nach
langer Trennung an ihre menschlichen Betreuer erinnern
und sich entsprechend verhalten konnten; die Frage lautet
vielmehr: Dachten sie auch an ihre Bezugspersonen, wenn
sie keinen persönlichen Kontakt mehr zu ihnen hatte? Na-
türlich können wir sie nicht fragen, und eine Methode zur
Beantwortung der Frage zu entwickeln, wäre ebenso heikel
wie festzustellen, ob Schimpansen über eine Theorie des
Geistes verfügen. Aber nach unserer Vorstellung unterschei-
det uns unsere Fähigkeit, ein Sozialleben auch in Abwesen-
heit anderer so fortzusetzen, als wären sie gegenwärtig, von
allen anderen Primaten. Das Sozialleben eines Schimpan-
sen spielt sich vor seinen Augen sowie rund um seine Nase
und Ohren ab. Für Menschen dagegen kann es auch ohne
die unmittelbare soziale Wahrnehmung eines anderen Indi-
viduums stattfinden. Sozialleben läuft in unserem Geist ab,
in unserer Fantasie. Ständig denken wir an andere aus un-
seren verschiedenen Netzwerken. Wir haben ihre Fotos auf
unserem Smartphone, ihre Geschenke auf unserem Regal
und ihre Worte in unserem Gedächtnis. Diese anderen sind
die kleine Stimme des Gewissens, die uns sagt, dass jemand
zusieht, wenn wir nach der nächsten Süßigkeit greifen oder
überlegen, ob wir etwas tun wollen, von dem wir wissen,
dass es den anderen wehtun würde, wenn sie es wüssten.
Und doch sind sie unter Umständen nicht im Zimmer, ja

nicht einmal in unserer Stadt, in unserem Land oder auf unserem Kontinent, wenn wir solche Gedanken haben. Wir tragen unser Sozialleben mit uns herum. Dass wir das tun, liegt an unserer in Kap. 2 beschriebenen Fähigkeit zur Mentalisierung, zu aktuellen sozialen Gedanken, denen wir unsere Theorie des Geistes verdanken. Damit können wir etwas erreichen, was noch keinem anderen Primaten gelungen ist: getrennt leben und dennoch in Verbindung bleiben. Wann das in der Vorgeschichte der Menschen erstmals geschah, werden wir in späteren Kapiteln genauer erfahren. Als es aber so weit war, befreite es uns von der Notwendigkeit, in der Nähe der anderen zu sein, um uns sozial zu verhalten. Das wäre, wie wir noch genauer untersuchen werden, ohne eine Verstärkung des materiellen Teils des sozialen Kerns nicht möglich gewesen – wir machten den Stoff der Natur zu den Dingen der Kultur. Eine solche Ausdehnung der zwischenmenschlichen Beziehungen über Zeit und Raum versetzte uns in die Lage, bei niedriger Bevölkerungsdichte und mit seltenen persönlichen Kontakten zu leben. Die Umwelt stellte für den Wohnort unserer Vorfahren keine Beschränkung mehr dar: Homininen mit solchen Fähigkeiten stand die ganze Welt offen.

Warum veränderte sich das Sozialleben?

Den Kern dieser Frage bildet der Gedanke, dass unser Sozialleben die Vergrößerung des Gehirns vorantrieb. Dass das Gehirn größer wurde, können wir nachweisen. Aus

archäologischen Funden können wir auch ableiten, dass ein schwacher Zusammenhang mit dem Auftauchen neuer Konzepte besteht (s. Abb. 3.4). Aber was waren die Ursachen dieser Trends, und wie können wir die Belege dazu heranziehen, unsere Theorien zu überprüfen?

Ein großes Gehirn hat seinen Preis – Nervensubstanz heranwachsen zu lassen und zu erhalten, ist sehr aufwendig. Das liegt vor allem daran, dass die Neuronen mit großem Aufwand in einem Zustand gehalten werden müssen, in dem sie bereit sind, Impulse abzugeben; dazu gehört, dass die Überreste früherer Nervenaktivität aus dem System entfernt werden, dass die Neuronen durch Produktion neuer Neurotransmitter in die Lage versetzt werden, erneut Impulse abzugeben, und dass an der Nervenzellmembran durch die sogenannte „Natriumpumpe" eine elektrische Spannung aufrechterhalten werden muss.[1] Die Aufrechterhaltung der Bereitschaft von Nervenzellen erfordert ungefähr zehnmal so viel Energie wie die Muskeltätigkeit, und wenn die Neuronen tatsächlich feuern (das heißt, wenn wir das Gehirn benutzen!) ist der Aufwand sogar noch beträchtlich höher. Wegen seines Energiebedarfs funktioniert das Gehirn am besten, wenn es mit qualitativ hochwertiger Nahrung gefüttert wird. Ein solcher Qualitätsanstieg war der Übergang von der Ernährung eines Schimpansen, die vor-

[1] Die Pumpe sorgt dafür, dass Natriumionen auf einer Seite der Membran verbleiben, sodass zwischen Außen und Innen ein Unterschied in der elektrischen Ladung bestehen bleibt. Wenn das Neuron einen Impuls abgibt, öffnen sich „Tore" in der Membran, sodass Natriumionen hindurchfließen können und die elektrische Ladung des Neurons sich ändert. Diese Ladung pflanzt sich durch die Nervenzelle fort, weil die Tore sich nacheinander öffnen, sodass ein elektrischer Strom in Richtung der Spitze fließt; dort geht er auf das nächste Neuron über und aktiviert es.

wiegend aus Blättern, Pflanzenschößlingen, Früchten sowie gelegentlich einer Nuss oder einem Kleinaffen besteht, zur Ernährung der Homininen mit wachsenden Mengen an tierischem Protein; und je weiter unser Gehirn heranwuchs, desto stärker entwickelte sich unser Geschmack für Fleisch. Außerdem wuchs das große Gehirn auf Kosten eines anderen aufwendigen Organs, nämlich des Darms. Wie Leslie Aiello und Peter Wheeler auf elegante Weise nachweisen konnten, musste ein Tauschhandel stattfinden, damit der Grundumsatz des Organismus, das heißt der tägliche Energieaufwand im Ruhezustand, im Gleichgewicht blieb. Als das Gehirn sich erweiterte, schrumpfte der Magen. Das hatte zur Folge, dass der Darm weniger gut in der Lage war, Nahrung zu verarbeiten. Eine Lösung für das Problem erläutert der Primatenforscher Richard Wrangham in seinem 2010 erschienenen Buch *Catching Fire: How Cooking Made Us Human* (dt. *Feuer fangen: wie uns das Kochen zum Menschen machte*): Unsere Vorfahren garten Fleisch über dem Feuer und bauten sich damit gewissermaßen einen äußeren Magen. Durch das Kochen werden die Enzyme abgebaut, und die Nahrung ist leichter verdaulich. Anhaltspunkte dafür, wann das geschah, werden in Kap. 5 vorgestellt.

Aus all diesen Überlegungen im Zusammenhang mit den hohen Kosten für Nervensubstanz kann man schließen, dass es einen sehr guten Grund geben muss, wenn die Masse des Gehirngewebes bei einer Spezies wächst. Aber was war der große Nutzen, den das immer größere Gehirn den verschiedenen Homininenarten einschließlich des modernen Menschen verschaffte?

Die Vorteile eines größeren Gehirns und einer größeren Gemeinschaft

In unseren Augen hatte es vor allem zwei Vorteile, die Gemeinschaft, in der man lebt, zu vergrößern; diese Vorteile überwiegen gegenüber dem hohen Aufwand für die Evolution eines größeren Gehirns, mit dem man die größere kognitive Belastung, sich an soziale Informationen über andere zu erinnern und entsprechend zu handeln, bewältigen kann. Diese beiden Vorteile sind Sicherheit und Beruhigung.

Schutz vor natürlichen Feinden und Verteidigung gegen andere

Welchen Nutzen das Leben in Gemeinschaften zunehmender Größe ganz allgemein für Primaten hat, liegt auf der Hand: Es *schützt* vor natürlichen Feinden. Primaten wie die Paviane, die in ihrem Lebensraum stark durch natürliche Feinde gefährdet sind (also insbesondere landlebende Arten und solche, die in offenen Lebensräumen zu Hause sind) bilden größere Gemeinschaften als solche, deren Lebensraum weniger Gefahren birgt. Das allein ist aber keine Erklärung dafür, dass in der Evolution aller unserer Vorfahren große Gemeinschaften entstanden. Es liegt auch nicht daran, dass die Körpergröße und die beträchtliche Kraft im Oberkörper die Menschenaffen (ihre Arme sind drei- bis fünfmal kräftiger als unsere, zweifellos damit sie so auf Bäume klettern können, wie es uns einfach nicht möglich ist)

immun gegen Raubtiere machen würde. Im Rahmen unseres Projekts entwickelte Julia Lehmann Modelle für die Biogeographie von Menschenaffen; aus ihnen geht hervor, dass Schimpansen nicht in Regionen leben, in denen sowohl Löwen als auch Leoparden vorkommen: Mit einer dieser Respekt einflößenden Raubtierarten kommen sie zurecht, aber nicht mit beiden. Sogar große Menschenaffen wie die Gorillas werden gelegentlich von Leoparden getötet, wenn diese sie unaufmerksam antreffen. Mit ihrer gewaltigen Körpergröße laufen die afrikanischen Menschenaffen sicher weniger Gefahr, von Raubtieren erlegt zu werden, aber völlig ausgeschaltet ist das Risiko nicht – vor allem natürlich deshalb, weil sie auch Junge haben, um die sie sich ebenso viel Sorgen machen müssen wie um sich selbst. Wichtig ist aber etwas anderes: Menschen wie Schimpansen bewältigen die Gefahr, die von natürlichen Feinden ausgeht, gleichermaßen auf der Ebene der nahrungssuchenden Gruppe, aber nicht in der gesamten Gemeinschaft.

Schimpansen setzen sich in der Regel auf der Hierarchieebene der nahrungssuchenden Gruppe (im typischen Fall 3 bis 5 Tiere) mit der Gefahr durch natürliche Feinde auseinander; bei Menschen erfüllt die Nachtlagergruppe (30 bis 50 Personen) oder die nahrungssuchende Gruppe (5 bis 15 Personen) diese Aufgabe. Menschen sind Raubtieren gegenüber insbesondere nachts wehrlos; das hat zwei Gründe: Erstens leben sie in offeneren Lebensräumen als andere Menschenaffen (Savanne mit Gehölzen im Gegensatz zum richtigen Wald) und können sich deshalb nicht so leicht auf Bäume retten, wenn sie angegriffen werden; und zweitens können sie einfach nicht so gut wie Menschenaffen auf

Bäume klettern. Deshalb brauchen Menschen als Schutz größere Gruppen als die anderen Menschenaffen. Dennoch ist hier nicht von der vollständigen Gemeinschaft aus 150 Individuen die Rede, denn so viele Personen findet man nur selten zur selben Zeit am selben Ort (eine Ausnahme sind sehr seltene, aber wichtige zeremonielle Ereignisse).

Warum also brauchen Menschen – wie vermutlich auch alle Arten unserer Vorfahren – die höhere Organisationsebene der Gemeinschaft? Plausibel sind zwei Möglichkeiten, die davon ausgehen, dass die Gemeinschaft für die *Verteidigung* gegen Gefahren notwendig ist. Erstens wäre es denkbar, irgendeine territoriale Ressource zu verteidigen. Diese Vermutung hat man für Schimpansen geäußert: Ihre Männchen verteidigen offenbar ein Revier, und dies verschafft ihnen den alleinigen Zugang zu den kleineren Gebieten, die von einzelnen Weibchen und ihren Nachkommen besetzt sind. Es ist eine Form der „revierbasierten Polygamie". Solche Systeme findet man bei Primaten häufig: Einzelne Männchen verteidigen Territorien und erlangen damit das Monopol entweder über eine Gruppe von Weibchen oder über mehrere einzelne Weibchen, die jeweils in ihrem eigenen kleinen Revier zu Hause sind. Der Unterschied besteht nur darin, dass in den meisten derartigen Fällen ein einzelnes Männchen ein Revier verteidigt, während sich bei den Schimpansen mehrere Männchen (in der Regel Brüder) zusammentun, das Revier schützen und die darin lebenden Weibchen unter sich teilen. Möglicherweise gehören auch manche Gemeinschaften heutiger Jäger und Sammler zu diesem Typ, zwei Faktoren legen jedoch die Vermutung nahe, dass dies nicht der Fall ist. Erstens

verteidigen Jäger und Sammler ihre Reviere nur in seltenen Fällen so eifrig wie Klein- und Menschenaffen, was vermutlich daran liegt, dass das Gebiet zu groß ist. Und wenn ein Revier verteidigt wird, sieht es zweitens so aus, als liege dies eher an Ressourcen – insbesondere an „Schlüsselressourcen", wie sie in der ökologischen Literatur genannt werden, das heißt an solchen Ressourcen, auf die man zurückgreifen muss, wenn alle anderen Möglichkeiten versagen. Für viele Jäger und Sammler, beispielsweise die Bewohner der Kalahari und der australischen Wüsten, handelt es sich dabei um permanente Wasserstellen. Aber angesichts der Tatsache, dass die ältesten Homininen sich aus Menschenaffen entwickelten, ist es dennoch eine plausible Annahme, dass die Gesellschaftsbildung der Australopithecinen in ihrer ersten Phase kaum anders war, als es für afrikanische Menschenaffen charakteristisch ist: Gruppen verwandter Männchen verteidigen ein gemeinsames Territorium, um sich das Monopol auf die fortpflanzungsfähigen Weibchen zu sichern.

Darüber hinaus könnten Homininen noch aus einem zweiten Grund große Gemeinschaften brauchen: Die üblichen natürlichen Feinde, die über die Gesellschaft von Klein- und Menschenaffen bestimmen, wurden durch einen anderen, insgesamt viel gefährlicheren natürlichen Feind verdrängt: durch andere Menschen. Das ist plausibel, denn schon Schimpansen lassen auf dramatische Weise erkennen, welche Gefahren von ihren Artgenossen ausgehen können. Schimpansenmännchen patrouillieren regelmäßig in Gruppen an den Grenzen ihres Reviers und ermorden ganz gezielt alle fremden Männchen, auf die sie dabei stoßen. Überfälle auf das Revier anderer Gruppen kommen

zwar ebenfalls vor, die Patrouillen konzentrieren sich aber offensichtlich vor allem auf eingedrungene Männchen; anders als in den Gesellschaften der Menschen geht es jedoch nicht um die Beschaffung von Weibchen oder anderen ökonomischen Ressourcen.

In jedem Fall folgt aus der Behauptung, dass dieser Mechanismus während der gesamten Geschichte der Homininen eine Erklärung für die Organisation auf Gemeinschaftsebene darstellt, dass die Bevölkerungsdichte der Vorfahren während des größten Teils unserer Evolutionsvergangenheit sehr hoch war, denn Überfälle sind stets eine Reaktion auf begrenzte Ressourcen und eine Populationsgröße, die dicht bei der ökologischen Tragfähigkeit liegt. Wie hoch die Bevölkerungsdichte im Paläolithikum war, lässt sich zwar nicht genau feststellen, aber eine besonders hohe Populationsdichte erscheint für Gruppen, die in offenen Waldlandschaften oder Savannen wohnten, nicht zuletzt deshalb unwahrscheinlich, weil Gruppen von Jägern und Sammlern in solchen Lebensräumen auch heute gezwungen sind, in sehr großen Gebieten mit niedriger Bevölkerungsdichte zu wohnen. Als Erklärung für die Frühphase der sozialen Evolution des frühen *Homo* erscheint ein solches Szenario also im besten Fall unwahrscheinlich. Eine bessere Erklärung bieten die Schlüsselressourcen. Dazu gehört der Zugang zu hochwertiger Nahrung für schwangere Weibchen und Säuglinge, die wegen ihres größeren Gehirns besonders hilflos geboren werden und längere Zeit versorgt werden müssen.

Hochwertiges Essen: Kooperation und Rückversicherung

Hochwertige Nahrung hat die Gewohnheit, davonzulaufen. Tiere sind mit ihren jahreszeitlichen Wanderungen oftmals launisch, und sie einzufangen, ist gefährlich. Hat man sie aber einmal erlegt, bieten sie für die erfolgreichen Jäger einen Schatz, den man teilen kann. Und wenn sie solche hochwertige Nahrung teilen, verstärken sie damit die sozialen Bindungen zwischen den Mitgliedern der Gemeinschaft. Richard Wrangham machte darauf aufmerksam, wie wichtig die hochwertige Nahrung für die *Kooperation* von Primaten ist. Genau diese Ressourcen wünschen sich die Weibchen, weil ihre Nachkommen damit die besten Aussichten haben, bis zum fortpflanzungsfähigen Alter am Leben zu bleiben.

Auf der Grundlage solcher Erkenntnisse haben Archäologen erforscht, welche pflanzlichen und tierischen Lebensmittel den Gemeinschaften im Paläolithikum zur Verfügung standen und von ihnen genutzt wurden. Sie griffen dabei in großem Umfang auf biologische Untersuchungen zurück und formulierten eine Reihe von Prinzipien, die unter der allgemeinen Überschrift einer Theorie der optimalen Nahrungssuche eingeordnet wurden. In diesen Forschungsarbeiten wurden die Ressourcen nach Eigenschaften wie Größe, Gewicht und ihrer Verteilung in der Landschaft eingestuft. Dahinter steht die Überlegung, dass die in Kalorien gemessene Nahrungsenergie eine Art Währung ist, die man nach rationalen ökonomischen Prinzipien verwalten kann und deren Preis demnach von Angebot und Nachfrage abhängt. Anschließend untersuchte man durch Konstrukti-

on einer Matrix, welche Möglichkeiten zu verschiedenen Jahreszeiten die besten sind, wo sich die Menschen in der Landschaft am besten aufhalten und wie viele von ihnen wie lange dort bleiben sollten. Durch solche Erkenntnisse wandelte sich nicht nur die Erforschung von Tier- und Pflanzenresten aus archäologischen Fundstätten, sondern auch unsere Vorstellung davon, was Jagen und Sammeln eigentlich bedeutet. Es ist demnach kein vom Zufall bestimmtes Dasein, in dem man nimmt, was man bekommt, sondern eine rationale Tätigkeit, bei der man Lösungen für die von der Umwelt gestellten Herausforderungen sucht.

Das alles verbesserte unser Bild von den Jägern und Sammlern, und gleichzeitig bildete es ein Gegengewicht zu Gordon Childes düsterer Einschätzung ihrer Fähigkeiten. Dies hatte aber auch eine Kehrseite, denn damit liegt die Vermutung nahe, dass man alles auf Entscheidungen zurückführen kann, die mit Nahrung im Zusammenhang stehen. Nahrung war sicher von lebenswichtiger Bedeutung, und ihre effiziente, gefahrlose Beschaffung beherrschte wohl zu einem großen Teil das Leben. Der Archäologe Rhys Jones, der in Nordaustralien bei den Aborigines gelebt hatte, sagte uns einmal, diese Jäger und Sammler seien nie weiter als 24 h vom Hunger entfernt.

Aber der Schlüssel für uns, um das Thema Nahrung zu verstehen, liegt in ihrer Bedeutung für die soziale Kooperation. Sie hat zwei Formen. Erstens gibt es die taktischen Anforderungen: Parteien müssen zusammenarbeiten, um gefahrlos und mit größeren Erfolgsaussichten jagen oder sammeln zu können. Dazu gehört die Verteidigung gegen natürliche Feinde ebenso wie die Beschaffung von Nahrungsmitteln, die als Brennstoff für aufwendige Gehirne gebraucht wer-

den. Und zweitens besteht die strategische Notwendigkeit, für schlechte Zeiten zu planen. Zu diesem Zweck sucht man auch außerhalb des unmittelbaren Umfeldes nach Hilfe. Statt den Zugang zu Ressourcen dadurch einzuschränken, dass man sie gegen jeden Hinzugekommenen verteidigt, lässt man besser andere Menschen zu. Wenn Individuen und ihre Gemeinschaften auf diese Weise in sehr großen geographischen Gebieten eine Verbindung eingehen, ergibt sich eine ökologische *Rückversicherung*. Archäologen sprechen in diesem Zusammenhang von sozialen Vorräten: In schlechten Zeiten werden „Wertmarken" gegen Nahrung getauscht, in guten Zeiten geschieht das Umgekehrte. Mit anderen Worten: Wenn sich die Bedingungen in dem Umfeld, in dem ihr euch gerade aufhaltet, verschlechtern, darf eure Gemeinschaft zu uns kommen und eine Zeit lang unsere Ressourcen nutzen. Später läuft das Ganze umgekehrt ab, und ihr könnt uns den Gefallen zurückzahlen. Ein solches System funktioniert gut, es setzt aber voraus, dass die Gemeinschaft insgesamt ein ausreichend großes Revier hat und ein breites Spektrum verschiedener Lebensräume bewohnt. Weniger gut klappt es, wenn die Territorien der Gemeinschaft klein sind und im Wesentlichen aus gleichartigen Lebensräumen bestehen. Eine plausible Grundlage dafür bildet die nomadische Lebensweise, die sich offenbar vor etwas weniger als 2 Mio. Jahren zusammen mit dem zum Gehen geeigneten Körperbau des frühen *Homo* entwickelt hat (s. Abschn. 4.6). Eine Gemeinschaft von 80 bis 100 Individuen von *H. ergaster* könnte nach Berechnungen unseres Projektmitarbeiters Matt Grove im tropischen Afrika eine Fläche von 130 Quadratkilometern bewohnt haben, genug, um zu gewährleisten, dass stets in einem Teil

dieses Gebietes die notwendigen Ressourcen zur Verfügung standen. Als sich aber das Klima wandelte und die Homininen es bei ihrer Ausbreitung nach Norden mit größeren jahreszeitlichen Schwankungen zu tun bekamen, erlangte die Motivation, sich rückzuversichern und sich mit anderen zusammenzutun, eine immer größere Bedeutung.

Zusammenfassung

Die Gedanken, von denen in diesem gesamten Kapitel die Rede war, erwachsen aus der Vorstellung vom sozialen Gehirn. Aus einer solchen Perspektive heraus konnten wir andere Überlegungen darüber anstellen, was wir mit „Sozialleben" in der entfernten Vergangenheit eigentlich meinen. In den Mittelpunkt sind dabei Erklärungen gerückt, die wir anhand archäologischer Befunde – denen wir uns in Kürze zuwenden werden – überprüfen können. Insbesondere haben wir jetzt eine Vorstellung davon, in welchem Maßstab wir arbeiten müssen und wie wichtig Materialien und Sinneswahrnehmungen für die Individuen waren, die in alten Zeiten ihrem Sozialleben nachgingen. Wir haben die Frage gestellt, welche Formen von Druck – natürliche Feinde, Verteidigung, Kooperation und Rückversicherung – die Entwicklung vorangetrieben haben. Als Archäologen haben wir gelernt, wie wichtig es ist, über die Beziehungen zwischen den Menschen und dem sozialen Kern der Materialien und Sinneseindrücke nachzudenken. Statt rationale Erklärungen dafür zu suchen, warum sie lieber Bisons anstelle von Rentieren jagten oder keine Fische aßen – eine berühmte Eigenschaft der Bewohner im abgelegenen

Tasmanien vor 6000 Jahren –, müssen wir uns eine ande-
re Sichtweise zu eigen machen: Wir dürfen nicht einfach
nur das Ziel der Kalorienaufnahme in Rechnung stellen,
sondern müssen uns fragen, welche Rolle Lebensmittel
und andere Materialien für den Aufbau von Beziehungen
spielten. Archäologische Erklärungen für die Entwicklung
der Menschen müssen nicht nur rational (wirtschaftlich),
sondern auch relational (das heißt sozial) sein. Sozialleben
gründet sich nicht allein auf Kalorien, sondern auch auf
die Beziehungen, die sich entwickeln, wenn Dinge herge-
stellt, getauscht, genutzt und aufbewahrt werden. Diesen
Themen wenden wir uns als Nächstes zu.

4

Vorfahren mit kleinem Gehirn

Der chronologische Kuchen wird aufgeschnitten

Mit der Vorstellung vom sozialen Gehirn verfügen wir über eine starke Hypothese: Danach war unser Sozialleben die Triebkraft für das Wachstum unseres Gehirns. Aber von welchem Zeitpunkt an wenden wir diese Hypothese auf die Evolution des Menschen an? Und wie überprüfen wir sie? Manche Hypothesen, beispielsweise dass Objekte mit unterschiedlicher Masse gleich schnell fallen, kann man mit einem einzigen Experiment verifizieren. Die Hypothese vom sozialen Gehirn wirft jedoch das Problem auf, dass ihr Kerngedanke in einer Kurve steckt, die sich je nachdem, wo

wir die Geschichte beginnen lassen, unter Umständen über viele Millionen Jahre erstreckt. Über die Form dieser Kurve bestimmen vielfältige Faktoren, deren Zusammenwirken wir nicht immer verstehen. Oder, wie es der Archäologe Ian Hodder einmal formulierte: Wenn wir eine Verteilung mit sehr wenigen Datenpunkten haben, beispielsweise in Form von Schädeln aus dem Pleistozän, lassen sich in der Regel mehrere Modelle damit in Übereinstimmung bringen. Und je dürftiger die Daten sind, desto schwieriger ist es, zwischen den Alternativen zu entscheiden. Eine eindeutige Antwort des Typs „ja oder nein" gibt es nicht: Genau das macht bei der Erforschung unserer weit entfernten Vergangenheit die Faszination und gleichzeitig auch die Frustration aus.

Man kann mit Fug und Recht behaupten, dass die Hypothese vom sozialen Gehirn von Anfang an ihre Berechtigung hat. Menschenaffen haben im Verhältnis zur Körpergröße ein größeres Gehirn als Kleinaffen, und wie Frans de Waal in seinem 1982 erschienenen Buch *Chimpanzee Politics* (dt. *Unsere haarigen Vettern*) so anschaulich geschildert hat, führen sie ein kompliziertes Sozialleben. Die Strategien seiner Affen zeichnet er mit Begriffen nach, mit denen Machiavelli auch seinen Fürsten beriet. So betrachtet, sind alle heutigen Menschenaffen und ihre Vorfahren schon seit mindestens 20 Mio. Jahren vielschichtige soziale Wesen. Und vor diesem Hintergrund entwickelten sich die ersten Homininen.

In den riesigen Zeiträumen stehen fossile Überreste wie seltene Wegmarken (s. Abb. 4.1). Außerdem gibt es keine handfesten archäologischen Belege, die älter wären als die 2,6 Mio. Jahre alten Steinwerkzeuge aus Gona in Äthiopien. Dennoch können wir den chronologischen Kuchen mithilfe der Graphik vom sozialen Gehirn in verdauliche Stücke zerlegen. Wir wetzen das Messer und zerschneiden

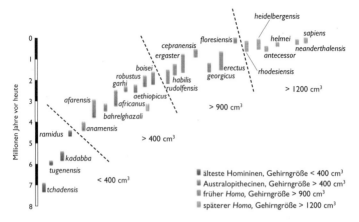

Abb. 4.1 Homininen mit kleinem und großem Gehirn und die Vielfalt der fossilen Arten. *Homo floresiensis* aus Indonesien ist ein spätes Fossil mit kleinem Gehirn, das dem allgemeinen Trend zuwiderläuft. Der wahrscheinlichste Grund für seine geringe Größe ist ein biologischer Prozess, der als Inselzwergwuchs bezeichnet wird und eine Reaktion auf das Fehlen natürlicher Feinde darstellt. (aus Foley und Gamble 2009; Abb. 2; © The Royal Society)

ihn aufgrund der Gehirngröße, eines Wertes, den man anhand der fossilen Schädel einigermaßen genau abschätzen kann. Wir schlagen dabei eine einfache Dreiteilung vor:

- heutige Menschenaffen und fossile Homininen mit einem Gehirnvolumen von weniger als 400 Kubikzentimetern,
- fossile Homininen mit kleinem Gehirn, das heißt mit einem Gehirnvolumen zwischen 400 und 900 Kubikzentimetern,
- Homininen mit großem Gehirn und alle heute lebenden Menschen mit einem Gehirnvolumen über 900 Kubikzentimetern.

Tab. 4.1 Homininen nach Größe von Gehirn und sozialer Gemeinschaft klassifiziert sowie die Zeit, die den Voraussagen zufolge für soziale Interaktionen aufgewendet wird

Gehirngröße	Geschätzte Größe der Gemeinschaften	Anteil der Tageslichtstunden, die für die Pflege sozialer Beziehungen aufgewendet werden (%)
Weniger als 400 cm³ (*Ardipithecus*, Schimpansen)	30–50	8–12
400–900 cm³ (grazile und robuste Australopithecinen)	60–100	13–30
Über 900 cm³ (früher und später *Homo*)	100–150	30–40

In diesem Kapitel wollen wir die beiden ersten Kategorien genauer betrachten; zu den Homininen mit großem Gehirn und den heutigen Menschen kehren wir in Kap. 6 zurück. Die Schätzungen für die Größe der Gemeinschaften in diesen Kategorien zeigt Tab. 4.1; sie wurden aus den in Kap. 2 erläuterten Gleichungen über das soziale Gehirn abgeleitet.

Tabelle 4.1 zeigt auch die Schätzungen für die Zeit, die für die Herstellung der höchst wichtigen sozialen Bindungen durch gegenseitiges Kraulen aufgewendet wird. Dabei fällt im Hinblick auf den Tagesablauf eines Homininen, der sich in einer größeren sozialen Gemeinschaft mit mehreren Interaktionspartnern befindet, sofort Folgendes auf: Ein unglaublich großer Teil des Tages muss dem gegenseitigen Kraulen gewidmet werden (s. Kasten in Abschn. 2.4).

Wenn es um die Evolution des Menschen geht, haben wir einen Zeitraum von 7 Mio. Jahren, mit dem wir spie-

len können. Er beginnt mit den molekularbiologisch begründeten Schätzungen für den Zeitpunkt, zu dem sich die Abstammungslinien von Homininen und Schimpansen trennten. Während der ersten 5 Mio. Jahre waren unsere Vorfahren im Wesentlichen Affen, die aufrecht zu gehen begannen. Ihr Gehirn war ebenso groß wie das von Menschenaffen, und ihre Entwicklung können wir unter der Überschrift „Vom Menschenaffen zu *Australopithecus*" zusammenfassen. Während der letzten 2 Mio. Jahre ist die Vergrößerung des Gehirns nicht zu übersehen – diesen Zeitraum können wir „Vom Homininen zum Menschen" nennen (s. Kap. 5). In dieser zweiten Phase unserer entfernten Vergangenheit spielte das soziale Gehirn für unsere Überlegungen eine zentrale Rolle, denn die Gehirngröße nahm während der fraglichen Zeit rapide zu (s. Kap. 6). In der noch weiter entfernten Vergangenheit ging die Zunahme langsamer vonstatten und ist deshalb weniger gut zu erkennen. Aber wir suchen hier nach Grundlagen und werden die Ansicht vertreten, dass beide historischen Abschnitte gemeinsam einen ununterbrochenen Ablauf des sozial bedingten Wandels bilden.

Vom Menschenaffen zu Australopithecus: Gehirne von weniger als 400 Kubikzentimetern

Diese Phase unserer Evolution entspricht den beiden ersten Schritten in Tab. 1.2. Aus fossilen Überresten wissen wir, dass Menschenaffen während des Miozän (vor ungefähr 23

bis 5,3 Mio. Jahren), als warme Temperaturen herrschten und Wälder sich über große Teile der Alten Welt erstreckten, weit verbreitet waren. Man findet sie im Südwesten und Osten Afrikas, in Griechenland, Italien, Pakistan und überall in Indonesien verteilt. Irgendwann, als die Kontinente sich verschoben und die Temperaturen zurückgingen, trat in der Umwelt ein – manchmal massiver – Wandel ein. Afrika stieß mit Asien zusammen, die Landmassen nahmen neue Umrisse an, und vor ungefähr 7 Mio. Jahren, in der Phase des Messiniums, trocknete das Mittelmeer dreimal aus. Tiere wanderten hin und her, und die Vorfahren der Pferde drangen zusammen mit den Familien der Gräser, die ihre Nahrung bildeten, nach Afrika ein. Irgendwo in diesem durcheinandergewirbelten Umfeld begann die Evolution der Homininen.

Um ihre Entwicklung nachzuzeichnen, mussten die Paläoanthropologen sich aus der Gegenwart in die Vergangenheit vorarbeiten. Als unsere Berufslaufbahn begann, gab es nur über 2 Mio. Jahre bewiesene Kenntnisse – alles, was darüber hinausging, lag im Nebel. Nur wenige Funde, darunter Fossilien von der Insel Rusinga in Kenia, deuteten darauf hin, dass es die Menschenaffen schon sehr viel länger gab. Die Schätzungen für den Zeitpunkt, als unsere Vorfahren sich vom Affendasein verabschiedeten, schwankten zwischen vor 15 und vor 5 Mio. Jahren. Die heutige, viel vollständigere Geschichte wurde sowohl durch genetische Erkenntnisse als auch durch zahlreiche neue Funde geprägt. Und tief in diesen Erkenntnissen verborgen liegen auch die Grundlagen für den späteren sozialen Wandel.

Der letzte gemeinsame Vorfahre (LGV) von Menschen und Schimpansen lebte vor ungefähr 7 Mio. Jahren. Seit

jener Zeit trennten sich die Homininen von ihren Menschenaffenvettern, vermutlich weil sie in einer trockeneren, stärker jahreszeitlich geprägten Umwelt geographisch von ihnen getrennt waren. Ihre ältesten Spuren findet man in Ost- und Zentralafrika. Am frühesten lebte ein Wesen namens *Sahelanthropus*, dessen Überreste man im Tschad gefunden hat. *Sahelanthropus tchadensis* spricht gegen die Vorstellung, irgendeine Besonderheit im ostafrikanischen Rifttal habe die Evolution der Homininen ausgelöst: Er lebte tausende von Kilometern weiter westlich vermutlich in der Nähe eines großen Sees, der später austrocknete. Man kennt *Sahelanthropus* nur aufgrund seines Schädels, aber der erwies sich als sehr aufschlussreich. Er ist affenähnlich und erinnert an einen Schimpansen, zeigt aber bereits wichtige Merkmale, die auf den Entwicklungsweg der Homininen hindeuten. Das Foramen magnum, die große Öffnung im Schädel, durch die die Nerven zum Rückenmark laufen, hat sich im Vergleich zu seiner Position bei Menschenaffen bereits verlagert und deutet damit auf eine stärker aufrechte Körperhaltung hin. Auch an den Zähnen sind Veränderungen zu erkennen – insbesondere begann eine Verkleinerung der Eckzähne, die auch ein typisches Kennzeichen der späteren Homininen ist.

Sahelanthropus ist nicht einhellig als echter Hominine anerkannt, aber Spuren eines ganz ähnlichen Vorfahren namens *Orrorin tugenensis* hat man in den Tugen Hills in Kenia gefunden. Seine Entdecker Martin Pickford und Brigitte Sénut halten *Orrorin* für den Vorfahren aller späteren Menschen. Sein Schädel ist nicht erhalten, aber der Oberschenkelknochen liefert gute Anhaltspunkte dafür, dass er aufrecht ging.

Ein weitaus vollständigeres Bild davon, wie die Homininen vor einigen Millionen Jahren aussahen, liefern die Funde von *Ardipthecus ramidus* aus Äthiopien, von uns umgangssprachlich kurz „Ardi" genannt. Eine amerikanisch-äthiopische Arbeitsgruppe entdeckte im Laufe von 20 Jahren zahlreiche Überreste. Zusammen geben sie uns einen Überblick über die meisten Teile des Skeletts einschließlich des Schädels – eine phänomenale Leistung der Finder. Unter anderem kennt man die nahezu vollständigen Überreste eines erwachsenen Weibchens, das ungefähr 1,20 m groß war und ein Gehirn von 325 Kubikzentimetern besaß. Ardi lebte vor 4,4 Mio. Jahren. Nach Ansicht eines ihrer Entdecker, Tim White, könnte *Ardipithecus* der „Stammhominine" sein; *Sahelanthropus* und *Orrorin* waren demnach entweder sehr nahe mit ihm verwandt oder gehörten sogar zur gleichen Abstammungslinie.

Eine Vorstellung davon, in was für einer Umwelt *Ardipithecus* lebte, verschaffen uns zahlreiche Fossilien von Säugetieren. Worüber viele Wissenschaftler anfangs überrascht waren: Es handelte sich weder um tropische Wälder noch um Savanne, sondern um eine dichte Waldlandschaft, in der es hier und da offene Stellen gab. Anhaltspunkte aus der Ernährung lassen darauf schließen, dass *Ardipithecus* ein Allesfresser war: Er verzehrte keine besonders harte Nahrung, aber auch noch nicht die Samen, Wurzeln und Tiere der Savannengraslandschaft – auch das eine bedeutsame Beobachtung, hatte man doch viele Jahre lang geglaubt, diese seien der Auslöser für den eigenständigen Evolutionsweg der Homininen gewesen. Stattdessen konnten Paläoanthropologen durch die Untersuchung abgenutzter Zähne und der in ihnen enthaltenen Isotope nachweisen, dass Pflanzen

und Tiere aus Graslandschaften erst nach Ardi, seit der Zeit vor 3 bis 2 Mio. Jahren, in der Ernährung eine wesentlich größere Rolle spielten.

Ardi: kleines Gehirn, kleine soziale Gemeinschaft

Zu Beginn stehen wir also vor einem Rätsel: Wie konnten die ersten Homininen überhaupt Homininen sein, wenn sie doch ein ebenso kleines Gehirn hatten wie Menschenaffen? Eine vollständige Antwort werden wir am Ende dieses Abschnitts geben, für ein Fossil wie Ardi lautet sie jedoch vielleicht einfach: Sie hatten keine andere Wahl; die Evolution eines großen, aufwendigen Gehirns ist schwierig und konnte nur unter einem starken, lang anhaltenden Selektionsdruck stattfinden. Aufgrund der geringen Gehirngröße bei Ardi können wir abschätzen, dass ihre Gemeinschaft aus etwa 50 Individuen bestand, ungefähr ebenso vielen wie bei Schimpansen, deren Gehirn geringfügig größer ist, aber immer noch unter dem Schwellenwert von 400 Kubikzentimetern liegt. Entsprechend erscheint es vollkommen plausibel, dass das gegenseitige Kraulen und der nahezu tägliche Kontakt mit allen Mitgliedern die Grundlage für Ardis Sozialleben bildeten. Das alles war in weniger als 15 % der Tageslichtstunden zu leisten, sodass genügend Zeit blieb, um Nahrung zu suchen, zu essen, zu wandern und sich auf Bäumen vor Leoparden und anderen Raubtieren in Sicherheit zu bringen.

Welche Eigenschaften von Ardi könnten sonst noch dazu beigetragen haben, die Entwicklung des sozialen Gehirns in Gang zu setzen? Erstens ist Ardi zwar sehr affenähnlich, sie ähnelt aber nicht den Schimpansen. Wenn es sich bei ihr tatsächlich um den Stammvorfahren handelt, lässt sie erkennen, dass die heutigen afrikanischen Menschenaffen in vielerlei Hinsicht ihren eigenen Entwicklungsweg gegangen sind, und dann muss man auch die Vorstellung, Schimpansen seien das beste Vorbild für den LGV, neu überdenken. White und seine Kollegen sind der Ansicht, dass Ardi diesem Vorfahren sehr viel näher steht. An den erhaltenen Überresten ist zu erkennen, dass die Homininen damals bereits zumindest während eines beträchtlichen Teils ihrer Zeit aufrecht gingen. Dafür gibt es in diesem Fall vielfältige Belege, die sich auf verschiedene Körperteile stützen. Ardis Becken ist im Vergleich zu dem der Menschenaffen deutlich kürzer und ähnelt stärker einer Schüssel; die Füße sehen weitaus mehr nach Füßen und nicht nach Händen aus, aber der abstehende große Zeh war noch in der Lage, beim Klettern zuzugreifen. Die Arme waren lang, der Daumen aber bereits opponierbar. Dem Kopf fehlen die großen Schneide- und Eckzähne, die sich bei den Menschenaffen entwickelt hatten, und der beträchtlich verdickte Zahnschmelz auf den Molaren weist darauf hin, dass das Kauen eine wichtigere Funktion erfüllte.

Zusammengenommen deuten diese Merkmale auf eine neue Form der Anpassung hin, aber die erforderte kein größeres Gehirn – jedenfalls noch nicht. Dennoch hatte sich bei diesen ältesten Homininen offenbar in mancherlei Hinsicht eine neue soziale Plattform entwickelt, die zu unserem Ausgangspunkt werden kann. Einen Überblick

über die Probleme der frühesten Menschwerdung gab der amerikanische Paläoanthropologe Owen Lovejoy schon lange, bevor er sich an der Beschreibung von *Ardipithecus* beteiligte. Lovejoy und seine Kollegen legten viel Wert auf die frühe Entstehung des aufrechten Gangs und die Veränderungen an den Zähnen der Homininen. Sie vertraten die Ansicht, am Erdboden habe sich ein neuer Komplex sozialer Eigenschaften entwickelt: Danach kooperierten die Männchen nun stärker, und sie brachten den Weibchen erstmals auch Nahrung. Wie Lovejoy in einem klassischen, 1981 erschienenen Artikel deutlich machte, gibt es für die Fortpflanzung der Menschenaffen einen Fallstrick: Jeder Säugling ist stark von der Mutter abhängig, und zwischen den Geburten liegt ein Zeitraum von mehreren Jahren – bei Orang-Utans sind es bis zu acht. Mit dem aufrechten Gang entwickelte sich eine neue Freiheit der sozialen Spaltung und Vereinigung, sodass mehrere Kinder nacheinander frühzeitig entwöhnt werden konnten und der Obhut der Geschwister oder auch anderer Erwachsener – vielleicht sogar der Großeltern – anvertraut wurden. Nach Ansicht von Lovejoy und Kollegen deuten die Erkenntnisse über *Ardipithecus* nachdrücklich auf drei wichtige Veränderungen der Sozialstruktur hin: die versteckte Ovulation bei Weibchen, die Paarbindung und den Transport von Nahrung. Der erste Punkt lässt sich leider weder durch anatomische noch durch archäologische Erkenntnisse belegen, irgendwann in der Evolution des Menschen wurde er aber zweifellos wichtig. Sehr wahrscheinlich war die versteckte Ovulation am „Ende des Anfangs" bereits entstanden – zu einem Zeitpunkt im Evolutionsverlauf, für den Ardi derzeit unsere beste Vertreterin ist.

Die Behauptung über die Paarbindung wird allerdings durch die Längenverhältnisse der Finger, wie sie im Kasten in Abschn. 3.3 beschrieben wurden, nicht gestützt. Mitarbeiter des Lucy-Projekts konnten sogar zeigen, dass Ardi sehr polygam war. Ein Vorbild ist vielleicht die Sozialstruktur bei den Gorillas: Ein sehr großer Silberrücken beaufsichtigt einen Harem mit den viel kleineren Weibchen und ihren Nachkommen. Dass bei *Australopithecus afarensis* ähnliche Verhältnisse herrschten, legt der Größenunterschied zwischen den großen Männchen und den kleinen Weibchen (darunter Lucy) dieser Homininenart nahe.

Das dritte Element, der Transport der Nahrung, erscheint plausibel. Die Veränderungen bei Fortbewegung, Form des Oberkörpers, Zähnen und größerem Geschlechtsdimorphismus (dem Größenunterschied zwischen Männchen und Weibchen) waren vermutlich die Folgen einer neuen Lebensform am Erdboden, die mehrere miteinander verbundene Aspekte des sozialen Wandels vorantrieb. Einer davon betraf die kleinen Nachkommen: Sie waren sehr verletzlich und brauchten mehr Fürsorge. Den Anforderungen des Mutterdaseins und der Nahrungssuche gleichzeitig gerecht zu werden, war für die Weibchen eine große Herausforderung; es könnte für sie also ohne Weiteres ein Fortpflanzungsvorteil gewesen sein, wenn sie Hilfe von der älteren Generation erhielten, wie es die Anthropologen Jim O'Connell, Kirsten Hawkes und Leslie Aiello annehmen. Sie richteten besondere Aufmerksamkeit auf die Rolle von Weibchen, die das fortpflanzungsfähige Alter hinter sich hatten. Eine eng gefasste darwinistische Analyse dieser „Oldies" wäre schwierig – wenn sie sich nicht mehr fortpflanzen können, sind sie für die Gruppe demnach nicht mehr

von Nutzen. In Wirklichkeit spielen sie aber als Großmütter eine lebenswichtige Rolle. Wenn sie für die Kinderbetreuung zur Verfügung stehen, steigt die Fortpflanzungsfitness ihrer Töchter, weil durch mehr Investition und Schutz mehr Kinder überleben. Durch die längere Abhängigkeitsphase der Säuglinge, die bei unseren Vorfahren eine Folge des größeren Gehirns der Kinder war, erlangte die Kinderbetreuung eine herausragende Bedeutung. Mütter konnten jetzt beispielsweise nach Nahrung suchen und die Kinder bei der Oma lassen. Großmütter wurden nicht nur toleriert, sondern hoch geschätzt. Aber ein längeres Leben führte auch zu größeren Gemeinschaften – die Dreigenerationengesellschaft wurde zum Normalfall. Das wiederum konnte bedeuten, dass die Menschen sich bemühten, am gleichen Ort zu leben oder den Kontakt wegen familiärer Verbindungen aufrechtzuerhalten, was in der Gemeinschaft insgesamt einen größeren Druck entstehen ließ, sich aufzuspalten oder zu vereinigen.

Ardis Platz in der Evolution des Menschen

Betrachten wir die Sache nun einmal im Überblick und stellen wir uns die Frage, welche Beiträge diese frühen Vorfahren zu unserer Idee vom sozialen Gehirn leisten können. Sie waren keine Menschen, und doch gehören sie zum ersten Teil unserer Geschichte. Sie befanden sich auf einem Weg, der zum Menschsein führte, wie dieser Weg aber im Einzelnen verlief, ist nicht geklärt. Deshalb müssen wir sie zual-

lererst als das sehen, was sie waren: Sie hatten im Vergleich zu anderen Affen einen wichtigen anpassungsorientierten Wandel vollzogen. Was trieb ihn an? Zunächst einmal erscheint es plausibel, diese Lebewesen als „Trockenlandaffen" zu betrachten – als Menschenaffen, die sich an eine anspruchsvolle Umwelt angepasst hatten, in der regelmäßige Niederschläge und der Nachschub mit Früchten und Kräutern nicht gesichert waren. Alle heutigen Menschenaffen leben in Regenwäldern und können sich vorwiegend von Früchten und weichen Kräutern ernähren; wo sie leben, hängt davon ab, wo diese Nahrung das ganze Jahr über verfügbar ist. Die gleiche Gesetzmäßigkeit gilt mit geringfügigen Abweichungen für Schimpansen, Gorillas und Orang-Utans, das heißt, sie ist wahrscheinlich sehr alt und reicht viele Millionen Jahre zurück. Im Ernstfall kann sie dennoch leicht versagen – zu manchen Zeiten finden Menschenaffen kaum genug zu fressen. In trockeneren Lebensräumen hätten sie keine Chance gehabt, während der Trockenzeit die traditionelle Menschenaffennahrung zu finden, und wie der Primatenforscher Richard Wrangham überzeugend dargelegt hat, mussten sie sich demnach an neue Nahrungsmittel halten. Die „Extras" in der Ernährung der Schimpansen liefern sicher einen Hinweis, worum es sich dabei gehandelt haben könnte: Honig, Insekten und Fleisch. Eine andere naheliegende Möglichkeit, die Kohlenhydrate der Früchte zu ersetzen, waren Wurzeln und Knollen, aber die erfordern wiederum neue Anpassungen, beispielsweise Werkzeuge zum Graben; außerdem waren sie schwerer verdaulich. Die neuen Ressourcen waren unterschiedlich und vermutlich ungleichmäßiger verteilt, und sie befanden sich sowohl in

unterschiedlichen Höhen über dem Erdboden als auch darunter. Wenn man sie nutzen und gleichzeitig beweglich sein musste, dürfte der aufrechte Gang der beste Kompromiss gewesen sein. Wir stellen uns diese Veränderungen häufig einzeln vor, insgesamt addieren sie sich aber zu einer neuen, komplexen Lebensweise. Die ersten Unterschiede zwischen Homininen wie Ardi und den Menschenaffen zeigen sich sehr deutlich in ihrer Art der Fortbewegung und an ihren Zähnen: Das waren die wichtigsten Mittel, mit denen sie sich in ihrer Umwelt das Überleben sicherten. Aber auch Geist und Gehirn waren in der schwierigeren Umwelt vermutlich bereits subtil gefordert, insbesondere wenn Nahrung während langer Trockenzeiten knapp wurde.

In Untersuchungen von Mitarbeitern des Lucy-Projekts zeigte sich, wie empfindlich die meisten Tiere schon auf geringfügige Veränderungen von Temperatur, Niederschlag oder Nahrungsangebot reagieren (s. Kap. 2). Diese „Sozioökologie" lässt sich in Form von Gleichungen und Landkarten darstellen; sie macht aber auch deutlich, wie stark die natürliche Selektion sein kann und wie sie manchmal schnellen Wandel als Preis für das Überleben erfordert. Im Laufe der letzten 7 Mio. Jahre veränderten sich die Homininen schneller als die Menschenaffen, und daraus können wir den Schluss ziehen, dass sie einem viel stärkeren Selektionsdruck unterlagen.

Einen stichhaltigen Anhaltspunkt dafür, dass die Veränderungen sich nicht nur bei einer Eigenschaft nach der anderen abspielten, sondern auch als „Verhaltenspakete", die mit einem Tauschhandel verbunden waren, liefern die Zähne. Alle Homininen, die nach Ardi lebten, hatten kräf-

tige Backenzähne zum Kauen, interessant ist dabei aber, dass die Schrumpfung der Vorderzähne bereits vollzogen war. Bei früheren und heutigen Menschenaffen sind diese großen Eckzähne dicke Stifte, die an den Mundwinkeln stehen und sich gut zum Zerreißen der Nahrung, zum Aufschlitzen und für sexuelles Imponiergehabe eignen; Menschenaffenmännchen haben weitaus größere Eckzähne als die Weibchen, woraus wir ablesen können, dass die Zähne nicht nur zur Nahrungsbeschaffung gebraucht wurden. Dass diese wichtigen Schaustücke bei den Hominiden verschwanden, lässt auf eine größere Veränderung schließen. Sowohl an *Ardipithecus* als auch an *Sahelanthropus* können wir erkennen, dass die Veränderung schon frühzeitig einsetzte. Bei *Ardipithecus* gibt es in der Morphologie der Zähne keinen Unterschied mehr zwischen den Geschlechtern. Dass das Kauen weiter hinten im Mund stattfindet, kann ernährungsbedingte Gründe haben, außerdem aber lässt sich der Kopf auf einem aufrecht stehenden Körper besser im Gleichgewicht halten, wenn er nicht durch diese massiven Vorsprünge nach vorn gezogen wird. Aber der Verlust derart wirksamer Angriffs- und Verteidigungswaffen wie der Eckzähne der Menschenaffen muss auch auf eine größere Veränderung im Verhalten hindeuten. Die Schrumpfung der Eckzähne ist von grundlegender Bedeutung: Männliche Homininen konnten nun nicht mehr vorwiegend damit zurechtkommen, dass sie ihre Zähne zeigten und benutzten – sie mussten sich anderer Waffen bedienen, um sich mit Feinden und Beutetieren auseinanderzusetzen. Bei Arten wie Ardi verschwand damit auch ein wichtiges Unterscheidungsmerkmal zwischen den Individuen und zwischen den Geschlechtern. Sieht man einmal von Vampirfilmen ab, be-

sitzen Menschen einfach nicht die Augenzähne, die Hinguckereckzähne der Menschenaffen und Raubtiere.

Eine der ältesten Überlegungen über die Evolution der Menschen besagt, die Hände, die durch den aufrechten Gang freigeworden sind, seien nun zum Halten von Stöcken und anderen Waffen sowie zum Tragen von Lebensmitteln verwendet worden. Wenn das stimmt, könnte die Funktion der Zähne als Waffen und Mittel des Drohverhaltens sich auf die Dinge verlagert haben, die mit den Händen gehalten wurden. Wenn aber *Ardipithecus* trotz seines aufrechten Ganges noch häufig durch die Bäume kletterte, was die Anatomie von Schulter, Händen und Füßen nahelegt, tat er das vermutlich nicht mit dem „Stab in der Hand". Er wäre geklettert, um Nahrung zu suchen oder natürlichen Feinden aus dem Weg zu gehen, irgendwann aber verlegten diese Menschenaffen mit ihrem kleinen Gehirn ihren bevorzugten Aufenthaltsort von den Bäumen auf den Erdboden, und *Ardipithecus* muss sehr nahe vor dem Beginn dieser Entwicklung gestanden haben. Das ist der Grund, warum wir sie als Homininen bezeichnet, während wir gleichzeitig erkennen, welchen Widerspruch dann ihr kleines, an Menschenaffen erinnerndes Gehirn aufwirft.

Letztlich sagen wir damit: Die Verlagerung der Alltagsaufgaben von den Zähnen auf die Hände drehte sich um Interaktionen zwischen Individuen und hatte weitreichende soziale Auswirkungen. Aus archäologischer Sicht ist nach unserer Auffassung am wichtigsten, dass die Technologie von Anfang an „sozial eingebettete" war – sie war ein Mittel zur Herstellung zwischenmenschlicher Beziehungen.

Australopithecinen: Menschenaffen mit einem Gehirn von über 400 Kubikzentimetern als Gelegenheitsarbeiter

Die Australopithecinen waren erfolgreich, da können wir sicher sein. Mit ihrem größeren Gehirn breiteten sie sich über ganz Afrika aus. Der Erfolg zeigt sich auch in einer neuen Artenvielfalt – ein Phänomen, das man als adaptive Radiation bezeichnet. Sie war nicht so spektakulär wie die Artbildung bei den Meeressäugern oder Altweltaffen, aber immerhin entstand eine ganze Reihe neuer Arten.

Die Wissenschaftler, die *Ardipithecus* beschrieben haben, stellen die alte Ansicht infrage, wonach ein schimpansenähnlicher LGV sich durch den „Übergang" zu den Australopithecinen in Richtung des Menschseins bewegte. Sie vertreten vielmehr die Auffassung, man müsse die Australopithecinen als charakteristische, eigenständige Anpassung betrachten. Die Vorstellung von einem ununterbrochenen Übergang ist unter anderem deshalb problematisch, weil die Australopithecinen so schnell auf *Ardipithecus* folgen: White und Lovejoy glauben, dass die Hintergliedmaßen eine sehr schnelle Evolution durchmachten. Eine Alternative wäre der Gedanke, dass *Ardipithecus* eine Schwesterspezies eines Australopithecinen ist, der noch besser aufrecht ging. Wie dem auch sei: Die Australopithecinen erscheinen vor mindestens 4 Mio. Jahren auf der Bildfläche; ihr erster Vertreter ist *Australopithecis anamensis*, eine Spezies, die man aus dem Norden Kenias kennt.

Aus der Zeit vor rund 3 Mio. Jahren finden wir Australopithecinen vom äußersten Süden Afrikas bis nach Äthiopien und im Westen mindestens bis zum Tschad. Nach einer einfachen Analyse können wir sie immer noch als aufrecht gehende Menschenaffen bezeichnen, und es gibt kaum Anhaltspunkte dafür, dass sie Steinwerkzeuge verwendeten. Den Menschenaffen ähnelten sie in mehrfacher Hinsicht: Die Backenzähne waren groß, die Arme sehr lang und der Brustkorb nach wie vor kegelförmig, was zusammen mit den langen, gebogenen Fingerknochen dafür spricht, dass viele Australopithecinen immer noch einen Teil ihres Lebens in den Bäumen verbrachten. Es gab aber auch eine entscheidende Veränderung: Die Hintergliedmaßen konnten nicht mehr greifen und waren vollständig an das Gehen auf dem Erdboden angepasst. Den unmittelbaren Beleg dafür liefern die berühmten Fußspuren aus Laetoli in Tansania. Sie stammen von einer kleinen Gruppe von Homininen, die vor mehr als 3,5 Mio. Jahren nebeneinander gingen (s. Abb. 4.2 und 4.3).

Was das soziale Gehirn angeht, überschreiten die Australopithecinen als erste Homininen den Schwellenwert einer Gehirngröße von 400 Kubikzentimetern. Ardi, *Sahelanthropus* sowie alle heutigen Menschen- und Kleinaffen liegen darunter. Gorillas haben ein Gehirnvolumen von mehr als 400 Kubikzentimetern, aber wie im vorangegangenen Kapitel erläutert wurde, liegt dies größtenteils an ihrem großen Kleinhirn; es ist eine notwendige Anpassung, damit sie ihre große Körpermasse koordiniert bewegen können. Für das soziale Gehirn ist aber die Größe des Neocortex entscheidend.

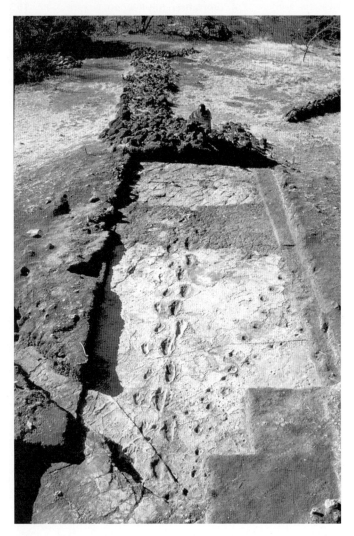

Abb. 4.2 Die fossilen Fußspuren in Laetoli in Tansania. Sie wurden auf ein Alter von 3,5 bis 3,8 Mio. Jahren datiert; die Spuren stammen von zwei ausgewachsenen und einem jugendlichen Australopithecinen, die ohne Eile über eine Ebene mit einer dünnen Schicht frischer Vulkanasche des nahe gelegenen Mount Sadiman gingen. (© J. Paul Getty Trust and the Tanzanian Department of Antiquities)

Abb. 4.3 Mary Leakey, eine berühmte Steinzeitarchäologin der letzten Generation, arbeitet in Laetoli an der Reinigung der Sedimente. (© John Reader/Science Photo Library)

Es gibt eine ganze Reihe „graziler" Australopithecinenarten – zu ihnen gehören zumindest *Australopithecus anamensis, africanus, afarensis, garhi* und *sediba*. Außerdem erkennt man die „robusten" Abstammungslinien, die durch ihre massiven Unterkiefer gekennzeichnet sind – *Australopithecus robustus, boisei* und *aethiopicus* (der von manchen Experten einer eigenen Gattung namens *Paranthropus* zugeordnet wird – daher spricht man auch von „Paranthropinen"). Ihre Gehirngröße ist unterschiedlich, liegt aber, wie der führende Paläoanthropologe Bernard Wood zeigen konnte, immer im Bereich zwischen 450 und 570 Kubikzentimetern. Als Faustregel entspricht das einer Gemeinschaftsgröße von 60

bis 80 Interaktionspartnern. Das wiederum übte Druck auf den Zeitplan während der Tageslichtstunden aus: In den größeren Gemeinschaften mussten bis zu 20 % der Zeit, in der es hell war, für soziale Tätigkeiten wie gegenseitiges Kraulen aufgewendet werden.

Alle unsere Fragen nach dem Sozialleben stellen sich auch bei den Australopithecinen. Neben den Fußspuren von Laetoli sprechen auch Fossilfunde aus Hadar in Äthiopien für die Existenz sozialer Gruppen. Wenn auch die Eckzähne kein Kennzeichen für Geschlechtsunterschiede mehr waren, so bestanden doch zwischen Männchen und Weibchen mit ziemlicher Sicherheit große Unterschiede in der Körpergröße. Lucy, das berühmte Typusexemplar von *Australopithecus afarensis* (s. Abb. 4.4), maß nur wenig über einen Meter, andere Funde aus derselben Region von Hadar in Äthiopien stammen dagegen von kräftig gebauten Männchen, die vermutlich so groß waren wie männliche Schimpansen. Dies ist unser bester unmittelbarer Beleg dafür, dass die Australopithecinen in ihrem Sozialverhalten den Menschenaffen vermutlich näher standen als den heutigen Menschen. Vergleichende Studien an Primaten deuten darauf hin, dass Gesellschaften, in denen große Männchen und kleine Weibchen leben, in der Regel nach dem „Haremprinzip" funktionieren. Ein Beispiel sind die Gorillas: Hier besteht die soziale Gruppe häufig aus einem älteren Männchen (dem Silberrücken), mehreren Weibchen und ihren Kindern. Wenn die Männchen erwachsen werden, müssen sie sich häufig von dem dominanten Silberrücken trennen, und am Ende gelingt es ihnen unter Umständen, eine eigene soziale Gruppe neu aufzubauen. Das Leben in der Gemeinschaft war sicher nicht nur ein Luxus: Wenn die Australopithecinen nicht mehr auf Bäumen lebten, waren sie

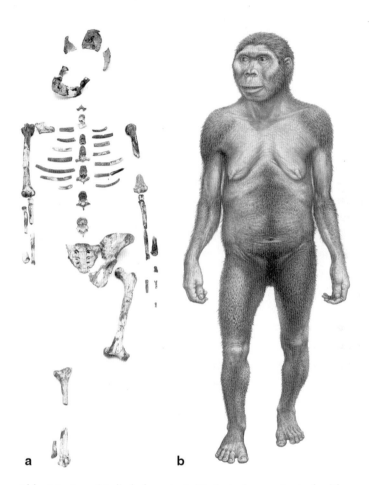

a b

Abb. 4.4 Lucy ist die bekannteste Vertreterin von *Australopithecus afarensis*. Skelettreste dieser Spezies zeigen, dass das Gehirn noch klein war; der aufrechte Gang hatte sich aber bereits entwickelt. (*links*: © John Reader/Science Photo Library; *rechts*: © John Sibbick)

stärker durch große, bodenbewohnende Raubtiere gefährdet, insbesondere durch Großkatzen und Riesenhyänen. Damit haben wir eine Antwort auf die Frage, wie Lucy so klein sein konnte: Offensichtlich wurde sie vor allem durch ihre Gemeinschaft geschützt. Tatsächlich muss es sogar so gewesen sein, denn der aufrechte Gang brachte es mit sich, dass Kleinkinder herumrannten. Die Säuglinge heutiger Menschenaffen werden von der Mutter herumgetragen, bis sie sich selbst in den Bäumen fortbewegen können. Funde aus Südafrika lassen darauf schließen, dass die Gefahren tatsächlich vorhanden waren – in der Höhle von Swartkrans sind zahlreiche Überreste von Australopithecinen erhalten geblieben, aber es gibt nur wenige Funde von späteren Arten des *Homo*, obwohl Steinwerkzeuge zeigen, dass diese dort gelebt haben. Folgt man der Argumentation von Bob Brain, waren die Australopithecinen an diesen Stellen nicht die Jäger, sondern die Gejagten, die regelmäßig Leoparden und anderen Großkatzen zum Opfer fielen.

An den Australopithecinen fällt auf, dass sich, ausgehend von ihrer ursprünglichen „Plattform", mindestens zwei ganz unterschiedliche Anpassungen entwickelt haben. Der aufrechte Gang schafft neue biomechanische Anforderungen für den Kopf – er befindet sich jetzt ganz oben und kann nicht ohne Weiteres mit vertretbarem Aufwand sowohl einen massiven Unterkiefer als auch ein großes Gehirn tragen. Irgendwo und irgendwie begünstigte die natürliche Selektion offenbar unter verschiedenen lokalen Umweltbedingungen das eine oder das andere. Bei einer Gruppe, den robusten Australopithecinen (oder Paranthropinen), entwickelten sich massive Kieferknochen und Zähne. Die großen Muskeln, von denen sie bewegt wurden, verliefen fast über den gesamten Schädel. Hier muss die Notwendigkeit bestanden

haben, große Mengen minderwertiger pflanzlicher Nahrung zu verarbeiten. Die meisten Gemeinsamkeiten in unserer Zeit weist der Gorilla auf: Er ist zwar ein Primat, man kann ihn aber als Pflanzenfresser bezeichnen, denn er verzehrt große Mengen von Stängeln, Rinde und Pflanzenmark.

Eine andere Möglichkeit war eine Begünstigung des Gehirns. Diese Tendenz wird nicht sofort erkennbar, aber bei manchen Arten entwickelte sich jedenfalls nicht die Spezialisierung der robusten Australopithecinen. Alle grazilen Australopithecinen kamen ohne die gewaltige Muskulatur ihrer robusten Vettern aus. Und wenn wir von einem größeren Gehirn sprechen, dann sprechen wir auch von den ältesten Vertretern unserer eigenen Gattung *Homo*. Die Grenze zwischen Homininen und Menschen ist willkürlich festgelegt – fossile Schädel wurden in den Menschenclub aufgenommen und wieder aus ihm verstoßen, je nachdem, ob Paläoanthropologen es sich angesichts neuer Befunde oder neuer Vorstellungen davon, was ein menschlicher Schädel ist, anders überlegten. Hier sei nur gesagt, dass der Übergang bei Homininen mit einem Gehirn in der Größenordnung von 400 bis 900 Kubikzentimetern begann.

Nach den arbeitenden Affen: die ersten Vertreter der Gattung Homo

Wegen der Unwägbarkeiten der Erhaltung und Entdeckung sind manche Zeitabschnitte durch mehr Funde repräsentiert als andere. Zufällig besitzen wir aus der Zeit vor 2,6 bis 2,0 Mio. Jahren weniger Schädelbruchstücke als aus den Phasen davor und danach. Genau in diesem Zeitabschnitt liegen vermutlich die Anfänge der Gattung

Homo, aber der wichtigste Beleg dafür sind die vielfältigen Überreste aus der Zeit vor weniger als 2 Mio. Jahren. Damals waren bereits zwei oder drei Arten entstanden, was darauf schließen lässt, dass die Wurzeln unserer Gattung noch weiter – vielleicht eine halbe Million Jahre – in der Vergangenheit liegen. Man erkennt *Homo* an bestimmten Einzelheiten von Schädel und Zähnen, der übergeordnete Indikator ist aber die deutliche Zunahme der Gehirngröße. In manchen Fällen, so bei dem berühmten Fund KNM-1470 aus dem Osten von Turkana, liegt sie bei 800 Kubikzentimetern und ist damit fast doppelt so groß wie bei durchschnittlichen Menschenaffen. Dieser Schädel wurde seit seiner Entdeckung immer als *Homo* eingeordnet, dann aber entweder den Arten *ergaster* oder *rudolfensis* zugeschlagen. Außerdem haben manche Exemplare von *Homo habilis* eine durchschnittliche Gehirngröße von 650 Kubikzentimetern, ungefähr 50 % mehr als die Australopithecinen, mit denen sie manchmal in einen Topf geworfen werden, aber deutlich weniger als *Homo rudolfensis* oder der spätere *Homo ergaster*. In Wahrheit gibt es bei der Gehirngröße keine eindeutige Grenze, oberhalb derer wir einen Fund als *Homo* bezeichnen könnten, während es sich darunter um einen älteren, nicht zur Gattung *Homo* gehörigen Vorfahren handeln muss. Wie wir an der immer wieder wechselnden Benennung fossiler Schädel ablesen können, bestehen an den Grenzen immer Unsicherheiten.

Unter dem Gesichtspunkt des sozialen Gehirns können wir für diese ältesten Vertreter der Gattung *Homo* mit einer Gemeinschaftsgröße von 80 bis 90 Individuen rechnen, ganz gleich, wie sie von den Paläontologen letztlich genannt werden. Solche Zahlen liegen deutlich oberhalb der Grenzen, die wir bei modernen Menschen- und Kleinaf-

fen beobachten, und auch oberhalb der Zahlen, die man für die Australopithecinen voraussagen würde. Sie müssen demnach ungefähr ein Viertel der Zeit bei Tageslicht für das Kraulen aufgewendet haben, um ihre sozialen Bindungen zu schaffen, zu bestätigen und zu verstärken. Über kurz oder lang musste sich daran etwas ändern.

Wie kam es zu dem Wachstum des Gehirns? Wir vertreten die Ansicht, dass die Voraussetzungen für die Entstehung einer neuen, größeren Form der Geselligkeit gegeben waren. Hier haben wir es im wahrsten Sinne mit einem sozialen Gehirn zu tun: Das Sozialleben treibt das Gehirnwachstum voran. Eine dieser Voraussetzungen waren die Steinwerkzeuge: Sie sind ein Musterbeispiel für den Verstärkungsprozess – das Signal einer vorhandenen Anpassung wurde stärker, um den Herausforderungen der größeren Gemeinschaft begegnen zu können. Welchen Ausdruck dies nach den Maßstäben des sozialen Gehirns im Einzelnen findet, werden wir noch genauer untersuchen. Zuerst jedoch müssen wir einen näheren Blick auf die Bedeutung der Werkzeuge werfen.

Der Weg der Werkzeuge

Noch heute sind wir fasziniert von Technologie und dem Schub, den sie uns in der Welt verleiht. Die Passagiere der Concorde konnten auf einer Anzeige vorn in der Kabine sehen, wann sie die doppelte Schallgeschwindigkeit erreicht hatten und damit in den Mach 2 Club aufgenommen waren. Entsprechend könnten auch Archäologen einen „2-Millionen-Jahre-Club" für diejenigen ins Leben rufen, die besonders alte Steinwerkzeuge gefunden und untersucht haben. Manche von uns können sich nie sicher

sein, ob sie dem Club angehören oder nicht, denn so exakt ist die Datierung nicht immer. Ohne Zweifel wurde die 2-Millionen-Jahresgrenze bei den Werkzeugen jedoch um 1970 durchbrochen, als rund um den Turkanasee im Norden Kenias neue Forschungsarbeiten stattfanden. Eine weitere Forschergeneration hat die Grenze noch weiter in die Vergangenheit geschoben, nämlich bis auf 2,6 Mio. Jahre, durch Funde in Gona in Äthiopien. Wir können ziemlich sicher sein, dass die Werkzeuge von einem wichtigen Evolutionsschritt auf dem Weg zum Menschen erzählen.

Was ist das Besondere an Steinwerkzeugen? Archäologen nutzen sie jetzt schon seit mehr als zweihundert Jahren als Markierungen der Vergangenheit; ihr großer Wert liegt unter anderem darin, dass sie nahezu unauslöschliche Spuren der früheren Gegenwart von Menschen darstellen. Solche Spuren zu besitzen, ist unendlich viel besser als wenn man sie nicht besitzt, aber damit beginnt eigentlich erst der schwierige Teil. Wir müssen wissen, wer sie gemacht hat, womit sie erzeugt wurden, wann sie erzeugt wurden und ob sie wirklich wichtig waren. Durch solche Fragen bleiben wir in engem Kontakt mit unserem sozialen Gehirn.

Um Antworten zu finden, müssen wir zuerst einen größeren Zusammenhang betrachten – nicht nur den der Menschen, sondern auch den der Tiere. Wir müssen nachzeichnen, wie sie leben und mit welcher faszinierenden Vielfalt verschiedener Mittel sie sich zu helfen wissen. Für die meisten von ihnen, ob Säugetiere, Vögel, Reptilien oder Fische, ist der eigene Körper das einzige Mittel, mit dem sie etwas bewerkstelligen können. Wenn etwas nicht mit Zähnen, Pranken, Schnabel oder Klauen auszuführen ist, wird es nicht ausgeführt. Viele Tiere finden aber auch einen Weg, um in der Welt mithilfe zusätzlicher, „extrasomatischer"

Dinge zurechtzukommen, die nicht zum eigenen Körper gehören – sie nutzen Material aus ihrer Umgebung, um auf etwas einzuwirken. Und nichts anderes sind Werkzeuge.

Manchmal handelt es sich um einfache Einzelfälle. Ein Vogel lässt eine Schnecke auf einen Stein fallen, damit ihr Gehäuse zerbricht. Makaken waschen Kartoffeln (wobei das Wasser das Werkzeug ist). Ein Delphin steckt sich einen Schwamm auf die Nase, um damit im Meeresboden zu wühlen. Andere Fälle sind beträchtlich komplexer. Die besten Leistungen erbringen dabei – neben den Neukaledonienkrähen – Kapuzineraffen, Schimpansen sowie natürlich die Homininen und die heutigen Menschen. Es ist ein faszinierendes Bild, denn ganz offensichtlich hängt nicht alles von engen Evolutionsverwandtschaften ab. Die große Mehrzahl aller Affenarten benutzt keine Werkzeuge, auch die engsten Verwandten der Kapuzineraffen nicht.

Menschenaffen sind in vielerlei Hinsicht intelligenter als Kleinaffen, und ihr Gehirn ist im Verhältnis zum Körper mit Sicherheit größer. Nicht alle von ihnen nutzen aber ihre Fähigkeiten, um Werkzeuge herzustellen. Systematisch tun das eigentlich nur die Schimpansen. Wie wir bereits angedeutet haben, richtet sich ihre Intelligenz grundsätzlich auf die Bewältigung sozialer und ökologischer Herausforderungen. Der Primatenforscher Richard Byrne hat darauf aufmerksam gemacht, dass Tätigkeiten wie die Zubereitung pflanzlicher Nahrung und der Nestbau in mancher Hinsicht die gleichen Fähigkeiten erfordern wie die Herstellung und der Gebrauch von Werkzeugen. Auch dieses Verhalten wird in einem sozialen Umfeld erlernt.

Unser Familienstammbaum und seine phylogenetische Verzweigungen haben einen seltsamen Aspekt: Wir und die Schimpansen sind näher verwandt als jeder von uns mit

den Orang-Utans, die am dritthäufigsten Werkzeuge herstellen. Orang-Utans stellen mit Sicherheit Werkzeuge her, allerdings nicht bei allen Gelegenheiten. Gorillas benutzen sie kaum einmal; und unser anderer nächster Verwandter, der Bonobo (auch Zwergschimpanse genannt), tut es ebenfalls nur selten. Angesichts einer solchen Verteilung sollten wir die Tatsache, dass die Schimpansen unsere nächsten lebenden Verwandten sind, nicht überbewerten, insbesondere da sie dieses Attribut mit den Bonobos gemeinsam haben; allerdings können uns die Schimpansen möglicherweise Hinweise darauf geben, wie der Werkzeuggebrauch unserer Vorfahren zu Beginn aussah. Natürlich ist es nicht sinnvoll, irgendwelche Verhaltensweisen aus der Gegenwart als unmittelbaren Schlüssel zur Vergangenheit zu betrachten, aber mithilfe der Schimpansen können wir erkennen, wie man ein Arsenal einfacher Werkzeuge für verschiedene Aufgaben einsetzen kann. Deshalb halten manche Fachleute den Schimpansen für das beste Modell, das uns für den letzten gemeinsamen Vorfahren von Homininen und Menschenaffen zur Verfügung steht. Diese Ansicht wird unter anderem von Schimpansenforschern wie Bill McGrew, Richard Wrangham und Andy Whiten vertreten. Andere würden argumentieren, dass die Schimpansen auch selbst wichtige neue Anpassungen erworben haben. Dennoch ist es bequem, sie als das beste *heute noch lebende* Modell zu betrachten.

Eines ist aber sicher: Schimpansen benutzen Werkzeuge häufiger und auf vielfältigere Weise als alle anderen Tiere mit Ausnahme unserer selbst (s. Abb. 4.5). Alle Schimpansenpopulationen setzen Werkzeuge ein, allerdings nicht immer die gleichen; außerdem dienen die meisten Aufgaben,

Abb. 4.5 Ein Schimpanse schlägt Nüsse mit einem Stein auf. Solche Verhaltensweisen sind bei verschiedenen Populationen wilder Schimpansen unterschiedlich weit verbreitet, und ihre Vervollkommnung dauert viele Jahre. (© Kathelijne Koops)

die sie damit erfüllen, zwar dem Überleben, manche sind aber auch nicht lebensnotwendig. Schimpansen nutzen vor allem Früchte und Kräuter als Nahrung, und zu deren Nutzung sind Werkzeuge nicht unbedingt erforderlich. Man kann also zwischen einer „harten" und einer „weichen" Werkzeugnutzung unterscheiden: Steine werden zum Schlagen verwendet, weichere Stängel und Blätter zum Termitenangeln und zum Fegen. In manchen Fällen beflügelt der Gebrauch von Werkzeugen durch Schimpansen unsere Fantasie. Im westafrikanischen Fongoli machen Schimpansen mit kleinen hölzernen Speeren Jagd auf Buschbabys; an anderen Orten bedienen sie sich eines ganzen Werkzeugar-

senals, um unterirdische Termitennester aufzubrechen oder Honig aus Bienenstöcken zu beschaffen, wobei sie allen Stichen und Bissen widerstehen.

Angesichts des gewaltigen Interesses, das die Werkzeuge von Menschenaffen ausgelöst haben, können wir einige sichere Erkenntnisse festhalten:

- Werkzeuge entstammen einem sozialen Umfeld.
- Ihre Verwendungszwecke haben nicht unmittelbar mit der Haupttätigkeit der Nahrungsbeschaffung zu tun.
- Die Technologie sagt eine Menge darüber aus, welche „Extras" im Leben der Schimpansen wichtig sind.
- 99 % der Schimpansenwerkzeuge würden nicht so erhalten bleiben, dass man daraus eindeutige archäologische Aussagen ableiten könnte.

Sagen die Werkzeuge etwas über Intelligenz aus (die hier recht eng als Fähigkeit zur Lösung von Problemen der Nahrungsbeschaffung definiert wird)? Wenn es darum geht, die Bedeutung der Werkzeuge aufzuklären, haben Primatenforscher und Archäologen ähnliche Probleme. Primatenforscher können ihre Studienobjekte nicht fragen, warum sie etwas tun oder nicht tun, weil Menschenaffen keine Sprache besitzen. Und Archäologen können ihre Studienobjekte nicht fragen, weil sie schon seit langer Zeit tot sind. Gerechterweise muss man festhalten, dass Menschenaffen, die keine Werkzeuge herstellen, bei der Bewältigung der Herausforderungen des sozialen Lebens ebenso intelligent wirken wie solche, die es tun. Aber Intelligenz – ein selbst im besten Fall unscharfer Begriff – scheint eine Voraussetzung zu sein. Irgendwie wird das kulturelle Wissen unter den

Schimpansen weitergegeben, denn andere Schimpansen sehen zu und lernen. Das meinen wir mit unserer Aussage, Werkzeuge würden dem sozialen Umfeld entstammen. Die Werkzeuge sind für Schimpansen nur von mäßiger Bedeutung, aber anscheinend wären sie viel wichtiger, wenn die Schimpansen in einer geringfügig anderen Umwelt leben würden, sodass sie einen höheren Anteil ihrer Nahrung nur mit Werkzeugen beschaffen könnten.

Die soziale Rolle der Werkzeuge

Insgesamt kann man Werkzeuge auf zweierlei Weise betrachten:

1. Die Welt ist vorwiegend ein soziales Umfeld, und Werkzeuge sind eine Art zufälliges Nebenprodukt, ein Epiphänomen.
2. Das Material, aus dem Werkzeuge hergestellt werden, ist ein zentraler Bestandteil des Rahmens, in dem sich unser Sozialleben entwickelt hat.

Die Tatsache, dass es in Bezug auf das Vorhandensein oder Fehlen von Werkzeugen sowohl bei Vögeln als auch bei Primaten sogar in Gruppen sehr eng verwandter Arten ausgeprägte Unterschiede gibt, spricht für die erste Ansicht; das gilt sogar für die heutigen Menschen. Manche traditionellen Gemeinschaften australischer Ureinwohner haben ein ungeheuer reichhaltiges Sozialleben, aber nur ein kleines Werkzeugarsenal. Andererseits betont die Geschichte der Evolution des Menschen, wie sie von Childe und anderen

Archäologen erzählt wird, die große Bedeutung des zweiten Punktes. Die technologische Basis war offenbar in der Evolution des Menschen eine unentbehrliche Voraussetzung für jeden größeren wirtschaftlichen Schritt nach vorn. Aber auch jeder wirtschaftliche Schritt ist an soziale Entwicklungen gekoppelt.

Bis zu einem gewissen Grad können wir beide Aussagen vereinbaren; das ist wichtig, wenn wir die Technologie mit dem sozialen Gehirn in Verbindung bringen wollen. Erstens ist klar, dass Werkzeuge uns für die Betrachtung der Vergangenheit einen sehr leistungsfähigen Maßstab an die Hand geben, und das Gleiche gilt auch für die Gegenwart. Selbst ein Schmuckstück ist ein Werkzeug, aus dem man Informationen über seinen Träger entnehmen kann. Vor allem aber werden Werkzeuge fast immer in einem sozialen Kontext hergestellt oder benutzt. Das gilt für den Werkzeuggebrauch der Primaten ganz genauso. In den letzten Jahren hat sich bei den Primatenforschern der Eindruck durchgesetzt, sie müssten beweisen, dass es ein „soziales Lernen" gibt, aber dazu gibt es eigentlich nur eine echte Alternative: dass der Werkzeuggebrauch von Individuen jeweils neu erfunden wird. So etwas dürfte kaum möglich sein; es ist das Wesen von Tradition, dass Individuen durch Kontakte, die man als sozial bezeichnen kann, von anderen lernen. Aufgrund dieser Argumentation können wir erkennen, dass die Technologie der Menschenvorfahren grundsätzlich sozial eingebettet war. Ohne eine solche Einbettung hätte es keine Weitergabe von Ideen und Methoden gegeben, keine Vererbung leistungsfähiger Methoden, um mit der Welt zurechtzukommen.

Technologie hat aber von Anfang an auch Auswirkungen: Sie führt zu sozialen Tätigkeiten, die nur aufgrund vorangegangener technischer Abläufe stattfinden können. So können wir beispielsweise nur deshalb in einer Hütte wohnen, weil wir sie zuvor gebaut haben. Das Leben in der Hütte verschafft uns unter Umständen neue soziale Möglichkeiten, aus denen sich wiederum technische Möglichkeiten ergeben. Auf diese Weise schaffen Rückkopplungsschleifen eine tiefgreifende Verbindung zwischen der Technologie, unserer Biologie und unserem Sozialverhalten, jenem Prozess, mit dem wir die Signale zum Aufbau eines sozialen Lebens durch immer engere Bindungen verstärken. In der biologischen und anthropologischen Forschung hat sich bereits eine Denkrichtung entwickelt, die diesen Prozess als „Nischenkonstruktion" bezeichnet: Die Menschen haben sich selbst eine große kognitive und technologische Nische geschaffen, aber deren Grundlagen sind sozial und beruhen auf Ideen. Wir Menschen können für uns in Anspruch nehmen, dass wir uns die Nische, in der wir leben, tatsächlich selbst bauen. Viele andere Tiere tun das ebenfalls, aber keine Nische ist so vielgestaltig oder komplex wie unsere. Wir sind eins mit unserer materiellen Umwelt und den Umfeldern, die wir uns gebaut haben und in denen wir leben – aber Menschen treiben diesen Prozess viel weiter. Oder, wie der Anthropologe Maurice Bloch es formulierte: Menschen haben die entscheidende Fähigkeit, in der Fantasie zu leben. Wir würden sagen: Wir sind in der Lage, die Intentionalität über die vierte Ordnung hinaus weiter zu treiben (s. Kap. 5). Wichtig ist dabei, dass die Anfänge dieser Entwicklung nicht in den Dörfern und Städten der neolithischen Revolution liegen. Sie begann bereits bei unseren

entfernten Vorfahren; die Steinwerkzeuge aus Gona kennzeichnen nur den derzeit bekannten Anfang.

Die Tatsache, dass solche uralten, in sozialem Umfeld erlernten Fähigkeiten zum Werkzeuggebrauch mitgeholfen haben, unsere charakteristische Nische aufzubauen, deutet auf eine anderes Verständnis von der Organisation des Geistes bei den Homininen hin. Wir neigen zu der Vorstellung von einem erweiterten Geist, zu dem abgeschlagene Steine ebenso gehören wie graue Gehirnsubstanz, und von einer sozialen Kognition, die sich auf die Umwelt der Homininen ausweitet. Damit meinen wir nicht, dass Steine buchstäblich ein Gehirn haben, aber der Geist der Homininen kartierte und modellierte alle diese Gedanken auf einer grundlegenden, intuitiven Ebene. Solche Gedanken werden im Kasten „Arten des Geistes" genauer erläutert. Sie weisen auf eine bruchlose Verbindung zwischen uns selbst und den Herstellern der ältesten Steinwerkzeuge hin – und das ist meilenweit entfernt von früheren Darstellungen, wonach die Jäger und Sammler sowie unsere Steinzeitvorfahren in ihrem Verhalten weitaus kindlicher und irrationaler waren. Dies war die feste Auffassung eines der größten Vertreter der Archäologie, des überzeugten Darwinisten General Pitt-Rivers, die er 1875 niederschrieb. Ähnliche Ansichten darüber, wer die Fähigkeit zum rationalen Denken und damit die intellektuellen Möglichkeiten zu Innovationen und Problemlösungen besaß, finden sich auch in Childes Einschätzung des wilden Stadiums der sozialen Evolution (s. Kap. 3).

Harte Funde: das Wann, Was und Wer der Werkzeuge

Irgendwann während dieses Evolutionsablaufs tauchten die ersten Steinwerkzeuge auf. Die ältesten bekannten Funde stammen, wie bereits erwähnt wurde, aus Gona in Äthiopien; ganz in der Nähe, aber in niedrigerer Höhenlage, befindet sich auch die Fundstätte von *A. afarensis* in Hadar. Die Werkzeuge wurden auf ein Alter von 2,6 Mio. Jahren datiert, die jüngsten Funde von *A. afarensis* dagegen sind mehr als 3 Mio. Jahre alt. Funde, die man 2010 weiter südlich in Äthiopien in Dikika machte, legen die Vermutung nahe, dass auf Knochen schon vor 3,3 Mio. Jahren Schnittspuren entstanden sind, die Belege werden aber derzeit noch heiß diskutiert. Die Vorstellung von einem so frühen Zeitpunkt sollte angesichts der Geschicklichkeit, mit der Primaten einfache Werkzeuge gebrauchen, nicht problematisch sein, aber dann wäre schwer zu erklären, warum man an anderen gut bekannten Fundstätten keine Werkzeuge entdeckt hat. Die weitläufige Landschaft von Laetoli wurde von erfahrenen Paläoanthropologen erforscht, die mit Steinwerkzeugen sehr vertraut waren, und doch wurde nie etwas gefunden. Auch in den älteren Australopithecinenhöhlen in Südafrika fand man keine Spuren von Steinwerkzeugen. Wenn solche Werkzeuge aus heiterem Himmel auftauchen, bringen sie für Paläoanthropologen zweierlei Nutzen. Erstens deuten sie auf die Gegenwart von Homininen hin – sie sind die Entsprechung zur modernen Smartphone-Technologie, denn sie sagen etwas darüber aus, wo jemand ist oder in diesem Fall war. Zuvor mussten Homi-

ninen sterben, damit wir sie entdecken konnten. Und zweitens erzählen Werkzeuge die Geschichte vieler alltäglicher Tätigkeiten und sagen etwas darüber aus, wie Probleme, die dabei auftraten, gelöst wurden.

Arten des Geistes

Das Gehirn von Menschen kann man vermessen und untersuchen. Große Fortschritte wird man zweifellos in den nächsten zehn Jahren mit MRT- und CT-Scanaufnahmen erzielen. Dann werden wir erfahren, welche Abschnitte unseres Gehirns aktiv sind, wenn wir verschiedene Werkzeuge herstellen oder uns der Sprache bedienen. Was die Experimente angeht, wird das eine Revolution bedeuten, vergleichbar den Freilandstudien an Schimpansen und Pavianen, an denen unsere Wissenschaftlergeneration beteiligt war.

Viel schwieriger lässt sich feststellen, was im Geist der Homininen vorging. Der Geist bleibt nicht erhalten – was überlebt, sind nur seine handgreiflichen Produkte. Ein wichtiger erster Schritt besteht aber darin, ein bestimmtes Modell des Geistes zugrunde zu legen; diese Entscheidung bestimmt dann darüber, was für Fragen man stellen kann und wie man die archäologischen Daten interpretiert.

Das bekannteste Modell des Geistes kann man bis ins 17. Jahrhundert zu dem französischen Philosophen und Mathematiker René Descartes zurückverfolgen. Er beschrieb den Geist als rationales Instrument, das Probleme außerhalb des Körpers löst. Damit vollzog er einen wichtigen Bruch mit dem mittelalterlichen Weltbild, und er schuf die Grundlagen für Wissenschaft und Medizin, wie wir sie heute kennen. Seit Descartes wurden seine Gegenüberstellung innerer und äußerer kognitiver Prozesse sowie seine anderen Dualismen – Geist/Körper und Objekt/Subjekt – in vielerlei Hinsicht verfeinert.

Zur Beschreibung dieser inneren Vorgänge hat man sich vieler Metaphern bedient, und wie nicht anders zu erwarten, werden heute oft Vergleiche mit Computern angestellt. Der Archäologe Steven Mithen verwendete in seinem bahnbrechenden,

1996 erschienenen Werk *The Prehistory of the Mind* den Begriff der mentalen Module, um damit seine Beschreibung der Evolution zu strukturieren. Bei diesen Modulen handelt es sich nach seiner Ansicht um unterschiedliche Intelligenzen, die sich mit ganz verschiedenen Bereichen wie dem sozialen Umfeld, Naturgeschichte, Sprache und Technologie beschäftigen. Diese Unterteilung des Geistes lieferte den dringend benötigten Ausgangspunkt für die Archäologie der Kognition, die ansonsten ein sehr vages Konzept war. Zur Erklärung des Wandels bediente sich Mithen des Begriffs der kognitiven Fluidität, die auf immer kompliziertere Weise die Module des Gehirns verknüpft. Nach seiner Vorstellung vereinigte sich das natürliche Intelligenzmodul zu irgendeinem Zeitpunkt in der Evolution des Menschen mit dem Modul für soziale Intelligenz. Die Rentiere, die zuvor einfach Nahrung gewesen waren, waren jetzt nicht mehr nur zum Essen gut, sondern sie eigneten sich auch dazu, über sie nachzudenken. Man nutzte sie nicht mehr nur als Kalorienlieferanten, sondern auch als Totems für die Sippe. Mit dem Bild von den Modulen des Geistes sind wir zwar nicht einverstanden – es ist für unseren Geschmack zu starr –, aber Mithens verblüffendes Evolutionsszenario ist das Kernstück einer Theorie, die das Wachstum der zwischenmenschlichen Bindungen, an die unsere Kognition hervorragend angepasst ist, in den Vordergrund stellt.

Nach ganz ähnlichen Prinzipien entwickelten der Archäologe Thomas Wynn und der Psychologe Frederick Coolidge auch ein Modell des Geistes von Neandertalern. Sie gehen nicht von Modulen aus, sondern betonen die Bedeutung des Kurz- und Langzeitgedächtnisses. In ihrem 2011 erschienenen Buch *How to Think Like a Neanderthal* erörtern sie ein breites Spektrum verschiedener Themen, darunter Witze, Träume und Charakter der Neandertaler, und stellen auf dieser Grundlage die vorgefassten Meinungen über die unbeholfenen Homininen mit ihrem großen Gehirn infrage.

Das verbindende Element zwischen diesen beiden wichtigen Büchern ist nach unserer Auffassung ihr Ausgangspunkt: der cartesianische rationale Geist. Dieses Modell ist von grundle-

gender Bedeutung, aber wir sind uns natürlich auch der emotionalen Grundlagen für das Verhalten der Menschen bewusst (s. Kap. 2); außerdem ist in unseren Augen eine Eigenschaft wichtig, die stärker mit Beziehungen zu tun hat: die in der Kognition der Menschen so herausragende Fähigkeit, Assoziationen zwischen Menschen und Dingen herzustellen. Damit reißen wir die Schranke zwischen dem Geist „hier drinnen" und der Welt „da draußen" nieder. Mit der Vorstellung von einem erweiterten Geist müssen wir unsere Definition für das, was wir als Geist einstufen, verändern. Er ist nicht mehr nur die graue Substanz in unserem Schädel, sondern er erstreckt sich über unsere Haut hinaus und schließt die Dinge, mit denen wir in Wechselbeziehung treten, sowie die Umwelt um uns herum ein. Diese Umwelt kann als von uns aufgebaute Nische unser eigenes Produkt sein. Die Tassen, aus denen wir trinken, sind ebenso unser Geist wie der Stuhl, auf den wir uns setzen, oder die Neuronen, die in unserem Gehirn ihre Impulse abgeben, wenn wir solche Tätigkeiten ausführen. Geist heißt nicht nur, dass wir in unserem Umgang mit anderen rational sind, sondern auch, dass wir Bindungen in einem wirklich sozialen Sinn herstellen. Deshalb finden wir unsere soziale Kognition nicht nur im präfrontalen Cortex und in den Schläfenlappen, wo Erinnerungen und Informationen über andere gespeichert werden. Sie findet sich auch in der Ansammlung von Artefakten, ihrer Form, ihrer Konsistenz, ihrem Geschmack und Geruch. So betrachtet, verteilt sich unsere soziale Kognition in der Welt, in der wir leben; sie ist ein grundlegender Bestandteil der Nische, die wir aufgebaut haben.

Über eine solche dezentrale Kognition verfügen auch andere Tiere. Wir sind jedoch auch in der Lage, unser Ich und unsere Fähigkeiten, unser Handeln in der Welt zu erweitern; dies tun wir durch die Dinge, die wir herstellen, kaufen, tauschen, behalten, schätzen oder wegwerfen. Das alles lässt auf eine sehr subtile Intelligenz schließen, die unser intensives Sozialleben sowohl widerspiegelt als auch aus ihm erwächst. Was die Geschichte eines solchen sozialen Gehirns angeht, lautet die große Frage: In welchem Umfang verfügten auch einige unserer Vorfahren oder alle über die gleiche Fähigkeit, die Chancen eines erweiterten Geistes zu nutzen und immer komplexere soziale Arran-

gements zu schaffen? Eine davon bestand darin, die Fesseln eines von Angesicht zu Angesicht ablaufenden Soziallebens abzuschütteln. Von der Notwendigkeit des unmittelbaren Kontakts befreit, führten die Homininen jetzt ein soziales Leben, indem sie aneinander dachten, wenn sie getrennt waren, und sich bei dem, was sie taten, von den Gedanken an das leiten ließen, was andere möglicherweise von ihnen hielten. Als Folge können wir beobachten, dass die frühen Homininen mindestens seit der Zeit vor 2 Mio. Jahren in einem weitaus größeren zeitlichen und räumlichen Rahmen agierten als ihre Vettern, die Menschenaffen. Waren das die Anfänge des modernen Geistes?

Damit Werkzeuge uns einen solchen Nutzen verschaffen können, brauchen sie nicht sehr hoch entwickelt zu sein. Die ältesten Artefakte waren einfache Steinsplitter, die von Kernsteinen abgeschlagen wurden, aber sie wurden mit einer souveränen Einheitlichkeit hergestellt, die auf Übung und Geschicklichkeit schließen lässt. Insgesamt stellen die Werkzeuge neben den Homininen selbst und ihrer Umwelt ein neues Gebiet für unsere Untersuchungen dar. Bisher wurden alle Werkzeuge, die älter als 2 Mio. Jahre sind, genau wie sämtliche Australopithecinen ausschließlich in Afrika gefunden. Üblicherweise werden die Werkzeuge alle einer einzigen Tradition zugeordnet, dem Oldowan, das nach der Olduvaischlucht in Tansania benannt ist. Dort beschrieb Mary Leakey (s. Abb. 4.3) erstmals die Werkzeuge aus großen Fundstätten, die sich nahe am unteren Ende der Schlucht befinden und auf ein Alter von 1,8 Mio. Jahren datiert wurden. Die spätere Erkundung brachte ähnliche Werkzeuge auch an einer Reihe anderer Stellen im Rifttal

von Äthiopien bis hinunter nach Malawi ans Licht, und man kennt sie auch aus mehreren südafrikanischen Höhlenfundstätten.

Die Prinzipien, nach denen sie benutzt wurden, veranlassten den Archäologen Glynn Isaac dazu, die Werkzeugmacher als „die ersten Geologen" zu bezeichnen. Schon aus den ältesten Fundstätten kann man schließen, dass sie genau wussten, wo man das am besten geeignete Gestein findet. Zu solchen Stellen wanderten sie regelmäßig, wobei es sich anfangs um Entfernungen von 3 bis 5 km handelte. Henry Bunn konnte solche Aktivitäten auf die Ostseite des Turkanasees zurückverfolgen; Rob Blumenschine und Kollegen gelang das gleiche am Olduvaisee. Dabei fällt auf, dass verschiedene Materialien oft unterschiedlich verteilt sind. Die Homininen waren auch höchst wählerisch: Sie transportierten nur Steine, die sich am besten zum Zerschlagen eigneten. Die archäologischen Fundstätten sind in der Regel Brennpunkte einer Aktivität, die über einen begrenzten Zeitraum von vielleicht einigen Tagen oder Wochen stattfand. Nick Toth und Kathy Schick konnten aber mit ihren Untersuchungen zeigen, dass solche Stellen immer zu einem größeren Netzwerk gehörten – jede von ihnen erforschte Oldowan-Fundstätte lässt Spuren des Imports wie auch des Exports von Steinen erkennen. Ganz grob kann man von der Vermutung ausgehen, dass die Homininen zunächst an der Stelle arbeiteten, an der sie die Rohstoffe gefunden hatten – das verhinderte, dass Material transportiert werden musste, das für Werkzeuge nutzlos war. Dann trugen sie das nützliche Material an eine günstige Stelle oder einen Arbeitsplatz, wo sie die fertigen

Werkzeuge herstellten, die anschließend zur Benutzung weggebracht wurden.

Das alles sind unentbehrliche Informationen über das soziale Leben – über die Entfernungen, die die Homininen zurücklegten, und über den Umfang ihrer Tätigkeiten. Was dabei von Anfang an entscheidend war: Ihr Aktionsradius war weitaus größer als die Reviere von Menschenaffen. Ebenso klar ist, dass es sich nicht um Tätigkeiten von Einzelnen handelt, denn in manchen Fällen wurden verblüffend große Gesteinsmengen bewegt. Es war kollektive, von gemeinsamen Absichten getragene Arbeit, die uns auch gewisse Rückschlüsse über die Größe der Gemeinschaften ermöglicht. Unbestreitbar ist, dass nicht nur das Tragen eines größeren Gehirns, sondern auch das Tragen von Steinen eine energieaufwendige Aktivität ist, die sich auszahlen musste. Die Werkzeuge müssen den Weg zu neuen Nahrungsquellen eröffnet haben, so unter anderem zu Fleisch, Wurzeln und Knollen. Außerdem erleichterten Steinwerkzeuge die Herstellung weiterer Werkzeuge – beispielsweise spitzerer Stöcke zur Selbstverteidigung oder zum Graben.

Hinreichend viele Belege sprechen dafür, dass ein ganzes Spektrum verschiedener Tätigkeiten ausgeführt wurde. In der Regel bevorzugten die Homininen kompaktes Material wie Basalt für schwere Werkzeuge und feinkörnige, glatte Rohstoffe wie Flintstein für scharfe Schneidkanten. Einige Fundstätten im Olduvaibett I weisen diese Kombination auf, die wir auch an Fundstätten in Israel aus viel späterer Zeit finden.

Die Fragen nach dem Wann und Was lassen sich im Zusammenhang mit den Steinwerkzeugen relativ leicht beantworten. Viel schwieriger ist die Frage, wer sie herstellte. Die ältesten Steinwerkzeuge hat man in den meisten Fällen nicht in Verbindung mit irgendwelchen fossilen Überresten gefunden. Und wenn das der Fall ist, wie in den untersten Schichten der Olduvaischlucht, muss man auch die Prozesse der Ablagerung, Verschiebung und Bewegung durch fließendes Wasser und andere natürliche Ursachen in Rechnung stellen. Berühmt ist das Bett I, in dem Louis Leakey den ersten Schädel eines robusten, damals als *Zinjanthropus boisei* bezeichneten Australopithecinen fand; nur zwei Jahre später kam dort ein graziler Hominine aus der gleichen Schicht ans Licht, dem man den Namen *Homo habilis* gab. Zinjs kurzfristiger Ruhm als Hersteller von Steinwerkzeugen wurde durch die Entdeckung des „geschickten Menschen" in den Schatten gestellt, aber das hatte weniger mit den Funden zu tun als vielmehr mit der Annahme, *Homo* müsse der Werkzeughersteller sein: „man the toolmaker" nannte ihn der Paläoanthropologe Kenneth Oakley in seinem einflussreichen, 1949 erschienenen kleinen Buch mit dem gleichen Titel, das bis 1972 nicht weniger als 6 Auflagen erlebte, ohne dass seine zentrale Aussage sich geändert hätte. Mittlerweile hatte aber *Homo habilis*, der vermutlich tatsächlich Werkzeuge benutzte, in den Augen mancher Paläoanthropologen seine Stellung als Mitglied der Gattung *Homo* verloren, und man ordnete ihn stattdessen bei den Australopithecinen ein.

Ehrlicherweise muss man sagen, dass wir es nicht wissen. Seit Oakleys Buch sind viele Fälle ans Licht gekommen, in denen Werkzeuge von nichtmenschlichen Wesen hergestellt wurden; deshalb haben wir unter dem Strich den starken Verdacht, dass Werkzeuge in unterschiedlicher Form nicht nur von Homininenarten mit kleinem Gehirn wie *habilis, africanus* und *robustus* hergestellt wurden, sondern vielleicht zur gleichen Zeit in unterschiedlichem Ausmaß auch von Populationen, die in verschiedenen Teilen Afrikas zu Hause waren. Eines ist jedenfalls klar: Die 2,6 Mio. Jahre alten Steinwerkzeuge von Gona sind ein ganzes Stück älter als die ersten Anhaltspunkte, die auf die ältesten Formen von *Homo* hindeuten. Auf das Thema werden wir in Kap. 5 zurückkommen, wenn wir uns die Neuerungen des Feuers und der Faustkeile ansehen.

Die Vorteile der Werkzeuge

Die ersten Werkzeuge können wir zusammenfassend mit zwei Beobachtungen und einer Frage beschreiben:

- Sie lösten Probleme.
- Sie vermittelten Ideen.
- Waren sie bewusst gestaltet?

Die Frage hört sich auf den ersten Blick trivial an, ist aber von grundlegender Bedeutung. In jedem Werkzeug fließen zwangsläufig Konzepte zusammen, und der Begriff der Konzepte steht im Mittelpunkt aller unserer Kommunika-

tionsnetzwerke und zwischenmenschlichen Beziehungen. Wenn man in einem Werkzeug ein Geflecht von Eigenschaften sehen kann, die es ausmachen, ist es eine kleine *Welt*, in der diese Eigenschaften Form annehmen – ganz ähnlich wie unser Netzwerk der Kontakte ein größeres Netz ist, ein Hilfsmittel zum sozialen Überleben. Schon ein einfaches Steinwerkzeug muss eine funktionierende Kante mit bestimmten Eigenschaften gehabt haben; es muss ausreichend groß gewesen sein, sodass man es festhalten konnte, und es musste eine geeignete Masse haben. Reicht das aus, um von „Gestaltung" zu sprechen? Leichter lässt sich diese Ansicht im Zusammenhang mit späteren Zeiten vertreten, als die Werkzeuge höher entwickelt waren; von seinem Wesen her ist aber jedes Werkzeug eine kleine Welt innerhalb der großen Welt, und in unserem Umgang mit beiden gibt es Parallelen. Ein Werkzeug verschafft uns die Möglichkeit, unsere Aufmerksamkeit auf Details zu richten und etwas zu studieren, dessen Herstellung vielleicht fünf oder zehn Minuten gedauert hat, das aber die Technologie der Homininen während einer halben Million Jahre repräsentiert. Und wenn wir unsere Aufmerksamkeit darauf richten, mit welcher Aufmerksamkeit die Homininen ihre Aufgabe bewältigten, wird das Ganze zu einer zutiefst sozialen Technologie. Damit meinen wir etwas, das seine Bedeutung aus banalen Akten der Beobachtung, der sozialen Interaktionen und des Lernens bezieht. Und wie wir im Zusammenhang mit der Konstruktion von Nischen bereits erfahren haben, können wir das Werkzeug nicht von dem Homininen trennen, der es hergestellt hat. Die Steinwerkzeuge des Oldowan waren ein Teil der dezentralen Kognition ihrer Hersteller (s.

Kasten „Die Arten des Geistes") und gehörten genauso zu ihrem Geist wie die Neuronen in ihrem Gehirn. Aus diesem Grund bezeichnete der Anthropologe Leslie A. White die Steinwerkzeuge als „symbolträchtig": Jedes Mal, wenn wir eines sehen, treten wir nicht nur zu dem Gegenstand in Beziehung, sondern auch zu seiner weiter gefassten Bedeutung. Wenn wir also Recht haben mit unserer Ansicht, dass das Sozialleben die Erweiterung unseres Gehirns vorantrieb, müssen wir auch anerkennen, dass die Technologie und die Welt, die alle Homininen umgab und in der sie sich zurechtfinden mussten, ebenfalls sozial bedingt sind.

Technologischer Wandel

Wenn wir den technologischen Wandel und seine Triebkräfte einschätzen wollen, können wir auch fragen, an welcher Stelle das soziale Gehirn ins Spiel kommt. Eine einfache Erklärung für die Entstehung der von früheren Generationen genutzten Technologie würde lauten: Es zahlte sich aus, schlauer zu sein, sodass man die Technologie entwickeln und nutzen und sich Ressourcen verschaffen konnte. Wenn dazu ein größeres Gehirn erforderlich war, wurde es begünstigt, und der Selektionsdruck sorgte dafür, dass es sich entwickelte. Mittlerweile können wir aber erkennen, dass diese Erklärung für die Triebkraft der Technologie zu einfach ist. Die meisten Menschen bedienen sich während des größten Teils ihrer Zeit nicht aktiv technischer Mittel, und deshalb sollte dies nicht übermäßig viel Gehirnleistung erfordern. In den Bevölkerungsgruppen unserer Zeit gibt es große Unterschiede: Die einen verfügen über gewaltige

Mengen an Technologie, die anderen über sehr wenig; dies scheint aber keine Auswirkungen auf die Leistungsfähigkeit des Gehirns oder die Intelligenz zu haben. Selbst ein Schimpanse kann nicht nur selbst Werkzeuge herstellen, sondern auch viele von Menschen gemachte Werkzeuge sehr effizient nutzen und sich dies häufig selbst beibringen.

Im Gegensatz zu einem technischen Szenario sagt die Hypothese vom sozialen Gehirn voraus, dass jede Zunahme der Gehirngröße in einer Homininenpopulation von sozialen Faktoren angetrieben wird. Eine einfache Erklärung für die Vorgänge im Zusammenhang mit der Entstehung der Gattung *Homo* (und auch der Technologie) lautet: Die Homininen mussten in einer offeneren Landschaft leben, und dazu mussten sie in größeren Gruppen, über größere Entfernungen und über längere Zeiträume hinweg tätig werden – und zur Organisation von alledem brauchten sie ein größeres Gehirn, ganz zu schweigen von der sozialen Notwendigkeit, getrennt zu leben und dennoch in Kontakt zu bleiben. Den eindeutigsten Hinweis auf die Größenordnung der Bewegungen liefern die Transportwege der Steinwerkzeuge. Oldowan-Werkzeuge wurden nur in seltenen Fällen aus Steinen hergestellt, die man über mehr als fünf Kilometer herantransportiert hatte; dennoch sieht es so aus, als seien sie ausgewählt worden, weil sie sich besonders gut abschlagen lassen. Im späteren Acheuléen verdreifachen sich die Entfernungen, und in einigen Fällen ist zu erkennen, dass die Steine über viel größere Entfernungen transportiert wurden. Auch hier lassen die Homininen, die Faustkeile herstellten, eine Vorliebe für ganz bestimmte Ausgangsmaterialien erkennen. Dora Moutsiou, die als Forschungsstudentin am Lucy-Projekt mitarbeitete, konnte

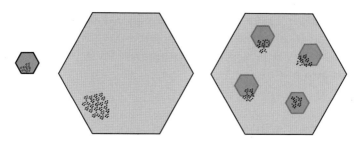

Abb. 4.6 *Links*: Schimpansen besetzen in der Regel kleine Reviere, in denen die Gemeinschaft sich aufgrund stimmlicher Kommunikation versammeln oder in Kontakt bleiben kann. *Mitte*: In den viel größeren Territorien der Homininen erlaubten es die Nahrungsquellen nur selten, dass die Gemeinschaft auf diese Weise zusammenfand. Vielmehr neigte sie dazu, sich in Horden zu unterteilen, die flexibel organisiert waren und sich häufig rund um Wasserlöcher und in Regionen mit reichhaltigerem Nahrungsangebot konzentrierten (*rechts*). (© John Gowlett)

in ihren Untersuchungen am Obsidian zeigen, dass dieses vulkanische Glas in Ostafrika im späten Acheuléen von seiner Abbaustelle über durchschnittlich 45 km transportiert wurde, und von Gadeb in Äthiopien sind aus der Zeit vor einer Million Jahren sogar maximale Entfernungen von hundert Kilometern bekannt. Ohne weitere Funde können wir aber über die Fragen des Warenaustauschs, von denen später noch genauer die Rede sein wird, bisher nichts Genaues sagen.

An diesen Entfernungen ist eindeutig zu erkennen, dass die Aufspaltung und Verschmelzung von Gruppen (s. Abb. 4.6), wie sie unter anderem durch Kollegen wie Filippo Aureli beschrieben wurden, in erweitertem Maßstab stattfanden. Von ihrem ersten Auftauchen in Ostafrika an weisen die Steinwerkzeuge auf systematische Bewegun-

gen über mehrere Kilometer hin, und indirekt dürften sie uns auch Aufschlüsse über viele weitere Wanderungen und Interaktionen liefern, die wir nicht unmittelbar beobachten können.

Gemeinsame Absichten

Menschen werden gemeinsam tätig, und deshalb kann die Größe archäologischer Fundstätten wichtige Aufschlüsse liefern. Schon zur Zeit des Oldowan waren manche Orte so attraktiv, dass die Homininen dort über lange Zeit hinweg eine große Zahl von Werkzeugen benutzten und wegwarfen. In der Olduvaischlucht kommen Werkzeuge manchmal in vielen aufeinanderfolgenden Schichtungen vor. Die Menschen kehrten sehr oft immer wieder dorthin zurück. Die aufschlussreichsten Fundstätten sind kleiner und bestehen häufig aus einem Geländestück mit einem Durchmesser von fünf oder zehn Metern. Ein besonders eindeutiges Beispiel untersuchte Helene Roche an der rund 2,3 Mio. Jahre alten Fundstätte Lokalalei in West Turkana. Manche derartigen Fundstätten enthalten Knochensplitter und Hinweise auf Werkzeugherstellung. Das Ausgangsmaterial besteht häufig aus 60 oder 70 Kernsteinen, von denen jeder vielleicht so groß ist wie eine Faust. Da ein Individuum ohne Mühe nur zwei oder drei solche Steine gleichzeitig tragen konnte (es sei denn, es gab bereits Taschen, von denen wir nicht wissen), sieht es so aus, als seien selbst diese kleinen Fundstätten die Produkte von Gruppen aus mehreren Individuen, die vielleicht ihr Material im Rahmen mehrerer einzelner Wanderungen dorthin brachten. Solche

Belege tauchen immer wieder genau in der Zeit auf, in der sich auch das größere Gehirn entwickelte.

Von Anfang an finden wir in den archäologischen Fundstätten auch Tierknochen. Selbst an den ältesten Stätten in Äthiopien wurden neben den Werkzeugen auch Knochenfragmente entdeckt, und das gleiche Prinzip setzt sich durch das gesamte Pleistozän hindurch fort. Dennoch muss man von einer Verzerrung ausgehen: Die Knochen kleiner Tiere zerfallen leichter, und auch oberhalb des Erdbodens bleiben Knochen nur begrenzte Zeit erhalten; je häufiger und länger eine Stelle genutzt wurde, desto unwahrscheinlicher ist es also, dass sie erhalten geblieben sind. Zwar machen auch manche anderen Primaten Jagd auf kleine Tiere, die scharfen Kanten der Werkzeuge weisen aber eindeutig darauf hin, dass die Homininen ein weitaus größeres Interesse an Fleisch hatten; auch dass man ganz allgemein Steine und Knochen gemeinsam findet, ist sehr auffällig. An den Knochen haben sich häufig Schnittspuren erhalten, die von Steinen stammen. Besonders bemerkenswert ist, dass man in vielen Fällen Artefakte gefunden hat, die rund um eine einzelne Karkasse verstreut waren – meist um ein großes Säugetier, beispielsweise einen Elefanten oder ein Flusspferd. Archäologen wissen schon seit langem um die Gefahr, dass die Knochen eines auf natürlichem Wege gestorbenen Tiers im natürlichen Umfeld durch Zufall mit Werkzeugen in Verbindung geraten sind. Aber in mehreren Fällen, die sich auf ganz Afrika verteilen, zeigt sich immer wieder das gleiche Bild: Die Menschen zerlegten mit Steinwerkzeugen einen einzelnen, häufig sehr großen Kadaver; ein besonders deutliches Beispiel ist das Elefantenskelett aus Barogali im Nordosten Afrikas, das auf ein Alter von 1,6 bis 1,3 Mio. Jahren datiert wurde.

Nach wie vor nicht geklärt ist die Frage, in welchem Umfang die Homininen auf die Jagd gingen, statt nur Aas zu verwerten. Das Thema wird, wie wir in Kap. 6 noch genauer erfahren werden, seit mehr als 30 Jahren diskutiert. Dass während der letzten 500.000 Jahre gejagt wurde, kann kaum bezweifelt werden: Dies wird durch hölzerne Speere und die schiere Anhäufung von Knochen belegt. Was aber die frühere Zeit angeht, so ist nur schwer zu erkennen, wie kleine und mit einem kleinen Gehirn ausgestattete Homininen etwas leisten konnten, was selbst modernen Jägern und Sammlern manchmal schwerfällt.

Vielleicht lässt sich das Problem umgehen: Auch Schimpansen jagen mit Sicherheit kleine und junge Tiere, und aus Kanam in Kenia kennt man Anhaltspunkte, wonach auch die frühen Homininen manchmal kleine Tiere bevorzugten. Gemeinsame Jagd ist bei Schimpansen belegt, und auf eine ähnliche Zusammenarbeit und „gemeinsame Absicht" kann man aufgrund der Anhäufung von Werkzeugen und der Strecken, über die Material durch die Landschaft getragen wurde, auch für die Homininen schließen. Die unentbehrliche Kooperation ist daran sogar deutlicher zu erkennen als die Jagd als solche (s. Abb. 4.7).

Warum das alles nicht einfach ist: Probleme der Erkennbarkeit

Sieht man einmal von den allgegenwärtigen Steinen ab, so ist es eine ernüchternde Erkenntnis, dass die meisten anderen technischen Entwicklungen nicht in Form archäologischer

Abb. 4.7 Irgendwann lernte der frühe *Homo*, Jagd auf Großtiere zu machen. Mit Schlauheit die natürlichen Abwehrmechanismen zu überwinden, die Tiere wie diese Blessböcke ständig wachsam sein lassen, ist im Wesentlichen ein soziales Unterfangen. (© John Gowlett)

Funde aus dem Paläolithikum überlebt haben. Ein Musterbeispiel für dieses Verschwinden ist die Beherrschung des Feuers, aber andere Materialien verschwanden fast ebenso erfolgreich. Da die meisten Werkzeuge von Menschenaffen aus weichem Material bestehen – aus Steinen oder Blättern –, kann man mit Fug und Recht annehmen, dass auch die Homininen ähnliche Gerätschaften in ihr Repertoire aufnahmen. Nach Feststellungen von Adrian Kortlandt bearbeiten Schimpansen einen ausgestopften Leoparden mit einem Stock (und nach Ansicht von Bill McGrew ist der Gebrauch von Waffen durch Schimpansen gut belegt, wenn

auch wenig bekannt). Robin Crompton konnte zeigen, dass
moderne Menschen dazu ausgestattet sind, in jeder Hand
eine kleine Last von ungefähr einem halben Kilo zu tragen.
Man kann sich deshalb nur schwer vorstellen, dass keine
Werkzeuge aus Holz benutzt wurden, aber es besteht nur
eine ungeheuer geringe Chance, dass sie erhalten bleiben.
Dennoch kennt man entgegen aller Wahrscheinlichkeit
drei Fälle: Hölzerne Werkzeuge, die 700.000 Jahren alt
sind, kennt man aus Israel, 400.000 Jahre alte aus Südaf-
rika und Deutschland. Diese Objekte wurden von Homi-
ninen mit großem Gehirn hergestellt, aber wahrscheinlich
reicht die Benutzung hölzerner Werkzeuge ein ganzes Stück
weiter in die Vergangenheit zurück. Lucys langer Daumen
beispielsweise hätte sich gut dazu geeignet, einen hölzernen
Stab zu greifen.

Die Archäologie verfügt aber nicht über die magische
Fähigkeit, ein Regelwerk für den Rückschluss auf Objekte
und Tätigkeiten zu schreiben, die wir nicht entdeckt haben.
Sie kann nur Hypothesen aufstellen, deren Überprüfung
realistisch erscheint und im Idealfall zu Beginn ihre Gren-
zen aufzeigt. Ein gutes Beispiel sind Werkzeuge aus Kno-
chen: Aus der Olduvaischlucht kennt man einen Knochen-
faustkeil, zahlreiche weitere hat man in Italien gefunden.
Wir wissen also, dass Knochenwerkzeuge vor mehr als einer
halben Million Jahren hergestellt wurden, und wir können
vermuten, dass es sie auch bereits vor 2,6 Mio. Jahren gab,
weil man aus dieser Zeit die ersten Knochentrümmer zu-
sammen mit Steinwerkzeugen gefunden hat. Wenn wir also
herausfinden wollen, wann das erste Knochenwerkzeug
hergestellt wurde, bleibt uns ein breiter Unsicherheitsspiel-

raum, der von ungefähr 2,6 bis 0,8 Mio. Jahren reicht. Ein derart langer Zeitraum ist in der Evolutionsforschung stets Anlass zu Kontroversen, und wir müssen immer vorsichtig sein, damit wir Belege nicht überinterpretieren (Abb. 4.8).

Eines ist allerdings sicher: Die frühen Homininen machten unter dem Einfluss eines starken Selektionsdrucks einen tief greifenden biologischen Wandel durch. Die Menschenaffen haben sich zwar in den letzten rund 7 Mio. Jahren ebenfalls verändert, bei unseren Vorfahren war der Wandel aber viel stärker – das ist der Grund, warum wir keine Menschenaffen mehr sind. Evolution verläuft nicht zwangsläufig nur in einer einzigen Richtung. Die sehr großen Zähne aus der Zeit vor 2 bis 3 Mio. Jahren zeigen, welcher Druck von den Notwendigkeiten der Ernährung ausging. In späteren Zeiten zahlte sich ein großes Gehirn mehr aus als große Zähne. Neben diesen offenkundigen Eigenschaften waren mit Sicherheit auch die Sozialstrukturen und das Verhalten der Homininen betroffen. Seit der Zeit vor 2 Mio. Jahren können wir mit Sicherheit davon ausgehen, dass der „Wind der Veränderung" wehte: Geographische Verteilung, Werkzeuge und Gehirn deuten zweifelsfrei auf den Erfolg der Homininen hin. Vielleicht ist es bemerkenswert, dass die Geselligkeit der ersten Homininen von Ardi bis zu den Australopithecinen kein größeres Gehirn erforderte. Aufgrund der Erkenntnisse über das soziale Gehirn können wir den Schluss ziehen, dass sich bis zu jener Zeit bereits biologische und soziale Wandlungen abgespielt hatten, ohne dass sich Populationsstruktur und Gemeinschaftsgröße grundlegend verändert hätten. Dann aber wurde das große Gehirn unter anhaltendem Druck zu einer teuren Notwendigkeit.

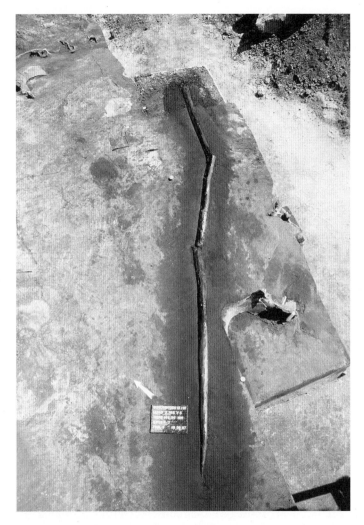

Abb. 4.8 Rund 300.000 Jahre alte hölzerne Speere, gefunden in Schöningen in Deutschland. Die Funde repräsentieren einen der seltenen Fälle, in denen Holz erhalten geblieben ist, die Technologie muss aber allgemein verbreitet gewesen sein. Die Funde erinnern uns daran, wie bruchstückhaft die archäologischen Ausgrabungen sind. (Mit freundlicher Genehmigung von Peter Pfarr, © Landesamt für Kultur und Denkmalpflege Niedersachsen)

Zusammenfassung

In diesem Kapitel haben wir uns mit einigen nicht greifbaren Aspekten der menschlichen Evolution beschäftigt, nämlich mit Gruppengröße und Sozialstruktur; außerdem haben wir die greifbaren fossilen Schädel und Steinwerkzeuge beschrieben. Zu den ersten Aspekten kommt durch die Hypothese vom sozialen Gehirn eine Sichtweise hinzu, die man aus den handfesten Knochen- und Steinfunden nicht ableiten kann. Wie im Weiteren noch deutlich wird, haben wir unsere Trickkiste bisher nicht vollständig geöffnet. Vorerst haben wir vorwiegend vergleichende Untersuchungen an der entfernten Vergangenheit unseres Soziallebens angestellt, indem wir auf Studien an heute lebenden Primaten zurückgegriffen und sie auf Fossilien übertragen haben. Dagegen wurden die Theorie des Geistes, die Grade der Intentionalität oder die Verstärkung des Soziallebens mithilfe der zentralen Ressourcen von Material und Sinneswahrnehmungen (s. Abb. 3.2) noch nicht erwähnt. Dafür gibt es einen stichhaltigen Grund. In dem Zeitraum, von dem in diesem Kapitel die Rede war, überschritt die Gehirngröße der ersten Homininen zwar die durch Menschenaffen und Ardi definierte Schwelle von 400 Kubikzentimetern, es handelte sich aber immer noch um Homininen mit kleinem Gehirn. Ihr Sozialleben war komplizierter als bei den Formen mit weniger als 400 Kubikzentimetern, aber im Vergleich zu dem, was später kam, hatte die Reise gerade erst begonnen. Was wir bisher gesehen haben, waren die Folgen des aufrechten Ganges, die Notwendigkeiten der Verteidigung gegen natürliche Feinde, die Auswirkungen der Ernährung auf die Größenverminderung des Darmes

und die Experimente mit sozialem Lernen, die auf die Herstellung und den Gebrauch von Gegenständen angewandt wurden. Nachdem wir dieses Fundament gelegt haben, können wir uns nun den Belegen für drei zentrale Veränderungen zuwenden, die das Sozialleben erweiterten, das gegenseitige Kraulen zu etwas Neuem machten und technische Veränderungen einleiteten.

5

Die Nische der Menschen wird aufgebaut: drei entscheidende Fähigkeiten

Kenne dich selbst und kenne deinen Platz

Was macht uns eigentlich zu Menschen? Wenn man die Evolution des Menschen erforschen will, besteht eines der größten Probleme darin, dass *wir uns selbst* definieren. Vor rund 300 Jahren taufte uns Carl von Linné, der große schwedische Klassifikator der Tiere und Pflanzen, auf den Namen *Homo sapiens*, der kluge Mensch. Und er schrieb auch: *„Homo. Nosce te ipsum"* („Mensch. Kenne dich selbst"). Damit griff er einen altgriechischen Wahlspruch auf, gab ihm aber einen neuen Dreh: Wir sollten uns als Spezies kennenlernen. Wissenschaftlich betrachtet, sind wir Richter und Geschworene, die darüber entscheiden, wer

zum Club der Menschen gehört und wer nicht – in der Natur findet man eine solche Entscheidung nicht, sondern sie erwächst aus dem Ballast kultureller Vorurteile und historischer Interpretationen. Archäologen müssen irgendwie entscheiden, wo sie bei unseren Homininenvorfahren die Grenze ziehen. In der Regel erstellen sie dazu Listen mit Kriterien wie Schmuck und Kunst, aber auch Tätigkeiten wie Jagd und Religion. Dabei stellt sich nur das Problem, dass wir für die ferne Vergangenheit nur über sehr kurze Listen von Merkmalen verfügen, die wir überprüfen können. Und da wir keinen unabhängigen Gerichtshof haben, der unsere Behauptungen beurteilen könnte, ist es kaum verwunderlich, dass keine Einigkeit darüber besteht, was uns im Einzelnen zu Menschen macht, ganz zu schweigen von der Frage, wann solche Eigenschaften zum ersten Mal auftraten.

In diesem Kapitel befassen wir uns mit drei Schlüsselelementen, die auf allen Listen stehen: mit den charakteristischen Steinwerkzeugen, die als Faustkeile bezeichnet werden, sowie mit Feuer und Sprache (wobei wir lustigerweise mit dem Lachen beginnen). Wir haben sie aus gutem Grund ausgewählt. Auf einer Zeitreise führen sie uns von Vorfahren mit kleinem zu solchen mit großem Gehirn, und alle tauchten auf – oder scheinen aufzutauchen –, als *Homo*, zumindest in Afrika, noch nicht allein war, weil auch die robusten Australopithecinen noch lebten (s. Abb. 5.1). Die drei Elemente stellen uns vor ganz unterschiedliche Herausforderungen: Faustkeile kann man mit Sicherheit finden; Feuer findet man, wenn man viel Glück hat; die Sprache aber ist unwiderruflich verschwunden – auf sie kann man nur aus anatomischen Merkmalen oder Symbolen schlie-

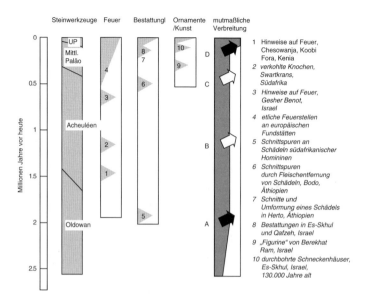

Abb. 5.1 Die wichtigsten Unterteilungen und Ereignisse im zeitlichen Ablauf des Pleistozän. Folgende Verbreitungsprozesse werden postuliert **a** erste dünne Verbreitung über Eurasien, **b** erste Einwanderung in Europa, **c** mögliche Wanderungsbewegungen von *Homo heidelbergensis*, **d** Ausbreitung der anatomisch modernen Menschen. (Nach © Gowlett et al. 2012; Abb. 4)

ßen. Alle aber stehen im Mittelpunkt von Fähigkeiten, die sich bis heute erhalten haben und deren Evolution weitergeht. Mithilfe des Feuers konnten Homininen die verschiedensten Materialien bearbeiten, ob sie nun Fleisch brieten oder Speerspitzen härteten; außerdem veränderte es die Stimmung der Orte und Tageszeiten, zu denen Menschen sich versammelten, womit es Interaktionen förderte. Durch die Sprache wuchs die Fähigkeit, zuzuhören und zu kommunizieren, womit sich die Grundlagen des Sozial-

lebens weiter wandelten. Eine entscheidende Rolle spielte
das Sprechen auch für die Entwicklung der Fähigkeit zur
Mentalisierung, mit der wir die Gedanken anderer lesen
und ihre Handlungen voraussehen können. Und Faust-
keile, die auch dann noch tapfer überdauern, wenn alles
andere verschwunden ist, offenbaren dem Archäologen viel
mehr als nur die Fähigkeit, zweiseitig abgeschlagene Steine
herzustellen – sie sind ein Hinweis auf ein Maß von Auf-
merksamkeit, Konzentration und Präzision, wie man es bei
keinem anderen Tier, das Werkzeuge herstellt, findet.

Alle drei Elemente und die Fähigkeiten, die wir aus ihrer
Entstehung ableiten können, werfen Licht auf die Evolu-
tion der Nische, die sich in dem langen, aber entscheiden-
den Zeitraum vor 2 bis 0,5 Mio. Jahren für die Homininen
entwickelte. Aus Sicht unseres sozialen Gehirns war die
Evolution dieser Fähigkeiten auf die Selektion zugunsten
immer vielschichtigerer, komplexerer sozialer Welten zu-
rückzuführen: auf die unterschiedliche Größe der sozialen
Welt eines Primaten und unseres mehr als doppelt so gro-
ßen sozialen Umfeldes mit der Dunbar-Zahl von 150. Da
die Homininen sich ihre Lebensnische und ihre soziale Ge-
meinschaft immer komplexer gestalteten, hängen alle drei
Elemente nach unserer Überzeugung eng zusammen – es
bestand eine Verbindung zwischen der Evolution von Ge-
hirn, Körper, materiellem Umfeld und weiterer Umgebung.
Vor rund einer Million Jahren hatte sich dann eine höchst
charakteristische Nische entwickelt, in der sich während der
nächsten halben Million Jahre die Entwicklung von Homi-
ninen mit großem Gehirn und komplexen Fähigkeiten ab-
spielte (s. Kap. 6). Und da unser Sozialleben der Faktor war,
der das Wachstum unseres Gehirns und den Gebrauch der

Materialien aus unserer Umgebung vorantrieb, halten wir diese Fortschritte für Beispiele einer sozialen Technologie. Ja, mit Faustkeilen konnte man gut Tierkadaver zerschneiden, und das Feuer hielt die Menschen warm; hinter diesen offenkundigen Funktionen lag aber eine tiefere Evolutionstriebkraft: Man lernte andere kennen und wusste damit auch besser, wie man das soziale Spiel spielt, das auf lange Sicht zum Evolutionserfolg führte.

In diesem Kapitel wollen wir die Anfänge des Weges von den Homininen zum Menschen bis hin zum Abschluss von Schritt 6 auf der Zeittafel in Tab. 1.2 nachzeichnen. Es ist die Geschichte von Homininen mit großem Gehirn, auch wenn die Australopithecinen mit ihrem kleineren Gehirn in Afrika noch bis vor 1,3 Mio. Jahren lebten. Die wichtigste Spezies ist *Homo erectus*, der in der Alten Welt erstaunlich weit verbreitet war (s. Kasten „Eine Brücke zwischen den Gehirnen"). Am Ende von Schritt 6 finden wir *Homo heidelbergensis* überall in Afrika und Europa; damit ist die Bühne frei für den Auftritt der ersten Jetztmenschen.

Eine Brücke zwischen den Gehirnen: *Homo erectus*

In den komplexen Abläufen der Evolution des Menschen hat sich eine Gestalt stets als besonders standfest und zuverlässig erwiesen: der *Homo erectus*. Er stand aufrecht und stabil und wanderte unermüdlich durch viele Teile der Welt. Allgemein betrachtet handelt es sich dabei um Lebewesen, die eindeutig menschlich waren und anscheinend über sehr lange Zeiträume hinweg mehr oder weniger unverändert blieben. Ihr Gehirn war deutlich kleiner als unseres, aber auch deutlich größer als das der ältesten Homininen. Dieses Bild ist immer noch ein guter Ausgangspunkt für die Betrachtung der letzten 2 Mio. Jahre, aber je mehr wir wissen, desto mehr lösen die Details sich auf

und bilden wie in einem Kaleidoskop neue Momentaufnahmen: Sie zeigen uns lokale Varianten von Homininen, deren Gehirngröße und Körperbau deutlich voneinander abweichen.

Die Geschichte beginnt jetzt mit Funden, die sich von dem „traditionellen", erstmals im Fernen Osten entdeckten *Homo erectus* so stark unterscheiden, dass man ihnen in einigen Fällen sogar eigene Namen gegeben hat wie *Homo ergaster* in Afrika und *Homo georgicus* in Dmanisi in Georgien. Beide haben ein recht kleines Gehirn – bei den Funden aus Dmanisi ist es mit weniger als 700 Kubikzentimeter sogar kleiner als bei früheren Vertretern der Gattung *Homo* in Afrika. Die afrikanischen Funde sind rund 1,5 Mio. Jahre alt, haben aber bereits nahezu moderne Proportionen; die Hintergliedmaßen der Homininen von Dmanisi dagegen sind eher Übergangsformen. Wenn wir diese Funde als *Homo erectus* einordnen, war die Spezies im Laufe von einer Million Jahren nicht immer und immer wieder genau gleich. Sie repräsentiert vielmehr ein Mosaik aus regional begrenzten Veränderungen: Der Körperbau ist hier ein wenig stämmiger, dort ein wenig schlanker, das Gehirn an einem Ort kleiner und an einem anderen größer.

Wenn etwas überraschend ist, dann die Tatsache, dass so weit voneinander entfernte Funde sich so ähnlich sein können. Man kann sich leicht ausmalen, dass *Homo erectus* sich über ganz Afrika und Eurasien ausbreitete, in Wirklichkeit klafft aber in unseren Kenntnissen eine riesige Lücke: Zwischen Dmanisi und China, auf etwa 8000 km, findet man keinen einzigen Schädel. *Homo erectus* wurde ursprünglich im Fernen Osten entdeckt, und aus Java und China stammt auch unser herkömmlicher Eindruck: robuste Menschen mit einem Gehirn von rund 1000 Kubikzentimetern, stämmigem Körperbau und sehr dicken Schädelknochen. Funde von vereinzelten Stellen in Afrika, darunter eine Schädeldecke aus der Olduvaischlucht, lassen darauf schließen, dass *Homo erectus* dort vor ungefähr einer Million Jahren schon ziemlich stark den fernöstlichen Populationen ähnelte. In Afrika müssen wir aber vermutlich auch nach den Wurzeln einer neuen Spezies suchen: nach den Vorfahren von *Homo heidelbergensis*, der spätestens vor 600.000 Jahren auf der Bildfläche erschien.

Faustkeile: ein Handwerk lernen

Manchmal ist ein Symbol so mächtig, dass wir es als Ikone bezeichnen – wie den Apfel auf einem Computer oder den Namen auf einer Armbanduhr. Das erste dieser großen Zeichen (und wir wissen noch nicht einmal, ob es überhaupt irgendwann ein Symbol sein sollte) ist der Faustkeil aus dem Acheuléen (s. Abb. 5.2). Heute ist er das Sinnbild

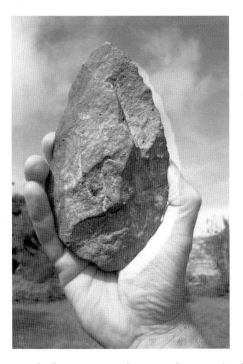

Abb. 5.2 Faustkeile waren Werkzeuge, die man in der Hand halten konnte. Ihre einfache Funktionsweise war vermutlich der Hauptgrund, warum sie so lange überdauerten. (© John Gowlett)

für die Steinzeit und immer noch in Gebrauch, beispielsweise als Anregung für das Logo der angesehenen britischen Royal Academy of Engineering. Der Faustkeil ist gut zu erkennen und äußerst nützlich, aber auch ein wenig rätselhaft, denn alle Spuren, die er hinterlässt, deuten zurück auf die Absichten seiner Hersteller.

Faustkeile tauchten in Afrika vor mindestens 1,75 Mio. Jahren zum ersten Mal auf. Die ältesten Funde stammen von den Fundstätten in Lokalalei auf der Westseite des Turkanasees und aus Konso-Gardula in Äthiopien; die jüngsten sind ungefähr 150.000 Jahre alt. An manchen Stellen, so in Olorgesailie oder Kilombe in Kenia, entdeckte man riesige Ansammlungen von Faustkeilen, an anderen Orten sind es nur seltene Einzelexemplare. Sie waren so erfolgreich, dass sie über eineinhalb Millionen Jahre hinweg benutzt wurden, und die Fundstätten erstrecken sich quer durch große Teile der Alten Welt; nur in Teilen des Fernen Ostens sind sie selten oder überhaupt nicht vorhanden. Der klassische Faustkeil ist ein Steingegenstand von vielleicht 15 cm Länge und der Breite einer Handfläche. Häufig ähnelt er in seinem Umriss einer Mandel oder einem Boot mit einer Spitze und einem abgerundeten Hinterende. Bei seiner Herstellung wurden Steine in der Regel von beiden Seiten bearbeitet, sodass um den ganzen Faustkeil herum eine scharfe, stabile Kante entstand. Faustkeile waren im Durchschnitt mit ungefähr 500 g ähnlich schwer wie eine Dose Bohnen oder eine kleine Tüte Zucker. Diese Zahl bezieht sich auf das typische Lehrbuchexemplar, in Wirklichkeit schwankt ihr Aussehen aber stark, und das nach überraschenden, faszinierenden Gesetzmäßigkeiten. Schon in einer kleinen Ansammlung findet man kürzere und längere,

breitere und schmalere, dickere und dünnere Exemplare. Diese Variationen sind so groß, dass sie absichtlich herbeigeführt worden sein müssen – ein großer Faustkeil ist unter Umständen zehnmal so schwer wie ein kleiner, und man findet kaum einmal Gruppen von Faustkeilen, bei denen keine Unterschiede zu erkennen sind.

Was können wir über Faustkeile lernen, wenn wir bei ihrer Betrachtung vom Modell des sozialen Gehirns ausgehen? Problematisch ist, dass wir bis heute nicht genau wissen, wozu die Werkzeuge verwendet wurden – manche eignen sich zum Schneiden, andere zum Schlagen. Es könnten einerseits Allzweckwerkzeuge nach dem Prinzip des Schweizer Armeemessers gewesen sein, wie Steven Mithen annimmt, sie könnten aber andererseits auch spezielle Verwendungszwecke gehabt haben. Wir wissen nur eines: Das Werkzeugarsenal bestand nie nur aus Faustkeilen (s. Abb. 5.3).

Die großen Ansammlungen von Faustkeilen sind ein Beleg für Organisation in der Landschaft. Sie lassen darauf schließen, dass die Menschen durch Regelsysteme, denen sie gehorchen mussten, an ihre Landschaft gebunden waren; diese Regelsysteme boten auf die gleiche Weise Orientierung, auf die eine mächtige Religion auch heute manchen Menschen Vorschriften für alle Facetten des Lebens machen kann. Dies erkennt man an der bemerkenswert gut erhaltenen, 500.000 Jahre alten Fundstätte Boxgrove in der Küstenebene von Sussex im Süden Englands. Wie die Wissenschaftler Matt Pope und Mark Roberts nachweisen konnten, wurde die Landschaft von *Homo heidelbergensis*, einem Homininen mit großem Gehirn, immer wieder nach den gleichen Prinzipien genutzt: Sie fanden geeignete Flint-

Steinchopper

Holzschaft

Formwandel

Faustkeil

Abb. 5.3 Höher entwickelte Werkzeuge repräsentieren häufig das Zusammentreffen von Ideen, die einzeln bereits im Umlauf waren. Dies kann man für die beidseitig bearbeiteten Werkzeuge aus dem Acheuléen vermuten: Demnach gab es ein Reservoir sozial vermittelter Erkenntnisse, die eine neue Flexibilität möglich machten. (© John Gowlett)

steine in einer zusammengestürzten Meeresklippe, trugen sie auf die Ebene, stellten dort charakteristische eiförmige Faustkeile her, zerlegten damit Tiere und warfen sie dann – das ist die faszinierende Wendung – an speziell dafür vorgesehenen Orten weg.

Ähnliche Aussagen macht Alain Truffeau, der Ausgrabungen in Nordfrankreich geleitet hat, auch über das Tal der

Somme. Dort setzte er Forschungsarbeiten fort, die bereits im 19. Jahrhundert begonnen hatten. Nach seinen Feststellungen kommen die gleichen Tätigkeiten und gleichartige Werkzeugarsenale an dem gleichen Ort immer und immer wieder vor, obwohl zwischen den Funden große zeitliche Lücken klaffen: 50.000 oder 100.000 Jahre später wurden die gleichen Tätigkeitsmuster wieder aufgenommen. Ähnliche Anhaltspunkte finden wir in Ostafrika: Auch dort kommen große Ansammlungen von Faustkeilen nur an ganz bestimmten Stellen vor. Wo sie entstanden, wiederholte sich immer und immer wieder das gleiche Muster. In Olorgesailie in Kenia konnte Rick Potts durch eingehende Untersuchungen zeigen, dass es sich bei dem Gebiet, in dem es viele Faustkeilen gab, um eine einzige Anhäufung in der gesamten umgebenden Landschaft handelte. Das Gleiche stellte John Gowlett in Kilombe weiter im Norden Kenias fest: Dort erstreckt sich das Fundgebiet der Faustkeile entlang einem archäologischen Horizont über 200 m, in den Nachbargebieten sind sie dagegen selten (s. Abb. 5.4).

Homo erectus und *Homo heidelbergensis*, die Hersteller dieser Werkzeuge, hatten ein Gehirn im Größenbereich von 800 bis 1200 Kubikzentimetern und damit eine doppelt so große Enzephalisation wie der frühe *Homo*; die Homininen an der Somme und in Boxgrove hatten mit ziemlicher Sicherheit die Schwelle von 900 Kubikzentimetern überschritten. Aber Faustkeile waren nicht nur eine Domäne von Homininen mit großem Gehirn. Sie lassen nicht zuverlässig darauf schließen, dass das Gehirnwachstum stattgefunden hatte, und sie zeigen auch die Sprachfähigkeit nicht sicher an. Oftmals sind sie außerordentlich symmetrisch und fein bearbeitet; aber der Zeitraum ihrer Entstehung

Abb. 5.4 Die berühmte Catwalk-Fundstätte in Olorgesailie im Süden Kenias. Hier ist eine der weltweit bekanntesten Ansammlungen von Faustkeilen erhalten geblieben. Viele tausend Faustkeile und Beile, die sich in sehr langen Zeiträumen angesammelt haben, liegen hier an der Oberfläche frei. (© John Gowlett)

reicht von Homininen mit kleinem Gehirn, die in ihren kleinen Gruppen auch ohne „verbales Kraulen" zurechtkamen, bis hin zu Formen mit großem Gehirn, bei denen dies nicht mehr möglich war.

Das soziale Leben der Steinwerkzeuge

An diesen Artefakten können wir ablesen, dass das Leben jetzt in einem größeren Maßstab – einem größeren Maßstab des Geistes – geführt wurde; daran waren größere Gruppen

und Gemeinschaften beteiligt, in denen mehr Informationen weitergegeben und bewahrt wurden. Dafür spricht die Struktur des Acheuléen. Ein Faustkeil erscheint uns als einzelnes Objekt, in Wirklichkeit ist er aber ein Knoten in einem weit gespannten Netzwerk. Die Menschen dürften das Material für Faustkeile über rund 10 km transportiert haben, und einzelne Exemplare hat man mehr als 100 km von dem Gestein entfernt gefunden, aus dem sie stammen.

Für die Wissenschaft haben Faustkeile einen so großen Aussagewert, weil sie die ersten Werkzeuge sind, in denen sich komplizierte Regeln verkörpern. Deshalb sind sie für uns so leicht zu erkennen und so weit über die Welt verstreut: Die Regeln sind immer ähnlich. Der Faustkeil ist eindeutig eine der ersten echten Erfindungen, aber das heißt nicht, dass er von einem Einzelnen gestaltet wurde. Vielmehr floss offenbar eine ganze Reihe von Ideen in Form eines langen Prozesses aus kleinen, vielleicht unbeabsichtigten Experimenten und Anpassungen zusammen. Einigen der ersten Exemplare fehlen manche klassischen Merkmale, aber als diese sich schließlich durchgesetzt hatten, wurden sie über 1,5 Mio. Jahre beibehalten und beibehalten und beibehalten.

Nach unserer Ansicht war das nur möglich, weil es einen fester gefügten, größeren sozialen Rahmen gab, als er den Australopithecinen oder Menschenaffen zur Verfügung stand. Dieser größere Rahmen war wahrscheinlich von entscheidender Bedeutung: Durch ihn konnte eine ausreichend große Zahl von Individuen so viel Wissen bereithalten, dass dieses immer zuverlässig zur Verfügung stand. In einer Gesellschaft von Menschenaffen gilt das nicht: Dort ist die Gemeinschaft alles, und kulturelle Kontakte müssen

ihre Grenzen über dünne Verknüpfungen und ohne Hilfe einer Sprache überwinden.

Das Wesen der kulturellen Weitergabe im Acheuléen untersuchte der Archäologe Stephen Lycett. Er baute dabei auf Gedanken auf, deren sich zuvor schon der bekannte Genetiker Luigi Luca Cavalli-Sforza bedient hatte. Die Frage lautet: Woher hat jeder Einzelne die Ideen, die in der Kultur genutzt werden, und warum bleiben diese Ideen gleich oder verändern sich? Was wir lernen, bleibt in unserem Gedächtnis erhalten, und anders als das genetische Erbe kann es sich durch erneutes Lernen verändern; es kann aber auch sehr festgefügt bleiben. Im Zusammenhang mit den Faustkeilen stellt sich das Rätsel, dass sie in so vielerlei Hinsicht gleich und doch unterschiedlich sind. Offenbar lautete die Regel für Faustkeilhersteller: Erstens verfolgst du immer die Grundregeln, und zweitens darfst du sie in einer Art „gleitender Anpassung" fast beliebig variieren. Treibst du es dabei aber zu weit, indem du sie zu lang oder zu dünn machst, wird die Realität dich krachend einholen, und sie werden zerbrechen. Ob die Grenzen von Mensch zu Mensch oder durch Überlieferung gelehrt wurden, wissen wir nicht, aber Cavalli-Sforza und der Mathematiker und Biologe Marcus Feldman skizzieren die wichtigsten Möglichkeiten: Der Lernprozess könnte sich vertikal von den Eltern zu den Nachkommen abspielen; oder horizontal, indem man von einer Gruppe Gleichaltriger lernt; oder von einem zu vielen, wenn ein Lehrer besonderen Respekt genießt; oder von vielen zu einem, wenn eine Gruppe älterer Personen die Tätigkeit erläutert. Diese Vorgänge führen, was die Originaltreue der Kopien und das Tempo des Wandels angeht, zu unterschiedlichen Ergebnissen. Der Anthropolo-

ge Dietrich Stout berichtet über die große Bedeutung von „Meistern" der Steinbearbeitung bei den Langda in Neuguinea, die Neulinge unter strenger Aufsicht halten. Nach Überzeugung von Stephen Lycett wurde für das Acheuléen die vertikale Weitergabe unterstellt, in Wirklichkeit lassen sich die Funde aber am besten mit dem Prinzip „viele zu einem" beschreiben (s. Abb. 5.5). Außerdem dürften Faktoren mitwirken, durch die das Acheuléen aus unserem mo-

Abb. 5.5 Soziale Weitergabe kann entweder vertikal oder horizontal erfolgen, beispielsweise von Eltern zu den Nachkommen oder unter Gleichaltrigen. Im Acheuléen lernte jeder Einzelne wahrscheinlich von einigen anderen, die Weitergabe erfolgte aber erstaunlich originalgetreu. (© John Gowlett)

dernen Erfahrungsbereich herausfällt. Nach Ansicht von Glynn Isaac lassen die Faustkeile des Acheuléen auf lokale Handwerkstraditionen mit lokalen Merkmalen schließen, gleichzeitig zeigen die Ähnlichkeiten in großen Regionen aber auch, dass die Kommunikation leichter und in größerem Umfang stattfand als in modernen Gesellschaften (in denen Artefakte wie Töpfe oder Keramik sich in Gestaltung und Verzierung ungeheuer stark unterscheiden). Nach seiner Vermutung stellten die früheren, einfacheren Sprachen keine so hohe Schranke zwischen Nachbargruppen dar wie Sprachen in späterer Zeit.

An dieser Stelle hilft uns die Hypothese vom sozialen Gehirn, die Zahlen genauer zu betrachten. Im Vergleich zu Menschenaffen oder Australopithecinen müssen die Individuen offener dafür gewesen sein, von mehreren Artgenossen zu lernen, und damit gab es auch einen größeren Informationsfluss über weite Entfernungen. In einer Horde von Jägern und Sammlern mit 30 Individuen beispielsweise steht eine Person, die als Kind etwas lernt, vorwiegend unter dem Einfluss von 6 anderen (das ist übrigens häufig die Größe einer kleinen Einsatzgruppe von Menschenaffen oder Menschen, was ebenfalls von der Hypothese des sozialen Gehirns vorausgesagt wird). Jedes Individuum wechselt aber während seiner Lebenszeit wahrscheinlich auch zwischen verschiedenen Horden, und das führt dazu, dass Erkenntnisse in größeren Regionen ausgetauscht werden.

Die Werkzeuge selbst zeugen unmittelbar von längeren Transportwegen. In fast jeder großen Acheuléenfundstätte findet man einige Werkzeuge, die über Entfernungen von 50 bis 100 Km transportiert wurden. Wie das geschah, ist nicht genau bekannt, es gibt aber zwei wichtige Möglich-

keiten: Entweder die Menschen wanderten, oder es gab einen Tauschhandel. In beiden Fällen müssen wir uns nach den Reisewegen, den Gruppen und der Gruppengröße fragen. Die Entfernungen scheinen so groß zu sein, dass man sie nicht mit den Notwendigkeiten des Nahrungserwerbs erklären kann. In Gadeb in Äthiopien fand J. Desmond Clark mehrere Faustkeile aus Obsidian, die über mehr als 100 km aus dem Rifttal herantransportiert worden waren. Ob es sich dabei um eine einfache Wanderung oder um den Beginn des Tauschhandels handelte, in beiden Fällen waren soziale Kontakte unentbehrlich, denn man musste sich mit Menschen, die weiter entfernt lebten, auseinandersetzen. Das größere Gehirn von *Homo erectus* ist ein deutliches Zeichen, dass solche sozialen Landkarten bereits im Entstehen begriffen waren.

Kinder lernten vermutlich schon in den ersten Lebensjahren das Handwerk das Steineklopfens. (Anatomische Befunde sprechen dafür, dass *Homo erectus* recht schnell das Erwachsenenalter erreichte.) Ob es so etwas wie einen Spielzeugfaustkeil gibt, wissen wir nicht, aber die Kinder moderner Jäger und Sammler besitzen tatsächlich Spielzeugbogen, die mit gutem Erfolg genutzt werden können. Im Verbund ihrer Horde übernahmen sie ihre wichtigsten Gedanken und Erfahrungen von wenigen anderen Individuen. Das Lernen konnte im nachdrücklichen Durchsetzen von Inhalten wie „mach' es so" bestanden haben. Das ist zwar nur eine Vermutung, die aber stützt sich auf immer wiederkehrende, sichtbare Indizien. Andere Primaten sind in dieser Hinsicht keine große Hilfe: Bei Schimpansen gibt es kaum so etwas wie einen Unterricht, und wenn, dann in der Regel nur von der Mutter zum Kleinkind. Jüngere Schimpansen

tun sich häufig zu Geschwistergruppen zusammen, und bei Grenzpatrouillen sowie in anderen Gruppen, die sich zu bestimmten Zwecken zusammenfinden, muss das Lernen und Lehren zwischen Erwachsenen stattfinden. Die Geselligkeit zwischen männlichen Homininen dürfte das Herzstück der neuen Möglichkeiten zur Menschwerdung gewesen sein, und die Zahl der Kernsteine, die transportiert wurden, deutet mit ziemlicher Sicherheit auf die Kooperation zahlreicher Männchen hin.

Die Macht der Konzentration

Was für Ideen wurden dabei weitergegeben, und was können wir sonst noch daraus lernen? Vermutlich müssen mindestens zehn Ideen oder Vorstellungen aufeinandertreffen, damit ein Faustkeil entstehen kann. Von anderen Steinwerkzeugen und später auch von Werkzeugen aus Holz oder Knochen wissen wir, dass die Konzepte in ähnlichen oder anderen Kombinationen auch zur Herstellung weiterer Werkzeuge dienen können. Ein Speer beispielsweise stellt seinen Hersteller wie ein Faustkeil vor schwierige Entscheidungen über Länge, Breite, Dicke und Gleichgewicht. Natürlich verkörpern sich in einem Speer, der im Querschnitt rund aussieht, geringfügig andere Konzepte als in breiten Werkzeugen wie einem Faustkeil, und genau darum geht es.

Die Handhabung solcher Gruppen von Konzepten ist selbst für heutige Menschen harte Arbeit. Die Hersteller der Faustkeile entwickelten bestimmte Arbeitsabläufe, damit sie im Normalfall nie an mehr als drei oder vier Faktoren gleichzeitig denken mussten. Ihre Aufgabe erforderte eine Kon-

zentration, die sich auch in der Ausübung sozialer Fähigkeiten wiederfindet – wobei anderen Individuen größere Aufmerksamkeit gewidmet werden muss. Nach unserer Ansicht richtete sich diese Konzentration zunächst auf den Aufbau stärkerer Bindungen in immer größeren Gruppen. Eine längere Aufmerksamkeitsdauer machte aber auch eine Verfeinerung der Technologie möglich, weil man ihrer Herstellung und ihrer Form mehr Zeit widmen konnte. Schimpansen können sich bekanntermaßen schlecht konzentrieren (außer in längeren Phasen des Nahrungssammelns), Menschen dagegen können Stunden darauf verwenden, einander in die Augen zu sehen, ein Problem zu lösen oder einer Predigt zuzuhören. Wir ziehen daraus den Schluss, dass die verbesserten Fähigkeiten bei der Werkzeugherstellung, wie man sie an der Form und Verfeinerung von Faustkeilen und anderen Gerätschaften beobachtet, untrennbar mit dem Sozialleben der Homininen verbunden waren. Wie wir es von einem sozialen Gehirn erwarten würden, waren die Fähigkeiten, die unser immer komplexeres Sozialleben und den Umgang mit immer größeren Belastungen möglich machten, die wichtigste Richtschnur. In einigen Fällen standen die gleichen Fähigkeiten aber auch für die Herstellung immer höher entwickelter, raffinierterer Werkzeuge zur Verfügung.

Erforderte die Herstellung von Faustkeilen auch eine Sprache, damit die Lerninhalte weitergegeben werden konnten? Wir würden sagen: nicht unbedingt, aber wir werden später auf das Thema zurückkommen. Als aber die Bedeutung der Sprache als Mechanismus der gegenseitigen Zuwendung wuchs, stieg wahrscheinlich auch das Aufmerksamkeitsniveau weiter an, weil das Zuhören bei der Herstellung von Bindungen an die Stelle der Berührungen

trat. Die Nische der Homininen wurde durch das soziale Gehirn verändert.

Bewältigung der kognitiven Belastung

Die Herstellung von Faustkeilen ist nicht einfach. Man kann sie mit verschiedenen Methoden anfertigen, aber normalerweise sind dazu drei Stadien notwendig: Zuerst wählt man das Rohmaterial aus, dann schafft man eine geeignete Schlagfläche, und als Drittes erhält das Werkzeug seine endgültige Form. Diese Schritte können durchaus geographisch getrennt ablaufen, denn die Werkzeugmacher verbreiteten ihre Gedanken durch Raum und Zeit – eine sehr menschliche Eigenschaft.

In Afrika spielten sich die beiden ersten Stadien in der Regel an demselben Ort ab, denn der Rohstoff stammte meist von einem Felsblock, der so schwer war, dass man ihn nicht weit bewegen konnte. Zur Herstellung des üblichen rohen „Zweiseiters" schlug man davon einen großen, vielleicht 20 cm langen Steinsplitter ab. (Der Begriff „Zweiseiter" oder französisch *biface* bezeichnet praktischerweise sowohl Faustkeile als auch Cleaver.) Hier sollten wir *Homo erectus* für die Fähigkeit bewundern, die notwendig ist, um solche Schläge zu setzen.

Je „richtiger" der so gehauene Rohling bereits war, desto weniger endgültige Formgebung oder Nachbearbeitung war notwendig. Louis Leakey fand in Kariandusi schon vor langer Zeit Exemplare, bei denen nur eine Seite des Zweiseiters noch weiter behauen werden musste. Unsere Analysen

zeigen, dass immer und immer wieder die gleichen grundlegenden Faktoren kontrolliert wurden. Für den Hersteller besteht die Schwierigkeit darin, alles gleichzeitig richtig zu machen. Das Problem kennt jeder moderne Heimwerker, der sorgfältig an einer Stelle Maß nimmt, dann aber feststellen muss, dass er damit etwas anderes um ein Stück verschiebt.

Cleaver aus dem Acheuléen stellten eine größere Herausforderung dar als die Faustkeile: Sie haben zwar dieselbe Grundform, aber die Schneidkante muss zur gleichen Zeit geformt werden wie der Rohling – bei „echten" Cleavern ist sie nicht durch spätere Nachbearbeitung entstanden. Die Werkzeugmacher des Acheuléen waren sich offenbar einig über die Notwendigkeit, diese Kante zu erzeugen, sie erzielten aber an verschiedenen Orten ähnliche Ergebnisse mit unterschiedlichen, komplizierten Vorgehensweisen. Bei dem in Ostafrika verwendeten Verfahren hatten die Hersteller eines Cleavers gleichzeitig vier Konzepte unter Kontrolle, wenn sie sich darauf vorbereiteten, den Rohling herauszuhauen: Länge, Breite, Breite der Schneidkante und auch die Dicke. Möglich wird das durch eine sorgfältige Vorbereitung des Kernsteins, und das Ergebnis erzielt man dann durch einen Schlag, der genau in der richtigen Richtung und mit der richtigen Kraft ausgeführt wird. Das alles setzt eine Art mentalen Jonglierens voraus, die wir normalerweise eher mit heutigen Menschen in Verbindung bringen. In der Regel fällt es uns schwer, mehr als drei Variablen gleichzeitig zu handhaben. Im Acheuléen bestand der Kunstgriff darin, die kognitiven Anforderungen durch eine genau festgelegte Reihenfolge der Handlungen zu vermindern. Das Gleiche findet auch heute in vielen techni-

schen Prozessen statt. Im Acheuléen des südlichen Afrika wird eine etwas eigenartige Methode zur Herstellung von Zweiseitern als „Victoria West" bezeichnet (s. Abb. 5.6). Sie zeigt, dass man genau darauf achtete, die endgültige Form des Werkzeugs vorzugeben, denn der behauene Kernstein war nicht viel größer als das Werkzeug selbst, und mit dem letzten Schlag wurde das nahezu fertige Produkt von ihm losgelöst.

Wenn uns diese recht technischen Verfahren ein wenig zu überfordern scheinen, sollten wir daran denken, dass *Homo*

Abb. **5.6** *Links*: Die Herstellung eines Acheuléen-Zweiseiterrohlings aus einem großen Kernstein. Durch sorgfältige Vorbereitung kann der Hersteller mehrere Dimensionen des Rohlings (hier mit 1–4 bezeichnet) mit einem einzigen Schlag steuern. Der Hersteller bearbeitet natürlich die ihm zugewandte Seite des Kernsteins, die hier der Übersichtlichkeit halber verschoben wurde. *Rechts*: Bei der im südlichen Afrika gebräuchlichen Victoria-West-Technik war der Kernstein häufig nur geringfügig größer als der Zweiseiter, der daraus hergestellt wurde. (© John Gowlett)

erectus ihnen gewachsen war. Die Victoria-West-Technik zeigt, dass diese Menschen über eine besondere Form von Einsicht verfügten, nämlich dass der ganze Prozess der Formgebung keinen Sinn hat, wenn man nicht weiß, was am Ende dabei herauskommt.

Nun ist die gerade gegebene Beschreibung zweifellos „technischer" Natur. Wir sind aber der Ansicht, dass die Handhabung mehrerer Konzepte im Kopf kein ausschließlich technischer Vorgang ist. Zuallererst werden in jedem Stadium des Prozesses soziale Entscheidungen getroffen. Sollen wir heute oder morgen zur Fundstelle für Steine gehen? Kollidiert das mit den anderen Dingen, die wir geplant haben? Werden wir (in einer Zeit, als es noch keine Sandwiches gab) etwas zu essen mitnehmen oder unterwegs Nahrung sammeln? Wie viele müssen wir sein, um die Rohlinge abzutransportieren? Wer passt auf die Kinder auf, während wir weg sind? Wen könnten wir unterwegs treffen? Auch hier erinnert die gleichzeitige Handhabung mehrerer Konzepte recht genau an die Ebenen der Intentionalität, von denen in Kap. 2 die Rede war.

Feuer: eine Sozialgeschichte

Das Naturphänomen Feuer hat ungeheuer stark dazu beigetragen, die Gesellschaften der Menschen zu prägen. Ohne die Wärme zu beherrschen, könnten wir kaum etwas tun, in den letzten hundert Jahren haben wir allerdings das offene Feuer in den Industrieländern weitgehend aus den Haushalten verbannt. Wir haben zwar genügend Anlass, die Geschichte des Feuers zu untersuchen, in der Praxis ist das aber nicht einfach.

Ein noch schwierigeres Problem ist die Frage nach der Nutzung des Feuers. Nur Menschen beherrschen das Feuer, und alle heutigen Gesellschaften sind dazu in der Lage, auch wenn nicht alle es üblicherweise ständig unterhalten. Deshalb gilt das Feuermachen bei manchen Gruppen – so beispielsweise bei den San im südlichen Afrika – als heilige Handlung; entsprechend bekommt möglicherweise nicht jeder Ethnograph auf die Bitte „Zeige mir, wie du Feuer machst" sofort eine Antwort. Aber zweifellos ist das Feuer ursprünglich eine natürliche Ressource; Menschen bedienten sich seiner erst, nachdem sie begriffen hatten, welchen Nutzen natürliches Feuer bietet.

In Bezug auf die Frage, wie und wann das geschah, gibt es viele Diskussionen. Manche Archäologen halten die Erkenntnis, welches Potential im Feuer steckt, für einen „kognitiven Sprung", eine Vision, die sich durch das Fehlen und die spätere Gegenwart von Feuerstellen in frühmenschlichen Siedlungen auszeichnet. Aber da Feuer zunächst ein Naturphänomen war, sind wir der Ansicht, dass seine Nutzung auch allmählich begonnen haben kann und sich im Laufe der Zeit immer mehr durchsetzte. Zu der Zeit, als es in die Siedlungen getragen und nach Belieben als „Herdfeuer" neu entzündet werden konnte, hatte die Nutzung des Feuers möglicherweise schon eine sehr lange Geschichte.

Argumente für das Kochen

Aus dieser weiter gefassten Perspektive heraus können wir die Ansicht vertreten, dass das Feuer sowohl die menschliche Ernährung entscheidend geprägt als auch am Aufbau

unseres großen sozialen Gehirns mitgewirkt hat. Betrachten wir zuerst einmal die Ernährung: Einige Hinweise, welche Nahrung ursprünglich verzehrt wurde, liefern uns die Menschenaffen. Schimpansen beziehen den größten Teil ihrer Nahrungsenergie aus Früchten, das heißt vorwiegend aus Kohlenhydraten. In Notzeiten fressen sie auch weniger nahrhafte Pflanzen, außerdem erweitern sie ihre Ernährung durch Insekten, Eidechsen und andere kleine Tiere, Honig und die seltene, aber regelmäßige Jagd auf Kleinaffen, junge Antilopen und andere Säugetiere. Auf diese Weise nehmen sie kleine, aber bedeutsame Mengen an Proteinen und Fetten auf. *Ardipithecus* war anscheinend eher ein Allesfresser (s. Kap. 4), und bei den Australopithecinen beobachten wir eindeutig eine Erweiterung des Speisezettels.

Schimpansen, Gorillas und Orang-Utans fressen hunderte von grünen Pflanzenarten oder nutzen sie auf andere Weise; außerhalb der Wälder und weiter von den Tropen entfernt nimmt die Nahrungsvielfalt jedoch ab. In der Trockenzeit steht viel weniger Nahrung zur Verfügung, sodass es leicht zu Engpässen kommt. Eileen O'Brien, Charles Peters und Richard Wrangham konnten in ihren Studien zeigen, wie wichtig unter solchen Umständen andere Kohlenhydrate sind, beispielsweise Wurzeln und Knollen, die zusammenfassend auch als unterirdische Speicherorgane oder USOs bezeichnet werden.

In einem wichtigen, Anfang der 1980er Jahre erschienenen Artikel untersuchten Peters und O'Brien im ganzen östlichen und südlichen Afrika pflanzliche Nahrungsmittel – insgesamt 461 Gattungen mit einer noch viel größeren Zahl von Arten – und verglichen, in welchem Umfang sie von Schimpansen, Pavianen und Jetztmenschen genutzt

werden. Sie stellten beträchtliche Überschneidungen fest,
aber eines war eindeutig zu erkennen: Zwar nutzen alle drei
Primaten eine große Zahl von Pflanzenarten, aber Schim-
pansen fressen in der Regel keine USOs, während Paviane
und Jetztmenschen es tun (s. Tab. 5.1). Leider sind solche
Nahrungsmittel oft sowohl für die Jetztmenschen als auch
für ihre Vorfahren nur schwer verdaulich.

Menschen können die Stärke aus Knollen nicht gut ver-
dauen, und ein Übermaß an Fleischprotein kann sogar gif-

Tab. 5.1 Pflanzliche Nahrungsmittel, die von Jägern und Samm-
lern, Schimpansen und Pavianen im mittleren und südlichen Afri-
ka verzehrt werden (N = Zahl der genutzten Pflanzengattungen).
Es bestehen beträchtliche Überschneidungen, aber unterirdische
Speicherorgane (USOs) werden von den Schimpansen, die auf
Früchte spezialisiert sind, nicht genutzt, und Menschen nutzen
mehr Arten von USOs als Paviane, vermutlich weil sie diese Nah-
rungsmittel durch Kochen besser verdaulich machen können

Nahrungsmittel	Menschen N (%)	Schimpansen N (%)	Paviane N (%)
Blüten/Blütenstände	2 (2)	1 (2)	5 (9)
Früchte	38 (41)	34 (72)	14 (26)
Samen/Schoten	9 (10)	3 (6)	11 (20)
Blätter/Schößlinge	22 (24)	7 (15)	15 (28)
Stängel	4 (4)	2 (4)	1 (2)
Unterirdische Speicher-organe	17 (18)	–(–)	8 (15)
Gesamt	92 (100)	47(100)	54 (100)

Daten nach © Charles Peters und Eileen O'Brien

tig wirken. Hier kommt ein entscheidender Vorteil des Feuers ins Spiel: Durch Kochen werden die Nahrungsbestandteile gespalten – die Stärkepakete in den Knollen ebenso wie die Proteinstränge im Fleisch; anschließend kommt der Darm besser mit ihnen zurecht. Gleichzeitig werden dabei schädliche Mikroorganismen abgetötet. Das alles wussten die frühen Homininen natürlich nicht. Zunächst stellten sie fest, dass die Nahrungssuche in der Nähe natürlicher Feuer dazu führte, dass mehr Nahrung zur Verfügung stand und dass sie diese Nahrung besser verzehren konnten, wenn sie zufällig in der Hitze gegart war. Die naheliegenden Objekte dafür waren Knollen und unterirdisch lebende Tiere, denn beide waren unter Umständen nach einem Brand besser sichtbar. Vieles zu dem Thema können wir ethnographischen Berichten über moderne Jäger und Sammler entnehmen, und in diesem Fall ist nicht zu bezweifeln, dass es in der Vergangenheit genauso ablief. Wir brauchen auch für den Anfang keinen kognitiven Sprung zu unterstellen, denn auch viele andere Arten, insbesondere Vögel, sind dafür bekannt, dass sie „dem Feuer folgen". An ihnen ist zu erkennen, dass Brände in der Natur mit ausreichender Regelmäßigkeit vorkommen und in Form gelernter Aktivitäten genutzt werden können. Dass Archäologen, die in einer grünen, angenehmen Landschaft zu Hause sind, Feuer für etwas Seltenes halten, ist nicht verwunderlich, aber jedes Jahr ereignet sich beiderseits des Äquators bis mindestens auf 50 Grad nördlicher oder südlicher Breite eine große Zahl von Blitzeinschlägen, und ein beträchtlicher Anteil von ihnen verursacht Brände. Das geschieht insbesondere dann, wenn die Vegetation trocken ist und wenn die Blitze einschlagen, bevor der Starkregen beginnt, der sie häufig

begleitet. Häufigkeit und Umfang der Brände hängen vor allem von lokalen Faktoren ab. In tropischen Regenwäldern ist fast alles so nass, dass es nicht brennt; in den Graslandschaften der halbtrockenen Zone dagegen kommt es so regelmäßig zu Bränden, dass viele Baumarten feuerresistent sind. In den Waldlandschaften und Wäldern der gemäßigten Klimazonen besteht jedes Jahr und insbesondere bei „brandheißem" Wetter große Feuergefahr.

Wann kam es erstmals zu solchen Begegnungen zwischen Homininen und natürlichen Bränden? Logischerweise geschah das, als sie ihr Verbreitungsgebiet auf Umgebungen erweiterten, in denen es regelmäßig brannte. Wie wir an den Steinwerkzeugen erkennen können, erfasste der Aktionsradius bei der Nahrungssuche vor 2,0 bis 2,6 Mio. Jahren auch Landschaften, in denen Brände nicht zu übersehen waren; heute erkennt man Feuer bei Tag und Nacht noch aus Entfernungen von mehr als 20 km (s. Abb. 5.7).

Manche Veränderungen der Ernährung sind als ununterbrochene Entwicklung von der Vergangenheit bis heute an den Zähnen der modernen Menschen zu erkennen: Insbesondere unsere Molaren zeugen von der Notwendigkeit, harte oder zähe Nahrung zu zermahlen. Unsere Zähne sind nicht vorwiegend zum Zerteilen geeignet, denn diese Aufgabe wurde im Rahmen der Nahrungszubereitung an Messer und ähnliche Werkzeuge abgegeben. Einen Hinweis darauf, wie frühzeitig sich solche Veränderungen ereignet haben dürften, liefert ein 1,7 Mio. Jahre alter Schädel eines frühen *Homo*, der in Dmanisi in Georgien gefunden wurde: Ihm fehlen sämtliche Zähne mit Ausnahme eines einzigen im Unterkiefer. Wie man an den abgeheilten Zahnlücken erkennen kann, überlebte „Old Toothless" wahrscheinlich

Abb. 5.7 Buschbrände sind in der Landschaft weithin sichtbar. Dieser ist von Kilombe in Kenia aus über eine Entfernung von 15 km zu sehen und war an dem Feuerschein auch nachts zu erkennen. Natürliche Brände gehören in niedrigen Breiten zum Leben und waren unseren frühesten Vorfahren sehr vertraut. (© John Gowlett)

noch mehrere Jahre. Das lag sicher daran, dass seine Nahrung auf geeignete Weise zubereitet war, und sehr wahrscheinlich gehörte er auch zu einer sozialen Gruppe, in der andere ihn unterstützten.

Wurde das Feuer tatsächlich schon seit so langer Zeit genutzt? Aus Dmanisi gibt es dafür keine Belege. Unter anderem muss man in Rechnung stellen, dass die Frühmenschen sich nach heutiger Kenntnis wahrscheinlich schon über die Alte Welt – von Afrika nach Georgien, China und Java – ausbreiteten, bevor ihr Gehirn größer wurde – dies unterstreicht auch ein Schädel, dessen Untersuchung 2013 veröffentlicht wurde. Die Verteilung lässt darauf schließen, dass die Wurzeln dieser Ausbreitung (und einer neuen, erfolgreichen Anpassung von *Homo*) weiter zurückreichen als alle Behauptungen über das Feuer (s. Abb. 5.8).

Dennoch glauben Richard Wrangham und seine Kollegen, dass das Feuer schon frühzeitig starke Auswirkungen hatte. Sie wollen mit ihren Argumenten nachweisen, dass die Homininen in der Savanne und während der Trockenzeiten nur überleben konnten, wenn sie ihre Ernährung beträchtlich veränderten und wenn sie insbesondere lernten, Fleisch und Kohlenhydrate zu kochen. Die Wissenschaftler weisen darauf hin, dass alle modernen Menschen gekochte Nahrung brauchen und dass es ohne sie mit der Gesundheit schnell bergab geht.

Die Zunahme der Gehirngröße um rund 50 %, die sich vor 1,7 Mio. Jahren abspielte, brauchte mit Sicherheit einen Treibstoff. Wurde sie vielleicht einfach von Verbesserungen der Nahrungsqualität bewerkstelligt, die ihrerseits durch ein stärker durch Unterstützung geprägtes soziales Umfeld ermöglicht wurde? Irgendein wichtiges Ernährungs-

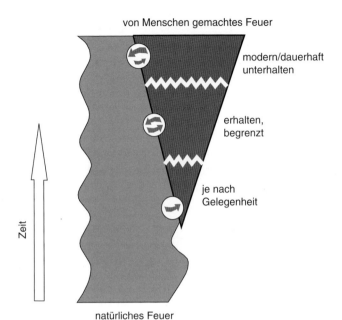

von Menschen gemachtes Feuer

modern/dauerhaft
unterhalten

erhalten,
begrenzt

je nach
Gelegenheit

Zeit

natürliches Feuer

Abb. 5.8 Ein allgemeines Schema für die Entwicklung des Gebrauchs von Feuer. Wie man daran erkennt, entwickelte er sich aus dem Umgang mit natürlichen (Wald-)bränden. Der Prozess gliedert sich in drei Stadien, in denen die Homininen jeweils mehr Kontrolle über diese lebenswichtige Technologie gewannen. (© John Gowlett nach Gowlett 2010; Abb. 17.4)

problem muss damals gelöst worden sein, sonst wäre *Homo* nicht ohne die frühere Megadontie (die mächtigen Zähne, die für viele Australopithecinen charakteristisch sind) ausgekommen. Das Gehirn des Menschen wächst schon in einem frühen Lebensstadium, zentrale Faktoren waren also die Gesundheit der stillenden Mütter und die Fähigkeit, die Kinder frühzeitig an hochwertige Nahrung zu gewöhnen. Der alte Mann von Dmanisi zeigt wieder einmal, dass

das Problem der Nahrungszubereitung gelöst war, aber war das durch Feuer geschehen oder durch soziale Zusammenarbeit und die sorgfältige Zubereitung der Nahrung mittels einer Technologie zum Zerschneiden und Zerstoßen? John Gowlett und Richard Wrangham gaben sich in einem 2013 erschienenen gemeinsamen Artikel große Mühe, die Kluft zwischen den Positionen zu überbrücken. Beide sind überzeugt, dass das Feuer schon frühzeitig in Gebrauch war, aber wie bei anderen Entwicklungen, so ist das Schwierigste für uns auch hier, uns die Form von Anpassungen auszumalen, die sich von den Gewohnheiten und dem Verhalten heutiger Menschen so stark unterschieden, dass man nicht einmal ohne Weiteres eine Analogie herstellen kann.

Feuer frei

Die archäologischen Anhaltspunkte für die Beherrschung des Feuers deuten auf einen langsamen Schwelbrand hin. Der Haken dabei ist, dass man nach Belegen suchen muss, die eigentlich nicht die ersten Hinweise auf die Beherrschung des Feuers darstellen (s. Abb. 5.9). Herdstellen in Siedlungen sind in späteren Zeiten weit verbreitet und werden immer seltener, je weiter man in die Vergangenheit vordringt. Manchmal sind die Lücken zwischen einzelnen Funden so groß, dass man daraus eine Warnung ableiten kann, sie nicht überzuinterpretieren. Sie zeigen, dass das Feuer keineswegs immer unterhalten wurde, selbst in Zeiten nicht, in denen seine Nutzung sich bekanntermaßen bereits durchgesetzt hatte. Die ältesten Spuren für Feuerstel-

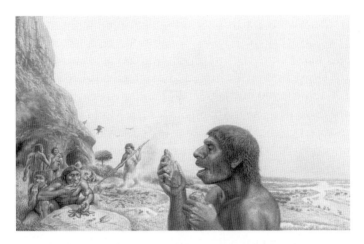

Abb. 5.9 Spätestens vor 400.000 Jahren, vermutlich aber schon viel früher, wurde das Feuer zum Mittelpunkt der sozialen und ökonomischen Aktivität. Es trug entscheidend dazu bei, dass die Homininen mit ihrem größeren Gehirn und dem verkürzten Darm einen größeren Teil des Tages für soziale Aktivitäten verwenden und ihre Nahrung braten konnten. (© John Sibbick)

len, die einen Herd darstellen könnten, stammen aus den ostafrikanischen Fundstätten Chesowanja, Koobi Fora und Gadeb. Alle werden regelmäßig genannt und dann in der Regel als nicht schlüssig abgetan. Zumindest in Koobi Fora und Chesowanja ist offenes Feuer nachgewiesen, und dass es sich um eine abgegrenzte Feuerstelle handelte, ist klar. In Chesowanja kann man auch nachweisen, dass die Temperaturen in der gleichen Größenordnung lagen wie bei einem modernen Lagerfeuer. Was fehlt, ist ein Beleg, mit dem man eine „Triangulation" vornehmen könnte: Wenn wir nachweisen könnten, dass auch Artefakte verbrannt wurden oder dass die Knochen in der Nähe des Feuers verkohlt

waren, würde dies die unterstützenden Verbindungen eines Dreiecks schaffen. Wie die Verhältnisse liegen, können wir aber nur zeigen, dass örtlich sehr begrenzt ein Feuer loderte.

Die nächsten Anhaltspunkte stammen aus der Zeit vor 700.000 bis 900.000 Jahren; die Fundorte reichen von Südafrika bis nach Bogatyri am Schwarzen Meer. Am bekanntesten ist Gesher Benot Ya'aqov in Israel, wo Menschen vor ungefähr 700.000 Jahren an einem kleinen See lagerten. Brandspuren an der Stelle lassen sich überzeugend mit den Menschen in Verbindung bringen, weil sie auf vielen Ebenen vorkommen, und winzige Stücke von verbranntem Flintstein kennzeichnen offenbar „Geisterherdstellen". Die Erforschung von Waldbränden in Nordamerika hat gezeigt, dass Feuer nach einem Blitzschlag in der Regel von Bergrücken ausgeht; dagegen deutet Feuer, das wie in Gesher Benot Ya'aqov immer wieder in der Nähe von Wasser entsteht, viel stärker auf Menschen hin. Die beiden südafrikanischen Fundstätten befinden sich in Höhlen, und beide sind ungefähr 800.000 bis eine Million Jahre alt. In der Höhle von Swartkrans hat man auf vielen Ebenen der Fundstätte 3 verbrannte Knochenstücke gefunden, von denen manche auch Schnittspuren tragen; in der Wonderwerk-Höhle ist ein ganzer Horizont voller Anhaltspunkte für Feuer, und mikrostratigraphische Studien zeigen, dass sich diese Spuren nicht mit brennendem Vogelkot (der in Höhlen manchmal vorkommt) vertragen. Zusammen liefern die beiden Fundstätten sehr gute Belege dafür, dass die Menschen das Feuer beherrschten, und wie in Kap. 4 bereits erwähnt wurde, stehen sie auch in Einklang mit etwas anderem: In den unteren Bodenhorizonten von Swartkrans und auch im nahe

gelegenen Makapansgat findet man viele Überreste von Australopithecinen – aus späterer Zeit jedoch, als die Höhle den gefundenen Steinwerkzeugen zufolge besiedelt war, gibt es nur sehr wenige Überreste von *Homo*. Man kann also vermuten, dass *Homo* besser vor Raubtieren geschützt war – und der wichtigste Faktor, der die Höhlen zu einem sicheren Wohnort machte, war vermutlich das Feuer.

Wenn man vielleicht an allen diesen Belegen noch zweifeln kann, liefert eine Reihe von Fundstätten in Westeuropa, dem Nahen Osten und Afrika mit einem Alter von rund 400.000 Jahren den Archäologen endlich das, was sie für eine sichere Aussage brauchen. Der deutsche Ort Schöningen ist bekannt für seine gut erhaltenen Holzspeere, aber nach Angaben des Grabungsleiters Hartmut Thieme gibt es dort auch Herdstellen, und in einer davon fand man einen weggeworfenen, teilweise verbrannten Holzspieß. Dieser liefert einen schlüssigen Beleg dafür, dass hier Menschen ganz gezielt am Werk waren. Wir können zwar nicht ganz sicher sein, ob am Ende des Spießes ein Steak gebraten wurde, aber in jeder anderen Hinsicht handelt es sich um einen definitiven Beweis. Ähnlich gut erhalten sind Herdstellen in Beeches Pit im Osten Englands. Zueinander passende Flintsteine (das heißt getrennte Splitter, die man wieder zusammensetzen kann) erzählen die Geschichte von einem Menschen, der am Feuer sitzt und aus einer großen Flintsteinknolle einen Faustkeil anfertigt. Dabei wurden mehr als dreißig Schläge geführt. Zwei Splitter fielen nach vorn ins Feuer und sind hellrot verbrannt, alle anderen sind unverändert.

Feuer und der soziale Tag

Beeches Pit liefert besonders gute Aufschlüsse darüber, wie verschiedene Tätigkeitsabläufe rund um ein Feuer zusammenliefen – es ist das bisher älteste Beispiel für Vorgänge, die wir in späterer Zeit immer häufiger beobachten. Große Feuer wie die von Beeches Pit benötigen jeden Tag 50 bis 100 kg Brennholz, was der Arbeitsteilung starken Vorschub leistet. Sie deuten darauf hin, dass es bereits zu einer Neuorganisation der zeitlichen Abläufe gekommen war (s. Abb. 5.10).

Unter dem Gesichtspunkt des sozialen Gehirns können wir aus dem Feuer noch etwas anderes ableiten. Das Leben im Norden oder im äußersten Süden hat den offenkundigen Nachteil, dass die Tage im Winter viel kürzer sind. Daraus ergibt sich eine Energielücke: Es stehen weniger Stunden bei Tageslicht für die Nahrungssuche zur Verfügung, gleichzeitig braucht der Organismus aber viel mehr Energie. Einfach ausgedrückt, muss sich ein Mensch nun nicht mehr 2000 Kalorien im Laufe eines 12- bis 14-Stunden-Tages beschaffen, sondern 3000 oder 4000 in 7 bis 8 h. Menschen nehmen ihre Mahlzeiten in der Regel nach Zubereitung der Nahrung in sehr kurzer Zeit und häufig gemeinsam ein – das Teilen der Nahrung hielt der Archäologe Glynn Isaac sogar für eine der wichtigsten Triebkräfte in der Evolution des Menschen (auch Schimpansen teilen zwar manchmal ihr Futter, sie bereiten es aber nicht gemeinsam zu). Für diesen Wandel, diese grundlegende Umstellung des Tagesablaufs, spielte das Feuer offenbar eine ungeheuer große Rolle. Weitere Belege dafür finden wir in unserem biologischen Tagesrhythmus: Menschen schlafen nur 8 h, und

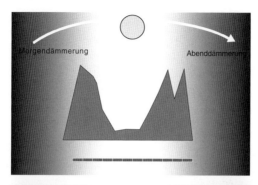

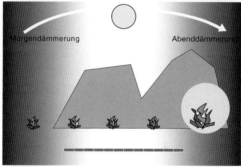

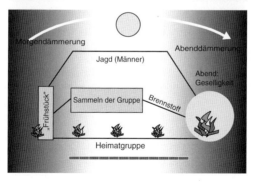

Abb. 5.10 *Oben*: Der Tagesablauf eines Gorillas, aufgezeichnet von dem Biologen George Schaller; der Tag wird durch das

ihre höchste Aufmerksamkeit ist am frühen Abend erreicht, gerade wenn Menschenaffen sich schlafen legen. Das Feuer war der Grund, dass der soziale Tag länger wurde; es veränderte die Zeiteinteilung für die Zubereitung und Aufnahme der Nahrung und regte die Arbeitsteilung an. Feuer sorgt für eine Aufteilung der Arbeit nach Effizienz, ermöglicht eine höhere Kalorienaufnahme aus der Nahrung, spendet Wärme und schützt vor Raubtieren. Das Feuer prägte unseren Tag neu und wurde zur Triebkraft für das Wachstum unseres sozialen Gehirns.

Derzeit stellt sich die Frage, ob das Feuer überall in Gebrauch kam oder ob es in manchen Regionen beliebter war als in anderen. Nach Ansicht der Archäologen Will Roebroeks und Paola Villa wurde das Feuer in der Frühzeit im Norden nicht genutzt. Ist es möglich, dass man das Feuer in den Tropen kannte und damit umgehen konnte, in nördlichen Breiten aber nicht? Das ist eine seltsame Idee, denn in kälteren Klimazonen wurde das Feuer insbesondere im Winter sicher gebraucht – und doch fehlen rätselhafterweise die Belege. In der Höhle von Arago in den Pyrenäen wurden schon vor mehr als 500.000 Jahren Rentiere zerlegt, aber die Knochen sind nicht verbrannt, und Feuerstel-

Abb. 5.10 (Fortsetzung) Tageslicht begrenzt und besteht im Wesentlichen aus Phasen der Nahrungssuche, die durch einen Mittagsschlaf getrennt sind. *Mitte*: Für Menschen ist der Tag viel länger geworden; die größte Aufmerksamkeit stellt sich am frühen Abend ein; mithilfe des Feuers wird zusätzliche Zeit für soziale Aktivitäten frei. *Unten*: Das Feuer ist für die täglichen Wanderungsmuster, die für Jäger und Sammler charakteristisch sind, zu einem wichtigen Faktor geworden. (Der Balken unten zeigt die ungefähre Länge des Tageslichts in den Tropen von 6 bis 18 Uhr) (© John Gowlett nach Gowlett 2010; Abb. 17.2)

len existieren nicht. Offenbar gibt es zwei Möglichkeiten. Einerseits wäre es denkbar, dass man mit dem Feuer nur an bestimmten Orten umgehen konnte, an denen Brennstoffe und Unterschlupf ohne Weiteres zur Verfügung standen – in diesem Fall werden wir den Beweis irgendwann finden; oder aber die Menschen konnten mit dem Feuer nicht so gut umgehen, dass sie sich darauf verlassen konnten – wenn man das Feuer nicht neu entzünden konnte, wäre es in dem kalten Klima, in dem es keine Blitzeinschläge gab, sehr gefährlich gewesen, sich davon abhängig zu machen (ähnliche Risikofaktoren gelten auch in unserer Zeit für manche Branchen der Wirtschaft). Dann hätte man mithilfe starker Beziehungsnetzwerke sicherstellen müssen, dass man Feuer bei Bedarf von jemand anderem holen konnte. Noch wichtiger wäre die Stärke solcher Netzwerke dann gewesen, wenn die Menschen gezwungen waren, in niedriger Dichte in der Landschaft zu leben. In einer anderen Studie des Lucy-Projekts konnte Matt Grove mithilfe mathematischer Modelle bestätigen, dass solche Faktoren tatsächlich starken Einfluss auf Menschen haben, die weit verstreut in den harschen nördlichen Breiten leben.

Sprache: die handfesten Belege

Wenn man sich ausmalt, wie Menschen am Lagerfeuer verschiedene Tätigkeiten ausführen, denkt man natürlich sofort an Kommunikation und Gespräche. War Sprache tatsächlich bereits in dieser Frühzeit ein Teil des Bildes? Prägte sie die Evolution der Menschen schon in ferner Vergangenheit? Über dieser wichtigen Frage haben Linguisten,

Archäologen und Anthropologen lange gerätselt. Bis heute sind ihre Meinungen sehr geteilt. Manche verlegen die Anfänge in die Zeit vor 2 Mio. Jahren, für andere begann die Sprache erst vor rund 50.000 Jahren mit der symbolischen Revolution, die sich durch die explosionsartige Vermehrung der Kunstwerke bemerkbar machte.

Angesichts unserer eigenen Erfahrungen mit dem Sozialleben denken wir sofort an Sprache. Demnach kann die Vorstellung vom sozialen Gehirn uns doch sicher helfen, die uralte Frage nach den Ursprüngen der Sprache zu klären? Nach unserer Überzeugung ist das tatsächlich der Fall. Die Erkenntnisse über den zeitlichen Ablauf der Sprachentwicklung gehören zu den wichtigsten Folgerungen aus unserer Hypothese. Betrachten wir aber zunächst einmal die handfesten Belege.

Um zu sprechen, um sich der Sprache zu bedienen, brauchten die Homininen folgende Mindestvoraussetzungen:

- ein Gehirn, das die Grundlagen der Sprache handhaben konnte – insbesondere die Syntax, das heißt die Regeln, die über die Anordnung der Wörter in einem Satz bestimmen. „Syntax" ist eine Kurzbezeichnung für die Aussage, dass sie den komplexen Vorgang verstanden, durch den Laute zur Beschreibung und Erörterung von Dingen und Vorstellungen in Gegenwart, Vergangenheit und Zukunft genutzt wurden,
- Stimmorgane, mit denen sie die Atmung so genau steuern konnten, dass sie die Sprachlaute im richtigen Tempo hervorbrachten,

- lohnende Gesprächsgegenstände, derentwegen sich die Evolutionsanstrengung einer Neugestaltung von Gehirn und Stimmorganen auszahlte.

Die erste Voraussetzung lässt sich nur schwer untersuchen und ist der wichtigste Grund für die Meinungsverschiedenheiten. Einige Hinweise liefern Abgüsse von der Innenseite von Homininenschädeln, aber an ihnen sind die meisten Details nicht mehr vorhanden. Rückschlüsse aus ihnen zu ziehen, ähnelt ein wenig dem Versuch, ein Gesicht hinter einer Strumpfmaske zu erkennen. Die Paläoanthropologen Ralph Holloway, Phillip Tobias, Dean Falk und andere konnten nachweisen, dass das Gehirn der Australopithecinen im Vergleich zu Menschenaffen neu organisiert wurde. An manchen Schädeln erkennt man Anzeichen für eine stärker entwickelte Lateralisation oder „Seitigkeit" des Gehirns, die im Zusammenhang mit Werkzeuggebrauch und Händigkeit stehen durfte, möglicherweise aber auch auf die Anfänge der Sprache hindeutet (s. Kasten „Seitigkeit des Gehirns, Händigkeit und Sprache").

Dennoch machte das Gehirn offenbar aufgrund der Sprache keine grundlegende Umstrukturierung durch; manche Wissenschaftler, unter ihnen Ralph Holloway, vertreten allerdings auf der Grundlage von Schädelabgüssen und insbesondere wegen der Lage einer Furche namens Sulcus lunatus die Ansicht, dass sich die Größenverhältnisse der verschiedenen Gehirnteile bei *Homo* im Vergleich zu *Australopithecus* verändert haben.

Seitigkeit des Gehirns, Händigkeit und Sprache

Als Seitigkeit des Gehirns bezeichnet man die Tatsache, dass seine beiden Hälften unterschiedliche Aufgaben erfüllen. Ein wichtiges Beispiel ist die Händigkeit. Wir modernen Menschen sind in unserer Mehrzahl ziemlich eindeutig entweder Rechts- oder Linkshänder. Auf der ganzen Welt liegt das Verhältnis von Rechts- und Linkshändern bei ungefähr 85 zu 15, und diese Aufteilung findet sich ausschließlich bei Menschen. Sie steht mit Sicherheit unter genetischer Kontrolle, ihre Ausdrucksform lässt sich allerdings durch fehlgeleitete kulturelle Bemühungen, die Linkshändigkeit zu unterdrücken, geringfügig beeinflussen. Wegen einer uralten Überkreuzung der Funktionen im Gehirn wird die rechte Hand von der linken Gehirnhälfte gesteuert. Das dominante Auge entspricht in der Regel der dominanten Hand, und Menschen können auch Links- oder Rechtsfüßer sein.

Entstanden ist die Händigkeit möglicherweise dadurch, dass das Gehirn sich auf komplizierte Aufgaben konzentrieren musste. Diese Konzentration zwischen zwei Händen und zwei Gehirnhälften aufzuteilen, dürfte für die erforderlichen, millisekundengenauen zeitlichen Abläufe und schnellen Reaktionen eine zu hohe Anforderung gewesen sein. Damit soll nicht geleugnet werden, dass wir Aufgaben auf einer niedrigeren Ebene auf beide Hände aufteilen können, beispielsweise wenn wir mit einem Spaten graben oder einen Spieß schnitzen. Bei solchen Aufgaben erbringen auch Schimpansen ausgezeichnete Leistungen, und wie wir benutzen sie in der Regel für jede Tätigkeit bevorzugt die eine oder andere Hand.

Im Großen und Ganzen ist auch die Sprache in einer Gehirnhälfte angesiedelt – bei Rechtshändern meist in der linken, bei Linkshändern aber nicht immer in der rechten. Das alles ist ein gewisses Rätsel – neben der Aufklärung der Verhältnisse bei heutigen Menschen stellt sich die Aufgabe, ein Evolutionsszenario zu entwickeln.

Die Händigkeit ist dabei der einfachere Teil, denn sie lässt sich in die Vergangenheit zurückverfolgen. In der Richtung der Schläge, die bei der Steinbearbeitung geführt wurden, spiegelt sich in der Regel eine rechts- oder linkshändige Tätigkeit wider, und auch bei den bearbeiteten Werkzeugen weist die Schneid-

kante meist in eine Vorzugsrichtung. Alle bisherigen größeren Studien lassen auf Populationen von Rechtshändern schließen, ganz gleich, ob es sich um Jetztmenschen, Neandertaler oder frühere Formen von *Homo* handelt. Interessanter ist für viele Fachleute die Sprache, aber hier werden die Verhältnisse komplizierter. An manchen Abgüssen des Schädelinneren fossiler Homininen kann man geringfügige lokale Asymmetrien des Gehirns messen. Die nachgewiesene stärkere Entwicklung des Broca- und Wernicke-Zentrums (wo sie liegen, zeigt Abb. 2.3) legt die Vermutung nahe, dass die Anfänge der Sprache bis zum frühen *Homo* zurückreichen. Ihre Lage ist jedoch viel weniger gut gesichert als bei der Händigkeit – und Händigkeit allein ist kein sicheres Anzeichen, dass eine Sprache vorhanden war. Vermutlich weist sie vielmehr auf eine Spezialisierung auf technische Prozesse hin, die Konzentration erforderten, und diese zeigen sich auch an den Werkzeugen, die mehr als 2 Mio. Jahre alt sind.

Kaum einfacher zu erforschen ist die Mechanik der Sprachproduktion. Das Sprechen erfordert einen millisekundengenau gesteuerten Luftstrom aus der Lunge. Einen handfesten negativen Beleg liefert das sehr gut erhaltene Skelett eines Homo-erectus-Jungen aus Nariokotome in Kenia, das auf ein Alter von 1,5 Mio. Jahren datiert wurde. Wie die Paläoanthropologin Anne MacLarnon nachweisen konnte, fehlten ihm die veränderten Nervenöffnungen in den Wirbeln, mit denen man rechnen würde, wenn er hätte sprechen können. Der Junge von Nariokotome konnte zwar Laute hervorbringen, er konnte sie aber nicht nach Art einer Sprache steuern. Er war nicht in der Lage, mit einem einzigen Atemzug lange Phrasen hervorzubringen und mit sehr schnellen Atemzügen zu unterbrechen. Genau das ist aber unsere Methode, Sprachmuster zu strukturieren und ihnen einen Sinn zu geben.

Solche Befunde waren für Alan Walker, den Entdecker des Jungen von Nariokotome, der Anlass für die Feststellung, dieser Hominine habe nicht über eine Sprache verfügt. Dagegen kann man an den Funden aus Dmanisi in Georgien den Angaben zufolge ablesen, dass der mit 1,8 Mio. Jahren etwas ältere *Homo georgicus* seinen Atem ganz ähnlich steuern konnte wie moderne Menschen. Um aber schlüssige anatomische Belege zu finden, müssen wir einen großen zeitlichen Sprung nach vorn machen und eine andere bemerkenswerte Fundstätte betrachten. Einige Schädel aus der Sima de los Huesos, die zum Höhlenkomplex von Atapuerca in Nordspanien gehört, sind so gut erhalten, dass wir sogar ihre knöchernen Gehörgänge kennen. Diese harten Umhüllungen des Außenohres sind so geformt, dass sie die Frequenzen von Sprache verstärken – ein Phänomen, das man bei Schimpansen nicht findet. Leider wurde das Alter dieser Funde nicht zur Zufriedenheit aller genau festgestellt. Allgemein herrscht aber Einigkeit, dass sie sich auf dem Evolutionsweg vom *Homo heidelbergensis* zum *Homo neanderthalensis* befinden; demnach wären sie höchstens 500.000 und mindestens 250.000 Jahre alt. Selbst wenn die jüngste Datierung stimmt, sind sie zweifellos Vorfahren der Neandertaler. Daraus kann man folgern, dass sowohl die Neandertaler als auch die Jetztmenschen diese sprachspezifische Eigenschaft hatten; entweder entwickelte sich die Sprache also bei beiden unabhängig voneinander, oder sie gehört zu einem Evolutionshintergrund, der mehr als eine halbe Million Jahre weit bis zu einem gemeinsamen Vorfahren zurückreicht. In jüngster Zeit konnten Genetiker aus der DNA in fossilen Knochen das Neandertalergenom isolieren und veröffentlichen; ihre Befunde zeigen,

dass unsere Vorfahren sich von denen der Neandertaler erst
während der letzten 400.000 Jahre abspalteten. Wir sind
also lange Zeit den gleichen Evolutionsweg gegangen wie
sie, es stand aber auch genügend Zeit für die Entstehung
wichtiger Unterschiede zur Verfügung.

Die Tatsache, dass es bei den Funden keine offenkundig
neuen anatomischen Merkmale gibt, veranlasste manche
Autoren zu dem Gedanken, die Sprache könne vorwiegend
ein erlerntes Phänomen oder vielleicht auch die plötzliche
Folge einer einzigen Mutation sein, die sich vielleicht vor
weniger als 50.000 Jahren ereignete. Diese Interpretation
erscheint unwahrscheinlich. Aus genetischen Untersuchun-
gen wissen wir, dass manche Populationen der Jetztmen-
schen sich bereits vor mehr als 50.000 Jahren voneinander
getrennt hatten, und doch sind wir alle mehr oder weniger
gleich und bedienen uns der Sprache auf die gleiche Wei-
se. Einen Anhaltspunkt könnte allerdings das Gen FOXP2
liefern; wir haben es mit vielen anderen Arten gemeinsam,
und es ist im Allgemeinen stark „konserviert", das heißt,
es hat sich im Laufe von Jahrmillionen kaum verändert –
außer bei den Menschen. In unserer Abstammungslinie
hat es einige wichtige Mutationen erlebt und wie sich he-
rausgestellt hat, macht dieses Gen – das kein Sprachgen,
aber für die Sprache unentbehrlich ist – Sprache unmög-
lich, wenn es durch eine Mutation ausgeschaltet wird. An
dem rekonstruierten Neandertalergenom konnte man ab-
lesen, dass auch dort die moderne Version vorhanden war;
in diesem Fall geht unsere heutige Form von FOXP2 also
wahrscheinlich auf den gemeinsamen Vorfahren von Nean-
dertalern und Jetztmenschen zurück, der vor rund 400.000

Jahren lebte, und sie wurde durch noch frühere Prozesse der natürlichen Selektion gebildet.

Nach der Hypothese vom sozialen Gehirn war die starke Zunahme der Gehirngröße im Pleistozän mit Veränderungen der Gruppengröße gekoppelt. Und die Gruppengröße bestimmt entscheidend darüber mit, ob wir eine Sprache brauchen. Als die Gehirngröße langsam zunahm, entwickelte sich wahrscheinlich auch ganz allmählich die Sprache. Das erklärt, warum es uns so schwerfällt, darüber nachzudenken: Wir stellen uns meist vor, Sprache sei vorhanden oder nicht vorhanden, genau wie man häufig annimmt, die Menschen hätten das Feuer entweder beherrscht oder nicht beherrscht.

Im Fall der Sprache geht es vor allem um die Frage, worüber gesprochen wurde. Häufig ging man fälschlicherweise davon aus, dass Sprache und Sprache immer das Gleiche ist, aber die Neandertaler zeichneten aller Wahrscheinlichkeit nach mit ihrer Sprache ein Bild von der Welt, das uns zutiefst fremdartig erscheinen würde.

Etwas, worüber man redet

Zusammenfassend kann man sagen: Die konkreten Belege für Sprache sind lückenhaft und lassen mehrere Interpretationen zu. Aber irgendwann zwischen den Homininen von Nariokotome und Sima de los Huesos hatten sich Kehlkopf und Gehirn so weit entwickelt, dass irgendeine Form von Sprache möglich wurde. Zur Klärung der Frage, wann das im Laufe dieser Million Jahre (vor 1,5 bis 0,5 Mio. Jahren)

geschah, kann die Untersuchung des sozialen Gehirns etwas beitragen.

Letztlich ergeben sich die Anhaltspunkte für das soziale Gehirn aus der Anatomie. Während des gesamten Paläolithikums ist eine Größenzunahme des Gehirns und insbesondere des Neocortex – wie sie in der oberen Graphik in Abb. 3.4 dargestellt ist – deutlich zu erkennen und erlaubt es uns, Aussagen über die Gruppengröße zu machen. Wie wir in den vorangegangenen Kapiteln erfahren haben, kann man aus dieser Graphik Vermutungen über die Zeit ableiten, die in größeren Gruppen für das gegenseitige Kraulen gebraucht wird – man kann davon ausgehen, dass ein Hominine mit einem Gehirn von 900 statt 400 Kubikzentimetern doppelt so viel Zeit dafür aufwenden muss, die meisten Individuen in seinem sozialen Umfeld zu kraulen. Wie Robin Dunbar in seinem 1996 erschienenen Buch *Grooming, Gossip and the Evolution of Language* (dt. *Klatsch und Tratsch: Wie der Mensch zur Sprache fand*) dargelegt hat, legen diese Zahlen eindringlich die Vermutung nahe, dass spätestens vor einer halben Million Jahren, wahrscheinlich aber schon früher neben dem Kraulen eine andere Form der Kommunikation notwendig wurde. In einem früheren, gemeinsam mit Leslie Aiello verfassten Artikel vertrat er die Ansicht, es müsse einen grundlegenden Wandel der Kommunikationsmittel gegeben haben, als durch die wachsende Zahl von Interaktionspartnern ein immer größerer Zeitdruck entstand. Eine Lösung dürfte darin bestanden haben, durch die Beherrschung des Feuers den sozialen Tag zu verlängern und damit einen Teil der Zeit nach Einbruch der Nacht sozial nutzbar zu machen. Nach unserer Auffassung geschah das auch, aber es war nicht mehr als

eine Teillösung. Irgendwann musste man das gegenseitige Kraulen als wichtigstes Mittel der Interaktion zwischen den Gruppenmitgliedern aufgeben. Dafür finden wir eine Form der stimmlichen Zuwendung, bei der es sich anfangs aber nicht zwangsläufig um Sprache in unserem Sinn gehandelt haben muss. Auch gibt es bei Menschen charakteristische Überbleibsel mehrerer Kommunikationssysteme – Gesten, Ausrufe (beispielsweise „autsch"), Lachen und gesprochene Sprache. Das Lachen dürfte sogar für die Evolution der Sprache sehr wichtig gewesen sein (s. Kasten „Der Klang des Lachens").

Die Zuwendung mittels der Stimme hat den großen Vorteil, dass sie die Interaktionen beschleunigt. Sie stellt eine Abkehr von den Berührungen und den beim gegenseitigen Kraulen ausgeschütteten Belohnungsopiaten dar. Mit hörbarer Kommunikation kann ein Einzelner sich an ein ganzes Publikum wenden, während das eigentliche Kraulen den intimsten Mitgliedern des sozialen Umfeldes vorbehalten bleibt. Eine grundlegende vokale Zuwendung (wie sie auch zusammengesetzt sein mag) ermöglicht außerdem eine nuancierte Verstärkung durch Singen und Rufen; unterstützt wird sie durch Gruppenaktivitäten wie Zeremonien, Tanzen, Musik, Lachen und Weinen.

Worüber also sprachen sie? Die Antwort ist einfach: übereinander. Menschen tratschen gern, und es besteht kein Grund zu der Annahme, dass es vor einer halben Million Jahren oder noch früher anders war. Sprache ist unsere uralte Methode, um etwas über andere zu erfahren und sie so zu beeinflussen, dass sie sich unseren zwischenmenschlichen Vorhaben anschließen. Das kann so banal sein wie die Entscheidung, was und mit wem man isst. Nachdem die

Sprache zur Verfügung stand, trug sie natürlich auch zur Nahrungssuche bei, und möglicherweise lernte man jetzt auch anders, wie und warum man bestimmte Dinge tut. Außerdem wurde sie zu einem Hilfsmittel für Ideologien und veranlasste am Ende tausende dazu, sich bestimmten politischen und religiösen Richtungen anzuschließen (s. Kap. 7).

Der Klang des Lachens

Die Fähigkeit zu lachen haben wir mit den Menschenaffen und insbesondere mit den Schimpansen gemeinsam, das Gelächter der Menschen hat aber eine übertriebene Form angenommen. Bei Menschenaffen ist es im Wesentlichen eine spielerische Lautäußerung, und es leitet sich von dem typischen Ruf ab, mit dem Primaten sich zum Spielen einladen. Bei Menschenaffen besteht es aus einer Reihe kurzer Stöße der Aus- und Einatmung auf der Grundlage des natürlichen Atemrhythmus. Beim Menschen dagegen ist es ein wiederholtes Ausatmen, und eingeatmet wird erst ganz am Ende, wenn die Lunge leer ist. Diese Fähigkeit, eine lange Reihe von Ausatmungen nacheinander zu vollziehen, haben nur die Menschen dank ihrer aufrechten Fortbewegung. Bei Vierbeinern wie Klein- und Menschenaffen hält die Schulter die Wand des Brustkorbes fest, sobald das Gewicht während der Bewegung auf einem Arm liegt, und deshalb können sie je Bewegungszyklus der Beine nur einmal einatmen. Bei uns Menschen dagegen sind die Arme von Gewichten befreit, sodass wir die Atmung von der Gehbewegung entkoppeln können. Dies wurde später wichtig für die Evolution der Sprache, denn die hängt ebenfalls davon ab, dass wir lange und ununterbrochen ausatmen können. Ansonsten würde jeder unserer Sätze nur aus einem Wort bestehen!

Lachen ist eine sehr soziale und höchst ansteckende Tätigkeit. Wenn mehrere andere Personen lachen, fällt es sehr schwer, nicht ebenfalls in Gelächter auszubrechen, selbst wenn wir den Witz nicht gehört haben. Nach unserer Vermutung war das Lachen anfangs vielleicht eine Form des wortlosen Skandierens, die es schon lange vor der Evolution der Sprache gab. Wenn

sich das Lachen der Menschen schon ganz in der Anfangszeit der Gattung *Homo* aus dem Gelächter der Menschenaffen entwickelte, könnte es sehr wirksam dazu beigetragen haben, die Größe der Gemeinschaften, die mit dem Endorphinbindungsmechanismus aufrechterhalten wurde, zu steigern. Es ermöglichte eigentlich eine Form des „Kraulens auf Entfernung" und versetzte den frühen *Homo* in die Lage, die Größenbeschränkungen der sozialen Gemeinschaften zu überwinden, die sich aus der Tatsache ergeben, dass das Kraulen eine Eins-zu-eins-Tätigkeit ist. Durch das Lachen ergab sich die Möglichkeit einer Zuwendungsbeziehung von einem Menschen zu vielen oder zumindest mehreren anderen.

Hier geht es vor allem um die Frage, wie groß eine typische Gruppe von Lachenden eigentlich ist. Wir denken an Gelächter häufig im Zusammenhang mit Comedyshows, bei denen ein Komiker und ein sehr großes Publikum sich gleichzeitig vor Lachen biegen. Als aber Guillaume Dezecache für ein Projekt zu diesem Thema in Kneipen auf Datensuche ging, stellte er fest, dass Gruppen, die gemeinsam lachten, in ihrer Größe ähnlich beschränkt waren wie Gesprächsgruppen, und das unabhängig davon, wie viele Menschen zufällig gerade zusammen waren. Die natürliche Obergrenze für Gesprächsgruppen liegt (wie Robin Dunbar vor einigen Jahren zeigen konnte) bei vier Personen, und die Zahl der Menschen, die gemeinsam lachen, war offenbar von Natur aus auf drei begrenzt. Das waren viel weniger, als wir erwartet hatten, aber es weist darauf hin, dass Lachen eigentlich ein intimes Verhalten ist. Vielleicht verleitet uns die Mode der Comedyvorstellungen zu der falschen Annahme, dass viele Menschen gemeinsam lachen können. In Wirklichkeit lässt schon die oberflächliche Beobachtung darauf schließen, dass in einem Comedyclub nur selten das gesamte Publikum gleichzeitig lacht: Stattdessen gibt es einzelne Stellen, an denen gelacht wird; das Gelächter wird dabei häufig von einer Handvoll Zuhörern ausgelöst und setzt sich dann wie eine stimmliche La Ola in der unmittelbaren Umgebung fort. Der Effekt verläuft aber schnell im Sande, und der Ausbruch des Gelächters kommt nicht weit voran.

> Wenn drei Menschen gemeinsam lachen, verdreifacht sich damit die Zahl der „Kraulpartner". Ich kann nur einen Menschen gleichzeitig kraulen, aber ich kann zwei Menschen zum Lachen bringen, und da ich dabei auch regelmäßig selbst lache, erleben drei Menschen zur gleichen Zeit den Endorphinschub. Zwischen der Zahl der Kraulpartner und der Größe der sozialen Gruppe besteht kein einfacher Zusammenhang, aber durch eine Verdreifachung der Zahl der Kraulpartner verdoppelt man letztlich die Größe der Gemeinschaft, die durch diesen Mechanismus zusammengehalten werden kann. Und eine Verdoppelung der Gemeinschaftsgröße von 50 auf ungefähr 100 Personen liegt genau in dem Bereich, in dem sich die Größenzunahme von den Australopithecinen bis zum Ende der Abstammungslinie von *Homo erectus/ergaster* abgespielt hat.

Gedanken auf der Zunge: Ordnungen der Intentionalität

Von der Fähigkeit der Menschen zur Mentalisierung war in früheren Kapiteln bereits die Rede; sie beruht auf einer Vorstellung, die als Theorie des Geistes bezeichnet wird. Die Mentalisierung umfasst die „Ordnungen der Intentionalität", wie Philosophen sie genannt haben; dabei repräsentiert jede Ordnung der Intentionalität einen Geist, der zusätzlich zu der Reihe hinzukommt (s. Tab. 5.1). In dieser Reihe stellt die Theorie des Geistes (oder die Intentionalität zweiter Ordnung) eine wichtige Grenze dar – man kann sich klarmachen, dass ein anderer wie man selbst einen Geist hat und die Dinge glauben kann, die man selbst glaubt. Hier müssen wir nun der Frage nachgehen, ob man ohne Sprache eine Theorie des Geistes haben kann. Im Rahmen des Lucy-Projekts beschäftigte sich James Cole, einer unserer

Doktoranden, mit dem Thema und suchte nach archäolo-
gischen Anhaltspunkten.

Entscheidend für die Entstehung der Sprache ist offen-
bar unsere Fähigkeit, über uns selbst nachzudenken und zu
reflektieren (s. Tab. 5.2). Über Selbstwahrnehmung verfü-
gen viele Tiere. Schimpansen und Elefanten erkennen sich
selbst im Spiegel, Katzen und Hunde aber nicht. Intentio-
nalität zweiter Ordnung, die Wahrnehmung des Geistes
eines anderen, erreichen nur Menschen und wenige gut
ausgebildete, in Gefangenschaft gehaltene Schimpansen.
(Eine Ausnahme könnten die Hunde sein: Angenommen,
unser Hund spürt, dass es uns schlecht geht, und setzt sich
zu unseren Füßen – vermenschlichen wir ihn dann zu stark,
wenn wir annehmen, dass er uns versteht? Daniel Dennett
äußert in seinem bekannten Buch *Animal Minds* die Ver-
mutung, dass Hunde heute in ungewöhnlich starkem Maße
sozialisiert sind.) Urteilt man nach der Gehirngröße im
Verhältnis zu der eines Schimpansen, der Komplexität ihrer
Artefakte und den Mustern ihrer sozial vermittelten Tätig-
keiten in der Landschaft, hatten die Hersteller der Acheu-
léenfaustkeile wahrscheinlich schon eine höhere Ordnung
der Intentionalität erreicht, vermutlich die dritte.

Nach Ansicht von James Cole verfügten die Hersteller
der Faustkeile wahrscheinlich nicht über eine Sprache mit
Syntax und dem komplexen Gebrauch von Symbolen. Man
kann aber wie John Gowlett mit gutem Grund vermuten,
dass die immer wiederkehrenden Konzepte, die sich in den
Faustkeilen verkörpern, auf eine frühzeitige Kennzeich-
nung oder Benennung mit sprachlichen Merkmalen hin-
deuten (irgendwie wurde eine große Informationsmenge
von einem Werkzeugmacher zum anderen weitergegeben).

Tab. 5.2 Ordnungen der Intentionalität und wer sie beherrschte

Ordnung der Intentionalität	Beherrschen	Beispiele
Sechste	Nur wenige Jetztmenschen	Komplexer Symbolgebrauch
Fünfte	Jetztmenschen mit Sprachfähigkeit, wie wir sie kennen	Erzählen immer kompliziertere Mythen und Geschichten, in denen echte und imaginäre Welten mit den zugehörigen Gestalten vorkommen
Vierte	*H. heidelbergensis* und Neandertaler	Gemeinsame religiöse Überzeugungen, in denen andere Menschen und Vorfahren vorkommen
Dritte	Alle Homininen mit großem Gehirn (>900 cm³)	Du glaubst etwas darüber, was sie glaubt, aber ich glaube das nicht
Zweite (Theorie des Geistes)	Fünfjährige Kinder, alle Homininen mit kleinem Gehirn (400–900 cm³) und vermutlich Menschenaffen	Ich glaube etwas darüber, was du glaubst
Erste	Klein- und Halbaffen, außerdem manche Säugetiere wie Elefanten und Delphine	Selbstwahrnehmung, zu erkennen an der Selbsterkennung im Spiegel; ein Glaube über etwas

Komplexe Gestaltung der Faustkeile erforderte einen mentalen Überblick, und da der Hersteller den zeitlichen Ablauf der Herstellung geistig integrieren musste, kann man behaupten, dass es eine Art operationaler Syntax gab. Mit Sicherheit fand irgendeine Form von Kommunikation statt, in deren Mittelpunkt die genaue Aufmerksamkeit für andere und die Auswertung visueller Anhaltspunkte standen. Und wie bei Klein- und Menschenaffen dienten wahrscheinlich auch Geräusche dazu, die Aufmerksamkeit in bestimmte Richtungen zu lenken und Stimmungen auszudrücken.

Wir können die Ebenen der Intentionalität bis zur fünften Ordnung verfolgen, die man bei modernen Menschen häufig antrifft. Intentionalität dritter Ordnung kennzeichnete einen Schritt in Richtung der Sprache, wie wir sie kennen. Hier kann man die gleichen Überlegungen zur Mentalisierung anstellen wie bei den Faustkeilen, aber dieses Mal gelten sie für zusammengesetzte Werkzeuge, ein Thema, das von dem Projektmitarbeiter Larry Barham erörtert wurde und in Kap. 6 genauer untersucht wird.

In ihrer Anwendung auf die Technologie sind solche Überlegungen mit der jüngeren Praxis der Menschen vergleichbar, eine allgemeine Verwandtschaftskategorie wie „Onkel" oder „Tante" zu schaffen und diese dann auch auf Personen anzuwenden, mit denen sie nicht verwandt sind, womit diese Personen von „Die" zu „Wir" werden. Die soziale Fähigkeit zur allgemeinen Verwandtschaft ist nach Ansicht des Anthropologen Alan Bernard tief in der Abstammungslinie der Homininen verwurzelt. Sie macht soziale Kategorien möglich, die von Natur aus (das heißt genetisch) nicht vorhanden sind, sondern geschaffen werden,

um durch das Knüpfen eines Netzes von Verpflichtungen den Notwendigkeiten des Überlebens Rechnung zu tragen.

Die Analyse der Gehirngröße von Neandertalern und anderen Frühmenschen durch die Projektmitarbeiterin Ellie Pearce macht eines sehr deutlich: Wenn sie eine Sprache hatten, kann es sich nicht um eine vollständige Sprache im heutigen Sinn gehandelt haben – sie konnten höchstens nach Intentionalität vierter Ordnung streben, und das hätte bedeutet, dass die Komplexität der Sprache stark vermindert war.

Die höchste Ordnung der Intentionalität (für die meisten Menschen die fünfte) findet man in Form einer Welt der Mythen, Legenden und Vorfahren. Eine derartige Erweiterung unseres sozialen Universums schafft die Möglichkeit, viele Formen der Intentionalität zu bewältigen. Nach unserer Vermutung spiegeln sich in der Geschicklichkeit, die man an der Technologie der vierten Ordnung beobachtet, neue Fähigkeiten im Umgang mit Abwesenheit und Trennung wider, durch die sich das soziale Leben fortsetzen kann. Eine solche Abwesenheit schließt das Jenseits ebenso mit ein wie den Aufenthalt in Übersee oder im Nachbarzimmer. Wenn Materialien über große Entfernungen transportiert und getauscht werden, oder wenn Körper und Objekte an eine Darstellungsweise angepasst werden, die in einem großen geographischen Gebiet als richtig anerkannt ist, spricht all das für die Fähigkeit, sich auch dann über die Gedanken anderer Menschen auf dem Laufenden zu halten, wenn man nicht jeden Tag mit ihnen zusammentrifft.

Um also unsere Frage zu beantworten: Irgendeine Form der Sprache, nicht aber unbedingt das Sprechen, war notwendig, wenn ein Hominine mehr als eine Intentionalität

zweiter Ordnung und eine richtige Theorie des Geistes be-
saß. Aber wie Cole deutlich gemacht hat, sollten wir nicht
zu streng sein, wenn wir darüber entscheiden, welcher Ho-
minine über welches Niveau der Mentalisierung verfügte.
Bei den Werkzeugen, die Schimpansen herstellen, gibt es
beträchtliche regionale Unterschiede – und ebenso unter-
schiedlich ist (wie wir seit den Pionierarbeiten von Wolf-
gang Köhler wissen) auch das Ausmaß ihrer Einsicht. Es
besteht kein Grund zu der Annahme, unter den einzel-
nen Populationen der Homininen habe es nicht ähnliche
Unterschiede gegeben. Man kann unmöglich behaupten,
eine weit verbreitete Spezies wie *Homo erectus* sei zu Inten-
tionalität dritter Ordnung in der Lage gewesen und habe
ausschließlich und immer auf dieser Ebene funktioniert.
Schließlich haben wir bereits erfahren, dass auch die Tech-
nologie des Acheuléen sowohl von Homininen mit kleinem
als auch von solchen mit großem Gehirn hergestellt wur-
de, die stimmliche Äußerungen hervorbrachten oder auch
nicht, während sie auf ihrem Weg zur Unsterblichkeit die
Steine klopften.

Zusammenfassung

Die Fossilfunde deuten darauf hin, dass die Gruppen der
Interaktionspartner in der Zeit vor 2 bis 0,5 Mio. Jahren
immer größer wurden. Bei allgemeiner Betrachtung erken-
nen wir auch, dass sich bei den Homininen ein grundlegen-
der, langfristiger Wandel in Richtung von Tätigkeiten voll-
zog, die räumlich und zeitlich größere Ausmaße hatten. Die
Maßstäbe der Gesellschaft erweiterten sich. Dies erkennt

man erstmals vor 2 Mio. Jahren. Die verstärkte Kommunikation *muss* ebenso weit zurückreichen und verkörperte sich in einer Theorie des Geistes. Wenn die Sprache keine größeren Spuren im Gehirn hinterlässt und die Asymmetrie der Seitigkeit nicht so ausgeprägt ist, dass sich dadurch größere Entwicklungen beweisen lassen, können wir zumindest sicher sein, dass sich der unentbehrliche Apparat entwickelte, sowohl im Hinblick auf die Kognition als auch in Form der anatomischen Voraussetzungen für das Sprechen. Insgesamt können wir aufzählen:

- die anatomischen Voraussetzungen für Input und Output,
- die Gleichungen des sozialen Gehirns,
- die Anforderungen einer erweiterten Landschaft,
- die Konzepte, die sich in Werkzeugen verkörpern.

Während dieser 1,5 Mio. Jahre waren die Frühmenschen zweifellos einem starken Selektionsdruck ausgesetzt. Betrachtet man die komplizierteren Ideen und Interaktionen, bestand eine dringende Notwendigkeit für eine bessere Kommunikation. Das alles spricht für die langfristige und langsame Entwicklung einer zunehmend sprachähnlichen Kommunikation (die nicht entweder vorhanden war oder fehlte und am Anfang sicher keine Sprache war, wie wir sie kennen), und die Hypothese vom sozialen Gehirn liefert insbesondere Hinweise darauf, wie vorteilhaft es war, Erkenntnisse über den Geist anderer zu gewinnen, die sich in Form immer höherer Ordnungen der Intentionalität ausdrücken.

In diesem Kapitel haben wir uns auf die drei entscheidenden sozialen Fähigkeiten konzentriert: Veränderung, Kommunikation und die Aufmerksamkeit auf das, was ein anderer tut oder sagt. Diese Fähigkeiten richten sich ebenso auf andere wie auf Dinge, ebenso auf Materialien wie auf die Sinneswahrnehmungen, auf deren Grundlage die sozialen Bindungen gestaltet werden. Jetzt kehren wir zu ihrer Verstärkung durch Vorfahren mit großem Gehirn zurück, die vor weniger als einer halben Million Jahre lebten. Es ist an der Zeit, dass wir *Homo heidelbergensis* und seine skurrilen Nachkommen kennenlernen: uns selbst und die Neandertaler.

6

Vorfahren mit großem Gehirn

Kollision der Welten

Stellen wir uns einmal Folgendes vor: Außerirdische besuchen, getrieben von langen Erinnerungen und der typischen Neugier intergalaktischer Touristen, alle 500.000 Jahre die Erde. Vor 1,5 und einer Million Jahren fanden sie bei ihren Visiten den *Homo erectus* und wunderten sich darüber, wie langsam der Wandel ablief. Bei ihrem nächsten Besuch vor 500.000 Jahren trafen sie auf *Homo heidelbergensis*, und der erinnerte sie mehr oder weniger an ihre beiden vorangegangenen Reisen, auch wenn der Kopf mittlerweile deutlich größer war. Das Letzte, womit sie für das nächste Mal gerechnet hätten, waren wir – der *Homo sapiens*, der in Städten lebt, eine hoch entwickelte Technologie besitzt,

das Sonnensystem erkundet und mit dem Smartphone kommuniziert. Verblüfft wären sie auch darüber, dass diese klugen Köpfe nicht viel größer sind als beim letzten Mal. Über die Reise nach dem Motto „Da ändert sich nicht viel" müssen sie nun zu Hause mit den Worten „Kaum drehst du dich um, schon hast du was verpasst" berichten.

Wie wir es auch betrachten: Der Wandel hat sich bemerkenswert beschleunigt. Er hat uns vom Silikat zum Silizium geführt, vom Herdfeuer in den Cyberspace und von einer Weltbevölkerung, die am Ende der letzten Eiszeit bei 7 Mio. lag, zu 7 Mrd. heute bei steigender Tendenz. Solche Veränderungen konnten sich nur vollziehen, wenn als Fundament geeignete Sozialstrukturen vorhanden waren, aber was trieb den Prozess voran?

Alle drei Arten von *Homo*, die in diesem Kapitel beschrieben werden – *H. heidelbergensis* und seine beiden eng verwandten Nachkommen *H. neanderthalensis* und *H. sapiens* – hatten ein großes Gehirn. Das Spektrum reichte dabei von 1200 bis über 1500 Kubikzentimeter. Alle drei Arten sind eng verwandt: *H. heidelbergensis* ist der Vorfahre sowohl der europäischen und westasiatischen Neandertaler als auch der Jetztmenschen in Afrika; sein Gehirn lag am unteren Ende des genannten Größenbereichs, war aber im Vergleich mit dem weit verbreiteten *Homo erectus* immer noch groß. Aber ein großes Gehirn und das entsprechend komplexere soziale Umfeld erklären noch nicht den zeitlichen Ablauf der Veränderungen, die unser gelegentlicher außerirdischer Besucher gesehen hätte. Außerdem ist Größe nicht alles – das werden wir im Zusammenhang mit dem Aufbau des Neandertalergehirns erfahren. Das Diagramm

des sozialen Gehirns sagt für die Neandertaler eine Gruppengröße von 140 bis 150 voraus, der Aufbau ihres Gehirns lässt aber auf eine geringere Größe von nur 120 schließen, die eher der von *H. heidelbergensis* entspricht. In diesem Kapitel befassen wir uns mit den Schritten 7 bis 9 in der Entwicklung vom Homininen zum Menschen (s. Tab. 1.2).

Mach mal lauter

Zu den archäologischen Rätseln, über die wir uns während des Lucy-Projekts den Kopf zerbrachen, gehörte das Fehlen von Neuerungen bei den Homininen mit großem Gehirn. Erst vor 50.000 Jahren, mehr als 800.000 Jahre nachdem *H. heidelbergensis* auf der Bildfläche erschienen war, fand eine ganze Reihe von Artefakten, die man locker unter der Überschrift „Kunst und Schmuck" zusammenfassen kann, allgemeine Verbreitung. In Afrika gibt es zwar Vorläufer wie die am Kap und in Marokko gefundenen einfachen Perlen aus Schneckenhäusern, aber in der übrigen Welt setzten sie sich erst viel später durch (s. Abb. 6.3). Und auch sie entstanden erst lange nachdem die Gehirngröße zugenommen hatte. Müsste ein so großes, aufwendig zu ernährendes Gehirn nicht sofort Auswirkungen auf die Gestaltung von Werkzeugen und die Fähigkeit zur symbolischen Nutzung von Artefakten durch die Erkundung höherer Ordnungen der Intentionalität haben? Mit einer solchen Auswirkung auf die Kultur würden zumindest die Archäologen herkömmlicherweise rechnen. Das Rätsel blieb also bestehen: ein großes Gehirn, komplexere soziale Gruppen, aber im

Großen und Ganzen die gleiche einfache alte Steintechnologie. Warum gelangten wir vom Paläolithikum nicht in einem Bruchteil der Zeit, die es tatsächlich dauerte, zur Technologie von heute?

Dann fiel der Groschen. Wir sind völlig an den technologischen und kulturellen Wandel gewöhnt. Er ist in unserer Welt eine Selbstverständlichkeit. Unser Gehirn ist aber immer noch genauso groß wie das eines *Homo sapiens* wie Herto aus Äthiopien, der vor 160.000 Jahren die Technologie des unteren Paläolithikums schuf, wie die Archäologen sie nennen. Was wir in der Zwischenzeit erlebt haben, ist ein Prozess der *Verstärkung*, die auf die Technologie angewandt wurde. Diese Verstärkung – wir vergleichen sie gern mit dem Höherstellen der Lautstärke in unseren Kopfhörern – kann man in Form der Vielfalt und Vielschichtigkeit kultureller Hervorbringungen und der Technik zu ihrer Herstellung messen. Ein ausgezeichnetes Beispiel nennt Brian Fagan in seiner 2004 erschienenen Übersicht *The Seventy Great Inventions of the Ancient World* (dt. *Die 70 großen Erfindungen des Altertums*), die bei den Steinwerkzeugen beginnt und mehr als 2 Mio. Jahre später mit Verhütungsmitteln und Aphrodisiaka, deren Alter auf 1400 Jahre datiert wurde, endet. In diesem großen Marsch durch die Geschichte stößt man auf eine atemberaubende Vielfalt ganz gewöhnlicher Gegenstände wie beispielsweise Keramik, während die Vielfalt des kulturellen Repertoires mit dem Übergang von der Stein- zur Metalltechnologie zunimmt.

Dieser Verstärkungsprozess schenkt uns die schiere Vielfalt der materiellen Güter, mit denen wir unser Sozialleben (das immer noch durch die Dunbar-Zahl strukturiert wird)

ausgestalten. Wie der Archäologe Larry Barham deutlich gemacht hat, erkennen wir schon vor 300.000 Jahren eine technologische Verstärkung: Als Steine an hölzernen Schäften befestigt wurden, entstanden die ersten zusammengesetzten Werkzeuge. Dieser Vorgang mag im Vergleich zu den tausenden Bauteilen eines Autos oder der verwirrenden Warenvielfalt in einem Supermarkt bis zur Bedeutungslosigkeit verblassen, aber nach den Maßstäben der damaligen Zeit stellt er eine Verstärkung der Technologie dar. Und er warnt uns davor, die Homininen von Herto mit ihren Faustkeilen als unveränderlich abzutun.

Was könnte sich sonst noch verändert haben? An dieser Stelle fiel ein zweiter Groschen. Sozialleben besteht nicht nur aus Artefakten wie Grabbeigaben und der künstlich geschaffenen Umwelt, die ihm eine bestimmte Form verleiht. Für das soziale Gehirn – und hier waren die Erkenntnisse der Primatenbeobachter in unserem Projekt von unschätzbarem Wert – besteht Sozialleben auch aus Interaktionen zwischen jeweils zwei Individuen wie Mutter und Kind. Auf dieser Ebene geht es um den Aufbau dauerhafter Beziehungen. Und eine der wichtigsten Ressourcen, die solche Bindungen so stark machen, sind unsere Gefühle. Mit unserer Fähigkeit zur Mentalisierung machten wir ein überlebensnotwendiges Gefühl wie die Angst zu einer komplexen sozialen Emotion wie der Habgier. Hier trug die kognitive Fähigkeit, die Stimmung eines anderen zu erkennen, entscheidend zum Begreifen der Abläufe bei.

Emotionen können mit oder ohne Nutzung der Technologie, die auf Materialien als zweite entscheidende Ressource zurückgreift, verstärkt werden. Ein gutes Beispiel ist

die Musik, ganz gleich, ob sie nur aus Singen – allein oder mit anderen – besteht oder ob Instrumente hinzukommen und ein Orchester oder eine Kapelle bilden. In jedem Fall verändert sie die Stimmung und verstärkt die sozialen Interaktionen. Das muss auch geschehen, denn mit wachsender Gruppengröße wächst auch die Notwendigkeit, mehr Sozialpartner einzuschließen und die Bindungen zu intensivieren.

Entsprechend sieht unser Lösungsvorschlag für das archäologische Rätsel des fehlenden Wandels aus: Bei unseren Gefühlen fand ein Prozess statt, der zur Verstärkung von Technologie und Kultur analog war. In diesem Kapitel werden wir genauer erörtern, was die emotionalen Bindungen bewirken, die hinter Musik und Verwandtschaft stehen, und welche Rolle die Religion für unsere emotionale und kognitive Entwicklung spielte. Alle diese Vorgänge können ohne Unterstützung durch die Technologie ablaufen. Insbesondere die emotionale Intensität von Musik und Religion wurde verstärkt, weil die Sinneswahrnehmungen, die ihnen zugrunde liegen, zum Anlass für neue Formen der Technik wurden, so für Trommeln, Weihrauchfässer, Tanzsäle oder das Echo eines Chores in einem Fächergewölbe.

Aber auch wenn bei uns der Groschen gefallen ist, haben wir den Verdacht, dass die meisten Archäologen unserer Lösung für das Rätsel skeptisch gegenüberstehen werden. Bevor sie sich überzeugen lassen, wollen sie nach wie vor die materiellen Spuren der verstärkten Gefühle sehen, denn so funktioniert die Archäologie: Sie ist keine experimentelle, sondern eine historische Wissenschaft. Dabei stellt sich nur ein Problem: Ein derart minimalistischer Ansatz lässt vieles von dem, was es bedeutet, ein Hominine zu sein, außen vor

und wirft uns damit leider wieder zum Klischee des Höhlenmenschen zurück, der keinen Scharfsinn besitzt und in einer Welt, in der es kaum ein Sozialleben gibt, mithilfe seiner groben Instinkte überlebt.

Die meisten Archäologen, die wir kennen, bewerten die Befunde und gelangen dann zu der Schlussfolgerung, dass sich das „wahre" Menschsein erst vor sehr kurzer Zeit durch „Revolutionen" entwickelt hat. Ihrem Ansatz liegt aber das Prinzip WYSWTW (*What You See is What There Was* – Was du siehst, ist das, was war) zugrunde. Wäre WYSWTW wahr, hätten sie den richtigen Ansatz gewählt. Wir wissen aber, dass die meisten Belege schnell verfallen: Je älter sie sind, desto mehr ist verschwunden, und das müssen wir in Rechnung stellen. Menschsein besteht zweifellos nicht nur aus abgeschlagenen Steinstücken, zerlegten Tierknochen und einfachen Halsketten aus Muschelschalen, die erhalten geblieben sind. Wir müssen einen Rahmen finden, der auch Raum für alle anderen charakteristisch menschlichen Eigenschaften bietet – für Verwandtschaft, Lachen, Sprache, den Gebrauch von Symbolen, aber auch für Musik und Zeremonien. Ein solcher Rahmen ist das soziale Gehirn mit seiner vergleichenden, fachübergreifenden Leistungsfähigkeit. Und außerdem kann man innerhalb dieses Rahmens danach fragen, wann solche Merkmale in ferner Vergangenheit bei unseren steinzeitlichen Vorfahren zum ersten Mal auftauchten.

Auf das Wann dieses langfristigen Prozesses hat sich viel Aufmerksamkeit gerichtet, das Wie wurde aber viel weniger beachtet. In diesem Kapitel wollen wir das Bild vervollständigen. Auf der Grundlage des sozialen Gehirns können wir einen anderen Ansatz wählen als die meisten

übrigen Wissenschaftler, denn wir können sofort die Liste
der allgegenwärtigen Kernressourcen einsetzen, jener Sin-
neswahrnehmungen und Materialien, mit deren Hilfe die
Homininen immer ihre unmittelbaren, überragend wichti-
gen sozialen Bindungen gestaltet haben (s. Abb. 3.2). Wir
werden uns einige neuartige soziale Formen ansehen, die
zur Unterstützung des Soziallebens geschaffen wurden.
Dazu gehören neue Gefühle wie das Mitleid, aber auch die
Musik zur Untermalung von Zeremonien, in die irgend-
wann auch die Vorstellung von einem Jenseits einfloss. Sie
spielten mit den Sinneswahrnehmungen, verstärkten sie auf
neue Weise und schufen damit stärkere Bindungen, die eine
größere Zahl von Individuen und bei Bedarf auch größere
physische Entfernungen in Rechnung stellten. Gleichzeitig
stand aber auch das handfeste Material zur Stärkung der
überragend wichtigen Bindungen zur Verfügung. Auf die
Bedeutung zusammengesetzter Werkzeuge wurde in Kap. 5
bereits hingewiesen. Diese setzten sich bei Homininen mit
großem Gehirn wie *H. heidelbergensis* und den Neander-
talern allgemein durch und erlangten schließlich in der
Technologie des *Homo sapiens* eine beherrschende Rolle.
Sie bestanden aus vielen Materialien und Kombinationen
von Bestandteilen wie die Messerschneide, die aus mehre-
ren Steinschneiden zusammengesetzt war. Dieses Interesse
daran, Dinge zusammenzusetzen und aus verschiedenarti-
gen Elementen neue Werkzeuge herzustellen, ist ein Zei-
chen dafür, dass die Menschen sich eine komplexere Welt
aufbauten und in ihr lebten. Am Ende erstreckte sie sich
auch auf Zeichen und Symbole. Entsprechend setzten sich
Zeichnungen, figürliche Kunst, Verzierungen und farbliche

Darstellungen mit Materialien wie Ocker allgemein durch. Schließlich wurden die Menschen selbst zu zusammengesetzten Artefakten: Sie legten Kleidungsstücke an, hüllten sich in Rüstungen, verzierten sich mit Schmuck, frisierten sich, benutzten Parfüms und Körperbemalung und trugen Tattoos. Solche zusammengesetzten Kreationen wurden ständig erweitert und führten sowohl zu kultureller Vielfalt als auch zu individueller Variation.

Homo mit großem Gehirn

Wenn wir die Entstehung solcher Faktoren richtig einschätzen wollen, müssen wir die drei Homininen, die zu Beginn dieses Kapitels vorgestellt wurden, genauer betrachten. Vor 500.000 Jahren war der Schwellenwert des großen Gehirns, den wir auf 900 Kubikzentimeter angesetzt hatten, eindeutig und wahrhaftig überschritten. *Homo erectus* (s. Kasten in Abschn. 5.1) schiebt sich gerade noch ans untere Ende des Spektrums. Die eigentlichen Homininen mit großem Gehirn jedoch sind die drei eng verwandten Arten seiner Nachkommen: *heidelbergensis, neanderthalensis* und *sapiens* (s. Tab. 6.1).

Einige Funde aus vielen Teilen der Alten Welt legen die Vermutung nahe, dass *Homo heidelbergensis*, die neue Form der Menschen, bereits vor 800.000 Jahren entstand. Der Paläoanthropologe Philip Rightmire hat diese Ansicht in einer Reihe von Artikeln erörtert. Für Vergleiche stehen nur erstaunlich wenig Funde zur Verfügung – drei oder vier aus Afrika und eine ähnliche Zahl aus Europa. Aus Afrika

Tab. 6.1 Drei Hominen mit großem Gehirn. Die geringere Größe, die für die Gemeinschaft der Neandertaler vorausgesagt wird, berücksichtigt den Aufbau ihres größeren Gehirns; Näheres dazu im Kasten in Abschn. 6.5.2

	Durchschnittliche Gehirngröße (cm³)	Theoretisch vorausgesagte Gruppengröße	Alter (Jahrtausende)
Homo sapiens (vor mehr als 11.000 Jahren, weltweit)	1478	144	200–11
Homo neanderthalensis (Eurasien)	1426	120	300–30
Homo heidelbergensis (Europa: Steinheim, Petralona, Atapuerca)	1240	128	600–250
Homo heidelbergensis (Afrika: Bobo, Kabwe, Ndutu)	1210	126	800–250

Daten aus © Rightmire 2004; Wood und Lonergan 2008

wurde nur der Schädel von Bodo in Äthiopien zuverlässig auf ungefähr 600.000 Jahre datiert, das Alter der Funde von Kabwe und Elandsfontein im südlichen Afrika ist dagegen nach wie vor nicht gesichert. Aber Bodo zeigt mit seinen 1250 Kubikzentimetern ausreichend deutlich, dass die Gehirngröße bei den afrikanischen Menschen zumindest in einigen Fällen um mehr als 200 Kubikzentimeter über die von *Homo erectus* hinausgewachsen war, ein An-

stieg von ungefähr 20 %, mit dem wir uns dem heutigen Größenbereich nähern. Die Schädel von Ndutu (in der Nähe der Olduvaischlucht) und Kabwe (in Sambia) sind kräftig gebaut, haben aber ein höheres Schädelgewölbe als *Homo erectus* und tragen auch in Gesicht und Gaumen modernere Merkmale. Nach Ansicht von Rightmire kann man die neue Spezies wegen ihrer Ähnlichkeiten mit späteren Funden aus Europa als *Homo heidelbergensis* bezeichnen. Letztere sind ausnahmslos jünger, ein deutlicher Hinweis darauf, wie spärlich die Primärdaten sind. Dennoch besteht kein Zweifel, dass irgendwann in der neuen Ära, dem mittleren Pleistozän, die lange Zeit des unveränderten *Homo erectus* zu Ende ging und die Evolution den Weg zu einem größeren Gehirn einschlug.

Angesichts der Tatsache, dass in riesigen Regionen keine Überreste von Homininen erhalten geblieben sind, repräsentieren diese wenigen Schädel einen guten Kandidaten für den Vorfahren aller späteren Menschen. Um uns über sie einen Überblick zu verschaffen, müssen wir zu uns selbst, dem modernen *Homo sapiens*, zurückkehren, aber auch zu unseren Vettern, den Neandertalern (*Homo neanderthalensis*). Damit bleiben immer noch große Teile der Welt übrig, und wir verfügen nur über vereinzelte, weit verstreute Funde. Eine große Hilfe sind jedoch die neuen Kenntnisse über ganze Genome. Diese zeigen zweifelsfrei, dass *Homo sapiens* und *Homo neanderthalensis* auf einen gemeinsamen Stammvater zurückgehen, der vermutlich vor ungefähr einer halben Million Jahre lebte, was genau zu *Homo heidelbergensis* passen würde (s. Abb. 6.1).

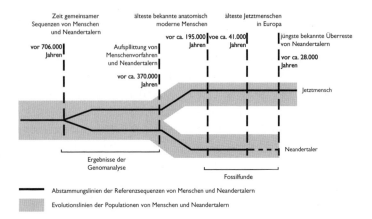

Abb. 6.1 Die Aufspaltung der Menschenpopulationen während der letzten Million Jahre, nachgewiesen durch genetische Untersuchungen und Fossilfunde. Die Zeitpunkte sind zwangsläufig näherungsweise. Neue Forschungsergebnisse legen die Vermutung nahe, dass es sich bei den Neandertalern und den (hier nicht gezeigten) Denisova-Menschen um Schwestergruppen handelt, deren Vorfahren sich vor rund einer halben Million Jahre trennten. (Nach © Noonan et al. 2006)

Ähnlich und doch anders

Was bedeutet ein großes Gehirn im Hinblick auf die Größe des persönlichen Netzwerks? Wie bereits erwähnt wurde, ist die Entstehung von *Homo* – das heißt der ersten Mitglieder unserer Gattung – vor rund 2 Mio. Jahren durch eine charakteristische Zunahme der Größe der Gemeinschaften gekennzeichnet: Sie umfassten jetzt zwischen 80 und 100 Individuen (mit einer geringfügigen Zunahme im Laufe der Zeit). Danach blieb sie aber für nahezu 1,5 Mio. Jahre mehr oder weniger konstant.

Dann, vor etwa 800.000 Jahren, entwickelte sich aus den Populationen des afrikanischen *Homo erectus* der erste Hominine mit großem Gehirn: *Homo heidelbergensis*. Nach unserer Überzeugung führte dies im weiteren Verlauf zu einer stetigen Zunahme der Gehirn- und Gruppengröße, die für die Entwicklung eines stärker organisierten Soziallebens unentbehrlich war. Im Norden gingen aus den Populationen von *Homo heidelbergensis* schließlich die Neandertaler (*Homo neanderthalensis*) hervor, die durch charakteristische anatomische Merkmale an das Leben im kalten Klima der hohen Breiten angepasst waren. Die Neandertaler waren eigentlich eine unglaublich erfolgreiche Spezies: Sie besiedelten seit der Zeit vor 200.000 Jahren oder noch früher Europa und den Westen Asiens bis an die Grenzen Sibiriens und verschwanden erst irgendwann vor weniger als 30.000 Jahren. Mit ihrem schweren, stämmigen Körperbau kamen sie mit den Problemen des Wärmeverlusts, mit denen sich alle Arten in hohen Breiten insbesondere im Winter zwangsläufig auseinandersetzen müssen, besser zurecht. Und mit ihrer größeren Körperkraft konnten sie auch bei der Jagd stärker auf Konfrontation setzen, was sich bei den großen Herden von Hirschen, Bisons und Mammuts, die sie in den Ebenen Europas südlich der polaren Eiskappe vorfanden, als höchst erfolgreich erwies. Mit ihren schweren Wurfspeeren konnten sie Jagd auf große, fleischreiche Beutetiere machen, und die proteinreiche Ernährung ermöglichte ihrerseits den Aufbau eines großen, muskulösen Körpers.

Im Zusammenhang mit dem sozialen Gehirn stellt sich hier eine Frage. Neandertaler und *Homo sapiens* hatten ein ähnlich großes Gehirn; wie kommt es dann, dass sie über so

unterschiedliche technische Fähigkeiten verfügten? Unsere Antwort lautet: Über lange Zeit war das nicht der Fall – bis vor rund 100.000 Jahren ließen die Neandertaler die gleichen Fähigkeiten und Vorgehensweisen erkennen wie ihre Vettern weiter im Süden. In gewisser Hinsicht jedoch wirken die Neandertaler stärker eingeschränkt oder eingegrenzt. Sie besiedelten im Norden ihre Territorien in weiten Bereichen Eurasiens, verließen aber diese Heimat nie und besiedelten weder in niedrigeren Breiten noch nördlich des Polarkreises unbekannte Länder. Die Ausbreitung nach Norden hätte ihnen die Möglichkeit eröffnet, weiter östlich die Beringlandbrücke[1] zu überqueren und so nach Amerika zu gelangen. Ganz anders dagegen der *Homo sapiens*: Er ergriff am Ende solche Gelegenheiten im Rahmen seiner weltweiten Ausbreitung, die vor ungefähr 100.000 Jahren in Afrika ihren Anfang nahm. Eine Antwort auf die Frage, warum Neandertaler und Jetztmenschen so unterschiedlich sind, gibt der Kasten „Neandertaler: große Augen, großes Gehirn".

Vom Homininen zum Menschen: einige gemeinsame Faktoren

Das große Gehirn war für den Übergang vom Homininen zum Menschen notwendig, aber dies allein ist ebenso wenig eine Erklärung wie die Technologie. Näher am Kern der Sache liegt der Aufbau des sozialen Umfeldes, und da-

[1] In Phasen mit niedrigem Meeresspiegel, als das Wasser wie während der Eiszeit als Eis gebunden war, öffnete sich in der Beringstraße zwischen Sibirien und Alaska eine Landbrücke, die Asien mit Amerika verband.

bei waren auch mehrere andere Faktoren sehr wichtig. Wir wollen hier insbesondere Musik, Verwandtschaft und Religion herausgreifen.

Musik und Gefühle

Im vorangegangenen Kapitel haben wir erfahren, wie schon etwas so Einfaches wie das Lachen zur Vergrößerung der sozialen Gruppe führen kann. Außerdem haben wir die Ansicht vertreten, dass die Sprache in der Geschichte der Homininen schon frühzeitig herangezogen wurde, um die Probleme der Zuwendung in größeren Gemeinschaften zu lösen. Wir haben sogar die Vermutung geäußert, dass die Sprache sich aus dem Lachen entwickelt hat. An dieser Stelle sind wir aber wieder einmal an eine Grenze gestoßen. Damit unsere drei Homininen mit großem Gehirn – *H. heidelbergensis*, die Neandertaler und *H. sapiens* – die Größe ihrer Gemeinschaften weiter erhöhen konnten, war noch etwas anderes erforderlich.

Dieses andere war, wie auch Steven Mithen in seinem 2005 erschienenen Buch *The Singing Neanderthals* erkannte, die Musik – oder genauer gesagt, Gesang und Tanz. Diese Formen der Musik ermöglichten den Übergang vom Lachen zum Sprechen. Das Singen konnte ausschließlich wortlos in Form des gemeinsamen Skandierens stattfinden, das sich vielleicht vom Lachen ableitete. Entscheidend ist dabei, dass es sich um eine sehr rhythmische Tätigkeit handelt, die für die Muskulatur anstrengend ist. Singen ist viel anspruchsvoller als Sprechen, und das Tanzen ist natürlich erst recht körperbetont. Und wie wir in Kap. 2 erfahren haben, ist das Musizieren in seinen verschiedenen Formen

auch ein guter Auslöser für die Endorphinausschüttung. Wie wir mit unseren Experimenten zeigen konnten, ist beim Musizieren vor allem die dafür erforderliche körperliche Anstrengung wichtig: Passiv Musik zu hören, ruft nicht den gleichen Effekt hervor.

Darüber hinaus hat das Musizieren eine weitere wichtige Eigenschaft: Es ermöglicht einer größeren Gruppe die Mitwirkung als das Lachen. Wo die Obergrenze für die Größe singender oder tanzender Gruppen eigentlich liegt, wissen wir nicht, aber sie ist sicher höher als bei den drei oder vier Individuen, die gemeinsam lachen. Entscheidend ist dabei aber, dass solche musikalischen Tätigkeiten auch eine andere Eigenschaft haben, aus der sich offenbar für die Endorphinausschüttung wichtige Folgerungen ergeben: Sie sind stark synchronisiert. Synchron etwas zu tun, führt offenbar im Vergleich zu der gleichen Tätigkeit, die man individuell ausführt, zu einer deutlichen Erhöhung der ausgeschütteten Endorphinmenge – ein Musterbeispiel für die Verstärkung von etwas bereits Vorhandenem, was dann eine Lösung für ein soziales Problem bietet. Außerdem ist damit erklärt, warum wir so gern im Gleichschritt marschieren, gemeinsam am gleichen Strang ziehen oder die gleiche Melodie singen.

Verwandtschaft und Mentalisierung

Verwandtschaft ist unter Menschen eine starke Bindungskraft. Sie ist ein gutes Beispiel für „soziale Lagerung": Verpflichtungen, Verbindungen und emotionale Bande werden fein säuberlich in eine Kiste mit der Aufschrift „Familie" gesteckt. Man kann um Gefallen bitten, ohne viel darü-

ber nachdenken zu müssen und ohne in größerem Umfang soziales Kapital aufzuwenden. Freunde um das Gleiche zu bitten, ist etwas ganz anderes.

Die Neandertaler: große Augen, großes Gehirn

Warum sind die Neandertaler so anders als Jetztmenschen, wo beide doch von einem gemeinsamen Vorfahren abstammen, der erst vor ungefähr einer halben Million Jahren lebte? Unter anderem könnte es daran liegen, dass die Neandertaler über lange Zeit hinweg viel weiter im Norden zu Hause waren als alle anderen Homininenarten. Das Leben in hohen Breiten wirft ein besonderes Problem auf, dem die Arten in den Tropen nicht gegenüberstehen: die geringe Lichtmenge, insbesondere im Winter. Dabei sind zwei Aspekte zu unterscheiden. Wenn man sich vom Äquator in Richtung eines Pols bewegt, muss das Sonnenlicht erstens wegen der Kugelform der Erde einen immer längeren Weg durch die Luft nehmen, wobei sich natürlich seine Stärke vermindert. Und es verringert sich weiter in hohen Breiten insbesondere auf der Nordhalbkugel durch die meist dichtere Wolkendecke. Zweitens ist das Klima obendrein in der Nähe der Pole viel stärker jahreszeitlich geprägt, weil die Erdachse im Verhältnis zur Umlaufbahn um die Sonne schräg steht, sodass die Sonne während des nördlichen Winters über dem südlichen Wendekreis steht und umgekehrt. Die Folge ist eine dramatische Schwankung der Tageslänge während des Jahres, die uns die Jahreszeiten mit kurzen Tagen im Winter und langen Tagen im Sommer beschert. Arten, die in hohen Breiten zu Hause sind, müssen mit langen, dunklen Nächten und kurzen, trüben Tagen zurechtkommen.

Als Lösung für dieses Problem entwickelte sich in der Evolution häufig eine größere Netzhaut (die lichtempfindliche Schicht an der Rückwand des Augapfels), die einen größeren Anteil des verfügbaren lichtes absorbieren kann. (Mehr oder weniger das gleiche Prinzip macht man sich auch bei Nachtsichtgeräten zu Nutze, die mehr Licht sammeln und durch die Pupille des Auges auf die dahinter gelegene Netzhaut fokussieren.) Und wer eine größere Netzhaut haben will, muss aus einfachen

physikalischen Gründen auch über einen größere Augapfel ver-
fügen, die sie aufnimmt. Tatsächlich hatten die Neandertaler
ungewöhnlich große Augen (sie waren um rund 20 % größer als
die heutiger Menschen). Außerdem waren sie durch ein anderes
charakteristisches Merkmal gekennzeichnet: den sogenannten
„Neandertalerknoten" am Hinterkopf. Unser Schädel ist mehr
oder weniger kugelförmig, bei den Neandertalern aber war er
länglich und hatte auf der Rückseite diese Verdickung. Im hin-
teren Teil des Gehirns befindet sich auch das Areal, das für die
Verarbeitung visueller Reize zuständig ist, und bei den Primaten
besteht generell zwischen dem Volumen der Sehfelder im Ge-
hirn, dem Volumen des Sehnervs sowie der dazwischen gelege-
nen Schaltstationen und dem Volumen des Augapfels eine sehr
enge Korrelation. Das ist nicht allzu verwunderlich, denn das
Sehsystem ist insgesamt wie eine sehr einfache Landkarte orga-
nisiert: Zu jedem Abschnitt der Netzhaut gehören passende Ab-
schnitte in den aufeinanderfolgenden Schichten der Sehrinde.
Wer also eine größere Netzhaut besitzt, muss auch im Gehirn
ein größeres Sehsystem haben, das die Lichtsignale verarbeitet.
Wenn die Neandertaler größere Augäpfel hatten, folgt daraus,
dass auch ihre Netzhaut und die zugehörigen Sehfelder im Ge-
hirn größer waren. Deshalb musste auch ihr Gehirn insgesamt
größer sein – es sei denn, sie wären bereit gewesen, einen ande-
ren Gehirnteil zu Gunsten der besseren Sehfähigkeit zu opfern.

Bei den Neandertalern dürfte dies der Fall gewesen sein.
Anders als ihre Schwesterspezies, der *Homo sapiens*, waren sie
offenbar im Hinblick auf die Evolution ihres Gehirns sehr kon-
servativ. Mit anderen Worten: Obwohl das Gesamtvolumen
ihres Gehirns wuchs, blieb der „normale" (das heißt frontale)
Teil unverändert: Nur die Größe der Felder im hinteren Teil des
Gehirns, die dem Sehen dienten, nahm zu. Entsprechend blieb
die Größe ihrer Gemeinschaften im gleichen Bereich wie bei den
archaischen Menschen, von denen sie abstammten. Dagegen
spielte sich in den Populationen ihrer afrikanischen Vettern, aus
denen die anatomisch modernen Menschen (das heißt wir) her-
vorgingen, aus irgendeinem Grund eine echte, funktionsabhän-
gige Zunahme der Gehirngröße ab. Da sich diese Vettern in den
Tropen entwickelten, brauchtes sie kein größeres Sehsystem,
sondern die Größenzunahme fand im vorderen Teil des Gehirns

statt. Und da die Stirnlappen offenbar für die Größe der sozialen Gruppen entscheidend sind, konnten ihre Gemeinschaften von der für archaische Menschen und Neandertaler typischen Größe von 100 bis 120 Individuen auf 150 anwachsen, die heute für uns charakteristisch ist. Als diese Populationen später (vor rund 70.000 Jahren) nach Eurasien vordrangen, konnte ihre Gehirngröße sich ebenfalls so anpassen, dass sie mit der geringeren Lichtmenge zurechtkamen – aber die Größe des sozialen Gehirns hatte bereits zugenommen, und so kam das Volumen für das Sehsystem hinzu, ohne dass in den Stirn- oder Schläfenlappen etwas geopfert wurde.

Um zu überprüfen, ob der Neandertalerknoten tatsächlich Teil einer Anpassung an die Lichtarmut in hohen Breiten war, untersuchte Ellie Pearce, eine Doktorandin aus dem Lucy-Projekt, zuerst heutige Menschen aus verschiedenen Breiten. Sie vermaß an Schädeln aus Museumssammlungen das Volumen von Gehirn und Augenhöhlen und setzte dies in Beziehung zu den geographischen Breiten, in denen die Menschen, von denen die Schädel stammten, früher gewohnt hatten. Es handelte sich dabei übrigens in allen Fällen um Menschen, die in den letzten 200 Jahren gelebt hatten. Sie stellte einen engen Zusammenhang zwischen der Größe der Augenhöhlen und der geographischen Breite fest, und eine ähnliche Korrelation zeigte sich auch zwischen dem Schädelvolumen (das mehr oder weniger der Gehirngröße entspricht) und dem Breitengrad. Mit anderen Worten: Menschen, die aus höheren Breiten stammen, haben tatsächlich größere Augäpfel und ein dazu passendes, größeres Gehirn. Anhand eines anderen Datenbestandes konnte Pearce aber auch zeigen, dass die Sehschärfe (das heißt die Fähigkeit, zwischen verschiedenen Formen zu unterscheiden) mit der geographischen Breite kaum schwankt. Als die Jetztmenschen vom Äquator aus weiter nach Norden (und nach Süden) wanderten, vergrößerte sich also ihre Sehsystem als Ausgleich für die geringere Lichtmenge, und gleichzeitig blieb dabei die Sehschärfe ungefähr gleich. Offenbar wohnten die Neandertaler einfach so frühzeitig in nördlichen Regionen, dass sich bei ihnen das vollständig ausgeprägte soziale Gehirn, das den *Homo sapiens* charakterisiert, nicht entwickeln konnte.

Die Verwandtschaft aus der Sozialanthropologie aufgrund archäologischer Daten nachzuzeichnen, ist unter Umständen nicht einfach. Aber in den langen Zeiträumen der Evolution erkennt man einige Orientierungspunkte. Der Anthropologe Alan Barnard beschrieb eine allgemeine Form der Verwandtschaft, die es heutigen Jägern und Sammlern gestattet, sich ungehindert in den großen Regionen zu bewegen. Die Vorstellung von Verwandtschaft reicht in diesem Fall über die enge genetische Beziehung hinaus. Sie bedeutet eher, dass man völlig fremde Menschen mit „Onkel" oder „Tante" anredet, um mit den Begriffen für Verwandtschaftsverhältnisse eine Bindung herzustellen. Nach Barnards Vermutung war diese universelle Verwandtschaft die älteste Form von Verwandtschaftsverhältnissen, die in den letzten 200.000 Jahren die Grundlage für alle menschlichen Gesellschaften bildete, auch für die der anatomisch modernen Menschen. Damit könnte er durchaus Recht gehabt haben. Ebenso könnte sie sich aber auch aus Bindungen entwickelt haben, die sich ausschließlich auf die Ähnlichkeit der Gene stützten. Mit anderen Worten: Die große Wanderung, mit der die Jetztmenschen seit der Zeit vor 50.000 Jahren die Grenzen der Alten Welt überwanden und bis nach Australien und dann nach Amerika vordrangen, wurde durch diese Entwicklung begünstigt; sie bedeutete einen Wandel, durch den zwischenmenschliche Beziehungen über Raum und Zeit hinweg ausgeweitet werden konnten. Das war befreiend in dem Sinn, dass soziale Bindungen durch die Abwesenheit der Partner nicht mehr durchtrennt wurden. Stattdessen wurden sie gestärkt, weil man sie je nach den kulturellen Regeln der Verwandtschaft neu gestaltete. In Kap. 2 haben wir beschrieben, wie jun-

ge Menschen, die auf die Universität gingen, ihre Freunde wechseln, nicht aber ihre Familienangehörigen. Die Kraft der Verwandtschaft hält auch über die Entfernungen hinweg, während man täglich Zeit aufwenden muss, um Beziehungen aufzubauen und aufrechtzuerhalten. Diese Studienanfänger sind im Kleinen die Entsprechung zu den ersten Siedlern, die vor 50.000 Jahren nach Australien gelangten, und auch jede andere neue Umgebung strapaziert durch Entfernung und Zeit die Fähigkeit, in Kontakt zu bleiben, bis an die Grenzen. Die Lösung bestand immer darin, die Freunde zu vergessen und den Verwandten zu vertrauen.

Die Schaffung verwandtschaftlicher Fernbeziehungen eröffnete auch die Möglichkeit, die Toten mit einzubeziehen. Die Fähigkeit, „hinüberzugehen", was auf der irdischen Ebene die Besiedelung neuer Kontinente bedeutete, versetzte Menschen auch in die Lage, eine andere, imaginäre Richtung einzuschlagen – die Richtung zu einer Welt des Jenseits und der Vorfahren. Zur Bewältigung dieser Aufgabe ist eine beträchtlich hoch entwickelte Theorie des Geistes erforderlich. Wenn man die Motive imaginärer Menschen und Wesen, zu denen nun auch Götter und Geister gehören, mit einbeziehen will, werden die Ordnungen der Intentionalität oder die Schritte im sozialen Denken ungeheuer komplex.

„Der Groschen fiel, und Henry *glaubte* seiner Feengöttin, die *wollte*, dass er Jane heiratete und damit die Wünsche seines verstorbenen Onkels erfüllte, statt den Ruf ihres Herzens *anzuzweifeln*, der ihr *einflüsterte*, dass Roger *vorhatte*, ihr einen Antrag zu machen und so die Ehre seiner Familie wiederherzustellen." Eine solche Intentionalität fünfter Ordnung strapaziert unsere Fantasie ebenso wie unser so-

ziales Denken. Es ist, als würde man im Schach den rich-
tigen Zug fünf Schritte im Voraus sehen. Verwandtschaft
macht diese Mentalisierung zum Teil einfacher, weil die
Menschen sich nicht als unabhängige Individuen verhalten,
sondern entsprechend den Rollen, in denen definiert ist,
was von Söhnen, Tanten, Großvätern und Vettern erwartet
wird. Feengöttinnen und verstorbene Onkel gehören eben-
falls zu dieser komplexen allgemeinen Verwandtschaft; ihre
Gegenwart deutet auf sehr hohe Ordnungen der Intentio-
nalität hin.

Wie wir in Kap. 2 erfahren haben, steht die Fähigkeit
zur Mentalisierung in Zusammenhang mit der Gehirngrö-
ße (und insbesondere mit dem Volumen der Stirnlappen).
Deshalb können wir abschätzen, inwieweit die Vertreter
verschiedener fossiler Homininenarten mentalisieren konn-
ten, und was am wichtigsten ist: Wir können uns der Rich-
tigkeit der Schätzungen einigermaßen sicher sein. Diese
legen die Vermutung nahe, dass *H. heidelbergensis* und die
Neandertaler mit Intentionalität vierter Ordnung umgehen
konnten. Dies dürfte eine sehr wichtige, beschränkende
Wirkung auf die grammatikalische Komplexität ihrer Spra-
che gehabt haben – und auch auf die Komplexität der Ge-
schichten, die sie erzählen konnten.

Dagegen lassen die Daten darauf schließen, dass die
anatomisch modernen Menschen frühestens vor 200.000
Jahren bei der Intentionalität fünfter Ordnung angelangt
waren. Dies impliziert, dass Homo-sapiens-Fossilien wie
der Fund von Herto trotz ihrer einfachen Steintechnologie
über eine überlegene Mentalisierungsfähigkeit verfügten.
Das mag überraschend erscheinen, wenn man daran denkt,
dass zwei Schädel aus Herto nach dem Tod absichtlich ver-

ändert wurden. Die Schnittspuren an Gehirnschädeln und Unterkiefern zeigen, dass sie gezielt zerlegt und vom Fleisch befreit wurden. Außerdem wurden sie abgekratzt und poliert. Der große afrikanische Archäologe J. Desmond Clark sprach in diesem Zusammenhang von Schmuck. Schnittspuren, aber keinen Schmuck fand man auch an dem älteren Schädel von *H. heidelbergensis* aus Bodo. Solche Begräbnisrituale reichen vielleicht nicht an die Mentalisierungsfähigkeit von Henry mit seiner Feengöttin heran, aber sie sind eine materielle Spur der komplexeren Geschichten, an die Homininen mit ihrem größeren Gehirn denken konnten. Das archäologische Mantra WYSWTW wird durch die Funde von Bodo und Herto, die ihrerseits durch die Hypothese vom sozialen Gehirn vorausgesagt wurden, infrage gestellt.

Religion und Geschichtenerzählen

Nachdem die Homininen mit ihrem großen Gehirn über Lachen, Musik und schließlich eine voll ausgeprägte Sprache verfügten, konnte ein dritter Endorphinmechanismus aktiv werden: die Rituale der Religion. Viele geheiligte Gebräuche, darunter Fasten und Bußübungen (vom Märtyrertum ganz zu schweigen) sind darauf angelegt, den Organismus unter Stress zu setzen und so die wichtigen Endorphinschübe zu erzeugen. Aber um zu wissen, dass man solche Rituale vollziehen soll und warum, braucht man eine Sprache. Vor rund 50.000 Jahren dürfte es sich bei der Religion um ein Schamanentum gehandelt haben, eine Form, die man noch heute bei Jägern und Sammlern sowie bei anderen Kleingesellschaften findet. Seine Merkmale wurden

auf denkwürdige Weise von David Lewis-Williams in dem 2004 erschienenen Buch *The Mind in the Cave* beschrieben: Er zieht darin Parallelen zwischen den Schamanen in der Kalahari und den halb menschlichen, halb tierischen Geschöpfen, die in Europa in der Kunst des oberen Paläolithikums dargestellt wurden.

Der Schamanismus gründet sich nicht auf Doktrinen, sondern er ist eine Religion der Erfahrungen. Eine solche Religion hat normalerweise keine Theologie und beinhaltet auch nicht den Glauben an Götter in der Form, wie man sie sich üblicherweise vorstellt. Stattdessen wird mit Musik und Tanz ein Trancezustand erzeugt, in dessen Verlauf der Gläubige in eine Welt der Geister eintritt, die von menschenähnlichen Tieren und Vorfahren bevölkert ist; manche dieser Wesen sind gefährlich, andere erfüllen die Funktion eines freundlichen spirituellen Führers. Aber um über die Reisen in die Welt der Geister, die man während der Trance erlebt hat, zu berichten, braucht man eine Sprache und vielleicht sogar eine hoch entwickelte Sprachfähigkeit. Solche religiösen Zeremonien haben auch eine stark therapeutische Wirkung – und zwar höchstwahrscheinlich, weil sie mit Tanz und dem dabei erzeugten Endorphinschub verbunden sind. Derartige Trancetänze dienen häufig ganz ausdrücklich dazu, die Gemeinschaft von schlechten Gefühlen zu reinigen, die durch die unvermeidlichen sozialen Belastungen des Gruppenlebens entstanden sind (s. Abb. 6.2).

Auch die Mentalisierung spielt in diesem Teil der Geschichte eine wichtige unmittelbare Rolle, denn Religion ist davon abhängig, dass man sich eine andere, spirituelle Welt vorstellen kann, die parallel zur Welt des alltäglichen

Abb. 6.2 Die Darstellungen in der südafrikanischen Felskunst waren die Grundlage für die Gedanken über den Schamanismus, die von David Lewis-Williams und seinen Kollegen entwickelt wurden. Das Bild zeigt die imaginäre Reise eines Schamanen in die Welt der Geister – eine Reise, die erst durch eine hoch entwickelte Theorie des Geistes möglich wird. (© David Lewis-Williams/Rock Art Research Institute, University of Witwatersrand, Johannesburg)

Erlebens existiert. Dies erfordert zumindest eine formelle Theorie des Geistes. Aber allein mit der Vorstellung einer solchen Welt ist noch nichts gewonnen: Um sie zur Religion zu machen, muss man mit anderen darüber sprechen, und das setzt zumindest dich, mich und eine dritte Partei sowie einen oder mehrere Geister in der spirituellen Welt (einen Vorfahren oder sogar einen Gott) voraus. Demnach ist Intentionalität vierter Ordnung die Mindestvoraus-

setzung für Religion; das könnte durchaus bedeuten, dass Homininen mit großem Gehirn wie die Neandertaler an eine Welt der Geister glaubten, aber mit der zusätzlichen Ordnung der Intentionalität, über die moderne Menschen verfügen, können solche Glaubensüberzeugungen deutlich verfeinert werden.

Den Unterschied zwischen Intentionalität vierter und fünfter Ordnung richtig einzuschätzen, fällt viel leichter, wenn man ihn im Zusammenhang mit einem anderen wichtigen Mechanismus betrachtet, der in großen Gemeinschaften zum sozialen Zusammenhalt beiträgt: dem Geschichtenerzählen. Wenn man eine gemeinsame Sichtweise für die Welt hat, kann man auch Ansichten und Meinungen darüber austauschen, wie die Welt ist oder sein sollte, und das Medium dafür sind in traditionellen Gesellschaften häufig Geschichten. Ursprungsmythen erinnern uns daran, wer wir sind und wie unser Dasein begonnen hat, und Volksmärchen sind häufig ein Mittel zur Bewertung moralischer Dilemmata. Die Qualität einer Geschichte, die wir erzählen (und als Zuhörer verstehen) können, hängt davon ab, wie viele Ordnungen der Intentionalität wir handhaben können – nicht zuletzt weil diese darüber bestimmen, wie kompliziert unsere Sätze sein können. Zwischen Intentionalität der vierten und fünften Ordnung besteht, was die Qualität der Geschichten angeht, ein recht auffälliger Unterschied. Demnach konnten die archaischen Menschen und Neandertaler mit ihrer Fähigkeit zur Intentionalität vierter Ordnung sich gegenseitig sicherlich Geschichten erzählen, deren Qualität spielte aber nicht in der gleichen Liga wie jene, die anatomisch moderne Menschen

formulieren konnten. Kurz gesagt, konnte die moderne Kultur, wie wir sie kennen, sich höchstwahrscheinlich erst entwickeln, nachdem vor rund 200.000 Jahren die anatomisch modernen Menschen der Spezies *Homo sapiens* auf der Bildfläche erschienen waren. Und selbst dann dauerte es noch lange, bis alle Bestandteile herangereift waren.

Ein großes Gehirn – und was dann?

Es gab drei Homininen mit großem Gehirn, aber offenbar stellte nur einer, der *Homo sapiens*, die Lautstärke höher. Lange Zeit hielt aber auch *Homo sapiens* als anatomisch moderner Mensch in Afrika die Lautstärke niedrig. Das jedenfalls würden die vielen Archäologen behaupten, die von einer „menschlichen Revolution" in jüngerer Zeit ausgehen. Sehr nachdrücklich formulierten sie ihre Ansichten auf Symposien, die von Paul Mellars, Chris Stringer und Katie Boyle organisiert wurden; die Ergebnisse wurden 1989 und 2007 veröffentlicht. Eine ähnliche Linie verfolgen auch führende Archäologen wie Ofer Bar-Yosef und Richard Klein.

Hinter dem Gedanken von einer menschlichen Revolution in jüngster Zeit – und mit „jüngster Zeit" ist dabei die Zeit vor weniger als 50.000 Jahren gemeint – steht der WYSWTW-Ansatz. Seine energischsten Befürworter hielten strikt daran fest, aber wie Sally McBrearty und Alison Brooks in ihrem 2000 erschienenen, treffend überschriebenen Artikel „The Revolution that Wasn't" („Die Revolution, die keine war") deutlich machten, gerieten sie damit

in Schwierigkeiten. Wie sich nämlich herausstellte, hatten viele bemerkenswerte Dinge aus der materiellen Kultur, darunter geritzte oder glatte Ockerstücke, Halsketten aus Schneckenhäusern, der Handel mit Rohstoffen über große Entfernungen und neue Mittel zum Lebensunterhalt wie Schalentiere, die alle angeblich zu den Errungenschaften der Revolution gehörten, in Wirklichkeit in Afrika schon eine lange Vergangenheit und waren viel älter als die ältesten Stücke, die man außerhalb des Kontinents fand (s. Abb. 6.3). Offenbar fand also keine Revolution statt, sondern die Fähigkeiten der anatomisch modernen Menschen nahmen über lange Zeit allmählich zu, bis sie schließlich die Leistungsfähigkeit der Neandertaler und zweifellos auch anderer, bisher nicht entdeckter regionaler Populationen in Afrika weit hinter sich gelassen hatten.

An dieser Stelle kommt die Hypothese vom sozialen Gehirn als eigenständiger neuer Forschungsansatz ins Spiel. Wir brauchen uns nicht mehr dem WYSWTW-Diktat zu unterwerfen, sondern können einen Schritt zurücktreten und fragen, was für den langfristigen Übergang vom Homininen zum Menschen wichtig war. In diesem Zusammenhang stellen wir zwei Fragen:

- Was veränderte sich, als sich scheinbar nichts veränderte? (Oder um noch einmal auf die Außerirdischen zurückzukommen, die uns vor 500.000 Jahren besuchten: Wann hätten sie festgestellt, dass das große Gehirn nicht von einer entsprechenden Erweiterung im Hinblick auf neue Werkzeuge und Handlungsweisen begleitet war?) Damit fragen wir, wie die Sinneswahrnehmung sich verstärkte und damit die sozialen Interaktionen intensivierte.

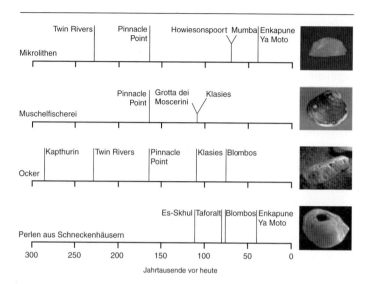

Abb. 6.3 Die Zeittafeln für vier wichtige Indizienketten, die auf eine immer höhere Entwicklung des Verhaltens der Menschen hindeuten: Mikrolithen, Schalentiere, Gebrauch von Ocker und Körperschmuck mit Perlen. (Zeittafel nach © McBrearty, S., Stringer, C., 2007 ‚The coast in colour.' *Nature* 449: 793–794; Abb. 2; Fotos (von *oben* nach *unten*) © Peter Mitchell; David Roberts, Bangor University; Christopher Henshilwood und Francesco d'Errico)

- Welche sozialen Veränderungen waren notwendig, damit die ungeheuer starke Entwicklung im Hinblick auf die Besiedelung der ganzen Welt und den Anstieg der Bevölkerungszahl stattfinden konnte, die sich zu gegebener Zeit einstellte? Sie begann bereits einige Zeit vor der Landwirtschaft, als die Gesellschaften noch klein waren und ihre Nahrung nicht produzierten, sondern suchten. Dies ist eine Frage nach der Verstärkung der in den Artefakten enthaltenen sozialen Signale, mit denen erfolgreiche soziale Interaktionen gewährleistet werden konnten.

Hinter beiden Fragen und eigentlich hinter unserem ganzen Ansatz, der Archäologie des sozialen Gehirns, steht die gleiche Vorstellung: Materialien und die Sinneswahrnehmungen, die die Voraussetzungen zur Herstellung sozialer Bindungen schaffen, *müssen sich nicht gemeinsam entwickeln.* Sie sind kein Tandem, auf dem beide Radfahrer die gleiche Anstrengung aufwenden müssen. Nach unserer Hypothese können sich Sinneswahrnehmungen und Emotionen unabhängig von Materialien und Artefakten wie den Steinwerkzeugen verstärken. Mit dem Umgekehrten ist ebenfalls zu rechnen. In dem Vergleich mit dem Tandem strengt sich der eine Radfahrer an, während der andere eine Zeit lang nur Nutznießer ist. Beide sind aber Ressourcen und deshalb als Bausteine jeder Gesellschaft von Homininen und Menschen so eng miteinander verbunden, dass Veränderungen des einen auch Veränderungen beim anderen auslösen. Sie befinden sich in einem Prozess der Coevolution, aber wie die beiden Radfahrer auf dem Tandem leisten sie nicht immer genau die gleichen Beiträge.

Gefühle werden kanalisiert

Wie wir in Kap. 5 erfahren haben, tat *Homo erectus* zuverlässig immer und immer wieder das Gleiche. Es ist, als wäre er wie wir gewesen, nur dass ihm eine unentbehrliche Dimension der Kreativität oder Einsicht fehlt. Oder war es eher eine Frage des Temperaments? Das ist ein interessanter Gedanke, denn Menschenaffen – oder zumindest Schimpansen – sind eigentlich viel emotionaler als wir. Alles,

was sich in ihrer Gemeinschaft abspielt, gibt den Anlass zu großer Aufregung. Manche Wissenschaftler machen darauf aufmerksam, wie wichtig Ideologien oder gemeinsame Abstammung sind – die primären Emotionen gehen auf eine Zeit weit vor unserer eigenen Gattung zurück und haben so viele Gemeinsamkeiten, dass wir sie nicht nur bei einem Schimpansen erkennen, sondern auch bei einem Hund. Nicht nur mit Schimpansen und Hunden, sondern mit allen Säugetieren haben wir Angst, Wut und Sexualtrieb gemeinsam, und wie sie werden wir durch Hunger und Durst zum Handeln getrieben.

Es gibt aber auch wichtige Unterschiede, die irgendwann erstmals ihre Spuren hinterließen. Philosophen und Wissenschaftler, unter ihnen auch Darwin, griffen die typisch menschliche Fähigkeit zum „rationalen" Denken heraus. Das führte zu der Ansicht, rationales Denken sei für Menschen das Ideal, das im Gegensatz zu einer primitiveren, weniger wünschenswerten emotionalen Lebenseinstellung steht. Eine einflussreiche Denkschule behauptet aber auch, charakteristisch menschliche Emotionen könnten viel dazu beitragen, unser Wesen zu prägen.

Der Verhaltensforscher Dylan Evans verlieh diesem Wert der Emotionen in seiner „Suchhypothese" Ausdruck: Danach sind Emotionen dazu da, unserem Handeln Grenzen zu setzen und spontane Entscheidungen möglich zu machen: „Hinzusehen, bevor man springt, ist schön und gut, aber es geht darum, zu springen. Irgendwann muss man aufhören zu denken und anfangen zu handeln." Dies bezeichnet er als Hamlet-Dilemma. Auch andere halten die Gefühle für tief verwurzelte „Faustregeln" für die Lebens-

führung. Unter Umständen muss man schnell entscheiden, ob man am Donnerstagabend lieber zu einem Fußballspiel geht, sich mit Freunden zum Essen verabredet oder zu Hause bleibt. Dabei siegt das Gefühl „Dieses ist mir lieb, jenes aber nicht" häufig über eine streng rationale Analyse. Man kann die Ansicht vertreten, dass wir uns von einer ganzen Sammlung tief sitzender „Neigungen" oder emotionaler Auslöser leiten lassen – der Anthropologe Pascal Boyer bezeichnet diese als „biologische Systeme". In einem gewissen Sinn handelt es sich dabei zweifellos um Systeme: Wenn wir uns draußen im Busch befinden und plötzlich einen Löwen sehen, empfinden wir im Bauch sofort einen Schreck; erkennen wir dann, dass es nur eine Antilope ist, spüren wir ebenso schnell die Gegenreaktion – und unter solchen Umständen könnte ein Physiologe genau erklären, welche Reaktionsfolge in uns abgelaufen ist.

Zu etwas Besonderem werden die modernen Menschen durch ihre einzigartige, ungeheuer kraftvolle Fähigkeit, Gefühle durch eigene Entscheidungen zu manipulieren und anzuregen. Die dazu erforderlichen Verknüpfungen befinden sich nicht in den alten Gehirnteilen des limbischen Systems, sondern sie sind im Neocortex verdrahtet, von dem im Zusammenhang mit dem sozialen Gehirn bereits einige Male die Rede war. Wir können uns entschließen, Shakespeares *Romeo und Julia* zu lesen, um dabei traurig zu werden. Wir können eine fiktive Tragödie im Kopf einer wirklichen Tragödie gegenüberstellen. Oder wir jagen uns mit Corbetts *Man-Eaters of Kumaon*, dem übernatürlichen Horror eines Edgar Allan Poe oder einem kompromisslos blutigen Splatterfilm selbst Angst ein. Oder – eine viel rea-

lere Gefahr – wir können uns entschließen, uns aggressive Gedanken durch den Kopf gehen zu lassen oder sogar andere darauf zu bringen. War das nicht spätestens seit der Zeit eines Demosthenes und Cleon, vielleicht aber auch schon viel früher, die übliche Rolle der Demagogen?

Hing *Homo heidelbergensis* am Lagerfeuer vielleicht Tagträumen nach? In Beeches Pit in Suffolk, wo John Gowlett zusammen mit vielen anderen Wissenschaftlern die Ausgrabungen leitete, saßen die Frühmenschen am Ufer eines Teiches oder Baches um das Feuer. Er schreibt über die Ausgrabungen: „Wir fanden das hintere Ende eines Faustkeils. Ich hoffte, wir würden auch die andere Hälfte entdecken, und schließlich konnten wir sie unter anderen neuen Fundstücken ausfindig machen. Ich ließ sie die Studenten ausgraben und selbst erkennen. Sie lag nur einen halben Meter von dem Hinterende entfernt. Wohl jeder moderne Mensch hätte anders reagiert, wenn ein Lieblingswerkzeug zerbrach – du oder ich, wir hätten es wahrscheinlich in den Teich geworfen." Aber *Homo heidelbergensis* ließ die beiden Bruchstücke in aller Stille nebeneinander liegen.

Etwas Besonderes machen

Gefühle sind zwar lebenswichtig, sie sind aber auch ein Durcheinander. Bei uns sind sie im Vergleich zu Schimpansen und Bonobos stark gedämpft, aber den Gorillas kann man kaum einmal übermäßige Aufregung vorwerfen. Unsere Emotionen wurden vielmehr neu gestaltet, und irgendwann in der Vergangenheit kochten sie hoch. Sie machten

uns zu Wesen, die lachen und weinen, von Musik das Innerste ihrer Seele berühren lassen und durch Dichtung kommunizieren können. Wir würden uns etwas vormachen, wenn wir glauben würden, dass die Archäologie den Ursprung all dieser Dinge zurückverfolgen kann, aber wir haben tatsächlich Grund zu der Annahme, dass die dazu erforderlichen wichtigen Veränderungen im Laufe der letzten 500.000 Jahre im großen Gehirn der Homininen Gestalt annahmen – und die Hypothese vom sozialen Gehirn bietet einen Rahmen, in dem wir unsere bruchstückhaften Daten überprüfen können. Hier konzentrieren wir uns auf die besten Belege, die wir besitzen: Grabstätten, Perlen und eine neue technische Komplexität. Kunst wäre eine weitere große Hilfe, aber sie ist nur äußerst bruchstückhaft erhalten geblieben. Wir werden auf die Kunst noch zurückkommen, aber zunächst einmal wollen wir einen wichtigen Gedanken festhalten: Zum Teil besteht Kunst einfach darin, „etwas Besonderes zu machen", und diesen Prozess können wir zu Beginn auf eine viel breitere Grundlage stellen.

Ein weiterer Aspekt der Anfertigung von etwas Besonderem ist der „Mehrwert". Damit meinen wir, dass Dinge eine zusätzliche Bedeutung annehmen können, die manchmal wichtiger ist als ihre ursprüngliche Funktion. Anhaltspunkte dafür finden wir erstmals vor 400.000 Jahren, als vielleicht eine in einen Faustkeil eingebettete fossile Muschelschale und nicht seine symmetrische Form oder die scharfe Schneidkante das beherrschende Merkmal dieses Werkzeugs war.

Allerdings müssen wir uns damit abfinden, dass es äußerst schwierig ist, die Anfänge dieser neuen Aspekte dingfest zu machen und zu datieren. Das ist der Grund, warum

die Archäologie allein nicht die ganze Geschichte erzählen kann. Immerhin können wir einige grundlegende, aber aufschlussreiche technologische Entwicklungen festhalten. In der beherrschenden Form der Artefakte trat ein Wandel ein. Seit der Zeit vor 2,5 Mio. Jahren waren Werkzeuge von der Hand und den Instrumenten, die sie formen konnte, beherrscht. Jetzt jedoch, in den letzten 500.000 Jahren, experimentierten die Menschen mit neuen Wegen, um ihre materielle Welt zu organisieren. Eine neue Vorgehensweise wurde durch die Beherrschung des Feuers möglich. Die Neandertaler konnten die Brenntemperatur bereits so gut steuern, dass sie Pech herstellen konnten, was über lange Zeit hinweg die Einwirkung gleichmäßiger Hitze erfordert. Die aus Kiefern- oder Birkenharz hergestellte Substanz war ein leistungsfähiger Klebstoff, der ganz neuartige Materialkombinationen möglich machte. Ein anderer Weg führte dazu, dass die Welt aufgrund einer Vorstellung von Behältnissen in Begriffe gefasst wurde. Es könnte durchaus mit Gegenständen, die so grundlegend waren wie Beutel und Eimer (und nicht erhalten geblieben sind), begonnen haben. Der wichtigste archäologische Beleg für diese Entwicklung ergibt sich jedoch aus der Form von Hütten und Häusern. Im Einzelnen sind die Befunde manchmal umstritten, aber Homininen mit großem Gehirn wie die Neandertaler bauten in ihrer Felsheimat im spanischen Abric Romaní überdachte Unterkünfte – ein künstliches Haus in einem natürlichen Haus. Diese sind in Form natürlicher Abgüsse, die von der Arbeitsgruppe um Eugene Carbonell sorgfältig ausgegraben wurden, erstaunlich gut erhalten.

Homininen als Zeremonienmeister

Die Anthropologin Wendy James bezeichnete uns Menschen einmal als „zeremonielle Tiere". Wir handeln auf vorgeschriebene Weise und haben auch das Bedürfnis danach. Wie bedeutsam dieses Prinzip ist, zeigen Mängel, die in dem System leicht auftreten können. Ein Vertreter des britischen Parlaments räumt ein, an einer Zwangsstörung zu leiden und alle Dinge viermal tun zu müssen – wenn er ein Zimmer betritt, muss er das Licht viermal ein- und ausschalten. Weniger extreme Neigungen zum Detail haben die meisten Menschen: Wenn wir an einem Tisch mit einem karierten Tischtuch sitzen, schieben wir und unsere Nachbarn unter Umständen unbewusst (oder auch bewusst) Gläser und Tassen an die „passenden" Stellen des Musters.

Das alles ist vielleicht wenig überraschend: Immerhin sind wir die Nachkommen des *Homo erectus*, der vor einer Million Jahren unbedingt ein Werkzeug „wie dieses" und nicht „wie jenes" herstellen wollte, sodass eng gefasste Ideen über hunderttausende von Jahren erhalten blieben. Entscheidend ist auch hier, dass wir „etwas Besonderes machen". Nach Ansicht von Wendy James „sind Rituale, Symbole und Zeremonien in den Dingen, die wir tun, nicht einfach vorhanden oder abwesend; sie sind vielmehr in das Handeln der Menschen eingebaut".

Der Wunsch, „etwas Besonderes zu machen", stand zu Beginn hinter ganz gewöhnlichen Tätigkeiten; später schuf er für die Menschen die Möglichkeit und das Bedürfnis, jenseits des Gewöhnlichen die ganz besonderen Dinge herauszugreifen. Warum kam es dazu? Höchstwahrscheinlich weil größere Gesellschaften stärkere Signale brauchen.

So fällt beispielsweise auf, dass in den meisten modernen Armeen nur die ranghöchsten Offiziere rote Kragenspiegel oder Schulterstreifen tragen – das Verhältnis liegt bei ungefähr einem Offizier je 500 oder 1000 (oder mehr) einfache Soldaten. Diese Rangabzeichen fordern Aufmerksamkeit. Menschen können sich hervorragend konzentrieren. Wir können uns in ein Kreuzworträtsel, ein gutes Buch oder alles andere, was unsere Aufmerksamkeit fesselt, vertiefen. Schimpansen besitzen diese Fähigkeit nicht. Sie kraulen einander vielleicht ein paar Minuten mit hingebungsvollem Blick, aber diese intensive Aufmerksamkeit übertragen sie nie auf die Herstellung oder den Gebrauch von Gegenständen (außer vielleicht wenn es um Nahrung geht). Zwei ästhetische Qualitäten fesseln unsere Aufmerksamkeit und eignen sich deshalb ideal für diese Form der Signalgebung: Farben und Glitzern. Und für beides hatten unsere Vorfahren mit großem Gehirn allen Befunden zufolge das gleiche Interesse wie wir. Beide ermöglichen auf einem hohen Niveau der Abgrenzung eine Vorstellung von Besonderheit, die in kleineren Gesellschaften in der Regel nicht notwendig ist.

Der Extremfall sind für uns Gold, Silber und Diamanten, aber sie zu gewinnen, ging über die Fähigkeiten früherer Menschen hinaus. In diesem Buch haben wir immer wieder die Ansicht vertreten, dass Technologie auch sozial ist. In unserer Zeit verschwimmen die Grenzen. Wenn jemand uns einen Geburtstagskuchen schenkt, ist das eindeutig eine soziale Handlung. Wenn der Kuchen gut schmeckt, hat er mit Ernährung zu tun, aber er ist auch ein Produkt der Technologie. Insbesondere aber transportiert der Kuchen

einen emotionalen Wert in die Außenwelt. Wenn es um Edelmetalle geht, übertreiben wir modernen Menschen es mit dem Wert und manchmal auch mit den Gefühlen. Sie können ungeheure Werte „abschöpfen", was bedeutet, dass sie schwer zu beschaffen sind (zum Vergleich können wir die seltenen Erden betrachten, die einen ungeheuer hohen Geldwert haben, ohne dass aber von ihnen ein besonderer Reiz ausgeht). Eine solche tief greifende Abhängigkeit muss sehr alte Wurzeln in unserer Evolution haben. Aber Gold, Silber und Diamanten sind als Produkte einer Technologie, die noch nicht einmal 5000 Jahre alt ist, erst in jüngster Zeit interessant geworden. Was waren ihre Vorläufer? Um es mit wenigen Worten zu sagen: offensichtlich Schneckenhäuser, roter Ocker und vulkanisches Glas.

Den ersten Anhaltspunkt für die große Bedeutung von Schneckenhäusern sind fossile Schnecken, die offensichtlich den Mittelpunkt von einem oder zwei Faustkeilen bilden und vor 400.000 Jahren hergestellt und von Kenneth Oakley erstmals beschrieben wurden. Man könnte die Ansicht vertreten, sie seien nur zufällig vorhanden. Für die Steinbearbeitung stellen sie aber eine Unbequemlichkeit dar, und vermutlich muss man absichtlich eine bestimmte Folge von Handgriffen ausführen, damit sie am Ende in der Mitte des fertigen Werkstücks stehen. Vor 120.000 Jahren wurden Schneckenhäuser mit Sicherheit durchbohrt und – vermutlich als Halsketten – aufgereiht. In der Blombos-Höhle in Südafrika fand man eine 70.000 Jahre alte Ansammlung von Schneckenhäusern, die diese Aussage verdeutlicht (s. Abb. 6.4); ähnlich alte Gehäuse der gleichen Schneckenart, die auf vergleichbare Weise durchlöchert waren, entdeckte

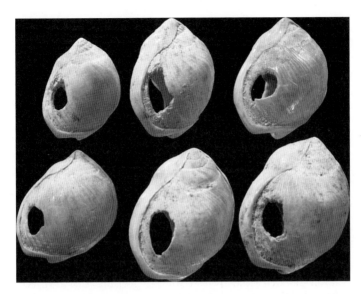

Abb. 6.4 Durchbohrte Schneckenhäuser wie diese aus der Blombos-Höhle in Südafrika waren wie Perlen aufgereiht – dies wird durch ihre Abnutzung bestätigt. Damit ist bewiesen, dass es Fäden oder Bänder gab und dass es wichtig war, sich zu schmücken. (© Christopher Henshilwood und Francesco d'Errico)

man auch bei Ausgrabungen in der Grotte des Pigeons bei Taforalt in Marokko.

In der materiellen Kultur der modernen Menschen sind Farben von großer Bedeutung. Rot dürfte als Gefahrenzeichen sogar der Auslöser für eines der biologischen Systeme von Pascal Boyer sein. In den Tätigkeiten der Menschen taucht es erstmals an archäologischen Fundstätten in Form von Ocker auf, so auch an der eine Million Jahre alten Stätte Bizat Ruhama in Israel. Roter Ocker wird in der heutigen Zeit wie schon in späteren Phasen der Vorgeschichte häufig benutzt und dient insbesondere in der Kunst als Farbstoff.

In Form von Punkten kommt er schon in den ältesten datierten Höhlenmalereien vor. Man kann annehmen, dass er das Leben oder Blut oder komplexere Gedanken symbolisierte. Man sollte aber nicht vergessen, dass er bei der Bearbeitung von Tierfellen, als Schmiermittel oder als Bestandteil von Klebstoffen auch praktischen Nutzen hat. Insbesondere in Afrika gewann der Ocker während der letzten 300.000 Jahre eine so große Bedeutung, dass er beispielsweise in Twin Rivers in Sambia in größeren Mengen abgebaut wurde. An der Fundstätte Kapthurin in Zentralkenia fand man eine Sammlung von ungefähr fünf Kilo Ocker, die auf ein Alter von 300.000 Jahren datiert wurde.

Auf der Nilinsel Sai im Sudan hat man mehr als 200.000 Jahre alten polierten und gemahlenen Ocker gefunden. Unser Kollege Larry Barham weist darauf hin, dass die Wurzeln dieser Funde bis ins Acheuleén zurückreichen. Die Archäologin Lynn Wadley und andere haben noch einmal betont, dass Ocker nicht nur „symbolische", sondern auch industrielle Verwendungszwecke hatte, aber es besteht kein Zweifel, dass der Mehrwert sich irgendwann in dieser Periode erstmals mit dem Material verband. Die symbolische Bedeutung des Ockers zeigt sich auch in der Blombos-Höhle an der südafrikanischen Küste. Dort fand man ein 70.000 Jahre altes Stück Ocker, in dessen Oberfläche sorgfältig ein Gittermuster eingeritzt war (s. Abb. 6.5).

Auch Steine konnten ein sehr reizvolles Aussehen haben. Menschen wählten sie mittlerweile seit mehr als 2 Mio. Jahren aus. Ein solches attraktives Material ist Obsidian, ein Vulkanglas, das in Schwarz, Braun und sogar in Rot vorkommt. Sehr gut kennen wir es aus der Mitte des Rift-

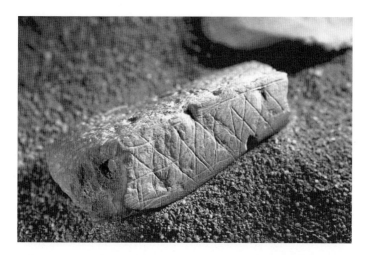

Abb. 6.5 Ein kleines Stück roter Ocker aus der Blombos-Höhle in Südafrika trägt das älteste geometrische Ritzmuster, das man kennt. Es gilt häufig als Beleg für symbolisches Denken. Ocker ist ein natürliches Pigment, das häufig verwendet wurde, um die Farbe des eigenen Körpers wie auch verschiedener Gegenstände zu verändern. Außerdem diente er vielfach zur Herstellung von Felskunst. (© Christopher Henshilwood)

tals in Kenia, wo John Gowlett arbeitet. In der Frühzeit wurde es gelegentlich für Faustkeile benutzt. In der Fundstätte Kariandusi, die erstmals von Louis Leakey erforscht wurde, kommen solche Faustkeile häufig vor. Etwa 50 km weiter, in Kilombe, ist Obsidian dagegen zwischen den vielen Faustkeilen aus Lavagestein sehr selten. Schon vor einer Million Jahren war dieses Material so attraktiv, dass man es gelegentlich transportierte, der eigentliche Wandel stellte sich aber erst in den letzten 200.000 Jahren ein. In dieser späteren Zeit kam Obsidian aus der mehr als 100 km weiter südlich gelegenen Region Naivasha, und dann wurde er zur

Herstellung vieler hundert kleiner Steinwerkzeuge verwendet. Die Forschungsstudentin Dora Moutsiou untersuchte im Rahmen des Lucy-Projekts, wie dieses Material seit der Zeit vor 40.000 Jahren auf der ganzen Welt immer stärker in Gebrauch kam. Wie sie außerdem zeigen konnte, wurde es von seinen vulkanischen Ursprungsorten über bis zu doppelt so große Entfernungen transportiert, wenn man es in Verbindung mit modernen Menschen findet. Kristallklarer Quarz hat für das moderne Auge ebenfalls seinen Reiz, und das Gleiche gilt offenbar auch für frühere Zeiten: Er wurde auf ganz ähnliche Weise über große Entfernungen transportiert.

Als wichtigster Beleg, dass solche Materialien eine hohe Wertschätzung genossen, gelten ihr Transport und ihre gezielte Verwendung für Werkzeuge. Werturteile mussten die Menschen schon in sehr frühen Zeiten fällen. Der Transport ist aufwendig, und deshalb wurde die Auswahl wichtig: Gute Dinge wurden mitgenommen, Geröll aber nicht. Auch in solchen Entscheidungen erkennen wir die Verbindung von technischen und sozialen Aspekten.

Bestattungsrituale

Als letzte große Neuerung unter den frühen Riten setzten sich die Bestattungsrituale durch, und daraus können wir etwas Besonderes ablesen. Im Rahmen der Hypothese vom sozialen Gehirn wird immer wieder deutlich, wie wichtig Beziehungen sind, aber manche davon, nämlich die in Verwandtschaft und Familie, sind noch wichtiger als andere.

Die ältesten bekannten Grabstätten aus dem Paläolithikum finden sich in Höhlen im Nahen Osten und sind mindestens 130.000 Jahre alt. Sie stammen sowohl von Jetztmenschen (in Qafzeh und Es-Skhul) als auch von Neandertalern (Et-Tabun). Steinzeitliche Grabstätten aus späterer Zeit kennt man von vielen Orten in Europa und Asien. Im klassischen Fall können wir an ihnen ablesen, dass die Menschen eine Religion mit einer Vorstellung vom Jenseits hatten und einen Angehörigen mit der Bestattung auf eine Reise schickten. Manche Revisionisten haben dieses emotional befriedigende Bild ziemlich verunstaltet: Blütenpollen, der bei Shanidar im Irak angeblich bestatteten Neandertalern mitgegeben wurde, könnte da durchaus störend wirken. Aber ein derartiger Revisionismus ist übertrieben. Zwar können wir immer noch nur mit Mühe einschätzen, was für eine Schatzkammer die Begräbnisstätten darstellen, aber in jedem Fall haben sie erheblichen Wert. Begeben wir uns einmal aus der Gegenwart in die Vergangenheit: Wir kennen Millionen von Grabstätten aus jüngster Zeit, viele tausende aus der Antike und in der Levante allein aus der sogenannten Periode des Natufien vor rund 10.000 Jahren mehr als 400. Aus der Zeit davor, dem oberen Paläolithikum, kennen wir einige hundert weitere, wobei die Menschen gelegentlich gruppenweise und mit auffälligen Grabbeigaben bestattet wurden. Es wäre schon seltsam, wenn sich in den mehreren hundert Grabstätten von Neandertalern und frühen Jetztmenschen, die späteren Bestattungen vorausgingen, irgendein ganz anderes Phänomen widerspiegeln würde. Schon eine solche Behauptung wirkt abwegig, und tatsächlich wird die Angelegenheit bei näherer Betrachtung

Abb. 6.6 Drei steinzeitliche Grabstätten in Höhlen. *Links* und *Mitte*: Neandertalergrabstätten in Kebara (Israel) und Shanidar (Irak); *rechts*: Grabstätte eines Jetztmenschen in Qafzeh (Israel). (Zeichnung © Rob Read)

der französischsprachigen archäologischen Literatur (insbesondere durch einige englische Muttersprachler) ganz einfach. In der Höhle von Qafzeh nicht weit von Nazareth sind die Grabstätten der frühen Jetztmenschen sorgfältig in ähnlichen Richtungen angeordnet (s. Abb. 6.6). Das Gleiche gilt für Es-Skhul am Mount Carmel. Die Anlagen zeugen nach Ansicht des Archäologen Avraham Ronen von einem großen Respekt für persönlichen Freiraum. Bei Le Ferassie in Frankreich sind erwachsene Neandertaler auf einem kleinen Friedhof in einem Felsunterstand als Gruppe bestattet, ihre Säuglinge findet man in der Nähe unter niedrigen runden Hügeln. Die Überreste der Säuglinge sind so empfindlich, dass sie buchstäblich keine Chance auf Erhaltung gehabt hätten, wenn sie nicht sehr sorgfältig bestattet worden wären. Man findet sie aber an vielen Stellen von Westeuropa bis in den Nahen Osten. Der Archäologe Paul Pettitt konnte im Rahmen einer umfassenden Studie überzeugend nachweisen, dass solche Bestattungsriten der

Neandertaler eine Phase der Modernisierung repräsentieren, die sich deutlich von älteren Fundstätten wie Atapuerca in Spanien, wo man viele Leichen am Boden eines tiefen Höhlenschachtes fand, unterscheiden. Selbst in der Phase der Modernisierung fanden nur wenige Bestattungen in offener Landschaft statt, aber eine davon, am Taramsa Hill in Ägypten, enthält einen frühen Jetztmenschen, der mit angewinkelten Beinen in einer Grube liegt.

In der letzten von Pettit beschriebenen Phase entwickelten sich die Bestattungspraktiken weiter; ein Beispiel sind verblüffende Funde aus Jebel Sahaba nicht weit vom Nil im nördlichen Sudan. Dort gibt es einen vollständigen Friedhof vom Ende des Paläolithikums vor 12.000 Jahren. Hier wurden mehr als 50 Tote bestattet, manche davon in kleinen Gruppen. In einigen Fällen sind die Spuren von Verletzungen durch Pfeilspitzen aus Feuerstein zu erkennen.

Kooperation in Leben und Tod

Was bedeuteten solche Bestattungsrituale für unsere sozialen Homininen mit ihrem großen Gehirn? Glaubten sie an ein Jenseits, an eine Reise in die Unterwelt, wie die alten Ägypter sie erwarteten? Das wissen wir nicht, aber wir vermuten, dass es nicht der Fall war. Sie hatten aber eine Vorstellung von einem jenseitigen Menschen, den Gedanken, dass die Toten noch Macht über die Lebenden haben. Das ist nicht verwunderlich, denn wir haben unseren Vorfahren mit ihrem großen Gehirn bereits eine hoch entwickelte Theorie des Geistes zugestanden. Ein Neandertaler war sich

296 Evolution, Denken, Kultur

mit seiner Theorie des Geistes bewusst, dass ein anderer
Neandertaler die Welt anders sah als er. Außerdem waren
beide zu sozialen Überlegungen in der Lage, das heißt, sie
konnten sich ausrechnen, mit welchen Absichten ein ande-
rer ein vorbestimmtes Ziel verfolgte. Dass man die Vorfah-
ren „bei sich behielt", indem man glaubte, ein Mensch sei
auch nach dem Tod als soziale Macht vorhanden, mit der
zu rechnen ist, steht völlig im Einklang mit dieser mentalen
Fähigkeit.

Schon frühzeitig waren die Menschen stark auf den
Körper fixiert, und die Argumente von Pascal Boyer legen
für uns die Vermutung nahe, dass die Ursache dafür in ei-
nem Konflikt zwischen zwei „biologischen Systemen" lie-
gen könnte. Das eine sorgt für unsere emotionale Nähe zu
Menschen, die uns wichtig sind (oder vielleicht auch für
Distanz gegenüber Feinden). In dem anderen spiegelt sich
unsere Abneigung gegen alles Tote oder Verwesende und
den Umgang damit wider – entsprechend wollen wir es los-
werden und gleichzeitig bei uns behalten.

In einer Hinsicht können wir einigermaßen sicher sein:
Unsere Vorfahren bestatteten Menschen, die ihnen etwas
bedeuteten, und das waren sehr häufig enge Angehörige.
Ein Beispiel ist die Gruppierung von Grabstätten, wie man
sie in Nordafrika und von Russland bis nach Frankreich
beobachtet. Ein anderes ist die Platzierung der Grabbei-
gaben. In den ältesten Fällen, wenn ein besonders gutes
Stück Fleisch oder einige Hörner von Tieren mit bestattet
wurden, kann man noch Zweifel haben – es könnte Zufall
gewesen sein. In anderen Fällen jedoch lassen die beson-
dere Behandlung von Ockerschichten, die beigegebenen
Halsketten aus Schneckenhäusern oder die Platzierung fein

gearbeiteter Werkzeuge keine Diskussionen mehr zu. Ähnliche Praktiken gibt es bis heute, und mit der Vermutung, in den ältesten Fällen könne es sich um etwas ganz anderes handeln (beispielsweise weil die Neandertaler möglicherweise in ihrer Kognition behindert waren), stellt man nach unserem Eindruck den Nutzen der Methode, ein Phänomen bis zu seinen Wurzeln zurückzuverfolgen, ganz grundsätzlich in Frage.

Man kann das Thema auch anders betrachten. Die Neandertaler beherrschten die Intentionalität vierter Ordnung. Über die Frage, ob sie an Personen im Jenseits oder ein Leben nach dem Tod glaubten, kann man lange diskutieren. Aber jeder Hominine mit einer derartigen Fähigkeit zur Mentalisierung hatte die sozialen Gefühle von Schuld, Scham und Stolz – Emotionen, die nur dann möglich sind, wenn man eine Ansicht über die Ansichten eines anderen hat. Zu diesen sozialen Gefühlen gehört auch das Mitleid, das so ganz anders ist als die primären, dem Überleben dienenden Emotionen von Angst, Wut und Glück, die wir mit allen anderen sozialen Tieren gemeinsam haben. Man kennt Fälle, in denen alte, gebrechliche Neandertaler von den 5, 15 oder sogar 50 Personen aus den verschiedenen Kreisen ihrer Gemeinschaft versorgt worden: Der „alte Mann" von La-Chapelle-aux-Saints in Frankreich war 40 Jahre alt und litt an Arthritis und anderen Krankheiten, und der Mann Nummer 1 aus Shanidar im Irak war blind und hatte einen verkümmerten Arm (s. Abb. 6.7). Und selbst wenn man diese Fälle als Beispiele für Mitgefühl noch nicht überzeugend findet, belegen sie zumindest die Kooperation und eine größere zwischenmenschliche Solidarität zwischen den Gruppen in der Gemeinschaft.

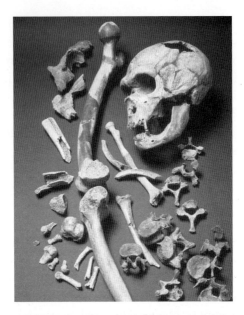

Abb. 6.7 Einige der berühmtesten Überreste von Neandertalern stammen aus dem Südwesten Frankreichs, darunter auch diese aus La-Chapelle-aux-Saints. Nachdem der französische Paläontologe Marcellin Boule diesen alten Mann mit seiner Arthritis beschrieben hatte, galten die Neandertaler als brutal. (© John Reader/Science Photo Library)

Die Beherrschung des Feuers und der Transport von Stein und anderen Materialien bedeuten ein starkes Element der Kooperation, das häufig für Nähe innerhalb der Gruppe zu sprechen scheint. Auch an der Größe der Fundstätten können wir ablesen, dass die Menschen häufig in Horden organisiert waren (s. Tab. 2.1), manchmal aber auch in kleineren Gruppen und gelegentlich in Gemeinschaften.

Belege für größere Gruppen finden sich nahezu ausschließlich in Verbindung mit dem *Homo sapiens*, nicht aber mit den Neandertalern. Der Archäologe Matt Grove erforschte die Größe der Lagerstätten anhand archäologischer Daten aus Boxgrove in Südengland (*H. heidelbergensis*, Alter 500.000 Jahre) und Pincevent, einer Fundstätte von *H. sapiens* im Pariser Becken, die vom Ende der Eiszeit stammt. Seine Analyse der Dichte und Menge archäologischen Materials aus diesen gut erhaltenen Fundstätten weist darauf hin, dass die Zahl der Menschen, die sie nutzten, von der Boxgrove-Zeit bis zur Zeit von Pincevent anstieg, wie es die Hypothese vom sozialen Gehirn voraussagt.

Manche besonders großen Lagerstätten in Europa vermitteln den Eindruck einer gewissen Dauerhaftigkeit. Am deutlichsten zeigt sich dies an der Bauweise von Hütten aus dem oberen Paläolithikum, die man insbesondere in Russland, aber auch in Deutschland und Frankreich findet. In Russland handelt es sich dabei in manchen Fällen um große Bauwerke, in deren Mitte sich in regelmäßigen Abständen Feuerstellen befinden (s. Abb. 6.8). Die Archäologin Olga Soffer schloss aus der Untersuchung von Tierknochen, die an den Fundstätten auf der russischen Ebene in Gruben zurückgeblieben waren, dass es sich dabei in vielen Fällen um temporäre Siedlungen für den Winter handelte. Kooperation zeigt sich auch darin, dass die Bewohner Jagd auf Mammuts und Rentierherden machten. Rentiere waren in Pincevent die bevorzugten Beutetiere; an anderen Stellen dagegen, so in Gönnersdorf und Andernach am Rhein, konzentrierte sich die Aufmerksamkeit gegen Ende der Eiszeit vor 14.000 Jahren auf Pferde; die Befunde wurden von Martin Street und Elaine Turner beschrieben.

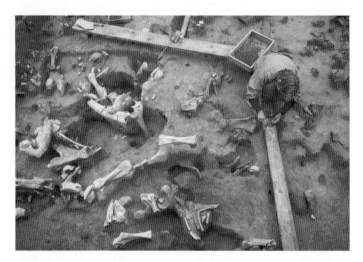

Abb. 6.8 Ausgrabungen steinzeitlicher Siedlungen wie hier bei Kostenki im Westen Russlands liefern häufig wertvolle Informationen über Beutetiere und ihre Verarbeitung durch Menschen, die in sozialen Gruppen zusammenlebten. (© Ira Block/National Geographic Creative)

Ein großes Gehirn: Neandertaler und Jetztmenschen im Vergleich

Kehren wir nun zur Mitgliedschaft im Club der Menschen zurück und fragen wir noch einmal, was uns zu Menschen macht. Die Neandertaler und die Jetztmenschen, zwei Homininen mit großem Gehirn, die von dem gleichen Vorfahren *Homo heidelbergensis* abstammen, bieten uns die Gelegenheit, das Thema zu erörtern und unsere vorgefassten Meinungen angesichts der Theorie vom sozialen Gehirn zu überprüfen. Kernstück des Vergleichs ist die Frage, die wir

schon in Kap. 1 gestellt haben: Wann wurde das Homini-
nengehirn zu einem menschlichen Gehirn?

Eine leidenschaftslose genetische Analyse tut dem An-
sehen der Neandertaler keinen Abbruch: Bei ihnen entwi-
ckelte sich nach unserer Auffassung eine rätselhafte „ande-
re" Art des Menschseins. Das ist eine faszinierende Idee,
und Kollegen wie Frederick Coolidge und Thomas Wynn
halten sogar Vorlesungen über Neandertalerpsychologie.
Nach unserem Eindruck ist allerdings die geographische
Trennung zwischen den beiden Arten nicht eindeutig –
lange Zeit gab es irgendwo im Nahen Osten durchlässige
Grenzen, die sich vielleicht mit dem Klimawandel verscho-
ben und manchmal die eine Gruppe, manchmal auch die
andere begünstigten. Auch Ideen konnten manchmal zwi-
schen den Populationen ausgetauscht werden, denn prinzi-
piell sind sie leichter beweglich als Gene. Konzepte wie die
Bestattung und die weit verbreitete Feuersteinbearbeitungs-
technik mit der Bezeichnung Levallois könnten solche Fälle
gewesen sein.

Wenn wir unsere Neandertalervettern genauer betrach-
ten, bietet sich uns ein faszinierendes Bild, das bereits viele
Male untersucht wurde. Vielleicht klingt hier wieder ein-
mal ein Widerhall von Boyers Systemen an: Die Neander-
taler sind uns so ähnlich und doch gleichzeitig so anders als
wir, und genau das weckt die Aufmerksamkeit (s. Abb. 6.9).

Wir wissen auch, dass sie in einer äußerst unwirtlichen
Umgebung lebten. Ja, es gab sie auch in den gemäßigten
Zonen und in wärmeren Perioden. Vielleicht über zwei-
hundert oder dreihundert Generationen hinweg ging es
ihnen dort gut. Aber mehr als tausend Generationen von
ihnen lebten ununterbrochen in eisiger Kälte, und auf diese

Abb. 6.9 Die deutliche Veränderung in den Funden aus dem europäischen Paläolithikum – von Neandertalern (*oben*) zu den Jetztmenschen (*unten*) – fasziniert Archäologen und Paläontologen schon seit mehr als hundert Jahren. (Nach © M. Boule, *L'Homme fossile de la Chapelle-suz-Saints, Annales de Paleontologie*, 1911–1913)

schwierige Herausforderung mussten sie sich einstellen. Ein unumstrittenes Zeichen für die Schwierigkeiten, die sich in früherer Zeit und in unerwarteten geographischen Breiten einstellten, sind die Rentiere. In La Caune d'Arago in Südfrankreich zerlegten Menschen der Spezies *heidelbergensis* bereits vor 600.000 Jahren Rentiere. In der letzten Eiszeit taten ihre Neandertalern-Nachkommen an Siedlungsstellen in ganz Europa systematisch das Gleiche, so auch in Salzgitter-Lebenstedt. Dort analysierte Sabine Gaudzinski die Funde noch einmal. Die Neandertaler waren durchaus in der Lage, sich mit einer gezielten Jagd auf die Nutzung einer einzigen Tierart zu konzentrieren. Mit Knochenspitzen und Schabern aus Feuerstein verarbeiteten sie die Kadaver so, dass auch jeder moderne Jäger und Sammler beeindruckt gewesen wäre. Neben ihren Fähigkeiten als Metzger ließen die Jäger von Salzgitter auch erkennen, dass sie den Nutzen von Kooperation und Teamwork kannten. Das ist nicht verwunderlich. Die Fähigkeit zur Kooperation reicht mehr als eine Million Jahre zurück, also in eine Zeit lange bevor sich die Neandertaler entwickelten. Ihre neue Er-

rungenschaft bestätigten die Isotope in ihren Knochen, an denen man ablesen kann, was sie aßen: Sie standen jetzt an der Spitze der Nahrungskette.

Die Leistungsfähigkeit der Neandertaler als Jäger wurde lange Zeit angezweifelt. Aber in dem harten Klima hätte kein Mensch überleben können, ohne umfangreiche Kenntnisse über die natürliche Umwelt zu besitzen und mit bewährten Methoden die wichtigsten Anforderungen des Lebens zu bewältigen.

Noch heute finden konstruktive Diskussionen zwischen den Vertretern zweier Lager statt: Die einen halten die Fähigkeiten der Neandertaler für gering, in den Augen der anderen stehen sie gleichberechtigt neben den Jetztmenschen. Sie lebten vielleicht in etwas kleineren Gemeinschaften als die Jetztmenschen und nutzten andere Aspekte der Umwelt. Das Gleiche könnte man auch über viele heutige Bevölkerungsgruppen sagen, wenn man sie einfach mit ihren Vorfahren aus der Zeit vor 100 Jahren vergleicht. Bei der Interpretation solcher Befunde müssen wir also sehr vorsichtig sein.

Häufig wird behauptet, die Neandertaler hätten im Gegensatz zu den Jetztmenschen nicht über eine Fantasiewelt verfügt, die über die grundlegenden Anforderungen des Lebens hinausging. Danach führten sie ein Leben ohne schöne Dinge wie Kunst, Schmuck und Zeremonien. Wie wir aber bereits erfahren haben, spricht manches dafür, dass die Neandertaler sich umeinander kümmerten – ein Beispiel sind die „alten Männer" von Shanidar und La-Chapelle-aux-Saints, die selbst nicht auf die Jagd gehen und sich Nahrung beschaffen konnten. Auch die sorgfältige Anordnung anderer Begräbnisstätten und die gefalteten Arme

der Funde von Kebara lassen auf ein ähnliches Gefühl der Wertschätzung für den Einzelnen schließen.

Im Vergleich zu dem, was die Jetztmenschen des oberen Paläolithikums in Europa seit der Zeit vor 40.000 Jahren schufen, sind Spuren von Schmuck und Kunst in der Zeit der Neandertaler tatsächlich viel seltener – man kann fast sagen, dass sie nicht existieren oder zumindest nicht erhalten geblieben sind. Bevor wir aber in diese Tatsache zu viel hineininterpretieren, sollten wir zur Kenntnis nehmen, dass das Gleiche in vielen Fällen auch für spätere Zeiten gilt. Die Fundstätte von Pincevent in Nordfrankreich stammt aus der späten Eiszeit und ist bemerkenswert gut erhalten; man findet dort umfangreiche Lagerstellen, viele Feuerstellen, tausende von Steinwerkzeugen und zahlreiche Knochen. Dennoch blieb auch dort nur ein einziger verzierter Knochenstab erhalten, den man bei weniger umfangreichen Ausgrabungsarbeiten leicht hätte übersehen können. Aufschlüsse über die Neandertaler liefert vielleicht das, was wir besitzen: Aus ihrer letzten Lebensphase in Frankreich gibt es keine Anzeichen, dass Knochen besonders behandelt wurden; eine Ausnahme bildet nur das sogenannte Châtelperronien in Mittel- und Südwestfrankreich. Lange Zeit glaubte man, das Châtelperronien stehe in Verbindung mit den Jetztmenschen, die seit der Zeit vor rund 35.000 Jahren eingewandert waren. Entdeckungen aus Arcy-sur-Cure und Saint-Césaire deuten aber darauf hin, dass die Werkzeuge in Wirklichkeit von Neandertalern hergestellt wurden. Unter ihnen befinden sich eine ganze Reihe verzierter Knochen, aber auch Steinwerkzeuge mit regionalem Charakter. Natürlich kann man die Ansicht vertreten, dass die Neandertaler solche Dinge nicht erfanden, sondern durch

den Kontakt mit frühen Jetztmenschen, die weiter östlich in Europa lebten, in ihren Besitz gelangten. Das ist möglich, schmälert aber kaum die Bedeutung der Verhaltensweisen: Auch die meisten von uns haben keine Ahnung von den Funktionen im Inneren der Computer und Telefone, die wir jeden Tag benutzen, ganz zu schweigen von der Fähigkeit, sie selbst zu bauen. Funde aus der Cueva Antón auf der iberischen Halbinsel, die João Zilhão und Kollegen in jüngster Zeit entdeckten, zeigen jedenfalls ganz eindeutig, dass die Neandertaler auch Farbstoffe benutzten und in Schneckenhäuser steckten. Diese Funde stammen eindeutig aus einer Zeit, in der es in der Region noch keine frühen Jetztmenschen gab. Alles in allem waren die Neandertaler sicher anders – und dürften auch anders gedacht haben –, aber Unterschiede zwischen ihren Fähigkeiten und denen der Jetztmenschen entwickelten sich sicher erst innerhalb der letzten 100.000 Jahre.

Zurück zum Homo sapiens: die Jetztmenschen

Aber der Wandel lag in der Luft, und in Afrika setzten sich Menschen in Bewegung, die aussahen wie wir und unsere Gene besaßen. Die genetischen Befunde liefern ein überraschend einheitliches, weit gefasstes Bild. Sowohl die Y-Chromosomen als auch die Mitochondrien-DNA deuten auf einen uralten Stammbaum hin, der mit seinen ältesten Wurzeln von Afrika ausgeht und sich dann über die gesamte Alte Welt verbreitet. In diesem Fall steckt zwar nicht gerade der Teufel im Detail, wohl aber ist die Da-

tierung im Detail schwierig. Ein Fixpunkt liegt am Ende der Linie, als Menschen zum ersten Mal über das Meer auf den riesigen Kontinent Sahul gelangten (Australien, Neuguinea und Tasmanien, die vor 50.000 Jahren wegen des niedrigen Meeresspiegels durch Landbrücken verbunden waren). Oft fehlen uns die Einzelheiten, darunter auch Funde aus wichtigen Teilen Asiens. Deshalb könne die Befürworter einer schnellen, aber späten Ausbreitung die Ansicht vertreten, die Wanderung „Out of Africa" habe erst vor 50.000 bis 60.000 Jahren begonnen und die Menschen, die über die Vorteile der Modernität verfügten, hätten sich so schnell ausgebreitet, dass sie vor 50.000 Jahren bereits in Australien angekommen waren. Anderen erscheint eine so schnelle Wanderung wegen ihrer hohen Anforderungen unrealistisch. Zu denen, die eine frühere Ausbreitung der Jetztmenschen für wahrscheinlicher halten, gehört Mike Petraglia von der Universität Oxford, und 100.000 Jahre alte Werkzeuge aus der mittleren Steinzeit, die kürzlich in Arabien entdeckt wurden, scheinen seine Position zu unterstützen.

Die Behauptung, das alles sei eine menschliche Revolution, setzt die unerschütterliche Überzeugung voraus, dass Kunst, hoch entwickelte Technologie und Glaubensüberzeugungen die Grundlage für die große Welle der Neuankömmlinge bildeten, die so schnell rund um die Welt fegte. Aber wie wir zuvor deutlich gemacht haben, waren große Teile der Alten Welt bereits von früheren Menschenformen besiedelt, und das häufig seit langer Zeit. Aus den genetischen Befunden wissen wir heute auch, dass die Bevölkerungsgruppen mäßig eng verwandt waren und sich untereinander kreuzen konnten (die meisten Eurasier haben offen-

sichtlich ungefähr 1 bis 4 % ihrer Gene von Neandertalern). Betrachten wir das Ganze mit mehr Distanz, so werden wir daran erinnert, dass eine Revolution der Symbole in großen Teilen mindestens 120.000 bis 130.000 Jahre zurückreichen dürfte; zu ihr gehören Grabstätten, Verzierungen und Knochenwerkzeuge. Eine echte Neuerung war offenbar nur die darstellende Kunst. Sie trat vor rund 30.000 Jahren in drei Ecken der Alten Welt in Erscheinung: in Europa, Südafrika und Australien; dies weckte zumindest den Verdacht, dass es sich bei ihr vielleicht doch nicht um einen völlig neuen Aspekt der menschlichen Lebensweise handelte.

Auf den ersten Blick sieht es so aus, als hätten die neu hinzugekommenen Jetztmenschen weiterhin das alte Spiel gespielt. Auch früher hatten Menschen schon Afrika verlassen, und deshalb vertrat der Archäologe Robin Dennell die Ansicht, zwischen Afrika und Asien habe während eines großen Teils der frühen Evolution des Menschen ein Verkehr in beiden Richtungen stattgefunden. Auch die Jetztmenschen waren sehr beweglich: Sie lebten davon, Tiere zu jagen und Pflanzen zu sammeln. Ihre sozialen Gemeinschaften waren klein, und sie lebten in niedriger Bevölkerungsdichte. Es war immer noch die Steinzeit.

Aber der Schein kann trügen. Die Jetztmenschen repräsentieren für den gesamten Rahmen des Menschseins eine geringfügige Veränderung. Sie waren zierlicher gebaut, was ihnen die Bezeichnung „grazil" eintrug. Kraft musste nicht mehr im Körper angesiedelt sein, sondern wurde zunehmend auf Hilfsmittel wie Pfeil und Bogen, Boote und Fallen übertragen. Vor dem Hintergrund der Theorie des sozialen Gehirns können wir vermuten, dass die Menschen auch über neuartige soziale Fähigkeiten verfügten, über die

Fantasie, mit der sie über das Hier und Jetzt des unmittelbaren persönlichen Kontakts hinausgehen konnten und in einer Gesellschaft mitwirkten, die für viele Beteiligte nicht nur auf der Bühne, sondern auch dahinter stattfand. Die Menschen orientierten sich an dem, von dem sie glaubten, dass andere es von ihren Handlungen hielten. Eine solche hoch entwickelte Theorie des Geistes war auch bei anderen Homininen mit großem Gehirn, insbesondere bei den Neandertalern, mit ziemlicher Sicherheit vorhanden. Die Jetztmenschen hoben sie aber nochmals auf ein anderes Niveau. Ihre lokalen sozialen Gruppen waren vielleicht nur geringfügig größer als die der Neandertaler, der eigentliche Unterschied lag aber in der Tatsache, dass die Verbindungen und sozialen Verantwortlichkeiten viel komplizierter wurden. Statt sich auf das lokale soziale Umfeld zu beschränken, in dem man mit den meisten anderen Mitgliedern des Bekanntschaftsnetzwerks regelmäßig zusammentraf, waren diese Jetztmenschen nun in der Lage, auch mit einer längeren Trennung und der Abwesenheit ihrer Partner zurechtzukommen. Außerdem begegneten sie auch regelmäßig Fremden.

Woher wissen wir das alles? Eine Indizienkette liefert die Wanderung von Afrika quer durch Asien und dann über das Wasser nach Australien. Ganz gleich, wie die Überquerung des Ozeans bewerkstelligt wurde, sie war mit Trennung verbunden. Eine zweite Indizienkette stammt aus dem Inneren Australiens. Die ersten Australier besiedelten schon kurz nach ihrer Ankunft alle wichtigen Lebensräume dieses Urkontinents einschließlich der Wüsten in seinem Inneren, die im Klima des Pleistozän knochentrocken waren. Bei Ausgrabungen an dem Felsunterstand von Puritjarra west-

lich der Stadt Alice Springs in Zentralaustralien fand Mike Smith Belege, wonach Menschen in der Region schon frühzeitig ansässig waren. Die Besiedelung war abhängig von einer zuverlässigen Wasserversorgung, die noch heute durch Löcher im Gestein gegeben ist. Diese wichtigen Ressourcen verminderten sich, als Puritjarra zum ersten Mal besiedelt wurde, was auf eine noch niedrigere Bevölkerungszahl in einem riesigen Gebiet hindeutet – auch das ein Anhaltspunkt, dass die Gruppen häufig getrennt waren.

Einen dritten Beleg liefern die Rohstoffe, aus denen zusammengesetzte Werkzeuge hergestellt wurden. Die Gesetzmäßigkeiten beobachtet man in der gesamten Alten Welt: Seit der Zeit vor 40.000 Jahren nehmen die Entfernungen zu. Steine werden regelmäßig von weiter entfernten Orten herantransportiert. Zum Teil lag das sicher an dem Wunsch, die besten Steine für die Bearbeitung zu verwenden. Die Entfernung hat aber auch andere nützliche Wirkungen. Der Austausch von Material als Geschenk und später als Handelswaren bindet die Menschen in Beziehungsnetzwerken aneinander. Die gehandelten Gegenstände symbolisieren die Handelspartnerschaft und sind ein Mittel, um weit entfernte Fremde zu nützlichen Verbündeten zu machen.

Mit den Jetztmenschen erweitert sich der geographische Maßstab. Mittlerweile erkennen wir immer besser, wozu sie in der Lage waren, als sie durch Asien in die russische Arktis und dann, als immer noch eine weite Landschaft vor ihnen lag, in die neue Welt Nord- und Südamerikas vordrangen. Der Prozess begann ganz allmählich im Urkontinent Beringia, dessen Mittelpunkt in Alaska lag. Irgendwann vor knapp 20.000 Jahren waren sie über die riesige nordamerikanische Eiskappe nach Süden vorgedrungen, wobei sie

die Haushunde und die Samen der tropischen Flaschen-
kürbisse mitbrachten. Da diese in den kalten Landstrichen,
die sie passieren mussten, nicht gediehen, kann man nur
vermuten, dass sie in der Hoffnung auf ein angenehmeres
Klima weiterwanderten.

Die Samen deuten aber auch noch auf einen anderen
wichtigen Wandel hin. Einerseits beobachten wir, wie die
Gesellschaft sich räumlich erweitert, wobei die Menschen
ganz buchstäblich durch immer längere Ketten der sozia-
len Verbindungen verknüpft sind, die ihren symbolischen
Ausdruck in Artefakten wie Perlen aus Schneckenhäusern,
Bernstein und kleinen Figuren finden, auf der anderen
Seite begann aber auch die Verdichtung der Bevölkerung,
ein Prozess, der in unserer eigenen Gesellschaft so deutlich
zutage tritt. Um an einem Ort eine größere Bevölkerung
aufbauen zu können, muss man Lebensmittel lagern. Wie
Lewis Binford im Rahmen seiner Studien an den Inuit in
Alaska deutlich machte, schafft die Lagerung der bei der
Rentierjagd erlegten Beute die Möglichkeit, die auf der Su-
che nach Wild zurückgelegten Strecken zu vermindern und
in temporären Dörfern zu leben. Auch die archäologischen
Funde verändern sich durch die Lagerung. Ein Rentier, das
im Sommer erlegt wurde, wird unter Umständen erst im
nächsten Frühjahr an einem ganz anderen Ort verzehrt.
Das hat Einfluss auf unsere Interpretation der Informatio-
nen über die Jahreszeiten, die wir aus Tierknochen ableiten
können. Ebenso wichtig ist, dass man die Lagerplätze gegen
andere Gemeinschaften verteidigen kann. Und die gelager-
ten Lebensmittel führen auch zu veränderten Anforderun-
gen an die Arbeitskraft – es ist jetzt nicht mehr ständig not-
wendig, Arbeit für die Suche nach Nahrung aufzuwenden,

sondern man kann diese Notwendigkeit auf wenige Wochen oder Monate des Jahres konzentrieren.

Die Lagerung der Nahrung gilt häufig als wichtiger Verhaltensaspekt der „komplexen" heutigen Jäger und Sammler, aber sie in der Vergangenheit nachzuweisen, ist schwierig. Wir sind an die Kornspeicher und Lagergruben der Bauern gewöhnt. Bei Jägern waren solche Einrichtungen viel seltener, und Gruben findet man in der Regel nur im kalten Klima des Nordens. Gute Beispiele sind die Fundstätten von Kostenki am Don in Russland (s. Abb. 6.8). Die Neandertaler hatten sich offenbar für eine Alternative entschieden: Sie lebten in einer Bevölkerungsdichte, bei der ein sicherer Lebensunterhalt einfach dadurch gewährleistet war, dass sie sich immer zwischen Herden von Mammuts, Nashörnern, Bisons, Pferden und Rentieren befanden. Die Jetztmenschen spielten ein anderes Spiel. Wo es möglich war, wurden sie sesshaft, und dann gründete sich ihre Lebensmittelversorgung auf die gelagerte Nahrung und ihre weit verzweigten Netzwerke. Die Herden waren dann zu manchen Jahreszeiten vielleicht viele Kilometer entfernt. Die Versorgung wurde durch die Lebensmittellager gesichert, aber wenn dies nicht gelang, konnten sie sich über ihre Beziehungsnetzwerke an andere wenden.

Auch wenn wir es nicht mit Sicherheit sagen können, sieht es so aus, als seien die Lagerung von Lebensmitteln, zwischenmenschliche Beziehungen und ihre Organisation nach den Regeln der Verwandtschaft notwendige Voraussetzungen für die bemerkenswerte geographische Ausbreitung der Jetztmenschen seit der Zeit vor 50.000 bis 40.000 Jahren gewesen. Ebenso wichtig war aber nach unserer Überzeugung, dass sie herausfanden, wie man ein Boot baut und eine Höhle mit Tierbildern ausmalt.

Zusammenfassung

Eine Reihe von Revolutionen, die sich spät in der Evolution des Menschen abspielten, ist weniger ein unmögliches Zusammentreffen (wie der Archäologe Paul Mellars es nannte), sondern vielmehr ein unmögliches Rätsel. Unsere heutige Spezies *Homo sapiens* konnte nicht zuerst und ohne besonderen Grund an ein größeres Gehirn gelangen, das dann vor 50.000 bis 40.000 Jahren plötzlich genutzt wurde. So funktioniert Evolution nicht. Das große Gehirn war zu irgendeinem Zweck da, wenn auch vielleicht nicht für die Dinge, für die wir es heute verwenden. Überlegungen über das soziale Gehirn haben den großen Nutzen, dass man mit ihnen vieles erklären kann, was sich nicht allein biologisch oder archäologisch begründen lässt. Wenn wir die letzte halbe Million Jahre betrachten, stehen wir zunächst vor dem Rätsel, dass die Menschen ein größeres Gehirn erworben hatten und in der Landschaft nun eine beherrschende Rolle spielten, während aber scheinbar – bei oberflächlicher Betrachtung – kaum etwas die großen kulturellen Veränderungen vorausahnen ließ, die sich mit der Entstehung der anatomisch modernen Menschen innerhalb der letzten 100.000 Jahre einstellten. Die Theorie vom sozialen Gehirn sagt uns, dass das soziale Umfeld und die Ordnungen der Intentionalität schon viel früher neue Höhen erreicht hatten – und dann stößt man bei näherem Hinsehen auch auf die archäologischen Schattenbilder, die diese Anfänge zeigen. Bestattungen, Perlen, neue Technologien, die neue soziale Organisation vor Ort – all das spricht für einen tief greifenden Wandel.

7
Leben in großen Gesellschaften

Menschen auf dem Weg der Gefahr

In der Menschheitsgeschichte gab es während der Laufzeit des Lucy-Projekts zwei Meilensteine. Im Jahr 2007 lebten zum ersten Mal mehr Menschen in Städten als auf dem Land, und 2011 wuchs die Weltbevölkerung auf mehr als 7 Mrd. Die Archäologie rückt diese Wendepunkte in den richtigen Zusammenhang. Vor 11.000 Jahren, am Ende der Eiszeit, bestand die Weltbevölkerung einer Schätzung zufolge aus 7 Mio. Menschen. Städte gab es nicht, und die Menschen lebten vom Fischen, Jagen und Sammeln. Sie verfügten über Kunst, ihre Zeremonien zeigten sich bei Bestattungen, ihre Architektur hatte die Form von Hütten

und Dörfern. Zu den technischen Errungenschaften gehörten Pfeile mit Steinspitzen, Sicheln und Messer, außerdem Schalen, Mahlsteine, Mörser und Pistille. Auch ein breites Spektrum pflanzlicher Materialien wurde verwendet – sie wurden zu geflochtenen Körben verarbeitet, oder man trug sie als Kleidung. Die wichtigste Lösung für die Probleme, die sich aus veränderlichen Ressourcen und zwischenmenschlichen Konflikten ergaben, bestand darin, den Problemen nach dem altbewährten Prinzip von Aufteilung und Verschmelzung, das man noch heute bei Jägern und Sammlern beobachtet, ganz buchstäblich aus dem Weg zu gehen.

Dann aber kam eine Zeit, in der das nicht mehr funktionierte; der Grund war ein tausendfacher Anstieg der Bevölkerungszahl, ausgelöst durch eine Revolution – die Revolution der Landwirtschaft. Über ihre Anfänge haben die Archäologen lange diskutiert, aber wie es dazu kam, spielt eigentlich für unsere Überlegungen über das soziale Gehirn keine große Rolle. Entscheidend ist, dass die Menschen nun Lebensmittelproduzenten waren und damit eine weitaus größere Bevölkerung ernähren konnten. Seit der Zeit vor rund 11.000 Jahren wuchs die bäuerliche Bevölkerung, Jäger und Sammler dagegen verschwanden mehr und mehr.

Als die Bevölkerung noch klein und mobil war, hatten Vulkanausbrüche und andere Naturkatastrophen nur geringe Auswirkungen. Eine solche Katastrophe ereignete sich vor 12.900 Jahren, als im Rheinland, dort wo sich der heutige Laacher See befindet, ein größerer Vulkanausbruch stattfand. Ihn beschreibt der angesehene Vulkanologe Clive Oppenheimer in seinem 2011 erschienenen Buch *Eruptions that Shook the World*. Die Rauchfahne stieg in bis zu 35 km Höhe auf, und der Krater, der sich dabei bildete, hat einen Durchmesser von 2 km. Der Ascheregen bedeckte bis zu

300.000 Quadratkilometer, und aufgrund der Windrichtung erstreckte sich die Rauchfahne von Mittelfrankreich bis nach Norditalien und von Südschweden bis nach Polen. In der unmittelbaren Nachbarschaft des Kraters findet man große Bimssteinvorkommen, die heute zur Gewinnung von Baustoffen abgebaut werden. Aber trotz derart verheerender Auswirkungen gibt es kaum Anzeichen dafür, dass die Menschen in der Region einen größeren Rückschlag erlitten hätten, der zu Abwanderung oder Aussterben führte. Sie konnten der Region den Rücken kehren, auf Netzwerke sozialer Bindungen zurückgreifen, die sich auch auf nicht betroffene Gebiete erstreckten, und sich an neuen Orten niederlassen. Auch die betroffene Region selbst wurde schon nach wenigen Generationen – im archäologischen Zeitmaßstab also im nächsten Augenblick – wieder besiedelt. Die Fähigkeit, wegzugehen, beruhte auf der uralten menschlichen Fähigkeit zum aufrechten Gang und auf dem sozialen Gehirn, das für den Umgang mit Freunden und Fremden eine Kultur der Verwandtschaft und des Teilens schafft.

Im Laufe der nächsten 11.000 Jahre sollte sich dieser Zustand vollständig verändern. Die Möglichkeit, weiterzuziehen, wurde zunehmend eingeschränkt: Einerseits war man auf Felder und Viehherden angewiesen, andererseits hatte man in Dörfer, Städte und den politischen Machtapparat investiert. Im Januar 2012 brachte die *Daily Mail*, eines der führenden britischen Boulevardblätter, einen Artikel über den Laacher See; die Schlagzeile lautete: „Wird nur 390 Meilen von London entfernt ein Supervulkan ausbrechen?" Als wissenschaftliche Begründung wurde nur angeführt, eine Eruption sei „überfällig", was immer das auch

bedeuten mag. Aber angenommen, die Zeitung hatte mit ihrer Panikmache recht, und der Wind würde dieses Mal von Osten kommen. Dann würden die schlimmsten Befürchtungen, die britische Boulevardblätter im Zusammenhang mit Europa hegen, Wirklichkeit werden: Die Landwirtschaft wäre zerstört, die Städte unter Asche begraben, der Verkehr käme zum Erliegen (wie der Luftverkehr im Jahr 2010, als eine winzige Aschewolke aus Island über den Kontinent zog), und wenn die Menschen ohne Smartphones zurechtkommen müssten, wären Unruhen vorprogrammiert.

Eine Weltbevölkerung von 7 Mrd., die sich in Städten konzentriert, fordert jeden Tag die Katastrophe heraus. Erdbeben und Tsunamis gehörten immer zur Evolution der Homininen. Aber ihre potenziellen Auswirkungen waren wegen der Zahl der Menschen nie so groß wie heute. Wenn es uns wirklich wichtig wäre, würden wir gefährdete Bevölkerungsgruppen in sicherere Regionen umsiedeln. Aber natürlich ist das nicht möglich; wir warten lieber ab und beschäftigen uns mit den Konsequenzen, wenn sie da sind.

Auf der Zielgeraden

Was besagt dieser Tanz auf dem Vulkan im Hinblick auf eine der Fragen, die wir in Kap. 1 gestellt haben? Wird man jemals genau sagen können, wann das Gehirn der Homininen zu einem menschlichen Gehirn wurde? Das könnte eine Frage für Philosophen sein, nur interessieren die sich kaum für die entfernte Vergangenheit, mit der wir uns in

diesem Buch beschäftigt haben. Was können wir selbst zu dem Bild beitragen?

Im Kasten „Arten des Geistes" war kurz von verschiedenen Modellen des Geistes die Rede; dabei haben wir den rationalen Geist, der Probleme löst, dem Beziehungsgeist gegenübergestellt, der durch die Anwendung allgemein verbreiteter sozialer Fähigkeiten für den Aufbau von Beziehungen sorgt. Der Rationalismus war eine der großen Errungenschaften der europäischen Aufklärung; eine andere war aber auch die Wiederentdeckung und Ausgrabung von Pompeji und Herculaneum. Diese Stätten zeigen in anschaulichen Einzelheiten, was ein vergleichsweise kleiner Vulkanausbruch in zwei kleinen Ortschaften anrichten kann. Wenn die Rationalität ein Kennzeichen des modernen Geistes war, hätte man Neapel nach diesen Entdeckungen doch sicher verkleinern und ein Fischerdorf daraus machen müssen, um zukünftige Katastrophen abzuwenden. Obwohl wir die Orte besuchen, ihre Museen besichtigen und in Ausstellungen über ihre Zerstörung strömen, veranlasst uns unser rationaler Geist nicht zu der naheliegenden Schlussfolgerung: Du darfst hier nicht bauen. Stattdessen sind wir durch familiäre, gesellschaftliche, wirtschaftliche und historische Bindungen an solche gefährlichen Orte gefesselt. Unter Nutzung unserer hoch entwickelten Theorie des Geistes vertrauen viele auf die Religion, um die Feuersbrunst fernzuhalten.

Nach unserer Auffassung gehören zur langfristigen Entwicklung des menschlichen Geistes, zu der sich heute auch Philosophen äußern können, im Prinzip auch die Entstehung immer höher entwickelter sozialer Fähigkeiten und

parallel dazu eine Größenzunahme der sozialen Gemeinschaften. Wie wir in diesem Buch immer wieder nachgewiesen haben, sind solche Fähigkeiten sehr alt. Sie sind nicht das alleinige Vorrecht der 7 Mio. Individuen von *Homo sapiens* am Ende der Eiszeit oder der 7 Mrd. heute lebenden Menschen. In mehr oder weniger großem Umfang waren sie auch bei früheren Homininen mit großem Gehirn wie *Homo heidelbergensis* und *Homo neanderthalensis* vorhanden. Dazu gehören die Fähigkeit zur Mentalisierung, zu Sympathie und Mitgefühl mit anderen und zu einer hoch entwickelten Theorie des Geistes, die uns Zugang zu den Absichten eines anderen verschafft; alle diese Eigenschaften sind tief in unserer Geschichte verwurzelt, und wie wir gezeigt haben, lassen sie sich bis in unsere Vergangenheit als Primaten zurückverfolgen. Zu einigen davon gehören die Sprache und die Nutzung von Gegenständen als Symbole oder Metaphern. Deshalb können wir über kein Artefakt und keinen fossilen Vorfahren eindeutig sagen: „Dieser hier hatte einen modernen Geist, jener aber nicht." Eigentlich wussten wir schon seit Beginn unseres Projekts zum sozialen Gehirn, dass die Bestrebungen, den modernen Geist zu definieren, der Suche nach Narrengold gleichen. Stattdessen haben wir den Geist als Kombination sozialer Fähigkeiten dargestellt, die im Laufe unserer Evolution einer ständigen Selektion unterlagen. Ihren Höhepunkt erreichte diese Entwicklung mit sozialen Gemeinschaften von 150 Personen und den kognitiven Fähigkeiten, die ein Individuum braucht, um eine solche Zahl handhaben zu können. Die Dunbar-Zahl von 150 hat sich als ungeheuer solider Baustein erwiesen, mit dem man immer größere,

raffiniertere Gebäude errichten kann – diese haben wir an vielen Beispielen unter dem Oberbegriff der Verstärkung beschrieben. In wenigen „Minuten" unserer Evolutionsgeschichte sind aus 7 Mio. 7 Mrd. geworden, und doch ist die kognitive Kernstruktur, die unser Sozialleben steuert, auf dem Weg von der Steinzeit zum Digitalzeitalter gleich geblieben. Während des hektischen Ritts, den wir seit dem Ende der Eiszeit erlebt haben, konnten wir beobachten, wie die Fantasie der Menschen entfesselt wurde und Ausgangsmaterialien in neue Formen von unglaublicher Vielfalt und beispielloser Menge brachte. Aber der Geist hinter dieser Vielfalt ist, was das Schmieden von Beziehungen zu anderen und die Lösung der Probleme angeht, mit denen alle unsere Vorfahren sich auf ihrem Weg in die Welt des Sozialen auseinandersetzen mussten, im Wesentlichen der Gleiche geblieben.

Noch einmal das soziale Gehirn

Unsere Kernaussage lautet: Während der letzten 11.000 Jahre haben die Menschen in einer schönen neuen Welt der großen Zahlen gelebt, aber ausgerüstet waren sie nur mit den sozialen Fähigkeiten und den Strukturen, die ihr viel älterer biologischer Zustand möglich machte. Kernstück der Theorie des sozialen Gehirns ist die Gruppengröße. Soziale Kognition ist aufwendig. Wo die Ökologie größere Gruppen begünstigt, ergibt sich eine Belastung des Gehirns, die wir als kognitive Last bezeichnen. Im Laufe der letzten 2 Mio. Jahre begünstigte die Evolution bei der Gat-

tung *Homo* ein immer größeres Gehirn. Der Wandel war eine allmähliche Antwort auf die Erfordernisse der Evolution. Als den Menschen dann ganz plötzlich kulturelle und technologische Umwälzungen gelangen, aus denen sich ungeheure Neuerungen wie die Landwirtschaft ergaben, war die Lage eine andere, und jetzt konnten sie auf das Wachstum der Gesellschaften nicht mehr mit einem weiteren Wachstumsschub des Gehirns reagieren. Stattdessen wurde das Leben nun zur Kunst des Möglichen. In einer größeren Gesellschaft kann man nicht jeden kennen. Früher spalteten Gruppen sich auf, wenn sie zu groß wurden, aber eine solche Lösung wurde jetzt viel schwieriger. Außerdem gab es auch Anreize, mit anderen Gruppen zurechtzukommen. Dass in alter Zeit Kriege geführt wurden, liegt auf der Hand, und in Spielen, in denen es um hohe Einsätze ging, müssen Allianzen zwischen Gruppen von entscheidender Bedeutung gewesen sein.

Während eines großen Teils der letzten 11.000 Jahre ging es darum, zu lernen, wie man mit großen Zahlen zurechtkommt, auch wenn man nur die alten, kleinen Zahlen verwendet. Noch heute ist die Dunbar-Zahl die Obergrenze für die Zahl der Menschen, die wir kennen und mit denen wir umgehen können. Meist leben wir in kleinen Kerngruppen aus 5 Personen, Unterstützergruppen von ungefähr 15 und „Horden" mit ungefähr 50 Mitgliedern. Für die größeren Zahlen waren neue Mechanismen erforderlich, und drei davon wollen wir genauer betrachten: Religion, Führerschaft und Kriegsführung. Aber um sie in einen bestimmten Zusammenhang zu stellen, werden wir zunächst eine archäologische Überraschung präsentieren.

Die vergrabenen Kreise

Nicht weit von der Stadt Urfa im Süden der Türkei befindet sich eine der bemerkenswertesten archäologischen Entdeckungen der letzten 20 Jahre. Am Göbekli Tepe (dem „schmerbäuchigen Hügel") fanden der Archäologe Klaus Schmidt und sein internationales Team eine Reihe von Steinringen, die auf ein Alter von 11.000 Jahren datiert wurden (s. Abb. 7.1). Sie wurden von Menschen erbaut, die weder Haustiere noch Nutzpflanzen oder Keramik besaßen. Ihre Wohnorte hat man noch nicht entdeckt. Sie waren Jäger und Sammler, und doch errichteten sie eine monumentale Architektur: Die riesigen, T-förmigen Steinblöcke sind bis zu sieben Meter hoch – eine raffinierte Version von Stonehenge, aber 8000 Jahre älter – und mit Ritzfiguren von Tieren bedeckt, darunter Füchse, Spinnen und Enten. Die Pfeiler stellen Menschen dar, zu erkennen an den aus dem Stein gehauenen Armen und Händen an den Seiten. Anschließend wurden die Steinringe absichtlich vergraben, und dabei entstand die charakteristische Form des Hügels.

Göbekli Tepe stellt viele archäologische Vorstellungen infrage (Abb. 7.1). Im Zusammenhang mit dem sozialen Gehirn fallen einem insbesondere zwei davon ein. Die erste ist die Annahme, Monumentalarchitektur könne nur im Rahmen einer sesshaften Lebensweise entstehen, die sich auf Haustiere und Nutzpflanzen gründet. Und die zweite besagt, die Errichtung derart großer Bauwerke sei nur möglich, wenn jemand das Projekt leitet: eine – stets männliche – Gestalt mit Visionen und Charisma, nicht unähnlich dem beliebten Bild vom Archäologen, der in Griechenland oder dem Nahen Osten größere Ausgrabungen leitet.

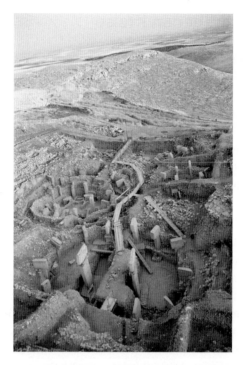

Abb. 7.1 Die erstaunlichen Steinkreise von Göbekli Tepe sind 11.000 Jahre alt und wurden demnach vor dem Beginn der Landwirtschaft errichtet; deshalb geben sie Anlass, neu über die Anfänge komplexer Gesellschaften nachzudenken. (© N. Becker/DAI)

Verbindungen

Göbekli Tepe zwang die Archäologen, eine ihrer Lieblingsgeschichten noch einmal zu überdenken. Darin war die Landwirtschaft eine Kraft, die alle Aspekte der Gesellschaft veränderte. Aber welche weiter gefassten Folgerungen ergeben sich aus dieser bemerkenswerten Fundstätte? Was

spielte sich mit unserem sozialen Gehirn nach der Entstehung der Landwirtschaft ab? Entwickelte sich bei uns sehr schnell ein neuartiges Gehirn, das Symbole besser verarbeiten konnte und damit das Leben in Dörfern und Städten möglich machte? Diese Ansicht vertritt der Archäologe Colin Renfrew: In seinem 2007 erschienenen Buch *Prehistory: Making of the Modern Mind* zeigt er sich beeindruckt vom Umfang der neuen Artefakte, den künstlerischen Stilen und der Architektur, die mit der neolithischen Revolution auf der Bildfläche erschienen. Diese neuen Dinge führten nach seiner Meinung zu einer grundlegend neuen Wahrnehmung für andere Menschen und die Umwelt. Für Renfrew war es eine Revolution der Sesshaftigkeit; ihre Grundlage war die Landwirtschaft, die es den Menschen erlaubte, sich auf zuvor unmögliche Weise mit ihrer materiellen Kultur zu beschäftigen. Es war die Geburt des modernen Geistes.

Wir sind da nicht so sicher. Das soziale Gehirn eines Jägers, der vor 20.000 Jahren in den offenen Weiten des Nahen Ostens lebte, scheint uns nicht zwangsläufig anders zu sein als das eines Bewohners in den beengten Wohnvierteln von Çatalhöyük, einer neolithischen Stadt mit 8000 Einwohnern in der Türkei, die erstmals 7500 v. Chr. besiedelt wurde. Was Art und Formenvielfalt der materiellen Dinge anging, die von diesen Jägern und Bauern hergestellt wurden, trat sicher ein gewaltiger Wandel ein. Aber die Steinkreise von Göbekli Tepe, die noch viel älter sind und von Menschen ohne Landwirtschaft erbaut wurden, stellen die traditionelle Ansicht der Archäologen infrage, wonach Fortschritte im Symbolgebrauch nur erzielt werden konnten, nachdem man sesshaft war und Getreide anbaute.

Wenn es um das „große Denken" geht, ist die materielle Umwelt dieser ersten Bauern im Nahen Osten sicher etwas Besonderes. Wir wollen aber wissen, ob hinter ihrem sozialen Umfeld immer noch ein kognitiver Rahmen stand, der eine viel ältere Abstammung hat. Als Analogie würden wir anführen, dass der Geist im 21. Jahrhundert sicher ganz anders ist als im Mittelalter; so ist beispielsweise Wissenschaft an die Stelle der Alchemie getreten. Aber auch wenn diese beiden kulturellen Welten sich auf ganz unterschiedliche Prinzipien zu begründen scheinen, gehen wir doch davon aus, dass die kognitiven Bausteine, durch die sich Menschen in Gruppen und Gemeinschaften zusammenfanden, ähnlich blieben.

Im Rahmen des Lucy-Projekts überprüfte Fiona Coward solche Annahmen. Als Region wählte sie den Nahen Osten, und dort untersuchte sie das Inventar von nicht weniger als 591 archäologischen Fundstätten, die man auf eine Zeit zwischen 21.000 und 6000 v. Chr. datiert hatte. Diese große Stichprobe schloss den gesamten Klimawandel von der Kälte der Eiszeit bis zur Wärme des Holozän ein, aber auch den Übergang von den Jägern zu den Bauern. Durch ihn wuchs die Bevölkerung, und die Menschen wurden sesshaft. War das die Geburt des modernen Geistes, wie Renfrew und andere behaupten?

Coward interessierte sich insbesondere für die Frage, wie die Beziehungsnetzwerke während dieses klimatischen und wirtschaftlichen Wandels aussahen. Um sie zu beantworten, ging sie von der einfachen Annahme aus, dass man solche Netzwerke anhand der materiellen Überreste

nachzeichnen kann. In früheren Kapiteln haben wir bereits erfahren, wie Rohstoffe die Menschen über große Entfernungen verbanden. Mit ihrer Datenbank konnte Coward die Untersuchung der sozialen Bindungen mithilfe der materiellen Kultur auf eine neue Ebene heben: Dazu erstellte sie Querverweise zwischen Artefakten vieler verschiedener Typen. In der Praxis bedeutete das, dass sie das Inventar von fast 600 Fundstätten aus dem gesamten Nahen Osten in 15 Zeitabschnitten von jeweils 1000 Jahren verglich. Die Fundstätten waren durch die Ähnlichkeit der in ihnen enthaltenen Gegenstände sozial verknüpft. Dabei wurden verschiedene Varianten der materiellen Kultur systematisch erfasst: Kunstwerke, Daten über Bestattungen, Architektur und andere Bauwerke, Mahlsteine, Feuerstellen, bearbeitete Steinwerkzeuge, Ocker, Verzierungen und Schmuck, Schneckenhäuser und bearbeitete Knochen. Daraus ergab sich für jeden Zeitraum eine Matrix der Beziehungen, mit der die Stärke der materiellen Verbindungen zwischen den Menschen an den einzelnen Stellen gemessen wurde.

Was waren die Ergebnisse? Seit 13.000 v. Chr. wurden die Netzwerkverbindungen im Nahen Osten immer stärker zentralisiert, und eine kleine Zahl von Stellen in dem Netzwerk wurde, was die materiellen Objekte anging, reicher als andere. Das ist zu erwarten, da sich das Klima änderte und da die ersten Siedlungen aus dieser Zeit stammen. Die Netzwerke der ersten Bauern waren auch viel weiter gespannt als die der früheren Jäger – sie erstreckten sich weit über die Entfernungen hinaus, die Jäger beim Transport von Rohstoffen überwanden. Die Verbindungen zwischen

den einzelnen Stellen wurden im Laufe der Zeit aufgrund der schieren Anzahl neuer Dinge, die man jetzt regelmäßig herstellte, immer enger. Interessanterweise findet man dazu allerdings keine Entsprechung, wenn man den Anteil der Verbindungen berechnet, die überhaupt geknüpft werden konnten. Dieser Anteil, der als Dichte des Netzwerks bezeichnet wird, ging im Laufe der Zeit sogar zurück.

Von der explosionsartigen Zunahme der materiellen Kultur während des Neolithikums waren die Archäologen immer so beeindruckt, dass sie sogar von einer Revolution sprachen. Manche halten dies für den Zeitpunkt, zu dem der Geist modern wurde. Sie dachten aber nicht daran, welche Beziehungsnetzwerke solche Gegenstände brauchten und welche kognitiven Fähigkeiten hinter ihrer Benutzung standen. Das Wachstum der materiellen Kultur im Neolithikum leugnen wir nicht, es ist aber kein Signal für die Entstehung des modernen Geistes. Coward ging mit ihrer Studie von der Theorie des sozialen Gehirns aus und konnte zeigen, dass eine Alternative wahrscheinlicher ist: die Verstärkung eines bereits vorhandenen kognitiven Rahmens. Statt eines neuen neolithischen Geistes finden wir Anhaltspunkte für die kontinuierliche Existenz eines sozialen Gehirns.

Coward schließt daraus, dass die materielle Kultur als solche der Katalysator dafür war, in großen Dimensionen zu denken. Schließlich gehörten Jäger und Bauern zu derselben Menschenspezies, dem *Homo sapiens*. Sie dürften die Welt unterschiedlich gesehen haben, ganz ähnlich wie ein mittelalterlicher Alchimist einen anderen Blick auf die Welt hatte als ein heutiger Naturwissenschaftler. Aber wenn es

um den Aufbau von Kontaktnetzwerken ging, bedienten sich beide des gleichen, in der Evolution entstandenen Rahmens, um mit den Problemen zurechtzukommen: Man hat am Tag zu wenig Zeit und nimmt eine zusätzliche kognitive Belastung auf sich, wenn man Menschen nicht als Zahlen behandelt, sondern auf sozial sinnvolle Weise mit ihnen umgeht. Das Netzwerk der Artefakte, das die Archäologen beim Vergleich von Neolithikum und Paläolithikum so beeindruckt, war der klassische Weg, um die Kosten aus dem kognitiven Bereich auf die Welt des Materiellen abzuwälzen. Am Beginn dieses Weges zur Komplexität standen die ältesten Homininen mit nicht viel mehr als ihren kleineren Gemeinschaften und einfachen Steinwerkzeugen. In der entscheidenden Phase von 21.000 bis 6000 v. Chr. beobachten wir eine Vermehrung der materiellen Dinge, die Menschen aneinander binden. Am Ende des Zeitraumes waren sie in Netze der Kultur verfangen wie Gulliver, der durch die Fäden der Liliputaner festgehalten wurde. Die Ebenen des sozialen Gehirns, darunter die Dunbar-Zahl von 150, blieben die Gleichen, aber dank der Landwirtschaft wurde nun ein zuvor unvorstellbares Wachstum der Bevölkerung möglich, und in dieser diente der gemeinsame kognitive Rahmen als Mittel der zwischenmenschlichen Interaktionen. Die Gesellschaft war im Vergleich zu den Jägern und Sammlern insbesondere im Hinblick auf die Zahlen ungeheuer viel komplexer geworden, aber das Sozialleben basierte nach wie vor auf einigen grundlegenden Gesetzmäßigkeiten der Kognition, die tief in unserer Vergangenheit verwurzelt waren.

Die Kraft des Charismas: Religion, Führerschaft und Kriegsführung

Konnten die Baudenkmäler von Göbekli Tepe errichtet werden, ohne dass ein Anführer die Arbeiten organisierte? Ein solcher Anführer hätte die Gestaltung, das Brechen der Steine, die Steinmetzarbeiten und den Aufbau leiten müssen, ganz zu schweigen von der Mühe, die Stelle später wieder mit Erde aufzufüllen. Um nur eine der ringförmigen Einfriedungen zuzuschütten, waren 500 Kubikmeter Geröll notwendig. Die Menschen mussten sich für die prachtvolle Konstruktion begeistern; welchen Nutzen sie davon hatten, ist uns ein Rätsel, insbesondere da die Arbeitskräfte eigentlich vom Jagen und Sammeln lebten. Wären sie Bauern gewesen, hätten sich die Archäologen viel weniger über die Bauwerke gewundert, aber das sagt auch viel über uns selbst und unsere Vorstellungen von der Vergangenheit.

Liefert die Religion ein Motiv und eine Erklärungsmöglichkeit? Einige der ältesten Anhaltspunkte für stärker organisierte Formen der Religion stammen aus Siedlungen in der Levante, die in der Phase des Neolithikums vor rund 8000 Jahren entstanden: Dort hat man manche Bauwerke als rituelle Stätten gedeutet – später allerdings scheuten vorsichtigere Archäologen davor zurück, die Funktionen dieser Gebäude überzuinterpretieren. Wir befinden uns aber auf festerem Boden im Hinblick auf die nachfolgende Bronzezeit, die vor rund 5000 Jahren begann: Hier sind Hinweise auf rituelle Stätten und religiöse Artefakte erheblich weniger umstritten. Da solche Dinge aber nur existieren können, wenn zuvor der notwendige begriffliche Apparat für

ihre Erschaffung vorhanden ist, kann man vermuten, dass die Religionen selbst als begriffliche und rituelle Phänomene weitaus ältere Wurzeln haben.

Da organisierte Religion die Funktion hat, eine Bevölkerung auf die Linie der Gemeinschaft einzuschwören, liegt die plausibelste Erklärung für den Aufschwung solcher Formen der Religion in den sozialen und psychologischen Belastungen, die große Gemeinschaften den Menschen auferlegen. Wenn man dauerhaft ein sesshaftes Leben führen will, gilt es zwei Probleme zu lösen. Erstens müssen die Belastungen abgebaut werden, die das Leben in enger Nachbarschaft mit sich bringt; davor zu flüchten, ist schwierig, denn die Lösung der Jäger, einfach wegzugehen, ist hier alles andere als einfach. Und zweitens muss man diejenigen unter Kontrolle haben, die auf „Trittbrettfahrten" aus sind. Die Aktivität von Nassauern, die etwas ohne Gegenleistung bekommen wollen, droht den Gesellschaftsvertrag zu unterminieren, von dem das Leben in größeren Dörfern zwangsläufig abhängig ist.

Ob die Landwirtschaft eine Lösung für ein ökologisches Problem war oder eine zufällige Entdeckung darstellte, durch die sich neuartige Gelegenheiten eröffneten, ist für uns nicht unmittelbar von Bedeutung. Hier geht es darum, dass das Leben in Siedlungen neue Spannungen entstehen ließ, und diese Spannungen hätten im weiteren Verlauf die Entwicklung des modernen Lebens, wie wir es kennen, mit all seinen kulturellen Verästelungen verhindern können. Hätten die Menschen keine Lösungen für die sozialen Einschränkungen gefunden, wäre die moderne Welt nie entstanden.

Besondere Bedeutung erlangte dabei wahrscheinlich das Phänomen der charismatischen Führungsgestalten, ein Thema, für das sich unser Mitarbeiter Mark van Wought besonders interessierte (sein Buch, das er 2010 zusammen mit Anjana Ahuja veröffentlichte, trägt den Titel *Selected: Why Some People Lead, Why Others Follow, and Why It Matters*). Während in Gesellschaften von Jägern und Sammlern jede soziale Unterscheidung vermieden wird (alle sind gleich), spielten charismatischer Anführer in allen postneolithischen Gesellschaften und den von Doktrinen geprägten Religionen, die aus ihnen hervorgingen, eine wichtige Rolle. Zum einen bieten sie Führung; zum anderen stellen sie auch einen Mittelpunkt dar, um den sich die Gemeinschaft versammeln kann.

In Gemeinschaften von 150 Personen, in denen jeder jeden kennt, sind Führer wahrscheinlich unnötig: Wenn die Gruppe nur ungefähr 20 bis 25 erwachsene Männer umfasst, ist ein Konsens darüber, was man tun soll, zwangsläufig viel einfacher zu erreichen als in einer Gemeinschaft von 1500 Individuen mit zehnmal so vielen erwachsenen Männern. Verschärft wird die Situation in solchen Gruppen noch dadurch, dass zwischen den Männern zwangsläufig Unterschiede in Alter, Fähigkeiten, Erfahrung und Ansehen bestehen – Eigenschaften, um die Männer konkurrieren und die zu Rivalitäten führen. Wenn zu viele Männer da sind, wächst das Risiko der Fraktionsbildung und Zersplitterung, weil zu viele von ihnen ungefähr in dem gleichen Ansehen stehen. In solchen Situationen bilden charismatische Anführer einen natürlichen Mittelpunkt, um den sich alle anderen sammeln und alles unterschreiben, wofür der Anführer zufällig gerade eintritt.

Eine besonders wichtige Rolle spielen charismatische Führer in der Religion. Die meisten doktrinären Religionen wurden von einzelnen charismatischen Personen gegründet, von Zarathustra bis zu Gautama Buddha und von Jesus Christus bis zum Propheten Mohammed. Alle großen Religionen unserer Zeit waren zu Anfang kleine Minderheiten, Sekten einer bereits vorhandenen Religion. Es ist sogar ein charakteristisches Merkmal von Religionen, dass sie offensichtlich von Natur aus häufig Sekten hervorbringen. In den meisten Fällen sind diese zunächst sehr klein, aber ob sie überleben, hängt letztlich davon ab, wie schnell sie engagierte Mitglieder anlocken können. Religiöse Glaubensüberzeugungen haben die Eigenschaft, dass sie ein intensives emotionales Engagement wecken können, ganz gleich, welchen Glauben die Menschen tatsächlich haben. Es ist, als hätte die Geistwelt eine besondere emotionale Macht über den Geist der Menschen.

Die Fähigkeiten, mit denen manche Menschen (meist Männer, aber nicht immer – man denke nur an Jeanne d'Arc) zu charismatischen Führern werden, spielten auch in der säkularen (das heißt politischen) Welt weiterhin eine wichtige Rolle, denn die von der neolithischen Revolution losgetretenen Kräfte ließen in den nachfolgenden Jahrtausenden immer größere politische Einheiten entstehen. Um 3000 v. Chr. gab es in den Stadtstaaten Könige und Wesire. Solche Menschen tragen auch heute noch zum Erfolg vielfältiger säkularer Organisationen bei, von Unternehmen über Schulen bis zu Krankenhäusern und karitativen Einrichtungen.

Im Zusammenhang der sehr großen Gemeinschaften erlangten charismatische Anführer vor allem deshalb ihre

Bedeutung, weil sie es der Gruppe ermöglichen, sich selbst eine gewisse Disziplin aufzuerlegen und die unterschiedlichen Niveaus ihrer vielen Mitglieder zu überwinden. Einen Anführer zu haben, der das Verhalten der Gemeinschaft koordiniert und lenkt, hat offenkundige Vorteile, es hat aber auch seinen Preis: Schließlich hat jeder Einzelne geringfügig andere Interessen, und letztlich muss jeder, der in eine Führungsposition aufsteigt, die Strategien verfolgen, die mit den eigenen Interessen mehr im Einklang stehen als mit denen aller anderen – nicht zuletzt, weil zwangsläufig jeder in der Gemeinschaft geringfügig andere Ansichten darüber hat, was man am besten tut. Ein charismatischer Führer, der alle davon überzeugen kann, trotz unterschiedlicher persönlicher Vorlieben gemeinsam zu handeln, kann auf lange Sicht nützlich werden, wenn die Vorteile einer solchen Handlungsweise gegenüber denen überwiegen, die sich ergeben, wenn jeder Einzelne sich entsprechend seinen persönlichen Interessen verhält.

Als wichtiger Faktor, der seit dem Neolithikum zur stetigen Größenzunahme der politischen Einheiten oder Gesellschaften beitrug, wurde der Schutz vor Plünderern genannt. Diese Ansicht vertreten der Soziologe Allen W. Johnson und der Archäologe Timothy Earle ganz ausdrücklich in ihrem bahnbrechenden, 1987 erschienenen Buch *The Evolution of Human Societies: From Foraging Group to Agrarian State*. Nach ihrer Ansicht, die von einer wachsenden Zahl evolutionsorientierter Sozialwissenschaftler geteilt wird, war Kriegsführung die wichtigste Triebkraft für die Entstehung immer größerer Siedlungen (Dörfer, Klein- und Großstädte, Stadtstaaten), die sich im Laufe der 7000 bis 8000 Jahre

nach den ersten Dörfern entwickelten. Überfälle sind eine Form des Nassauertums – man bereichert sich auf Kosten anderer. Warum soll man arbeiten, wenn man mit geringem Energieaufwand und wenig Risiko alle Bedürfnisse durch die Produkte der Mühen anderer befriedigen kann? Die Verteidigung gegen Überfälle wird immer notwendiger, je größer die Vorteile dieser Form des Nassauertums (und damit die Versuchungen) werden. Und organisierte militärische Einheiten mit klaren Kommandostrukturen und organisierter Leitung sind stets erfolgreicher als zusammengewürfelte Armeen, in denen die Koordination fehlt. Genau vor diesem Hintergrund kommen charismatische Anführer oder Anführerinnen voll zur Geltung.

Mit dem Aufstieg der charismatischen Anführer überschreiten wir in einem gewissen Sinn die Grenze zwischen der Vorgeschichte und der Geschichte, und damit verlassen wir die wichtigsten Themen dieses Buches. Uns geht es aber darum, dass die Samen vieler Entwicklungen, die sich zwischen dem Neolithikum und unserer Zeit abspielten, ihren Ursprung den Bemühungen verdanken, die Belastungen zu umgehen, die sich ergaben, als Menschen erstmals in großen Siedlungen zusammenwohnten. Säkulare charismatische Anführer mit ihren Statussymbolen wie Leibwächtern und aufsehenerregenden Auftritten ähneln religiösen Führern mit ihren Priestern, Riten und zeremoniellen Räumen. Beide versuchen ihre Gefolgsleute dazu zu bringen, dass diese sich in die Gemeinschaft einordnen und so eine leistungsfähigere Zusammenarbeit ermöglichen. Eine solche Form der Zusammenarbeit ist aber von ihrem Wesen her instabil, denn die Linie der Gemeinschaft eignet sich

niemals gleichermaßen für alle – immer haben manche ihrer Mitglieder den Eindruck, sie würden einen überproportional großen Anteil zur gemeinschaftlichen Anstrengung beitragen, und irgendwann fühlen sie sich so gekränkt oder machtvoll, dass sie sich auflehnen.

Genau wie Religionen, die ständig in neue, um charismatische Anführer herum aufgebaute Sekten zerfallen, so zerbrechen auch politische Gebilde durch Gruppenrivalitäten und Revolutionen. Die Lösungen unserer Spezies für die Probleme, die sich durch den wirtschaftlichen Wandel des Neolithikums stellten, sind im besten Fall unvollkommen. Meist liegt das daran, dass wir sie mit den psychologischen Mechanismen mobiler Jäger und Sammler lösen, die in ihren weit verstreuten Gemeinschaften leben wie unsere Vorfahren in den vergangenen 7 Mio. Jahren.

Aussuchen und Auswählen

Das Wachstum der Menschheit wurde durch wirksame Faktoren wie charismatische Anführer und organisierte Religion nachdrücklich unterstützt. Es gibt aber auch andere, „alte" Merkmale, die ebenso dazu beigetragen haben, die neuen, großen Gesellschaften zu organisieren. Die Zahl der einzelnen Menschen, mit denen wir umgehen können, hat sich, wie wir erfahren haben, nicht verändert. Die „Dunbar-Zahl" ist heute für uns ebenso real wie für die Menschen vor 100.000 Jahren. Wir haben aber gelernt, selektiv persönliche Netzwerke aufzubauen. Zwei Schimpansen haben in ihrer Gemeinschaft nahezu das gleiche Netzwerk – jeder

kennt jeden. In unserer Welt dagegen kennen wir vermutlich die meisten anderen Menschen in unserem Dorf oder unserer Straße, aber am Arbeitsplatz, im Sport oder bei unseren Freizeitbeschäftigungen haben wir völlig andere Netzwerke. Wir wechseln mit Leichtigkeit selektiv hin und her.

Auf den Ursprung dieses Wechsels weisen die Berufsstände und Hierarchien hin, die Gordon Childe für das Neolithikum beschrieb. Kaufleute wollten und mussten Handel mit anderen Kaufleuten betreiben, die vielleicht hunderte von Kilometern entfernt waren. Töpfer und Metallarbeiter wollten mit anderen, die über die gleichen Fähigkeiten verfügten, über ihre Methoden sprechen. Anführer hatten mit Anführern zu tun: Als William der Eroberer England zwischen 180 seiner Gefolgsleute aufteilte, handelte er in brutaler Einfachheit nach den Prinzipien des sozialen Gehirns.

Charismatischer Anführer, Religion und selektive Netzwerke sind bis heute machtvolle Kräfte, und wie Göbekli Tepe zeigt, verstehen wir ihre historischen Wurzeln nicht ganz. Eines aber möchten wir betonen: Die Archäologie versetzt uns in die Lage, den großen Bogen der Menschheitsgeschichte vielfach auch in kleinen Details zu beobachten. Wer einmal einen alten Stadthügel, eine Pyramide oder die Megalithalleen von Carnac gesehen hat, kann sich dem Staunen über diese handfesten Belege für die ungeheuren sozialen Anstrengungen früherer Zeiten nicht entziehen. Ob gleichberechtigte Menschen zusammenarbeiten oder ob die Zusammenarbeit von oben angeordnet wurde, die gemeinsam erbauten Denkmäler zeigen, wie Menschen regelmäßig in einer Zahl zusammenkamen, die weit über die Gruppengröße ihrer Vorfahren hinausging. Diese Gesell-

schaften funktionierten, weil die „alten" Gehirne mit den neuen Maßstäben des Soziallebens zurechtkamen. Die selektiven hierarchischen Netzwerke bildeten einen Rahmen für das Wachstum der Institutionen und politischen Gebilde. An dieser Stelle übergibt die Archäologie das Staffelholz der Dokumentation an Geschichtsforschung, Soziologie und Psychologie.

Die Technologie des dezentralen Geistes: Schreiben und Simsen

In ihrer Studie zu den Netzwerken der Gegenstände im Nahen Osten weist Fiona Coward darauf hin, dass die Objekte einen Rahmen darstellen, in dem man in großen und immer größeren Dimensionen denken kann. Dies ist ein gutes Beispiel dafür, wie der dezentrale Geist (s. Kasten „Arten des Geistes") die Technologie verstärkt, um neuen Herausforderungen zu begegnen, in diesem Fall der wachsenden Zahl von Menschen. Wie wir in Kap. 5 dargelegt haben, füllte die Sprache schon vor der explosionsartigen Vermehrung der Gegenstände die Lücke der Zuwendung, die sich durch die Größenzunahme von Gehirn und Gemeinschaften aufgetan hatte. Ähnliche Lücken wurden durch zwei weitere Technologien gefüllt, aber dieses Mal trugen sie dazu bei, die riesigen Populationen der letzten 11.000 Jahre zu organisieren und zu koordinieren. Diese Technologien waren Schreiben und Simsen.

Das Schreiben entstand nach unserer Vermutung als Mechanismus, der den Druck des Lebens in größeren Gesellschaften minderte. Man konnte nun formell aufgezeichnete Befehle verschicken, diplomatische Nettigkeiten austauschen und Bilanzen aufstellen. Die erweiterte Kommunikation war auch die Voraussetzung für die Entstehung formeller Institutionen. Im Mittelalter kümmerte sich der heilige Franz von Assisi, das Musterbeispiel eines charismatischen Anführers, überhaupt nicht um Eigentum oder Organisationen. Die katholische Kirche dagegen, mit der er es zu tun hatte, bestand darauf, eine gewisse administrative Kontrolle auszuüben; der Schlüssel dazu waren schriftliche Aufzeichnungen.

Die Schrift gewährleistete während der letzten 5000 Jahre die historische Kontinuität. Chinesen, Griechen und Römer sind uns aufgrund ihrer schriftlichen Aufzeichnungen, in denen häufig die Schwierigkeiten mit Organisation und Verwaltung geschildert werden, weitaus besser bekannt als andere Völker der gleichen Zeit. Der zweite Faktor, der stark zum sozialen Zusammenhalt beigetragen hat, waren Verbesserungen in Kommunikation und Technologie. Beide zeigen sich an den archäologischen Funden in einem Schiff, das im Jahr 1323 bei Sinan vor der Südküste Koreas sank. Es war auf der Seidenstraße von China nach Japan unterwegs und mit tausenden von Keramikgegenständen beladen. Die bis heute erhaltenen Waren, Rechnungen und Etiketten erzählen von Kaufleuten, die von China nach Japan reisten, und von Mönchen, die andere Reisen unternahmen. Unzählige weitere Details aus den letzten paar Jahrtausenden sind für uns erhalten geblieben, aber die we-

nigsten sind so überzeugend wie das, was die Archäologie in Zeitkapseln wie Sinan, Pompeji, Herculaneum oder der *Mary Rose*, dem Flaggschiff Heinrichs VIII., gefunden hat. Sie alle liefern faszinierende Einblicke in die Netzwerke der Vergangenheit.

Auch das Digitalzeitalter wurde erst durch die Schrift möglich. Und wie die Schrift, so eröffnet uns auch das Internet die Aussicht, den Kreis unserer Beziehungen stark zu erweitern. Genau das versprachen anfangs die Gründer vieler sozialer Netzwerke. Aber haben sich die hochtrabenden Versprechungen erfüllt? Die Antwort lautet offenbar laut und deutlich „Nein". Trotz der Möglichkeit, mit einem Klick auf den „Freund"-Button neue Verbindungen herzustellen, führen die Facebook-Seiten der meisten Menschen nur zwischen 100 und 250 Namen auf – dies zeigte sich kürzlich in einer Studie an einer Million solcher Seiten. In einer unserer Studien gingen Tom Pollet und Sam Roberts der Frage nach, ob regelmäßige Facebook-Nutzer größere Beziehungsnetzwerke haben als Menschen, die Facebook nur gelegentlich nutzen. Dies war nicht der Fall. In zwei anderen Studien, die sich mit dem Nachrichtenaustausch in E-Mail- und Twitter-Communities beschäftigten, stellte sich heraus, dass diese ebenfalls in der Regel zwischen 100 und 200 Menschen umfassten.

Offenbar können wir die Zahl unserer zwischenmenschlichen Beziehungen selbst dann nicht radikal steigern, wenn die Technologie die Möglichkeit zu bieten scheint. Die Beschränkung liegt dabei nicht in der Zeit oder in den Erinnerungen an die Ereignisse, an denen wir oder unsere Freunde beteiligt waren, sondern vielmehr an dem begrenzten Raum, der in unserem Geist für Freunde zur Verfügung

steht. Es gibt aber noch einen anderen Grund, warum das Internet uns nicht in die Lage versetzt, größere oder komplexere Beziehungsnetzwerke zu pflegen: Wir finden den Aufbau neuer Beziehungen über textbasierte Medien nicht sonderlich befriedigend. Im Rahmen einer Studie von Tatiana Vlahovic und Sam Roberts sollten Versuchspersonen angeben, wie zufrieden sie in einem Zeitraum von zwei Wochen mit den Interaktionen mit ihren fünf besten Freunden waren. Dabei wurden persönliche Begegnungen und Kontakte über Skype als befriedigender eingeordnet als Interaktionen mit den gleichen Freunden, die über das Telefon, SMS, Instant Messenger oder soziale Netzwerke stattfanden. Zum Teil lag es daran, dass diese anderen Medien langsam und schwerfällig sind – wenn auf eine witzige Äußerung überhaupt eine Antwort kommt, trifft sie erst nach einer unvermeidlichen Verzögerung ein. Wenn sie dann da ist, hat sich die Begeisterung über den Austausch bereits gelegt. Skype schneidet offenbar deshalb besser ab, weil es das Gefühl schafft, sich gemeinsam in demselben Raum aufzuhalten und gemeinsam anwesend zu sein. Deshalb spielt sich auch der Austausch weit schneller ab, als es mit textbasierten Medien jemals möglich ist: Schon wenn ich meinen Witz erzähle, sehe ich, wie sich auf deinem Gesicht das Lächeln breitmacht. Dieser Effekt ist so wirksam, dass Witze, über die wir in der Kneipe begeistert sind, als E-Mail platt wirken. Außerdem verläuft der Austausch über Skype wie bei persönlichen Begegnungen über mehrere Kanäle (wir hören *und* sehen), was eine redundante Kommunikation möglich macht.

Eines haben die digitale Welt und die Milliarden Menschen, die heute in ihr verknüpft sind, erreicht: Sie haben die vorhandene Kommunikationstechnologie verstärkt. Ein Beispiel möge genügen: die Zahl der Wörter. Im Jahr 1950 umfasste die Weltbevölkerung 2,5 Mrd. Menschen, und die Zahl der Wörter in der englischen Sprache lag bei einer halben Million. Fünfzig Jahre später ist die Zahl der Wörter, wie Google NGRAM zeigt, auf über eine Millionen gestiegen, das heißt um 8000 neue Wörter im Jahr. In der gleichen Zeit ist die Weltbevölkerung noch schneller gewachsen, sodass sie heute mehr als 7 Mrd. Menschen umfasst. Das Wachstum des Wortschatzes wurde durch das Bevölkerungswachstum vorangetrieben und durch die Möglichkeiten von HTML, das 1993 von Tim Berners-Lee erfunden wurde, verstärkt. Die größere Bevölkerung und eine neue Technologie ließen gemeinsam durch den uralten Prozess der Verstärkung die Zahl der Wörter steigen, mit denen wir uns heute in unseren unzähligen sozialen Gemeinschaften verbinden. Das Gleiche hat sich auch bei den Bildern abgespielt, aber sie lassen sich, ganz ähnlich wie archäologische Objekte, nicht so einfach zählen wie Wörter. Das alles wird zwangsläufig die Folge haben, dass das Englische in mehrere neue Sprachen zerfällt, denn jeder Mensch und jede Gemeinschaft interagierender Menschen kommt nur mit einem begrenzten Wortschatz (ungefähr 60.000 Wörter) zurecht, die bekannt sind und regelmäßig genutzt werden.

Und noch etwas anderes fehlt in der digitalen Welt: die Berührung. Berührungen, selbst mit Fremden, sind ein wahrhaft wichtiger Teil unseres sozialen Umfeldes. Das gegenseitige Kraulen, das wir von unseren Primatenvorfahren geerbt haben, begleitet uns noch heute. Wie wir jemanden

berühren, kann mehr darüber aussagen, was wir wirklich meinen, als alle ausgesprochenen Worte. Worte sind etwas Mehrdeutiges: Je nach Betonung, Tonfall oder begleitenden Gesten kann ein Satz genau das Gegenteil dessen bedeuten, was seine Worte zu sagen scheinen. Das Problem der virtuellen Berührung hat bisher niemand gelöst, aber wenn das eines Tages geschieht, dürfte es für den Aufbau riesengroßer, durch enge Bindungen verknüpfter Gemeinschaften im Internet einen wichtigen Fortschritt darstellen.

Twitter war in der digitalen Welt natürlich ein ganz neues Phänomen, das vielfach als große demokratische Neuerung gefeiert wurde. Heute können wir mit einem Tastendruck Flashmobs und Massenproteste in Gang setzen. In einem gewissen Sinn stimmt es: Twitter spielte für die Koordination der Aufstände während des Arabischen Frühlings eine entscheidende Rolle. Aber Twitter kann keine Beziehungen schaffen – es ähnelt eher einem Leuchtturm, der seine Blitze in die Dunkelheit sendet, ganz gleich, ob draußen auf dem Meer ein Schiff ist, von dem aus man sie sehen kann. Diejenigen, die sich mit dem Phänomen beschäftigt haben, sind zu einer klaren Erkenntnis gelangt: Der Arabische Frühling hatte seine Wurzeln nicht in Twitter an sich, sondern in Netzwerken einer kleinen Zahl charismatischer Führer, die sich persönlich kannten und alles in Bewegung setzten. Twitter schafft die Möglichkeit, eine Versammlung an einem bestimmten Ort und zu einer bestimmten Zeit zu koordinieren, es schafft aber keine gesellschaftliche oder politische Bewegung. Diese entstehen wie kulturelle Errungenschaften aus den persönlichen Beziehungen zwischen Anführern und Anhängern – und die gleiche Gesetzmäßigkeit galt in unserer Geschichte schon immer.

Epilog: in großen Dimensionen denken

Mit unserer Ausbildung in Evolutionspsychologie und Archäologie haben wir als Autoren dieses Buches den Vorteil, dass wir einen Schritt zurücktreten und das große Bild betrachten können. Wir können in großem Denken schwelgen. In der ungeheuren Vielfalt der Verhaltensweisen moderner Menschen erkennen wir uralte, immer wiederkehrende Muster. Die Zunahme der Gehirngröße während der letzten 2 Mio. Jahre ist eine Reaktion auf Notwendigkeiten, die mit Sicherheit sozialer Natur waren und nicht im unmittelbaren Verhältnis zur Außenwelt, sondern innerhalb unserer eigenen Spezies wirksam wurden. Die Zunahme der Gehirngröße ging mit einer Größenzunahme der Menschengruppen einher – diese Beobachtung bildet das Kernstück der Theorie vom sozialen Gehirn, ist aber bei Weitem nicht alles. Die Korrelation mit der Gehirngröße gilt zwangsläufig nur näherungsweise. Der Körperbau der Menschen ist heute weniger vielgestaltig als vor 30.000 Jahren während der letzten Eiszeit, und unser Gehirn ist heute geringfügig kleiner. Aber die Gehirne aller Menschen gleichen sich in Größe und Aufbau, was ihnen die gleichen Fähigkeiten verleiht, ihnen aber auch die gleichen Beschränkungen auferlegt. Wirklich wichtig sind heute in unserem Alltagsleben die Dinge, die seit den Anfängen der Zeit immer wichtig waren, die Umstände von Geburt und Heranwachsen, die Freundschaften, die wir schließen, und die Gelegenheiten, die wir ergreifen.

Zu Beginn dieses Buches haben wir gefragt: „Wann wurde aus dem Gehirn der Homininen der Geist des Menschen?" Diese Frage hat einen Haken, den wir bis auf die Zeit zurückverfolgen können, als Linné unsere Spezies erstmals als *Homo sapiens* bezeichnet – als „klugen Menschen". Die Gattung *Homo* erscheint vor mehr als 2 Mio. Jahren erstmals auf der Bildfläche. Vermutlich sollten wir schon diese Vorfahren als Menschen bezeichnen und sie nicht mit recht rätselhaften Bezeichnungen wie „archaisch" von uns trennen. Wenn wir den Artnamen *sapiens* aus biologischen Gründen tragen, verlegt die Genetik ihn in die Zeit nach der Trennung von den Neandertaler-Vorfahren, und die Befunde an den Skeletten verlegen ihn nach Afrika in die Zeit vor rund 200.000 Jahren. Wenn wir uns fragen, ob wir die Menschen von Herto (die zu den ältesten anatomisch modernen Menschen gehören) zum Abendessen einladen würden, so müssen wir zugeben, dass solche Fragen etwas Künstliches haben. Selbst heute schafft die Kultur der modernen Menschen eine solche Vielfalt, dass ein Leser aus einem Industrieland sich angesichts der Unannehmlichkeiten im Leben der brasilianischen Yanomamo oder der Viehzüchter in der eurasischen Steppe nicht unbedingt wohlfühlen würde. Werden Menschen aus Kleingesellschaften in ein größeres Umfeld verpflanzt, empfinden auch sie Verwirrung – so ging es dem britischen Prinzen Caractacus, der im ersten Jahrhundert n. Chr. in Ketten nach Rom geschleppt wurde und dort seine Peiniger fragte: „Ihr habt doch das hier [Rom mit seinen prunkvollen Bauwerken] … Warum kommt ihr in unsere armen Hütten?" Solche Unterschiede sprechen nicht gegen die grundlegende Einheitlichkeit in den kulturellen Fähigkeiten aller heute lebenden Men-

schen. Und wenn wir noch einmal auf die Frage nach den Herto-Menschen zurückkommen wollen: Auch sie gehören zu uns. Die Vielfalt der modernen Menschen lässt sich auf gemeinsame Wurzeln zurückführen, die weniger als 200.000 Jahre alt sind, und in einem gewissen Sinn sind wir alle Vettern, wenn auch sehr entfernte Vettern. Der Kegel, der sich seit 200.000 Jahren erweitert, repräsentiert die Menschheit im umfassendsten Sinn des Wortes.

Kann die Theorie vom sozialen Gehirn auch dazu beitragen, den nächsten großen Widerspruch zu klären – dass nämlich diese modernen Menschen während der ersten 100.000 Jahre kaum etwas Modernes taten? Selbst wenn wir uns in vollem Umfang die Vorstellung von einer „Revolution der modernen Menschen" vor 50.000 Jahren zu eigen machen – was wir in diesem Buch nicht getan haben –, bleiben immer noch 40.000 Jahre und mehr, bevor die Menschen sich auf Landwirtschaft, Dörfer, Städte und Zivilisation verlegten. Vor dem Hintergrund der Vorstellung vom sozialen Gehirn erkennen wir, dass diese Ausweitung nur möglich war, weil die Menschen bereits über Ordnungen der Intentionalität, Sprache und Bindungsfähigkeit verfügten, alles Hilfsmittel für das Leben in größeren Gesellschaften. Wie die Landwirtschaft auch begann, in jedem Fall führte sie zu einer größeren Zahl von Menschen. Von da an wurden die Organisationsprinzipien, die wir auf den vorangegangenen Seiten skizziert haben, in der Spezies namens *Homo sapiens* unvermeidlich.

Ein dramatisches Beispiel aus unserer Zeit für die Kräfte des Wandels ist das Internet. Nur sehr wenige Menschen ahnten seine potentielle Macht voraus (und niemand konnte alle seine Folgen vorhersehen). Auf einer gewissen Ebe-

ne repräsentiert das Internet eine Verhaltensänderung der Menschen im weltweiten und auch speziesweiten Maßstab, und abgespielt hat sie sich innerhalb einer Generation seit 1993. Als einzelnen Bürgern steht es uns frei, diese elektronische Revolution zu ignorieren, aber das wird von Tag zu Tag weniger möglich. Sie durchdringt unser Leben von unserem Zuhause bis zum Arbeitsplatz und vom Strand bis ins Restaurant.

Auf einer anderen Ebene spielen aber immer noch die Beziehungsnetzwerke, von denen in diesem Buch die Rede war, die beherrschende Rolle. Internetriesen wie Facebook und Twitter verdanken ihren Erfolg dem Wunsch der Menschen nach sozialen Kontakten und Vernetzung. Und in der politischen Sphäre werden sie in gewisser Weise durch die Repräsentanten der Regierung „personifiziert" – persönlich gemacht. Gipfeltreffen wie G8 und G20 sind nur die Spitze dieses Eisberges. Interessant ist die Feststellung, dass es auf der Welt ungefähr 200 Staaten gibt (was im natürlichen Schwankungsbereich rund um die Dunbar-Zahl liegt), aber wenn man auf der Skala abwärts geht, haben die obersten 12 – und in geringerem Umfang die obersten 36 – mit Abstand am meisten zu sagen. Sie sind durch ihre Staatsoberhäupter vernetzt, aber auch durch Zusammenkünfte von Ministern und Beamten, die wiederum ihre eigenen ausgewählten Netzwerke haben. Durch diese Form der Vernetzung funktioniert die Welt. Wenn wir die entfernte Vergangenheit des sozialen Gehirns studieren, können wir unter anderem zeigen, dass Netzwerke in bestimmten Größenordnungen und mit einer bestimmten Intensität zwangsläufig existieren müssen (s. Abb. 7.2). Die Gegenwart funktioniert nur wegen der Vergangenheit, wie sie am

Abb. 7.2 Umfang und Komplexität des modernen Lebens verlangen dem sozialen Gehirn eine neue Fähigkeit zum Auswählen ab: Mit den alten Prinzipien der Netzwerke findet der Einzelne seine Wege durch das Leben. (© James R. Gowlett)

Lagerfeuer, auf der Jagd und in den Graslandschaften, in denen unsere Evolution stattfand, geprägt wurde. Soziale Netzwerke repräsentieren die angesagte Technik des Augenblicks, den „Vorsprung durch Technik". Aber bei allem Glamour, der von der neuesten Bindungs- und Kommunikationstechnologie ausgeht, haben die Prinzipien, die sich in ihr verkörpern, ihren Ursprung in unserer fernen Evolutionsvergangenheit.

Weiterführende Literatur

Kapitel 1: Psychologie trifft Archäologie

Eine detailliertere Einführung in das Lucy-Projekt und die dahinterstehenden Gedanken findet sich in Dunbar und Shultz (2007) und in den von den Projektmitgliedern herausgegebenen Büchern Dunbar et al. (2010), Allen et al. (2008) und Dunbar et al. (2013).

Die Notwendigkeit eines sozialwissenschaftlichen Ansatzes, wie wir ihn in in diesem Buch verfolgen, wurde in zwei kürzeren Artikeln der Autoren dargelegt: Gamble et al. (2011) und Gowlett et al. (2012). Der Gedanke, dass auch Klein- und Menschenaffen über soziale Intelligenz verfügen, auf dem die Hypothese vom sozialen Gehirn größtenteils basiert, wird umfassend dargestellt in der Artikelauswahl in Byrne und Whiten (1988). Belege für die Hypothese vom sozialen Gehirn selbst werden erläutert in Dunbar (1992).

Das Buch, dem das Projekt seinen Namen verdankt, ist *From Lucy to Language* von Johanson und Edgar (1996); es ist bis heute eine der am besten illustrierten Darstellungen der Evolution des Menschen, seit seinem Erscheinen vor fast zwanzig Jahren sind allerdings einige wichtige Fossil-

funde hinzugekommen. Das Buch von Stringer und Andrews (2011) bringt die Geschichte auf den neuesten Stand und hat seine besonderen Stärken bei der Evolution des *Homo sapiens*, also der sogenannten Jetztmenschen. Über neue Zugänge zur entfernten Vergangenheit und die Neubewertung des Faustkeils, durch den diese möglich wurden, berichtet Gamble und Kruszynski (2009).

Allen, NJ, Callan H, Dunbar RIM, James, W. (Hrsg) (2008) Early human kinship: from sex to social reproduction. Blackwell, Oxford

Byrne RW, Whiten R (1988) Machiavellian intelligence: social expertise and the evolution of intellect in monkeys, apes and humans. Clarendon Press, Oxford.

Childe VG (1951) Social evolution. Watts, London. [dt. Soziale Evolution.Üb. v. Sass HW. Suhrkamp, Franfurt 1968]

Dunbar RIM (1992) Neocortex size as a constraint on group size in primates. Journal of Human Evolution 22:469–493.

Dunbar RIM, Shultz S (Hrsg) (2007) Evolution in the social brain. Science 317:1344–1347.

Dunbar RIM, Gamble C, Gowlett JAJ (Hrsg) (2010) Social brain and distributed mind. Oxford University Press, Oxford. Proceedings of the British Academy 158.

Dunbar RIM, Gamble C, Gowlett, JAJ (Hrsg) (2013) The Lucy project: benchmark papers. Oxford University Press, Oxford.

Gamble C, Kruszynski R (2009), John Evans, Joseph Prestwich and the stone that shattered the time barrier.' Antiquity 83: 461–475.

Gamble C, Gowlett JAJ, Dunbar RIM (2011) The social brain and the shape of the Palaeolithic. Cambridge Archaeological Journal 21:115–135.

Gowlett JAJ, Gamble C, Dunbar RIM (2012) Human evolution and the archaeology of the social brain. Current Anthropology 53:693–722.

Johanson DC, Edgar B (1996) From Lucy to language. Simon & Schuster, New York [dt. Lucy und ihre Kinder. Übers. v. S. Vogel. Spektrum Akademischer Verlag, Heidelberg 1998; aktualisierte Ausgabe 2006].

Stringer C, Andrews P (2011) (2. Aufl.). The complete world of human evolution. Thames & Hudson, London.

Kapitel 2: Was ist ein soziales Wesen?

Einen allgemeinen Überblick über Struktur und Funktion menschlicher Gesellschaften gibt Dunbar (1996, 2008). Der ursprüngliche Vorschlag für die Dunbar-Zahl steht in Dunbar (1993), Belege dafür sind dort und in Dunbar (2008) zusammengefasst. Belege für die Schichtstruktur zwischenmenschlicher Netzwerke und die „Dreierregel" liefern Zhou et al. (2005); die Erkenntnis, dass dies auch für den Aufbau von Organisationen wie der Armee gilt, ist zusammenfassend dargestellt in Dunbar (2008, 2011, 2012) und in Lehmann et al. (2013). Informationen über die Funktionen der verschiedenen Schichten, die Bedeutung sozialer Interaktionen für ihre Aufrechterhaltung und die gesellschaftsfördernde Folgen finden sich in Roberts und Dunbar (2011), Sutcliffe et al. (2012) und Curry et al. (2013). Der Zusammenhang zwischen Netzwerkgröße, emotionaler Nähe und Gehirnvolumen wird erörtert in Stiller und Dunbar (2007), Dunbar (2008) und Powell et al. (2012)

Curry O, Roberts SBG, Dunbar RIM (2013) Altruism in social networks: evidence for a „kinship premium". British Journal of Psychology 104: 283–295.

Dunbar RIM (1993) Coevolution of neocortex size, group size and language in humans. Behavioral and Brain Sciences 16:681–735.

Dunbar RIM (1996) Grooming, gossip and the evolution of language. Faber & Faber, London. [dt. Klatsch und Tratsch: wie der Mensch zur Sprache fand. Übers. v. S. Vogel. C. Bertelsmann, München 1998]

Dunbar RIM (2004) The human story. Faber & Faber, London.

Dunbar RIM (2008) Mind the gap: or why humans aren't just great apes. Proceedings of the British Academy 154:403–423.

Dunbar RIM (2011), Constraints on the evolution of social institutions and their implications for information flow.' Journal of Institutional Economics 7:345–371.

Dunbar RIM (2012) Instant expert #21: evolution of social networks. New Scientist 214:1–8.

Dunbar RIM, Baron R, Frangou A, Pearce E, van Leeuwen EJC, Stow J, Partridge P, MacDonald I, Barra V, van Vugt M (2012) Social laughter is correlated with an elevated pain threshold. Proceedings of the Royal Society, London 279B:1161–1167.

Dunbar RIM, Kaskatis K, MacDonald I, Barra V (2012) Performance of music elevates pain threshold and positive affect. Evolutionary Psychology 10:688–702.

Lehmann J, Lee PC, Dunbar RIM (2013)2013. Unravelling the evolutionary function of communities. In Dunbar RIM, Gamble C, Gowlett JAJ (Hrsg), The Lucy project: benchmark papers. Oxford University Press, Oxford 245–276.

Powell J, Lewis PA, Roberts N, García-Fiñana M, Dunbar RIM (2012) Orbital prefrontal cortex volume predicts social network size: an imaging study of individual differences in humans. Proceedings of the Royal Society, London 279B:2157–2162.

Roberts SBG, Dunbar RIM (2011) The costs of family and friends: an 18-month longitudinal study of relationship maintenance and decay. Evolution and Human Behavior 32:186–197.

Stiller J, Dunbar RIM (2007), Perspective-taking and memory capacity predict social network size. Social Networks 29:93–104.

Sutcliffe AJ, Dunbar RIM, Binder J, Arrow H (2012) Relationships and the social brain: integrating psychological and evolutionary perspectives. British Journal of Psychology 103: 149–168.

Zhou W-X, Sornette D, Hill RA, Dunbar RIM 2005. Discrete hierarchical organization of social group sizes. Proceedings of the Royal Society, London 272B:439–44.

Kapitel 3: Sozialleben in alter Zeit

In diesem Kapitel bedienen wir uns des Kontextes von Nachbardisziplinen. Cilde und seine Bücher prägten die Archäologie und kommen in vielen Darstellungen vor, so auch in Daniel und Renfrew (1988). Die Bedeutung der Jäger und Sammler wird erläutert in *Man the hunter* (Lee und DeVore 1968); eingehend behandelt werden Völker und Anthropologen in Lee und Daly (1999). Unverzichtbar ist auch die Informationssammlung über Sammler und Jäger von Binford (2001). Eine evolutionsorientierte Sichtweise für die Bedeutung der Sozialanthropologie liefert Barnard (2011). Die unten stehende Liste nennt weitere wichtige Beiträge zur Anthropologie, zu anderen weit gefassten Aspekten des menschlichen Verhaltens und zur Primatenforschung, die insbesondere durch das Studium heutiger Menschenaffen viele Vorstellungen vom Ursprung des Menschen verändert hat.

Barnard A (2011) Social anthropology and human origins. Cambridge University Press, Cambridge.

Binford LR (2001) Constructing frames of reference: an analytical method for archaeological theory building using ethnographic and environmental datasets. University of California Press, Berkeley.

Boesch C (2012) Wild cultures: a comparison between chimpanzee and human cultures. Cambridge University Press, Cambridge.

Childe VG (1951) Social evolution. Watts, London. [dt. Soziale Evolution.Übers. v. Sass HW. Suhrkamp, Franfurt 1968]

Daniel G, Renfrew C (1988). The idea of prehistory. Edinburgh University Press, Edinburgh.

d'Errico F, Backwell L (Hrsg) (2005) From tools to symbols: from early hominids to modern humans. Witwatersrand University Press, Johannesburg.

Dillingham B, Carneiro RL (Hrsg) (1987) Leslie A. White's ethnological essays. University of New Mexico Press, Albuquerque.

Gowlett JAJ (2009) The longest transition or multiple revolutions? Curves and steps in the record of human origins. In Camps M, Chauhan P (Hrsg), A sourcebook of Palaeolithic transitions: methods, theories and interpretations. Springer, Berlin 65–78.

Gowlett JAJ (2009) Artefacts of apes, humans and others: towards comparative assessment. Journal of Human Evolution 57:401–410.

Lee RB, Daly R (1999) The Cambridge Encyclopaedia of Hunters and Gatherers. Cambridge University Press, Cambridge.

Lee RB, Devore I (Hrsg) (1968) Man the hunter. Aldine, Chicago.

McGrew WC, Marchant LF, Nishida T (Hrsg) (1996) Great ape societies. Cambridge University Press, Cambridge.

Moss C (1988) Elephant memories. Montana, London. [dt. Die Elefanten vom Kilimanscharo. Übers. v. Schröder I. Rasch und Röhring, Hamburg 1990].

Nelson E, Shultz S (2010) Finger length ratios (2d:4d) in anthropoids implicate reduced prenatal androgens in social bonding. American Journal of Physical Anthropology 141:395–405.

Nelson E, Rolian C, Cashmore L, Shultz S (2012) Digit ratios predict polygyny in early apes, *Ardipithecus*, Neanderthals and early modern humans but not in *Australopithecus*. Proceedings of the Royal Society, London 278B:1556–1563.

Roberts SGB (2010) Constraints on social networks. In Dunbar RIM, Gamble C, Gowlett JAJ (Hrsg) Social brain and distributed mind, Oxford University Press, Oxford. Proceedings of the British Academy 158, 115–134.

Runciman WG (2009) The theory of cultural and natural selection. Cambridge University Press, Cambridge.

Sahlins M (1974) Stone Age economics. Tavistock Publications, London.

Shennan SJ (2002) Genes, memes and human history: Darwinian archaeology and cultural evolution. Thames & Hudson, London.

Kapitel 4: Vorfahren mit kleinem Gehirn

In diesem Kapitel beschäftigen wir uns mit den ältesten Homininen und ihren Nachkommen, den Australopithecinen. Die meisten neuen Homininenfunde werden in den wichtigen Fachzeitschriften *Nature* und *Science* publiziert, mehr Einzelheiten finden sich im *Journal of Human Evolution*, dem *American Journal of Physical Anthropology* und dem französischen Fachblatt *Palevol*. Über die Projekte in Ostafrika berichten auch große Monographien wie die Olduvai-Serie (z. B. Leakey 1971). Reynolds und Gallagher (2012) enthält viele Artikel mit Einzelheiten über die Funde aus Afrika. Die Frühzeit in Asien wird erörtert in Dennell (2009). Über die ältesten Funde aus Dmanisi berichten Lordkipanidze et al (2013).

Die Gehirngröße der fossilen Homininen und ihre Einteilung werden behandelt in Aiello und Dunbar (1993); dort werden auch die Methoden zur Berechnung der Grup-

pengröße erläutert. Aktualisierte Berechnungen mit überarbeiteten Gleichungen finden sich in Dunbar (2009). Wood und Lonergan geben einen gut verständlichen Überblick über die Benennung der fossilen Vorfahren und ihre Gruppierung durch „Lumper" und „Splitter". Ein klassischer Aufsatz von Lovejoy (1981) kennzeichnet die moderne Sichtweise, in der fossile oder archäologische Überreste nicht mehr nur beschrieben, sondern als Homininen mit kulturellen und körperlichen Anpassungen betrachtet werden, die sich in der Evolution aufgrund verschiedener Formen von Selektionsdruck entwickelt haben. Wie wertvoll dieser Ansatz ist, zeigt die kürzlich erschienene Beschreibung des wichtigen Fossils von *Ardipithecus* in einer Sonderausgabe von *Science* (Bd. 326, 2009). Einen umfassenden Überblick über Steinwerkzeuge geben Schick und Toth (1993).

Aiello L, Dunbar RIM (1993) Neocortex size, group size and the evolution of language. Current Anthropology 34:184–193.

Brain CK (1981) The hunters or the hunted? An introduction to African cave taphonomy. University of Chicago Press, Chicago.

Dennell R (2009) The Palaeolithic settlement of Asia. Cambridge University Press, Cambridge.

Domínguez-Rodrigo M (Hrsg). 2012. Stone tools and fossil bones: debates in the archaeology of human origins. Cambridge University Press, Cambridge.

Dunbar RIM (2009) Why only humans have language In Botha R, Knight C (Hrsg), The prehistory of language, Oxford University Press, Oxford, 12–35.

Gamble C (2014) Settling the Earth: the archaeology of deep human history. Cambridge University Press, Cambridge.

Holdaway S, Stern N (2004) A record in stone: the study of Australia's flaked stone artefacts. Victoria Museum, Melbourne.

Leakey MD (1971) Olduvai Gorge: excavations in Beds I and II 1960–1963. Cambridge University Press, Cambridge.

Lordkipanidze D, Ponce de Leon MS, Margvelashvili A, Rak Y, Rightmire GP, Vekua A, Zollikofer CPE (2013) A complete skull from Dmanisi, Georgia, and the evolutionary biology of Early *Homo*. Science 342:326–331.

Lovejoy CO (1981) The origin of man. Science 211:341–350.

Lycett SJ, Chauhan PR (2010) New perspectives on old stones: analytical approaches to Paleolithic technologies. Springer, Dordrecht.

Reynolds SC, Gallagher A (Hrsg) (2012) African genesis: perspectives on hominin evolution. Cambridge University Press, Cambridge.

Schick KD, Toth N (1993) Making silent stones speak: human evolution and the dawn of technology. Simon & Schuster, New York.

Suwa G, Asfaw B, Kono RT, Kubo D, Lovejoy CO, White TD (2009) The *Ardipithecus ramidus* skull and its implications for hominid origins. Science 326: 68e1–7.

de la Torre I (2011) The origins of stone tool technology in Africa: a historical perspective. Philosophical Transactions of the Royal Society of London B 366:1028–1037.

de Waal F (1982) Chimpanzee politics. Johnathan Cape, London. [dt. Unsere haarigen Vettern: neueste Erfahrungen mit Schimpansen. Übers. v. Summerer S, Kurz G. Harnack, München 1983].

de Waal F (2006) Primates and philosophers: how morality evolved. Princeton University Press, Princeton [dt. Primaten und Philosophen: wie die Evolution die Moral hervorbrachte. Übers. v. Schickert H. Hanser, München 2008].

Wood B, Lonergan N (2008) The hominin fossil record: taxa, grades and clades. Journal of Anatomy 212:354–376.

Kapitel 5: Die Nische der Menschen wird aufgebaut: drei entscheidende Fähigkeiten

In diesem Kapitel haben wir uns auf drei Hauptthemen konzentriert: Faustkeile, Feuer und Sprache. Gren-Inbar und Sharon (2006) lassen dem ersten Gerechtigkeit widerfahren, Machins 2009 erschienener Artikel befasst sich mit den sozialen Folgerungen. Das Feuer wird in mehreren Büchern und Artikeln aus der unten stehenden Liste behandelt. Deacon (1997) gibt einen ausgezeichneten Überblick über den Zusammenhang der Sprachevolution, über den er auch in unserem Konferenzband (Dunbar et al. (2010) geschrieben hat. Aiello und Dunbar (1993) liefern die klassischen Grundkenntnisse über den Zusammenhang zwischen Gehirngröße, Gruppengröße und die Ursprünge der Sprache. MacLarnon und Hewitt (2004) und Martinez, Rosa und Arsuaga berichten über anatomische Befunde im Zusammenhang mit der Entstehung der Sprache.

Aiello L, Dunbar RIM (1993) Neocortex size, group size and the evolution of language. Current Anthropology 34:184–193.

Aiello L, Wheeler P (1995) The expensive-tissue hypothesis: the brain and the digestive system in human and primate evolution. Current Anthropology 36:199–221.

Alperson-Afil N, Goren-Inbar N (2010) The Acheulian site of Gesher Benot Ya'aqov. Volume II: Ancient flames and controlled use of fire. Springer, Dordrecht.

Deacon T (1997) The symbolic species: the co-evolution of language and the human brain. Allen Lane, The Penguin Press, London.

Dunbar RIM, Gamble C, Gowlett JAJ (Hrsg) (2010) Social brain and distributed mind. Oxford University Press, Oxford. Proceedings of the British Academy 158.

Goren-Inbar N, Sharon G (Hrasg) (2006) Axe age: Acheulian toolmaking from quarry to discard. Equinox, London.

Gowlett JAJ (2010) Firing up the social social brain. In Dunbar, Gamble, Gowlett, 341–366.

Gowlett, JAJ (2011) The empire of the Acheulean strikes back. In Sept, Pilbeam, 93–114.

Gowlett JAJ, Wrangham RW (2013) Earliest fire in Africa: the convergence of archaeological evidence and the cooking hypothesis. Azania: Archaeological Research in Africa 48:5–30.

Isaac B (Hrsg) (1989) The archaeology of human origins: papers by Glynn Isaac. Cambridge University Press, Cambridge.

Lycett SJ, Gowlett JAJ (2008) On questions surrounding the Acheulean „tradition". World Archaeology 40(3):295–315.

Lycett SJ, Norton CJ (2010) A demographic model for palaeolithic technological evolution: the case of East Asia and the Movius Line. Quaternary International 211:55–65.

Machin A (2009) The role of the individual agent in Acheulean biface variability: a multi-factorial model. Journal of Social Archaeology 9(1):35–58.

MacLarnon AM, Hewitt GP (2004) Increased breathing control: another factor in the evolution of human language. Evolutionary Anthropology 13:181–197.

Martinez M, Rosa M, Arsuaga J-L, et al. 2004. Auditory capacities in Middle Pleistocene humans from the Sierra de Atapuerca in Spain. Proceedings of the National Academy of Sciences USA 101:9976–9981.

Sept J, Pilbeam D (Hrsg) (2011) Casting the net wide. Studies in honor of Glynn Isaac and his approach to human origins research. American School of Prehistoric Research Monograph Series. Peabody Museum, Harvard.

Walker A, Leakey R (Hrsg) (1993) The Nariokotome *Homo erectus* skeleton. Harvard University Press, Cambridge MA.

Wrangham RW (2009) Catching fire: how cooking made us human. Profile Books, London. [dt. Feuer fangen: wie uns das Kochen zum Menschen machte – eine neue Theorie der menschlichen Evolution. Übers. v. Rennert U. DVA, München 2009].

Kapitel 6: Vorfahren mit großem Gehirn

Die drastische Ausweitung von Technologie und Kultur, die sich vor 50.000 Jahren abspielte, wird häufig als menschliche Revolution bezeichnet. In diesem Kapitel betrachten wir dagegen unter dem Gesichtspunkt des sozialen Gehirns viel ältere Wurzeln der charakteristischen Facetten des Menschseins. Was Musik und Verwandtschaft angeht, empfehlen wir die zwei von Bannan (2012) und Allen et al. (2008) herausgegebenen Werke. Lewis-Williams (2003) liefert nach wie vor Anregungen für einen kognitiv orientierten Ansatz zur Erforschung der Vergangenheit: Er untersucht die Verbindungen zwischen der ältesten Kunst und dem Schamanismus; die Rolle der Gefühle in der Evolution des Menschen wird untersucht von Turner (2000). Die Auswirkungen dieses evolutionären Wandels auf unsere Verbreitung als globale Spezies untersucht Gamble (2014). Ein wertvoller Leitfaden zur Archäogenetik früherer Menschenpopulationen findet sich in Oppenheimer (2004).

Allen NJ, Callan H, Dunbar RIM, James W (Hrsg) (2008) Early human kinship: from sex to social reproduction. Blackwell, Oxford.

Bannan N (Hrsg) (2012) Music, language, and human evolution. Oxford University Press, Oxford.

Evans D (2004) The search hypothesis of emotion. In Evans, Cruse 179–191.

Evans D, Cruse P (Hrsg) (2004) Emotion, evolution and rationality. Oxford University Press, Oxford.

Gamble C (2007) Origins and revolutions: human identity in earliest prehistory. Cambridge University Press, New York.

Gamble C (2012) When the words dry up: music and material metaphors half a million years ago. In Bannan, 85–106.

Gamble C (2014) Settling the Earth: the archaeology of deep human history. Cambridge University Press, Cambridge.

Green RE, Krause J, Briggs AW et al. (2010) A draft sequence of the Neandertal genome. Science 328:710–722.

Lewis-Williams D (2003) The mind in the cave. Thames & Hudson, London.

Mellars P, Bar-Yosef O, Stringer C, Boyle KV (Hrsg) (2007) Rethinking the human revolution. McDonald Institute, Cambridge.

Mithen S (2005) The singing Neanderthals: the origins of music, language, mind and body. Weidenfeld & Nicolson, London.

Noonan JP, Coop G, Kudaravalli S et al (2006) Sequencing and analysis of Neanderthal genomic DNA. Science 314: 1113–1118.

Oppenheimer S (2004) Out of Eden: the peopling of the world. Robinson, London.

Papagianni D, Morse MA (2013) The Neanderthals rediscovered: how modern science is rewriting the story. Thames & Hudson, London.

Pearce E, Stringer C, Dunbar RIM (2013) New insights into differences in brain organization between Neanderthals and anatomically modern humans. Proceedings of the Royal Society, London 280B: doi: 10.1098/rspb.2013.0168.

Pettitt PB (2011) The Palaeolithic origins of human burial. Routledge, London.

Rightmire GP (2004) Brain size and encephalization in early to mid-Pleistocene *Homo*. American Journal of Physical Anthropology 124:109–23.

Shryock A, Trautmann T, Gamble C (2011) Imagining the human in deep time. In Shryock A, Smail DL (Hrsg), Deep history: the architecture of past and present, University of California Press, Berkeley 21–52.

Stringer C (2006) Homo britannicus: the incredible story of human life in Britain. Penguin, London.

Stringer C, Gamble C (1993) In search of the Neanderthals: solving the puzzle of human origins. Thames & Hudson, London.

Turner JH (2000) On the origins of human emotions: a sociological inquiry into the evolution of human affect. Stanford University Press, Stanford.

Wood B, Lonergan N (2008) The hominin fossil record: taxa, grades and clades. Journal of Anatomy 212:354–376.

Kapitel 7: Leben in großen Gesellschaften

Der Klimawandel, die Zunahme von Naturkatastrophen und die globale Bevölkerungsexplosion werden aus Sicht der Archäologie und Vulkanologie gut behandelt von Fagan (2008) und Oppenheimer (2011). Die Verknüpfung der alten und modernen Welten sowie die Fähigkeit kleiner Dinge, große Geschichten zu erzählen, werden deutlich in MacGregor (2010).

Boyer P (2001) Religion explained: the human instincts that fashion gods, spirits and ancestors. William Heinemann, London. [dt. Und Mensch schuf Gott. Übers. v. Enderwitz U, Noll M, Schubert R. Klett-Cotta, Stuttgart 2011].

Coward F (2010) Small worlds, material culture and ancient near eastern social networks. In Dunbar RIM, Gamble C, Gowlett JAJ (Hasg) Social brain and distributed mind. Oxford University Press, Oxford. Proceedings of the British Academy 158, 449–480.

Coward F, Gamble C (2008) Big brains, small worlds: material culture and the evolution of mind. Philosophical Transactions of the Royal Society of London B 363:1969–1979.

Dietrich O, Heun M, Notroff J, Schmidt K, Zarnkow M (2012) The role of cult and feasting in the emergence of Neolithic communities. New evidence from Göbekli Tepe, south-eastern Turkey. Antiquity 86:674–95.

Fagan BM (2008) The great warming: climate change and the rise and fall of civilizations. Bloomsbury Press, London.

Foley R, Gamble C (2009) The ecology of social transitions in human evolution. Philosophical Transactions of the Royal Society of London B 364:3267–3279.

Johnson AW, Earle T (1987) The evolution of human societies: From foraging group to agrarian state. Stanford University Press.

MacGregor N (2010) The history of the world in 100 objects. British Museum Press, London.

Oppenheimer C (2011) Eruptions that shook the world. Cambridge University Press, Cambridge.

Trigger BG (2003) Understanding early civilizations: a comparative study. Cambridge University Press, Cambridge.

Van Vugt M, Ahuja A (2011) Selected: why some people lead, why others follow, and why it matters. Random House, Toronto.

Sachverzeichnis

Printing: Ten Brink, Meppel, The Netherlands
Binding: PHOENIX PRINT, Würzburg, Germany